Turner Barry Venning

ART&IDEAS

Turner

Introduction 4

1 **The Lesser Walks of Art**

Training and Early Years 11

2 **Nationality with All Her Littleness**

In the Shadow of Napoleon 59

3 **Beaten by Frost**

The Later War Years and Beyond 117

4 **Yellow Fever**

Italy and Its Impact 153

5 **The First Genius of Thermodynamics**

Art, Science and History 199

6 **The Graduate of Oxford**

Turner, Ruskin and *Modern Painters* 243

7 **The Last Days of Admiral Booth**

The Final Years 279

8 **From Maiden Lane to Fifth Avenue**

Turner's Posterity 301

& Glossary 330

Brief Biographies 332

Key Dates 337

Map 342

Further Reading 343

Index 345

Acknowledgements 350

Opposite
Dido Building Carthage; or the Rise of the Carthaginian Empire, (detail of 78), 1815. Oil on canvas; 155·5× 232 cm, 61¼×91⅜ in. National Gallery, London

In 1796 Joseph Mallord William Turner (1775–1851) exhibited
a watercolour entitled *St Erasmus and Bishop Islip's Chapel*
(1), an interior view of Westminster Abbey, London. It is an
impressive performance by a young artist who had already
spent several years perfecting his skills as an architectural
draughtsman. In one important respect, it differs from his
other paintings of gothic buildings: he signed it by placing his
name and his date of birth in Latin on a tomb slab in the left
foreground. It is tempting to assume that a 21-year-old painter
who stakes his claim to such a prestigious resting place is
being either tongue-in-cheek or presumptuous, but in Turner's
case it is a sign of his overwhelming ambition and deep faith
in his own powers. As a young man he sought and achieved
wealth, status and the recognition of his peers. He went on
to demonstrate his mastery of all forms of landscape, but also
tried his hand at genre and history painting, and, with his
patriotism sharpened by the Napoleonic Wars, he measured
himself against the continental painters of his day. In fact, as
he grew older, his ambitions became correspondingly larger until
finally he demanded nothing less than a place in the canon of
European painting, alongside the past masters he most admired.

St Erasmus and Bishop Islip's Chapel introduces the themes of
mortality and immortality that occur with increasing frequency
in Turner's middle and later years. As he grew older he became
more conscious of the brevity of life and the frailty of human
ambitions. He tended to keep silent about his religious beliefs,
but there is little to suggest that he was consoled by the
Christian promise of salvation, and it may be that the only
immortality he envisaged was his posthumous reputation,
hence the tenacity with which he strove to keep his name
before the public. In this he was triumphantly successful –

1
St Erasmus and Bishop Islip's Chapel, Westminster Abbey, 1796. Watercolour and pencil; 54·6×39·8 cm, 21½×15¾ in. British Museum, London

Turner has never been more popular than he is now, more than a century and a half after his death. Major exhibitions of his work are mounted all over the world, a controversial prize for contemporary British art bears his name, and scholars submit his massive and varied output to close and continued scrutiny. Paradoxically, the prodigious quantity of his surviving works – his bequest to the nation alone includes over 300 oils and more than 30,000 watercolours and pencil sketches – is one of the main reasons why historians have found it difficult to understand him and to summarize his achievements.

Turner's original public, who saw only the exhibited and engraved pictures, found it easy to admire his early works,

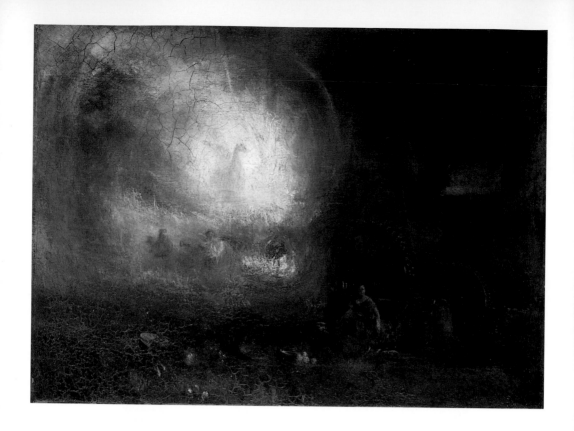

because they were highly skilled, descriptive and easily placed within the existing tradition of landscape painting. His style changed so dramatically over his career, however, that many of the later oils, such as *The Angel Standing in the Sun* (see 170), often produced bafflement and hostility. Their chromatic brilliance, unconventional compositions, scant detail and emphasis on the material qualities of the paint itself were unparalleled in contemporary British art. To his detractors these qualities seemed perverse; they variously dubbed him 'the William Blake of landscape painters' (Blake's name was a byword for the irrational and eccentric), castigated him as a bad example for young artists, and memorably likened his pictures to the contents of a hospital spittoon. Time has reversed these judgements, and Turner's later paintings now hold few terrors for a public familiar with the development of Modernist art. Hindsight allows us to compare his output with later artists' work from Monet to Rothko (see Chapter 8). He has often

emerged from these comparisons looking like a prophet – someone for whom colour and the physical properties of paint became gradually more important than the subject matter.

Nevertheless, the modern enthusiasm for Turner has been secured at a price. His contemporaries knew him to be a complex artist, and if they found some of his work difficult to understand, it was for good reasons: in his attempt to communicate complex meanings he sometimes made unreasonable demands of them. The more recent view of him as ahead of his time oversimplifies his achievements, principally by focusing on the late pictures or the many unfinished, private works that became widely known only after Turner's death, when he left the contents of his studio and gallery to the nation. Since the 1960s scholars such as Lawrence Gowing or Ronald Paulson have represented these works as the 'true' Turner and played down the significance of his earlier work. The differences between such modern responses to Turner and those of his contemporaries are highlighted by his oil painting entitled *The Hero of a Hundred Fights* (2). When he began it after 1800, it represented an interior with industrial machinery, the function of which has never been identified. Turner dramatically reworked it forty years later, which meant that the extremes of his early and late styles were compressed into the same picture. Most contemporary reviewers were so shocked by the newly added burst of colour on the left that they did not notice the stylistic mismatch. A modern viewer on the other hand, who is more attuned to the late Turner, is likely to be surprised at the precision with which he has depicted the machinery on the right. And because it is often assumed that Turner's works are primarily studies in light, colour and atmosphere that can be taken in at a glance, it is easy to overlook the meanings of the image. When Turner repainted *The Hero of a Hundred Fights* he gave it a topical and patriotic subject. In its final form it represents the casting in 1845 of the equestrian statue by Matthew Cotes Wyatt (1777–1862) commemorating the achievements of the Duke of Wellington (see 175).

2
The Hero of a Hundred Fights, c.1800–10, reworked 1847.
Oil on canvas; 91×121cm, 35³₄×47⁵₈ in.
Tate, London

This example illustrates some of the dangers of approaching Turner with exclusively modern preoccupations. If we wish to understand the creative decisions and problems that faced him, or indeed to appreciate quite how audacious he was, we must look at his work in its original contexts. Turner is often situated within the Romantic movement, along with William Blake (1757–1827), Caspar David Friedrich (1774–1840) and Eugène Delacroix (1798–1863), not necessarily because their works look similar but because they shared many attitudes and ideas. The painters and writers who are described as Romantic are usually those who distrusted artistic rules and precepts but exalted imagination, experience, originality and expressive power. Their art is generally contrasted with the contemporary style known as Neoclassicism, whose practitioners, including Jacques-Louis David (1748–1825) and Jean-Auguste-Dominique Ingres (1780–1867), took their cue from the artistic legacy of ancient Greece and Rome. Landscape played a lesser role in Neoclassicism than it did in the Romantic movement, where nature was used by poets and artists as the vehicle for expressing a range of strong emotions. Like the poet William Wordsworth, John Constable (1776–1837) and Friedrich used the landscape to embody religious sentiments, while John Martin (1789–1854) is principally remembered for cataclysmic scenes in which human frailty confronts nature at its most hostile. The range of Turner's imagery is wider than theirs, or indeed of any landscape painter whatsoever, and while the term 'Romantic' is a convenient shorthand way of characterizing many aspects of his art, it can also tend to exclude or mis-represent others. In order to explore the breadth of Turner's interests, therefore, this book avoids the major style labels of the period. It presents him as an artist who sought to address the dramatic changes of the nineteenth century, but whose tastes and ideas were formed in the eighteenth. The greatest influence on his artistic outlook was Sir Joshua Reynolds (1723–92), the only modern poet he extravagantly admired was Lord Byron, and there is no evidence that he ever read a novel.

Turner and his contemporaries knew, however, that they were living through an extraordinary epoch – one that witnessed, among other things, industrialization, urban growth, the rise of nationalism, constitutional reform and, above all, prolonged warfare with France. From his earliest beginnings as a water-colour painter, Turner realized the extent to which Britain's architecture and scenery bore the imprint of its history, but these recent events also left their mark on the landscape, and this allowed him to render both the nation's past and its present in his art. Occasionally he would compare the two in an attempt to place modern Britain within an overall scheme of human history.

Turner's concern both with historical events and with history seen as a process is a distinctive feature of his output. During his lifetime history became an academic discipline, taught and practised by salaried professors at the great European universities. Its most influential exponent was the German scholar Leopold von Ranke, who believed that the historian had a duty to be as objective as possible and to carry out painstaking archival research to uncover 'what essentially happened' in the past. Turner's vision of history was very different. It was shaped from a miscellany of sources that included conventional historical texts but also travel literature, legends, the local histories penned by amateurs and antiquarians, and poetry, especially Lord Byron's fictionalized account of his European travels, *Childe Harold's Pilgrimage* (1812–18). They led Turner to hint in his paintings that there might be parallels between the fortunes of earlier societies and the prospects for his own.

The unprecedented social and historical changes that took place during Turner's career had enormous implications for British culture. Long-established ideas concerning the visual arts were in a state of flux, especially the assumption that 'taste' was the preserve of a privileged, landed élite. Turner's early patrons, and indeed his opponents, such as Sir George Beaumont, were drawn from this élite, but they were gradually

superseded by those who made their money in commerce or the manufacturing industries. One effect of this change was that talking and writing about art were no longer the prerogatives of wealthy connoisseurs – John Ruskin (1819–1900), the most profound and influential of all Turner critics, came from the new merchant class. Turner himself did not find it easy to express his ideas in writing, but he felt a real compulsion to do so as a poet, lecturer and theorist. His reflections on painting in general, and his own practice in particular, had significant repercussions for his work.

The main aim of this book is to place Turner's output in its historical context, but it would be a mistake to immobilize it in the past. Every era brings its own values and concerns to bear when approaching the art of its predecessors, and the painters who exert a continuing fascination are those whose work is rich enough to support a range of historical and critical interpretations. Turner's art is of this kind. His admirers have included the novelist Marcel Proust, the composer Claude Debussy and the philosopher Gilles Deleuze, but ultimately it is largely because his paintings had so much to offer later generations of artists that they still seem important. Unlike art historians, painters are not constrained by demands that they should be objective, and when an artist such as Mark Rothko (1903–70) looked at Turner's work, he did so in the light of aesthetic problems or choices he encountered in his own practice, just as Turner did in his dealings with the Old Masters. The extent to which this led Rothko and others to form genuine insights into the art of their great forebear is the subject of the book's final chapter.

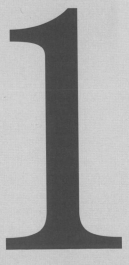

At first sight, J M W Turner's origins and early years seem an inauspicious start to the career of a great painter. He was born in 1775, the same year as the novelist Jane Austen, and, although the exact date is unknown, he later claimed (perhaps from patriotic zeal) that it was 23 April, St George's Day. His father, William Turner, was a barber and wigmaker; his mother, born Mary Marshall, came from a line of prosperous London butchers but stood little chance of inheriting any of her family's wealth. Reliable information concerning Turner's youth is scant, and historians still use Walter Thornbury's account, the first substantial but much criticized biography of the artist, published in 1861. Turner's mother remains a shadowy figure, partly because the artist seems to have discouraged any reference to her once he became successful. Thornbury described her as a woman of 'ungovernable temper', and her instability led to her confinement in Bethlem (or Bedlam) hospital, where the mentally ill were subject to harsh treatment and filthy conditions. Mary Turner died on 15 April 1804, by which time her son was a full member of the Royal Academy and his mother's situation would have been an embarrassment to him. With his father (4), on the other hand, Turner had a powerful and enduring emotional bond. Turner senior eventually gave up his own profession to look after his son, support his career and provide him with a stable home. He also became the painter's studio assistant, priming his canvases and occasionally providing them with home-made stretchers. Their closeness, combined with Turner's distrust of what he termed 'Woman's temper', precluded the possibility of marriage. When, in later life, he did have long-term liaisons with women, they were virtually clandestine.

It seems likely that most of Turner's formative years were spent in the vicinity of Covent Garden in central London, which had

3
Aeneas and the Sibyl, Lake Avernus, 1798.
Oil on canvas;
76·5×98·5 cm, 30⅛×38¾ in.
Tate, London

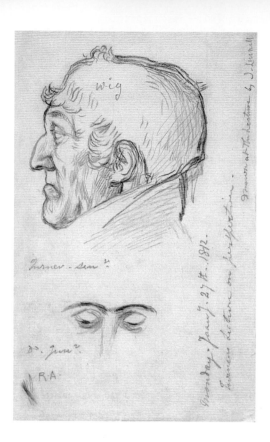

wig

Turner - Sen.

D.° Jun.

R.A.

Drawn at The Lecture by J. Linnell

Monday - January 27th - 1812.
Turner's Lecture on perspective.

4
John
Linnell,
*Turner's
Father, with
a Sketch of
Turner's
Eyes, Made
During a
Lecture,*
1812.
Pencil;
22·5×18·9 cm,
$8^7_8 × 7^1_2$ in.
Tate, London

5
Samuel
Scott,
*Covent
Garden
Piazza,*
c.1750.
Oil on canvas;
110×166·7 cm,
$43^3_8 × 65^5_8$ in.
Museum
of London

been a fashionable district in the early eighteenth century. By 1750, the date of Samuel Scott's view of *Covent Garden Piazza* (5), it was as famous for its taverns, gambling dens and whorehouses as it was for its fruit and flower markets, or the many trades that flourished nearby. Turner's father rented premises in Maiden Lane, a narrow street not far from the piazza and near London's principal theatre district. Although the environment was insalubrious, it was also a thriving artistic quarter just north of the Royal Academy of Arts in Somerset House, on the Strand (6). William Turner displayed his son's earliest drawings in his shop window, where they received professional scrutiny from such clients as the academician Thomas Stothard (1755–1834).

In some respects Turner was handicapped by his background. His speech, his dress, his manners and his education were a constant reminder that he was different from most of his Royal

Academy colleagues. Modern historians tend to analyse societies in terms of class, but when Turner was a child contemporaries used a different vocabulary of 'ranks' and 'orders' to describe their highly stratified society. They maintained a keen awareness of ancestry, wealth, religion, occupation, connections and locality, all of which helped to determine an individual's place in the social order. These fine discriminations of status are familiar to the modern reading public because they play such an important part in the fiction of Jane Austen. As a barber's son, Turner occupied a situation above the mass of semi-skilled and unskilled labourers but beneath the wealthier professional groups. His values and outlook were shaped by the fact that his father was a self-employed tradesman. It is in this context that one should understand the frequent allegations of miserliness that were levelled against him once he became successful, for, as he recalled, his father 'never praised him for anything except saving a half-penny'. These inherited values may also explain why, in his early years at least, he could sometimes be inept in his dealings with aristocratic clients. In 1801, having received

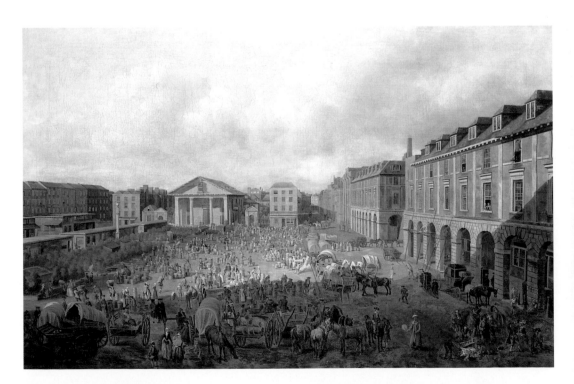

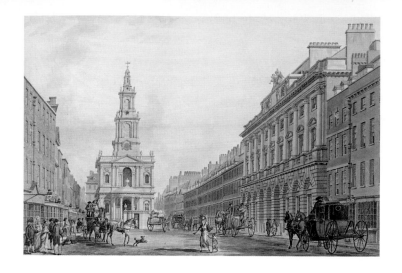

the high price of 250 guineas (a guinea was worth £1 1 shilling) from the Duke of Bridgewater for his *Dutch Boats in a Gale* (see 33), Turner later tried to obtain a further 20 guineas for the frame. Strictly speaking, he was entitled to charge for the cost of framing, but his colleagues thought he was short-sighted to do so, and the duke misread his behaviour as sharp practice.

However stratified English society may have been, individuals of outstanding merit could rise above the low status to which they were consigned by birth. William Wordsworth's father was a yeoman or small landholder, yet Wordsworth became Poet Laureate, one of his brothers Master of Trinity College, Cambridge, and another a sea captain with the East India Company. Turner's colleagues at the Royal Academy included others who came from the lower orders, such as his close friend the architect John Soane (1753–1837), who was the son of a bricklayer and builder, or the sculptor Francis Chantrey (1781–1841), whose father was a carpenter (both were later knighted). But whereas Chantrey developed the social skills and sophistication necessary to become, as one contemporary described him, 'at ease in the company of princes', Turner could never kick over the traces of his early life. As a result he was ridiculed for his pronunciation when he spoke in public and repeatedly passed over for a knighthood. Their obscure origins

were doubtless partly responsible for the driving ambition that Chantrey and Turner shared, but the more successful they became, the more likely they were to feel insecure in a milieu for which their upbringing had not prepared them. Even Chantrey, who became a social and political insider, suffered mild vertigo when he reflected on his rise from delivering milk in Sheffield to carving a monument to the bishop of Calcutta. Turner was keenly aware of his artistic abilities, but in social terms he was less self-assured than Chantrey, and this may help to explain his fervent belief in the concept of genius. As far as he was concerned, it took precedence over all distinctions of birth, and he expected his noble clients to treat him with due respect.

Little is known of Turner's early schooling, but one point is beyond dispute: he did not receive the level of education generally required in order to achieve a high status within his chosen profession. In Georgian England, education was not regulated by the state; nor was it freely available, since all but the relatively small number of charitable schools charged fees. In his *Inquiry into the Nature and Causes of the Wealth of Nations* (1776) the economist Adam Smith deplored this state of affairs, contrasting it with Scotland, where a system of parish schools 'taught almost the whole common people to read, and a very great proportion of them to write and account'.

In 1785 Turner was sent to stay with his uncle at Brentford, west of London, where he became a pupil at John White's free school. Thornbury allowed his imagination free rein with this episode in Turner's life, conjuring up playground fights, beatings and struggles with Latin grammar. In reality the education Turner received at Brentford, and in a similar establishment at Margate in Kent the following year, may have been quite rudimentary, for the sketchbooks he used in adult life often contain notes that reveal his persistent attempts to fill the gaps in his knowledge. In this he was far from unique: both the great radical journalist William Cobbett and the celebrated mathematician Charles Hutton also had to educate themselves.

The inadequacy of Turner's formal schooling had far-reaching implications for his later career. He may have lacked the cultural framework that a privileged education provided, but he had a powerful intellect and great energy, which he used to teach himself in an unsystematic but voracious campaign of reading. After conversing with Turner at a Royal Academy dinner in 1813, John Constable tellingly described him as 'uncouth' yet remarkable for his 'wonderful range of mind'. This self-acquired erudition went far beyond the typical curriculum of the day, and when Turner brought it to bear on his art, sometimes unexpectedly combining ideas from different areas of his knowledge, few were capable of following all his meanings.

Although Turner could widen his intellectual horizons through his own efforts, he could do little to disguise his awkwardness with the English language. The artist and critic Roger Fry (1866–1934) was consulted in 1902 about a scheme to publish the lectures on perspective that Turner gave at the Royal Academy, but his excitement turned to dismay when he found them 'unintelligible'. His verdict was far too pessimistic, but it reflected a widely held belief that Turner was semi-literate and that his intelligence was primarily visual. In recent decades greater sensitivity to learning difficulties has led to the suggestion that his arbitrary punctuation, erratic spelling and failures of syntax, to be found throughout this book in his notes and picture titles, were signs of dyslexia. It is an attractive argument, but during Turner's day literacy rates were low – around 40 per cent of men and over 60 per cent of women could not sign their names in the parish registers when they married. In so far as the lower orders became literate at all, far greater priority was placed on reading than writing. Rather than suffering from a learning disorder, it is more likely that Turner was equipped by his upbringing only with the language skills one would expect in a barber's son. This placed him at a disadvantage when faced with the subtle discourse of the Royal Academy, where eloquence was usually a prerequisite for high office.

In late eighteenth-century England, children learnt many of the skills they needed at work, and Turner was no exception – even in his most juvenile efforts, earning and learning went hand in hand. At Brentford he received his first commission from John Lees, a friend of his uncle, who paid him twopence for every engraving he coloured in a copy of Henry Boswell's *Picturesque Views of the Antiquities of England and Wales* (7). This book was typical of eighteenth-century topographical publications, in which landscape images accompanied a historical and antiquarian text. They provided a vital source of employment for landscape painters, whose drawings or watercolours were translated by professional engravers into black-and-white printed illustrations. Later in his career, much of Turner's work as a watercolourist was destined for reproduction in this way, and although the pictures he coloured for John Lees had little aesthetic value, they intro-duced him to an extended sequence of landscape images at a formative stage in his life.

Turner's father supported his ambition to become a painter and even made financial sacrifices to further his son's career. Nonetheless, Turner contributed whatever he could to the family's income, and in this respect his situation was far removed from that of his colleague, Constable, who received an allowance from his wealthy family. Turner was fortunate in his search for employment; there were myriad opportunities in and around London for a resourceful painter to earn a living, since the commercial success and wealth of the city was a great stimulus to consumer demand for luxury goods and entertainments of all kinds. This in turn created a pluralist market in which a range of art forms and activities could thrive, and by the time he was twenty-one Turner had tried his hand at many of them. He made copies, worked as a theatrical scene painter, taught drawing, and, according to his friend the Scottish painter David Roberts (1796–1864), he exploited the popularity of recreational sketching by selling studies of skies for amateurs to complete with landscapes of their own. While the wide range of his early

Eastgate sculp

CAERNARVON CASTLE, *in* NORTH WALES. Pl.I.

Publish'd according to Act of Parliament, by Alex.ʳ Hogg, N.º 16, Paternoster Row.

Eastgate sculp

CAERNARVON CASTLE, *in* NORTH WALES. Pl.II.

Publish'd according to Act of Parliament, by Alex.ʳ Hogg, N.º 16, Paternoster Row.

employment may have helped to foster his lifelong versatility, it was as an architectural draughtsman that he first made his mark.

Turner's early biographers mention several architects with whom he may have had a professional connection, but the most important was Thomas Hardwick (1752–1829), to whom he was introduced around 1788. He probably employed Turner to visualize the buildings on which he was working and to represent them in the landscape settings in which they would eventually appear. By all accounts, the time he spent with Hardwick was happy and formative, but the kind of work he was doing was held in low regard and offered little scope for professional advancement. The academician John Francis Rigaud (1742–1810) persuaded him to extend his training at the Royal Academy Schools, which then provided the only formal art education in England. He applied in December 1789, aged fourteen, and was accepted as a probationary student. From then onwards the Academy became the fulcrum of his social and professional life. That same year he left Hardwick to work with the architectural draughtsman Thomas Malton (1748–1804; see 6), whom Turner described as his 'real master'. In addition to his practice as a painter, Malton gave lessons in perspective, and in later life, when Turner taught the same subject at the Royal Academy, he paid tribute to Malton in his lectures and passed on some of his advice. This was not merely a sign of his enduring respect; it honoured a man who had been denied Associate status by the Academy because he was merely an architectural draughtsman. Turner's view of *Radley Hall from the South East* (8) of 1789, the year he entered Malton's studio, has much in common with his teacher's work. The subject of this meticulous watercolour was a shrewd choice, since country-house portraits were a profitable sub-genre of landscape painting. It was based on sketches Turner made while on a visit to his uncle and aunt, who then lived in Oxfordshire. Inevitably, he makes careful use of limited pictorial resources. The framing trees seem contrived, but they allow him to control the spectator's gaze and remove some of the difficulties he might otherwise have had in handling

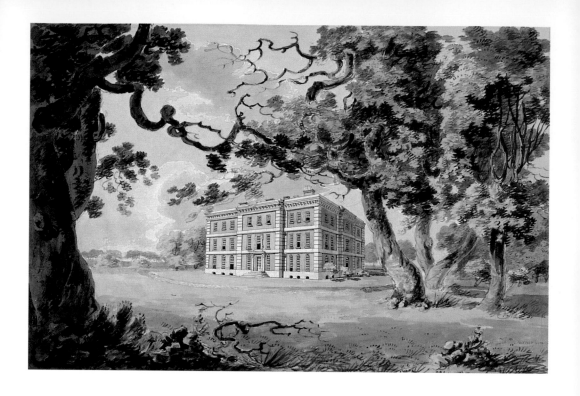

the spatial recession. He enhances the effect of depth, however, by taking an oblique view of the building, in which one corner projects towards us, causing the top and bottom edges of the receding walls to converge towards two distinct vanishing points. His graphic technique is competent but highly conventional: the main outlines are drawn in pencil with ink for emphasis; the architectural details are ruled in, and the foliage is created with repeated stylized loops. Colour is applied with touches and washes of watercolour, hence the name 'tinted drawing' that was given to this manner of working.

Radley Hall from the South East serves as a valuable benchmark against which to measure Turner's rapid progress. In the following year he felt confident enough to submit an architectural scene to the annual exhibition of the Royal Academy. *The Archbishop's Palace, Lambeth* (9) is more complex and engaging than the earlier work, due partly to his artfully deployed figures and partly to his audacity in placing the principal subject behind more commonplace buildings. A jury

of Royal Academicians selected the picture for the exhibition in April 1790, the first occasion on which Turner's work appeared before a large public. The annual exhibition of the Royal Academy was the most important forum for the sale and display of new art, and Turner showed there for six decades. The admission charge of one shilling (5 pence in today's money) ensured that visitors were drawn from the more affluent sections of society, but news of the exhibition reached a wider audience through the reviews that appeared in newspapers and periodicals. Their readership expanded rapidly during the nineteenth century. *The Times*, for example, sold only 3,000 copies a day in the 1790s, but by Turner's death in 1851 its circulation had reached over 50,000. The more perceptive critics included William Hazlitt and Thomas Wainewright (who had another, more lurid career as a poisoner), but reviews were generally unsigned, often repetitive and occasionally superficial. They were important, however, because they represented an unofficial voice, beyond the control of the Royal Academy, and frequently at odds with its theories and precepts. As such, they subverted the belief that 'taste' was confined to a cultured élite. They set out to entertain as much as to inform, but they also provided much-needed publicity, carrying artists' names and brief evocations of their work, in comprehensible language, to readers who

8
*Radley Hall
from the
South East*,
1789.
Pencil and
watercolour
with some
pen and
brown ink;
29·4×43·8 cm,
11½×17¼ in.
Tate, London

9
*The
Archbishop's
Palace,
Lambeth*,
1790.
Pencil and
watercolour;
26·3×37·8 cm,
10⅜×14⅞ in.
Indianapolis
Museum
of Art

were unable to visit the exhibition. This was important, given the huge trade in engraved reproductions, whose sales made a significant contribution to a landscape painter's income.

Turner took great care in the choice of work he sent to the Academy. *The Pantheon, the Morning after the Fire* (10), for example, which was accepted in 1792, was a likely crowd-pleaser, thanks to its dramatic and topical subject, but it also had personal significance for the artist. Designed by James Wyatt (1747–1813), the Pantheon was a grand theatre in Oxford Street whose dignified stone façade concealed a highly combustible wooden dome. Turner spent several weeks there in 1791 painting scenery, and when the building caught fire the following January he sketched the ruins and worked the sketches up into two finished pictures. It has been observed that these scenes were on a par with the work of the most respected topographers such as Edward Dayes (1763–1804; 11), but at the time topography in general was held in low esteem. Henry Fuseli (1741–1825), the Academy's professor of painting, dismissed it as 'map-work'. Even Dayes regarded it as a lesser form of art and nursed an ambition to be taken seriously as a painter of historical subjects. Throughout his career, Turner retained a strong commitment to topographical work, but if he was to achieve the status and success he desired, he could not afford to confine himself to a branch of painting that received such contempt. He had to demon-strate to the Royal Academy that he was both ambitious and exceptionally gifted, and at the same time to confront a cardinal principle of academies everywhere: that because the subject largely made the picture, the various genres (or branches) of painting could be arranged in a hierarchy according to their content. In the words of Sir Joshua Reynolds, landscape was one of 'the lesser walks of art', inferior by far to history painting and even to portraiture.

The rationale for this was that the 'higher' genres – above all, historical works – made great demands upon the intellect of

10
The Pantheon, the Morning after the Fire, 1792. Watercolour over pencil; 39.5×51.5 cm, 15¹⁄₂×20¹⁄₄ in. Tate, London

11
Edward Dayes, *Christ Church from near Carfax*, 1794. Watercolour over pencil; 30×48 cm, 11³⁄₄×18⁷⁄₈ in. Ashmolean Museum, Oxford

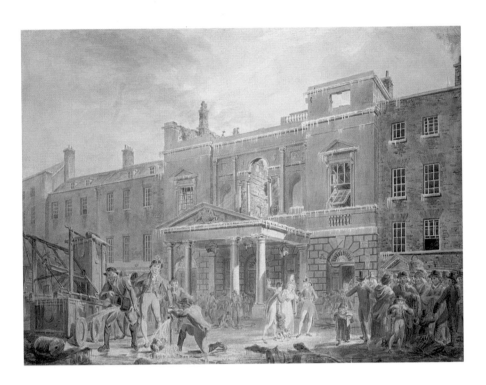

both the painter and the viewer. Landscape painting, however, was regarded primarily as a skill of hand and eye, a simple process of recording nature's likeness. It followed, therefore, that even the uncultivated spectator could enjoy and pass judgement on it. Although he revered Reynolds, these beliefs were anathema to Turner, whose attempt to demonstrate that landscape deserved parity with historical painting is the most insistent feature of his life's work. Nor was his a lone voice: in their different ways, his compatriot John Constable and the German artist Caspar David Friedrich both sought to undermine the hierarchy of genres by producing landscapes whose subtlety and moral profundity were the equal of any historical subject.

The views of the Royal Academy were so important to young artists such as Turner because, since its foundation in 1768, it had been the chief custodian of the visual arts in England. There had been earlier institutions that aimed to regulate and advance the profession, but these predecessors were unstable, faction-riddled and short-lived. They lacked the authority of the Academy, which was derived from the royal mandate bestowed by King George III (r.1760–1820), which in turn granted it centralized control of many aspects of contemporary artistic life. Not only did it organize the most important exhibition of the year and educate an élite of young painters, sculptors and architects through its Schools; it was also responsible for establishing official standards of taste. It provided a social forum in which friendships, alliances and even rivalries between artists could be played out. Above all, it was charged with enhancing the prestige of the visual arts in a land that was widely believed, by European writers, to have no real aptitude for them.

Like the older academies of France and Italy on which it was modelled, the Royal Academy was profoundly hierarchical. Not only the genres of painting, but also the academicians them-selves were stratified: the most junior were the associates; from their ranks the full members were elected, and beyond them

stood the senior officials such as the treasurer, secretary and president, the first of whom was Sir Joshua Reynolds. Other offices, such as the various professorships, also brought enhanced prestige for those elected to them. This structure provided Turner with a career path, but even for someone with his gifts, professional advancement was not a simple matter. The Academy was anxious to promote artists who would bring international respect, but its continental rivals would judge it mainly on its achievements in the field of historical subjects.

As a student at the Royal Academy Schools, therefore, the education Turner received was based on the study of the human body, for it was designed primarily for the aspiring history painter. It consisted largely of drawing, under supervision, firstly from plaster casts of antique sculptures, and then, once the student had acquired sufficient skill, from the life model. Turner spent two and a half years copying works such as the *Apollo Belvedere* (12) before graduating to the life class in June 1792, which he then continued to attend long after he ceased to be a student. Turner's figure drawing was consistently criticized in later life, but he apparently had little difficulty in satisfying the teachers (or visitors, as they were known) with the accuracy of his life studies.

Although he and his peers were taught to draw to a high degree of competence, they were given no practical tuition in painting. This startling omission was to be found in all the major European academies, because they feared the loss of status that might follow if they acknowledged too publicly that painting was a craft. They regarded drawing as a cerebral activity in which the artist's ideas were made manifest, but the application of paint was altogether too material and reminiscent of manual labour. The result was that artists had to learn to paint for themselves, which made the acquisition of a sound technique a hit-and-miss affair. There were various means open to them: William Etty (1787–1849), who specialized in nudes and mythological subjects, paid 100 guineas to receive instruction

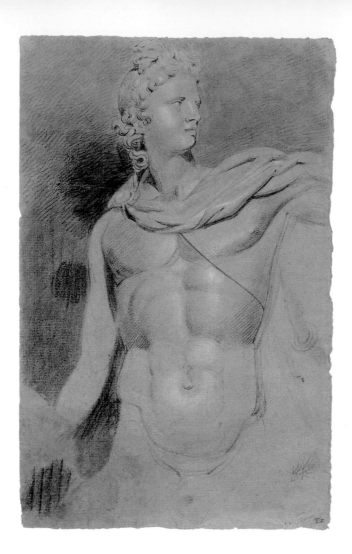

12
*Study of the
Head and
Torso of
the Apollo
Belvedere,*
c.1792.
Black and
white chalks
on buff-grey
paper;
41·9×26·9 cm,
16½×10⅝ in.
Tate, London

from Thomas Lawrence (1769–1830); others, such as Turner, experimented using information gleaned from books, or by seeking advice from colour merchants and fellow artists. This habit of improvisation continued far beyond his novice years, and in many respects it served him well, since he achieved some breathtaking effects of colour and surface and tried out the newest pigments as soon as they became available. But there were also risks attached to this kind of approach. Some of his practices, particularly as an oil painter, were highly unorthodox, and they left certain pictures vulnerable to the effects of time, neglect or careless handling.

One indispensable means by which painters learnt their craft was by copying the works of acknowledged masters. Turner's early watercolours bear witness to his close observation of Malton and Dayes, but he also made copies from prints after Michael Angelo Rooker (1743–1801), Paul Sandby (1725–1809) and the Revd William Gilpin (1724–1804). These monochrome images were widely available and by copying them an artist could learn compositional skills, but they offered no lessons in handling colour. To develop as a colourist and as a technician, a young artist needed to study original works at close quarters, and in 1792 the seventeen-year-old Turner transcribed part of a watercolour of *Battle Abbey* by Rooker (13, 14), an artist noted for the skill with which he represented minutely varying tones of masonry. As the art historian Eric Shanes has demonstrated, it was from Rooker that he learnt the procedure known as the 'scale practice'. This was a technique in which the painter worked systematically with one colour at a time, beginning with the lightest tone and applying it wherever it was required on the paper, then repeating the procedure with progressively darker tones of the same colour. The whole process would then begin again, as often as necessary, with different colours. Laborious as it sounds, 'scale practice' was a more efficient way of painting than working up first one area and then another. It simplified the business of mixing colours, and even allowed Turner to produce several pictures simultaneously.

To gain access to the work of other artists in an era in which there were no public museums or galleries, Turner and his colleagues had to rely on the goodwill of private collectors. One of these, Dr Thomas Monro (15), was a distinguished physician specializing in the treatment of mental illness, whose patients included King George III. His successful practice allowed him to indulge his passion for art by building up an impressive collection that was particularly strong on English watercolours. Turner probably met Monro in 1793, and by the following year he was regularly spending Friday evenings at the doctor's house in the company of Thomas Girtin (1775–1802), another promising

13
Michael
Angelo
Rooker,
The
Gatehouse of
Battle Abbey,
1792.
Pencil and
watercolour;
41·8×59·7cm,
16^1⁄$_2$×23^1⁄$_2$in.
Royal
Academy
of Arts,
London

14
Transcription
of part of
Rooker's
'Battle
Abbey',
1792.
Watercolour;
17·2×14·6cm,
6^3⁄$_4$×5^3⁄$_4$in.
Tate, London

15
John Varley,
*Dr Thomas
Monro*,
c.1812.
Pencil;
33×22·8cm,
13×9in.
Victoria
and Albert
Museum,
London

16
**Dr Thomas
Monro?**,
J M W Turner,
c.1795.
Pencil;
9·2×6·3 cm,
3⅝×2½in.
Indianapolis
Museum of Art

young artist. On one or more of these occasions, somebody –
possibly Monro himself – made a series of informal sketches of
Turner, Girtin and the other regular attenders (16).

Monro paid them to make copies either of works he owned,
or that were loaned to him by artists or fellow collectors.
As they later recalled to the diarist and academician Joseph
Farington (1747–1821), 'Girtin drew in outlines and Turner
washed in the effects.' These evenings were referred to, even
by contemporaries, as an unofficial academy, but they were
also convivial occasions on which Monro and his painters
enjoyed a meal together. Nonetheless, Turner and Girtin had
more than just social reasons for continuing at Monro's
'academy' for three years. The doctor had an extensive
network of contacts, some of whom, such as John Julius
Angerstein and the Viscount Malden (later Earl of Essex),
subsequently became Turner's patrons. But there is also
evidence to suggest that they regarded making copies for
Monro as an educational experience and not just a production
line, as Farington's account might suggest. Cornelius Varley
(1781–1873), who also worked for Monro and whose brother
John (1778–1842) drew his portrait (see 15), recalled Girtin
complaining that his role of tracing or copying outlines did not
give him 'the same chance of learning to paint' as Turner had.

Turner was already acquainted with the work of some of the artists, such as Thomas Hearne (1744–1817) or Dayes, whose topographical watercolours he was asked to replicate. While they may well have helped to consolidate his technique, it is also noticeable that familiarity with the ways in which his elders constructed their pictures allowed Turner to devise more original solutions of his own. This was important in a competitive market where the same views or buildings might occur repeatedly in the work of different artists. Around 1796 Turner painted *Christ Church from near Carfax* (17), one of four views of Oxford bought by Lord Mansfield, which is similar to Dayes's slightly earlier version of the same subject (see 11). Turner takes a more distant view, widens the street, includes more of the surrounding buildings, provides evidence of working life and enhances the grandeur of Tom Tower, which stands over the gateway of the college.

Although Monro employed Turner and Girtin to copy the work of many artists, the only one Farington named in his diary was John Robert Cozens (1752–97), whose Swiss and Italian subjects displayed a mastery of atmospheric effects and expertise in the handling of scale and distance. Cozens suffered a mental collapse in 1794 and remained a patient of Monro until his death three

17
Christ Church from near Carfax,
c.1796.
Watercolour over pencil with pen and dark ink;
25×33·1 cm,
9⁷₈×13 in.
National Gallery of Canada, Ottawa

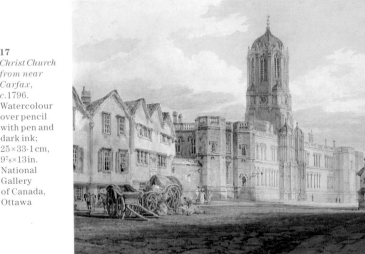

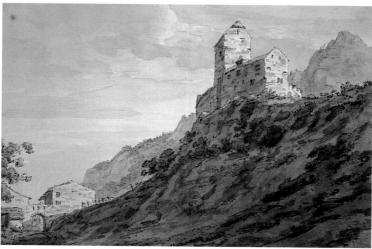

years later. As Cozens's physician, Monro had access to his drawings and sketchbooks, and it was these that Turner and Girtin were asked to copy. Their version of the *South Gate of Sargans* (18) is virtually the same size as Cozens's drawing (19), which suggests that Girtin may have traced the outlines, as Farington claimed. Turner's washed-in 'effects', on the other hand, do not follow Cozens very closely – he reverses the light and shadowed areas in the original.

In his own paintings Turner never set out to imitate Cozens, as he had Malton, Dayes and Hearne. In general the architectural subjects on which he was engaged in the 1790s gave him little

scope to explore the range of effects that he encountered in Cozens's art. Although it is unwise to be too dogmatic about what precisely Turner owed to the older man, one thing is clear: Cozens's pictures offered an alternative to the more prosaic works of the topographers, and showed that watercolour could be a subtle, highly personal medium. This is what Constable meant when he later described Cozens's work as 'all poetry'. For many contemporaries it was this quality, achieved through the manipulation of light, atmosphere and climatic effects, that raised the landscape watercolour above 'the tame delineation of a given spot' (as Henry Fuseli put it) to the level of genius.

The Trancept of Ewenny Priory, Glamorganshire (20), which Turner showed at the Royal Academy in 1797, was an attempt to do something similar with an architectural subject. Turner made a sketch of the building on a tour of South Wales in 1795, and a few weeks later he went to Stourhead in Wiltshire, the home of his patron Sir Richard Colt Hoare. Hoare was a learned and wealthy man, an antiquarian whose collection included etchings by Giovanni Battista Piranesi (1720–78). The latter's fame was based on his innovative and imposing treatment of architectural subjects, and echoes of these celebrated images are present in Turner's picture. Above all, *The Trancept of Ewenny Priory* is notable for the way in which he modelled the forms of the decaying structure by the play of light through the intervening atmosphere. This imparts a melancholy grandeur to the building, despite its occupation by farmyard animals. The work lacks the crisply delineated architectural detail of *Christ Church from near Carfax* (see 17), but Turner was more concerned to suggest a mood than to convey information.

During the years when he was working for Monro, Turner also tried his hand at oil painting, because he knew that it would improve his chances of professional advancement. Just as the Royal Academy imposed a hierarchy on the genres of painting, it also accorded differential status to the various media in which they were produced. Oil was the most prestigious, whereas

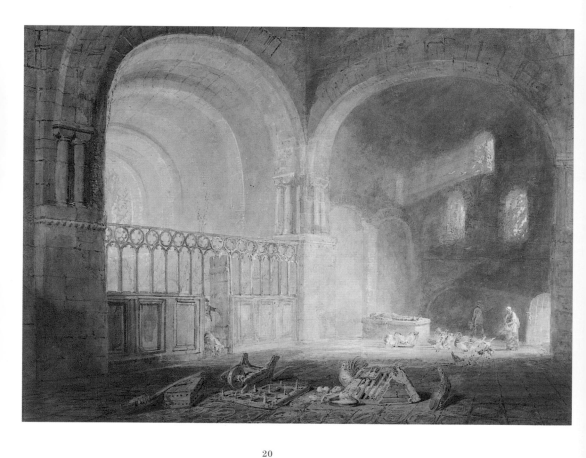

20
*Trancept of
Ewenny Priory,
Glamorganshire,*
*c.*1797.
Pencil,
watercolour,
scratching-out
and stopping-out;
40×55·9 cm,
15³₄×22 in.
National
Museums and
Galleries of
Wales, Cardiff

watercolour was treated as relatively inferior, and engravers were denied membership of the Academy altogether, at least in the early years. The supremacy of oil painting seems paradoxical, given that the technique was not taught at the Academy Schools, but it was closely associated with the Old Masters and thus the great tradition of European art. It was also synonymous with the so-called higher genres because it lent itself to ambitious large-scale work that required elaborate planning. Watercolour, on the other hand, was mainly used by landscapists, and the modest size of their works was taken to signify the artists' limited aspirations. In this, as in much else, the Royal Academy was out of step with contemporary taste, since there was a greater market for watercolours in England than in any other European country.

The clientele for Turner's early watercolours included many members of the social and cultural élite, but from the Academy's point of view the medium as a whole was compromised by the number of indifferent practitioners and by its frank commercial appeal, both of which threatened the rising status of artists in England. As his career progressed, Turner became intent on demonstrating that watercolours could be as ambitious and impressive as oil paintings, but for this he had to prove his mastery of both media. Although he may have begun to experiment with oils as early as 1793, it was not until 1796, when he was twenty-one, that he felt confident enough to exhibit his first oil painting at the Academy, the *Fishermen at Sea* (21). It was such an assured performance that it caught the eye of the critic Anthony Pasquin, who wrote: 'We do not hesitate in affirming that this is one of the greatest proofs of an original mind in the present display.'

The painting contains a view of Freshwater Bay on the Isle of Wight, where Turner had toured and sketched in 1795. The size of the canvas was carefully chosen: it was big enough to command attention on the crowded walls of the Royal Academy exhibition, but not so large that it would expose his inexperience or technical limitations. It was not quite as

21
*Fishermen
at Sea*,
1796.
Oil on
canvas;
91·5×122·4 cm,
36×48¼ in.
Tate, London

original as Pasquin suggested. Fishing scenes were common enough, and would become a staple of Turner's early work as a marine painter. Moonlit scenes were also regularly exhibited, and closely associated with the work of Joseph Wright of Derby (1734–97); but the combination of the two was unusual. Turner employed a conventional manner of painting in order to demonstrate his skill with the less familiar oil medium. His smooth, highly finished and meticulously detailed surface has been compared to those of the French sea painter Joseph Vernet (1714–89), and to the academician Philippe Jacques de Louterbourg (1740–1812). When he no longer needed to prove the point, and when this self-effacing technique became restrictive, he discarded it in favour of freer brushwork, and an impression of greater spontaneity. One of the models to whom Turner looked in this connection was the Welsh painter Richard Wilson (1713/14–82), a founder member of the Royal Academy whose output included Italian scenes, historical productions such as *The Destruction of the Children of Niobe* (see 32) and domestic landscapes such as *The Thames near Twickenham* (see 65). Wilson's technique could be, by turns, vigorous and refined, and Turner copied his work in both oil and pencil. As the art historian David Blayney Brown has observed, during the war with France Wilson provided a British alternative to the slick technique Turner had learnt from de Louterbourg.

But de Louterbourg had more to teach Turner than just the handling of oil paint. *Fishermen at Sea* was the opening move in a campaign to secure his election to the Royal Academy. As a practitioner in one of the less exalted genres, Turner's candidature would normally carry less weight than that of a historical painter or portraitist, but, as a member of both the French and English Academies, de Louterbourg had already negotiated this obstacle and Turner could learn from his example. The older man was a versatile artist whose career straddled the worlds of high art and popular entertainment. He made a public impact with his stage designs for the

22
Philippe Jacques de Louterbourg, *Landscape with Carriage in a Storm*, 1804. Oil on canvas; 72·4×104·8 cm, 28½×41½in. Mead Art Museum, Amherst College, Massachusetts

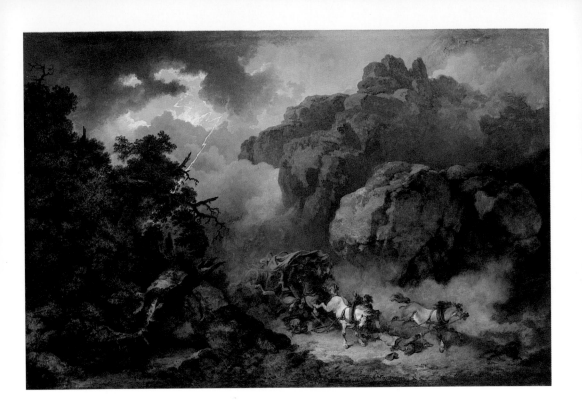

theatrical impresario David Garrick, who paid him £500 a
year. He also devised a spectacle called the eidophusikon –
a miniature theatre in which painted scenes were animated
by changing light and sound effects. But de Loutherbourg's
academic status was based upon his work as a landscapist,
especially the dramatic scenes of nature at its most threat-
ening, such as his *Landscape with Carriage in a Storm* (22).

Instead of prosaically recording the details of a scene, de
Loutherbourg's pictures of storms, avalanches and angry seas
gave the spectator a frisson of terror. In the artistic terminology
of the day they would have been described as 'sublime'. It was
a term that writers and critics had used since antiquity, but
during the eighteenth century its most famous exponent was
Edmund Burke, whose *Philosophical Inquiry into the Origins
of our Ideas of the Sublime and Beautiful* (1757) exerted a
huge influence in Europe and North America throughout
Turner's lifetime. According to Burke:

Whatever is fitted in any sort to excite the ideas of pain and danger, that is to say, whatever is in any sort terrible … is a source of the Sublime; that is, it is productive of the strongest emotion the mind is capable of feeling.

As Burke later explained, these emotions could be produced only by objects or phenomena of great power – the kind that brought human beings face to face with their own insignificance and mortality. But whereas in real life they would induce paralysing fear, in a picture or a book they could be a source of what Burke termed 'a sort of delightful horror'. His treatise had profound implications for the theory and practice of landscape painting, for although the term 'sublime' could be used to describe most awe-inspiring imagery, many of Burke's examples were drawn from nature and the elements, and his writings furthered the cause of landscape as an object of serious aesthetic interest.

Burke's writings may have helped to shape the public response to Turner's work, but the extent to which the artist himself became involved with theories of the sublime has been disputed. Like most of his contemporaries, he used the word from time to time, but there is no evidence that he actually read Burke. He cannot have remained ignorant of the contents of Burke's *Philosophical Inquiry*, even if they were learnt at one remove through conversations with colleagues or patrons, but it nonetheless seems unlikely that he was directly influenced by Burke's ideas. Turner began to record many of his own thoughts on art after becoming the Academy's professor of perspective in 1807 (see Chapter 2), but it is worth observing in this context that he expressed a profound scepticism towards the theories of anybody who had no practical experience as a painter. In his opinion a direct encounter with nature was worth far more than 'all the splendid theory of art'.

Turner's earliest encounters with the kind of scenery that was conventionally described as sublime were the result of tours he

made to sparsely inhabited areas of northern England, North Wales and Scotland in search of new subjects. Touring was a professional necessity for a landscape painter, but during the eighteenth century it was also a fashionable pursuit for amateurs, who were encouraged by such writers as William Gilpin to view the countryside through which they travelled as they would a series of landscape paintings. Many employed a visual aid known as a Claude Glass – a small, hand-held convex mirror, usually oval in shape and slightly tinted. When natural scenery was viewed as a reflection in the curved surface of the glass it was distorted to resemble a composition by Claude Lorrain (1600–82). This vogue for travelling around Britain was at its height during the 1790s, partly because warfare with France had closed off the Continent since 1793.

Turner was an inveterate and lifelong traveller. He undertook his tours in the summer, after the Royal Academy's exhibition had closed, and usually returned to London by early October. He travelled by mail or stagecoach and made meticulous plans for each expedition, some of which survive in his sketchbooks as itemized lists of clothing, distances, places to visit and even his expenses. He tried to keep his costs low, for although his patrons or the publishers who commissioned engravings after his watercolours sometimes sponsored his travels, he frequently had to finance them himself. Touring could be an expensive business, as his friend Girtin discovered on a journey in North Wales in 1798, when he was forced to borrow £25 from a travelling companion – a sum equivalent to several months' wages for a skilled craftsman. Turner was better organized, more parsimonious and preferred to travel light and alone.

In 1797 he made his first extensive tour of the north of England, taking in much of Yorkshire, the Lake District and the Northumberland coast. On the way he filled two sketchbooks with drawings, which provided him with the material for the glowing watercolour of *The Dormitory and Trancept of Fountain's Abbey – Evening* (23), where there is a depth and richness of

tone that are normally associated with oils. It is a subtle, innovative work, in which Turner employs the unusual device of making the darkest part of the picture its principal focus by silhouetting the dormitory wall against the setting sun. In its concern with transitory effects of light, it is comparable to the oil painting of *Morning amongst the Coniston Fells, Cumberland* (24), which, like *Fountain's Abbey*, was exhibited in 1798. This Lake District scene shows how accomplished Turner had become in the two years since showing his first oil painting at the Academy. He created shadows and mists with a series of thin, semi-transparent washes known as glazes, and

23
The Dormitory and Trancept of Fountain's Abbey – Evening, c.1798. Watercolour; 45·6×61cm, 18×24in. York City Art Gallery

24
Morning amongst the Coniston Fells, Cumberland, 1798. Oil on canvas; 123×89·7cm, 48³⁄₈×35¹⁄₄in. Tate, London

by a technique known as scumbling, in which a nearly-dry brush is dragged over the picture surface, leaving clear traces of the underlying colour. The flock of sheep was modelled using thicker, impasted paint. Turner suggested the height of the fells by employing a vertical format and by reducing the sky to a narrow band of light that contrasts with the dark foreground.

Morning amongst the Coniston Fells made a powerful impression on the critics, one of whom praised Turner's 'strength of mind'. These lines from John Milton's great epic poem *Paradise Lost* (1667), which accompanied the catalogue entry for the

picture, may have influenced their judgements.

Ye mists and exhalations that now rise
From hill or streaming lake, dusky or grey
Till the sun paints your fleecy skirts with gold,
In honour to the world's great Author, rise

Turner was taking advantage of the Royal Academy's new ruling that allowed painters to juxtapose poetic quotations with their work. His choice of Milton was significant, because *Paradise Lost* was usually the preserve of historical painters such as Fuseli. For Turner to couple his scene with Milton's lines was a sign of his intention to produce serious and ambitious landscapes, even when they represented no historical subject. Turner continued to use such captions throughout his career and was fascinated by the relationship between what were often called the 'sister arts' of poetry and painting. On this occasion his imagery is very close to that of his great literary source, although as he later observed in private notes, painters had the power to depict the beauties of nature directly, whereas poets were forced to rely more on metaphor and allusion, as Milton did in the passage above. Turner believed that however different their means, when juxtaposed the two arts 'heighten each others beauties … like mirrors'.

Even within the Academy, Turner found support in unlikely quarters for his increasingly elevated view of landscape. As the institution's president, Sir Joshua Reynolds was bound to uphold its belief in the primacy of historical painting, but in his public lectures or *Discourses* he was realistic enough to acknowledge tacitly that few of the Academy's students would specialize in the genre. If they did, they were unlikely to find many patrons, for, unlike France, where historical painting received support and encouragement from the state, English art was wholly subject to consumer demand, which favoured landscape, portraiture and scenes of ordinary life.

Reynolds's response to this situation was to direct aspiring landscape painters away from the Dutch tradition, which was

considered to produce simple transcripts of nature, towards the 'nobler' forms of landscape created by such artists as Claude Lorrain and Nicolas Poussin (1594–1665), whose classical and biblical subjects appealed to the viewer's imagination. Instead of copying the natural world directly, these artists idealized their subjects by selecting the best parts of nature and eliminating what Reynolds described as its 'accidents' or 'deformities'. This process, which was comparable to the way history painters idealized the human body, was thought to place great demands on the painter's taste, intellect and judgement. Turner's first exercise in this kind of historical landscape was *Aeneas and the Sibyl, Lake Avernus* (see 3) of 1798, the first of many paintings based on the Roman poet Virgil's *Aeneid*. At this stage in his career he had no first-hand knowledge of Italy. He derived the topography of Lake Avernus, near Naples, from a drawing made by the work's intended patron, Sir Richard Colt Hoare, but for his chief pictorial model he looked once again to Wilson, whose work Turner had previously copied in both oil and watercolour.

Although he had profound respect for Reynolds, and continued to paint ideal and historical landscapes throughout his career, Turner also remained committed to topographical work, which provided a substantial part of his income. He attempted to strike a balance between their conflicting demands. In 1798 he visited the London house of the merchant and insurance underwriter John Julius Angerstein, where he studied Claude's *Seaport with the Embarkation of the Queen of Sheba* (25). Echoes of the painting occur throughout Turner's work, but he first adapted its pictorial formula in a view of *Caernarvon Castle* (26) in 1799, where he used it as a framework around which to organize his study of the Welsh landscape. The way in which Turner adapted the topography becomes clear when his view of *Caernarvon Castle* is compared with the prosaic image of the same scene that he coloured as a child (see 7). Claude was particularly admired for his handling of light. In Angerstein's painting it has a calm, glowing quality, despite the fact that the viewer looks directly towards the sun and its reflection in the

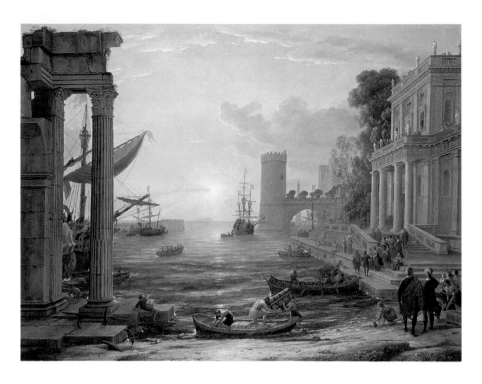

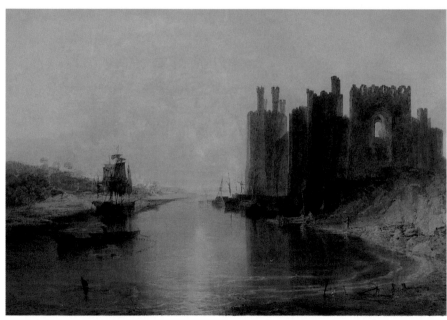

water. So impressed was Angerstein by the way in which Turner achieved a similar though stronger effect in *Caernarvon Castle*, he offered 40 guineas for the picture – a very high sum for a watercolour. When compared with the £10 Turner had accepted for his oil painting *Fishermen at Sea* (see 21), it illustrates how dramatically his reputation had risen in just two years.

With his enhanced reputation Turner became a serious candidate for election as an associate of the Royal Academy. His first attempt, in November 1798, had been unsuccessful, probably because his rivals, the sculptor Charles Rossi (1762–1839) and the portraitist Martin Archer Shee (1769–1850), were older and had a clutch of academic prizes to their names. Turner was only twenty-three, and the statutory minimum age for an associate was twenty-four. Six months later Joseph Farington reassured him that if he put his name down once again 'there could be no doubt of his being elected'. In April 1799, Turner was approached by Lord Elgin to act as draughtsman on an expedition to Greece and Turkey, in the course of which Elgin acquired much of the surviving sculpture of the Parthenon. When negotiations broke down over the question of his salary, Turner is unlikely to have been disappointed, since he knew that to leave the country at that point would jeopardize his chances of being elected to the Academy. Farington's prediction was proved right on 4 November 1799, when Turner beat the other candidates by a large margin. In response to his new status he moved to better lodgings at 64 Harley Street, a more fashionable area of London. Around the same time he found accommodation nearby for his mistress, Sarah Danby, the widow of John Danby, a composer and friend of Turner. Her liaison with the painter seems to have begun soon after her husband's death in 1798, and she bore him two daughters, Evelina and Georgiana. Their relationship, which lasted until around 1813, remained unofficial, possibly so that she could continue to claim her husband's pension. Turner was apparently not an attentive parent – in 1839 he even altered the terms of his will to leave his children nothing.

25
Claude
Lorrain,
*Seaport
with the
Embarkation
of the Queen
of Sheba*,
1648.
Oil on canvas;
148·6×193·7cm,
58$\frac{1}{2}$×76$\frac{1}{4}$in.
National
Gallery,
London

26
*Caernarvon
Castle*,
1799.
Watercolour
over pencil;
57×82·5cm,
22$\frac{1}{2}$×32$\frac{1}{2}$in.
Private
collection

Over the next two years Turner left his colleagues in no doubt about his ambition or versatility, though some of the most impressive works he produced around this time were not made to be shown in public. *Valley of the Glaslyn, near Beddgelert, with Dinas Emrys* (27) was one of a series of large experimental watercolours of scenery in North Wales, where he toured in 1798 and 1799. The methods he had learnt as a topographical or architectural draughtsman did not prepare him for the grandeur of the Welsh mountains, the changeable climate, or the fugitive but dramatic effects of light he encountered. In order to represent them he had to develop a flexible, improvised technique. In July 1799 he explained to Farington that he had 'no systematic process for making drawings … [but] by washing and occasionally rubbing out, he at last expresses to some degree the idea in his mind', sometimes beginning a picture outdoors and continuing it in the studio. He may have been drawn to Beddgelert because his friend Girtin's visit there the previous year had prompted some of his boldest work (28). According to Farington's diary for February 1799, some patrons, such as Edward Lascelles, were 'disposed to set up Girtin against Turner' in the belief that Girtin was the greater genius and that Turner relied too much on hard work and meticulous finish. In his Welsh scenes Turner was exceptionally

28
Thomas
Girtin,
*Near
Beddgelert,
North Wales,*
c.1798.
Watercolour;
29×43·2 cm,
11¹₂×17 in.
British
Museum,
London

bold, and although he produced few finished watercolours from
his large studies, they helped him to develop the technical
resources necessary to represent such alpine scenes as *Fall
of the Reichenbach* (see 44) in 1804.

His tours of North Wales also gave rise to the important oil
painting of *Dolbadarn Castle* (29), which he exhibited in 1800.
He enhanced the impression of the castle's height and isolation
by using a vertical format, silhouetting it against the sky and
playing down the surrounding mountains. These devices, together
with the dark tones and deep shadows, contributed to the work's
sublime effect. Unfortunately, the painting has darkened in the
intervening centuries, possibly due to Turner's use of what is
known as megilped paint, made from mastic resin and linseed oil.

Dolbadarn Castle is more than an exercise in the sublime; it
is also a meditation on the loss of liberty. The scene includes
a group of figures, one of whom is held captive, with his arms
behind his back, an allusion to the plight of the Welsh prince
Owain Goch, who was imprisoned in the castle by his brother
from 1255 to 1277. Early in his career Turner may have absorbed
the idea that the meaning of a landscape was inseparable from
its history through the topographical publications of his day
(see 7), but *Dolbadarn Castle*, with its theme of lost liberty,

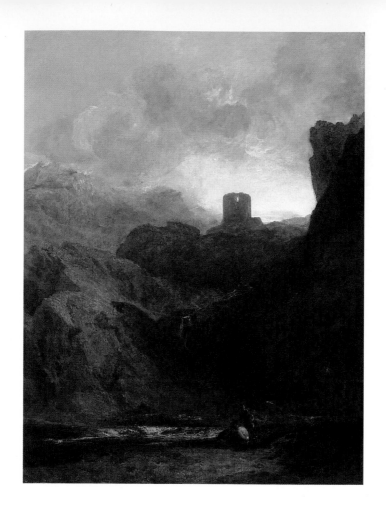

29
Dolbadarn
Castle,
1800.
Oil on canvas;
119·5×90·2 cm,
47×35½in.
Royal
Academy of
Arts, London

also had strong contemporary resonances. During the 1790s,
the fear that revolution would spread from France to Britain
led the government of William Pitt the Younger to curtail
personal freedom by a series of repressive acts of parliament.

During the 1800 Academy exhibition, *Dolbadarn Castle*
was overshadowed by *The Fifth Plague of Egypt* (30), a
larger painting and the first overtly historical landscape
Turner showed at the Academy. It was bought, and possibly
commissioned, by William Beckford, a man of immense wealth
and extravagant tastes who had been introduced to Turner by
his friend Sir Richard Colt Hoare. Beckford's appetite for the
sublime extended beyond paintings to the creation of a vast
gothic edifice known as Fonthill Abbey, of which Turner made

several sketches in 1799. The critics rightly saw *The Fifth Plague of Egypt* as a demonstration of mastery, and overlooked the fact that Turner had actually depicted the hail and fire of the seventh plague, rather than the murrain of the fifth as the title has it. For the reviewer of the *St James's Chronicle* it was in 'the grandest and most sublime stile of composition', adding that 'the whole of the conception is that of a great mind'. No subject was more terrifying than the wrath of God, and, as the anonymous critic implied, it took an artist of great power to dramatize human powerlessness so effectively. In such works as *Morning amongst the Coniston Fells* (see 24), Turner had discovered that a degree of judicious obscurity and looseness of handling helped to promote an impression of awe, and these are intensified in *The Fifth Plague of Egypt*. Although the theme is one of chaos and destruction, the work depends primarily for its impact on a dramatic but carefully composed effect of light and shadow, in which the light within the growing vortex of angry clouds on the right is balanced by the distant view of daylight and blue sky on the left. In a stroke of pure daring Turner makes the pyramid in the centre the fulcrum of the composition, and lights it so brilliantly that it stands out as a stark, semi-abstract triangle of white paint.

Some contemporaries realized that *The Fifth Plague of Egypt* owed a debt to earlier historical landscapes, especially those of Poussin and Wilson. Whereas Claude's paintings offered a model of tranquil beauty, those of Nicolas Poussin often possessed a stern grandeur and conveyed strong emotional effects. In his *Landscape with Pyramus and Thisbe* of 1650–1 (31), Poussin used a violent storm and dramatic chiaroscuro, similar to that of Turner's *Fifth Plague of Eygpt*, in order to express Pyramus's grief on discovering what he mistakenly believes to be the dead body of his lover Thisbe. There are echoes of Poussin in Wilson's *Destruction of the Children of Niobe* (32), which was generally regarded as the greatest historical landscape ever painted by a British artist. Reynolds, however, criticized Wilson in his fourteenth *Discourse* for

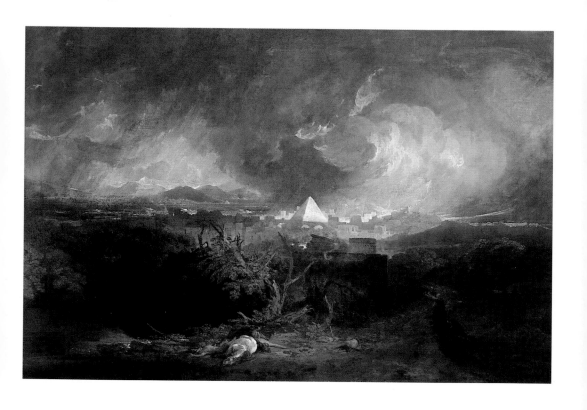

30
*The Fifth
Plague of
Egypt*,
1800.
Oil on canvas;
121·9×182·9 cm,
48×72 in.
Indianapolis
Museum of Art

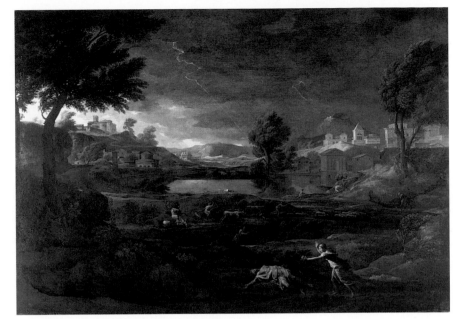

31
Nicolas
Poussin,
Landscape
with Pyramus
and Thisbe,
1650–1.
Oil on canvas;
192·5×273·5 cm,
75³⁄₄×107³⁄₄ in.
Städelsches
Kunstinstitut,
Frankfurt

32
Richard
Wilson,
The
Destruction
of the Children
of Niobe,
*c.*1760.
Oil on canvas;
147·3×188 cm,
58×74 in.
Yale Center
for British Art,
Paul Mellon
Collection,
New Haven

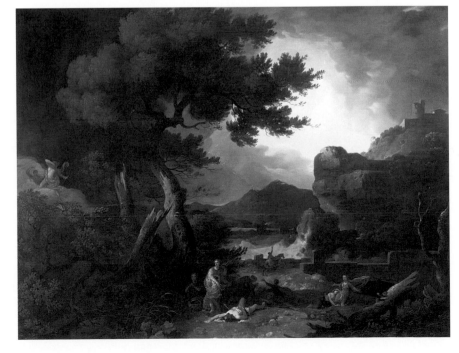

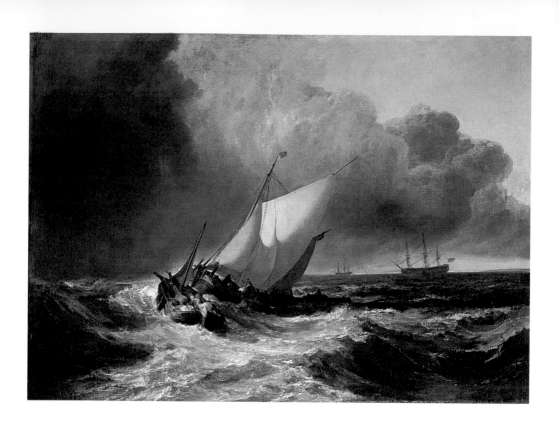

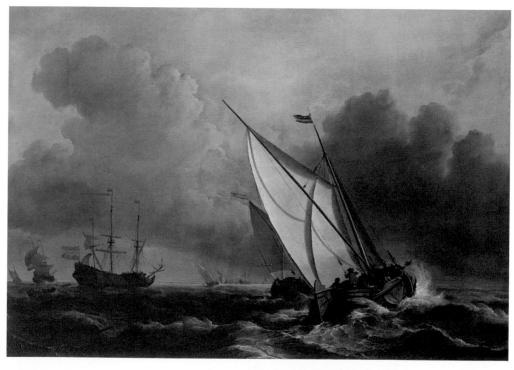

spoiling a fine storm effect with poorly conceived mythological figures. Turner, who knew Reynolds's writings intimately, avoided this pitfall by representing the elements themselves as the instruments of divine anger.

In his dealings with the painters of the past Turner was respectful but rarely deferential. He learnt from them, but he also pitted himself against them, inviting comparisons in his favour as a means of advancing his own standing. In the case of *Dutch Boats in a Gale: Fishermen Endeavouring to put their Fish on Board* (33), comparisons were thrust upon him. The subject was painted on commission from the Duke of Bridgewater, who wanted a companion piece for a work (34) in his collection by the seventeenth-century Dutch artist Willem van de Velde the Younger (1633–1707). Turner once claimed that the sight of a print after one of Van de Velde's pictures was what made him a painter. If the story is true, then his confrontation with this artistic 'father figure' has fascinating psychological implications. In the event, Turner conclusively outreached Van de Velde. He reversed his mentor's composition, but he also improved on the original with a larger canvas, a narrative element (the two fishing boats are about to collide), bravura handling of paint, and a more compelling chiaroscuro, or scheme of light and shadow. The latter made such an impression on Benjamin West (1738–1820), then president of the Academy, that he claimed it was 'What Rembrandt thought of but could not do'. Some reviewers were becoming a little edgy about Turner's brushwork, which was much freer than that of earlier marine painters such as Samuel Scott (*c*.1702–72). One lamented that 'we hardly ever see a firm determined outline in anything he does', but in general the acclaim that greeted the *Dutch Boats in a Gale* in 1801 strengthened Turner's chances of promotion within the ranks of the Academy.

In the next elections, which took place on 10 February 1802, the 26-year-old Turner became a full academician, along with his friend the architect John Soane. The year also saw the death of

33
Dutch Boats in a Gale: Fishermen Endeavouring to put their Fish on Board (The Bridgewater Sea-Piece), 1801.
Oil on canvas; 162·5×221 cm, 63×87 in.
National Gallery, London

34
Willem van de Velde the Younger, *A Rising Gale*, 1671–2.
Oil on canvas; 129·5×189 cm, 51×74½ in.
Toledo Museum of Art, Ohio

another friend, Thomas Girtin, of whom he is supposed to have said 'if Tom Girtin had lived, I would have starved'. In reality, Turner would have been in no danger of starvation, since their career patterns had already diverged, and Turner's output had a far wider range of both media and subject matter. This diversity would remain a hallmark of his art in the decades to come.

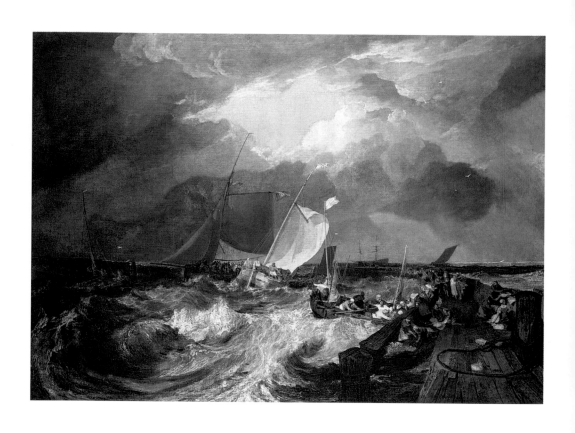

35
*Calais Pier,
with French
Poissards
Preparing
for Sea: An
English
Packet
Arriving,*
1803.
Oil on
canvas;
172×240 cm,
67³⁄₄×94¹⁄₂ in.
National
Gallery,
London

Turner's election as a full academician at the youngest possible age in 1802 was a recognition by his peers of his exceptional abilities. In the following years he aimed to build on his early achievements in a bid to enhance both his own professional status and that of his chosen branch of painting. In 1807 he sought election as the Royal Academy's professor of perspective, extended his involvement in the print market after 1811, and throughout the period exhibited a series of works that suggested there were no limits to his ambitions. His activities during this period were shaped by the conflict with France, which began in 1793 after the Revolutionary government executed King Louis XVI (r.1774–93) and then sent invading armies into the Netherlands. It continued, after a brief peace in 1802–3, as a struggle against the imperial ambitions of Napoleon Bonaparte. Turner was seventeen when war was declared and forty when it was finally concluded with the Battle of Waterloo in 1815.

It would be hard to exaggerate the impact that the shared experience of prolonged struggle had on all aspects of the nation's life and attitudes, from the economic disruption caused by taxation or Napoleon's blockade of British trade, to military service, the fear of invasion and the growth of nationalism. A sense of national identity did exist before 1793 among the social and political élite, based on Britain's island status, its Protestantism, constitutional monarchy and what were considered its traditional 'freedoms'. The historian Linda Colley has shown that, under the pressures of war, this self-image began to filter through the population, and that there was much active patriotism even within the working classes, especially during the period 1803–10. Turner himself was fiercely loyal to his country and thoroughly aware of what was at stake if Britain succumbed to Napoleon. However, the

conflict also offered him the chance to demonstrate just how versatile and effective landscape art could be, by expressing the nation's preoccupations, anxieties and glories more fully than history painting. In England the state exerted little direct control over the patronage of art, so there was less demand for large works of propaganda like those painted by David (see 37) or Antoine-Jean Gros (1771–1835; see 88) in France. There was, however, a ready market for landscapes, which could be adapted to carry patriotic meanings. To do this, however, Turner had to extend the resources of the genre, which in turn required him to read and reflect on the principles and purposes of his art. These two strands, of contemporary history and art theory, are intertwined throughout the period 1802–19.

One of the most immediate effects of the war was the restriction it placed on foreign travel, although this was lifted when the short-lived Peace of Amiens was signed on 27 March 1802. Like many of his colleagues, Turner took advantage of the lull in hostilities to board a packet boat for Calais, and embark on his first European tour. It was funded by a consortium of noblemen who wanted Turner to have the chance to travel in relative comfort and see more works by the great artists of the past than he ever could in Britain. The Channel crossing gave him his earliest experience of the open sea. To judge by the sequence of sketches he made after the event in his *Calais Pier Sketchbook*, which carry brief inscriptions such as 'our situation at Calais Bar' and 'nearly swampt', it was a stormy passage that both exhilarated and alarmed him. He drew on his experiences in an oil painting entitled *Calais Pier* of 1803 (35), a work that demonstrates how the wartime circumstances sometimes produced subtle transformations in marine and landscape imagery. It contains high drama in the form of an impending collision between an English passenger boat and a departing French fishing vessel, and low comedy in the enraged fisherman who has put to sea without his bottle of brandy. The picture has been interpreted as an artful comment on the poor state of French seamanship, since they are to blame for the impact that

is about to happen. This may seem far-fetched, but contemporary Britons were much more attuned to the fine points of nautical manoeuvres than a modern public, and they took pride in their command of the seas. Furthermore, Turner always emphasized the courage of British fishermen, and he pictures their French counterparts as buffoons in a manner reminiscent of William Hogarth (1697–1764) or of contemporary caricatures.

As Turner's colleague Fuseli acknowledged, the work displays 'great power of mind'. It is cleverly staged, for the spectator occupies an unusual viewpoint on the right, observing the drama from the pier, like the painted onlookers. An intense patch of blue sky illuminates the central vessel and relieves the otherwise dark tones that threaten to overwhelm the scene. As in his *Dutch Boats in a Gale* (see 33) Turner used broad touches of white to suggest the motion of the foaming sea, but in *Calais Pier* they were more thickly applied. For many commentators the paint was too palpable to create an illusion of moving water and they misunderstood Turner's vigorous handling as carelessness.

Safely across the Channel, Turner travelled through France to Switzerland, where he encountered scenery more spectacular than anything he had previously seen. Other British artists had preceded him, notably John Robert Cozens and Francis Towne (1739/40–1816), but none conveyed the grandeur of the Alps as he did in the monumental watercolours (see 44) he painted after arriving back in England. On the return journey from Switzerland he stopped in Paris, where he joined a throng of British artists and travellers in the Louvre, which at that time contained an incomparable collection of great works of art that Napoleon had systematically looted from conquered territories. His colleague Joseph Farington, a landscape painter whose diaries give a detailed picture of the Royal Academy and its intrigues, reported some of Turner's Parisian experiences, but as a rule Turner preferred to confide his artistic judgements to the pages of a small sketchbook. He described the

Entombment by Titian (c.1485–1576), of which he produced a copy (36), as 'the first of Titian's pictures as to colour and effect', while Poussin's *Gathering of the Manna* he pronounced 'the grandest system of light and shadow in the Collection'. He commented on a range of painters, noting with interest their compositional and expressive uses of colour and chiaroscuro.

Turner's visits to the Louvre had a further, unexpected result: they underlined the differences between French and British art. French values seemed to be the opposite of everything British painting stood for. Turner accused them of pursuing detail at the expense of breadth, of praising painstaking labour rather than power, and of forsaking colour and chiaroscuro for drawing and outline. The debate concerning the relative merits of drawing and colour was centuries old, but during the war the differences between the French and British schools of painting were seen as an expression of national character. Turner knew his judgement was swayed by wartime jingoism (or 'nationality with all her littleness', as he put it), but many British artists and critics voiced similar opinions. The Scottish miniaturist Andrew Robertson (1777–1845), for example, wrote: 'French

36
Copy of Titian's 'Entombment' from the *Studies in the Louvre Sketchbook*, 1802. Watercolour; 11·2×12·9 cm, 4¹₂×5 in. Tate, London

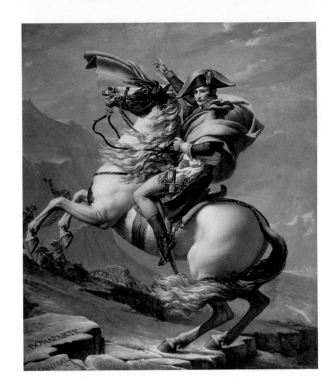

37
Jacques-
Louis David,
*Napoleon
Crossing the
Great St
Bernard
Pass*,
c.1800.
Oil on canvas;
260×221 cm,
102³⁄s×87 in.
Musée
National de
Malmaison

artists excel us in drawing, but in painting [they are] mere
infants … their little works good, but their great ones as if
done with small pencils [*ie* brushes].' The painter who typified
these French excesses was Jacques-Louis David. Like other
visitors to Paris in 1802, Turner visited his studio, where he
saw the magnificent portrait of *Napoleon Crossing the Great
St Bernard Pass* (37). He would not have admired its style,
but he recognized its power and even quoted from it twenty-five
years later in an image of the Battle of Marengo, produced as
an illustration to Samuel Rogers's *Poems*.

The battle lines between French and British artists became
very clear when they met one another in the Louvre. There was
a widespread belief in both France and Britain that Italy had
slid progressively into decadence since the seventeenth century,
and that cultural power and authority had shifted to northern
Europe. Napoleon used this myth to legitimize both the French
invasion of Italy and the theft of its greatest treasures. Once
these trophies were installed in the Louvre they created the

impression that the French were the rightful custodians of European culture. Turner's riposte was that they were in no position to understand or truly value the works they had stolen. As he put it: 'They who have returned with all the exquisite productions of ransacked countries look with cool indifference on all the matchless power of Titian's glowing tones because precision of detail is their sole idol.'

The British, on the other hand, revered such painters as Titian and Anthony van Dyck (1599–1641) because their own art

38
Anthony van Dyck, *Cardinal Guido Bentivoglio*. 1622–3. Oil on canvas; 196×145 cm, 77⅛×57 in. Palazzo Pitti, Florence

shared similar qualities of vivid colour, chiaroscuro and lively handling of paint. They felt a special affinity with Van Dyck, who spent extended periods in England at the Stuart court. His great portrait of *Cardinal Guido Bentivoglio* (38) was a particular source of contention: Turner and the British contingent admired it for 'its amazing power of Breadth color and apparent ease and facility of execution'; the French, in contrast, thought it was poorly drawn and finished. According to Turner, they pitied the British for their lack of taste.

By fostering the conviction that a flair for colour and painterly handling was what constituted 'Englishness' (to the English the terms 'England' and 'Britain' were then more or less synonymous) in art, the conflict with France undermined the Royal Academy's insistence that drawing was the most important attainment for any painter, whereas colour or captivating brushwork were ornamental qualities, unpredictable and not wholly to be trusted. The war years were a period of shifting and unstable tastes, and there were many commentators, including the influential connoisseur Sir George Beaumont, who still regarded a fondness for strong colour and bold handling as the chief vice of British painting. He described it as an 'influenza', with Turner and Thomas Lawrence the worst afflicted. But the circumstances of the war presented those same qualities in a patriotic light, and, although they remained controversial, they were increasingly seen as defining features of the nation's art.

The Peace of Amiens collapsed in May 1803, leaving Turner and his colleagues confined once again to British shores. But in the following years he sent a number of continental subjects to the Royal Academy, including his *Festival upon the Opening of the Vintage at Mâcon* (39) of 1803, which was purchased the following year by Lord Yarborough for the enormous sum of 400 guineas. He had patronized Turner since 1798 and seems to have been part of the consortium that financed the artist's continental tour. At first sight the *Mâcon* seems merely to plagiarize a famous painting by Claude, *Landscape with Jacob and Laban and his Daughters* (40) in the Earl of Egremont's collection – the arrangement of Turner's figures, water, bridge and trees closely match those of Claude. But Turner made a more sophisticated use of his source than first appears, for rather than just paraphrasing its pictorial qualities, he drew upon the things that Claude stood for in the public mind. As he once gushingly wrote, the French artist's works were rich with 'the cheerful blush of fertilization', meaning that they epitomized the great generosity of nature, which suited Turner's celebration of the Mâcon vineyards perfectly. His choice of

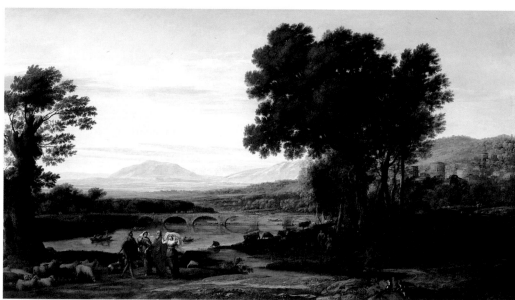

subject matter is nonetheless intriguing, given his confession to Farington that 'He found the Wines of France and of Switzerland too acid for his Constitution, being bilious.'

Turner's use of Claude in the *Mâcon* owed much to Reynolds's suggestion that 'quoting' from the Old Masters was one way of dignifying a modern picture and overcoming the limitations of the so-called 'lesser genres'. In his celebrated portrait of

39
The Festival upon the Opening of the Vintage at Mâcon,
1803.
Oil on canvas;
146×237·5 cm,
57¹₂×93¹₂ in.
Sheffield City Art Galleries

40
Claude Lorrain,
Landscape with Jacob and Laban and his Daughters,
c.1654.
Oil on canvas;
143·5×252 cm,
56¹₂×99¹₄ in.
Petworth House, Sussex

41
Sir Joshua Reynolds,
Mrs Siddons as the Tragic Muse,
1789.
Oil on canvas;
239·7× 147·6 cm,
94³₈×58¹₈ in.
Dulwich Picture Gallery

the actress *Mrs Siddons as the Tragic Muse* (41), Reynolds demonstrated how this might be achieved. It is a learned image, with a range of pictorial and literary associations more typical of historical work. Sarah Siddons's pose, for example, is borrowed from Michelangelo's figure of the prophet Isaiah on the Sistine Ceiling, while the shadowy figures behind her (Pity and Terror) are drawn from the ancient Greek philosopher Aristotle's

definition of tragedy. The picture taxed the spectator's knowledge and intellect in a way that a mere likeness would not have done. Moreover, it offered a lesson that was easily adapted to landscape, although Turner also made highly sophisticated use of it around 1803–5, in *Venus and Adonis* (42), one of his rare forays into history painting.

This work is based on Titian's *Death of St Peter Martyr* (43), a celebrated painting that was destroyed by fire in 1867. It so moved Turner when he saw it in the Louvre that he scribbled three pages of analysis in his sketchbook. As he explained in his lectures, it affected him so strongly because, despite the fact that it was a historical scene, the landscape made an enormous contribution to its effect and meaning. It is often assumed that Turner relied heavily on Titian because he was working in an unfamiliar genre and lacked confidence, but the borrowing was so blatant and Titian's picture so famous that Turner must have expected his contemporaries to make the link. In fact he was probably counting on it, for he was not just stealing the composition, he was grafting some of the meanings of Titian's landscape on to his own mythological scene. In the *Death of St Peter Martyr*, the dark, turbulent forms of the trees echo the butchery taking place in front of them. In comparison, Turner's painting is lighter in tone, and, it would appear, in subject. As Adonis leaves his lover Venus to go hunting, Cupid unties his shoe in a final attempt to make him stay. After ignoring Venus's warnings about the dangers of the hunt, Adonis is killed by a boar and she is grief stricken. Turner has deliberately hidden the lovers' facial expressions, possibly because human physiognomy was not his strong point, but in so doing he also removes the obvious signs of sorrow or impending tragedy. In fact, the only hint Turner gave of the sombre outcome is the connection he could reasonably expect an educated viewer to make between the borrowed landscape forms and the violent death of St Peter Martyr. By using Titian's picture in this way, Turner exploits the capacity of his public to make associations between objects (or images) and ideas. This

was a principle that assumed great importance throughout his career and is discussed more fully later in this chapter.

On returning home from his first continental tour, Turner began a series of Alpine subjects that included the *Fall of the Reichenbach, in the Valley of Oberhasli, Switzerland* (44) of 1804. Faced with the task of rendering these spectacular views, Turner generally chose watercolour, which was well suited to representing the mountain cloud and mist. He employed a range of techniques, including broad washes, a semi-dry brush to apply detail and scratched out highlights, but he worked on a scale that was more typical of an oil painting. Several of them, including *Fall of the Reichenbach*, are over a metre in height or width, and Turner often used a vertical format to convey the sheer scale of the Alps. The size of the pictures was undoubtedly prompted by the awesome subject matter but also suggests that Turner was making implicit claims for the parity of watercolour with the more prestigious oil medium. Works in oil were given priority at the Royal Academy exhibition, and watercolours were not always shown to advantage. This is one reason why Turner chose to display the *Fall of the Reichenbach* in his own newly built gallery, adjacent to his Harley Street house, in Queen Anne Street, which he opened in 1804. Though relatively modest in size, the gallery was top lit (see 182) and provided favourable conditions for viewing his pictures, which no longer had to compete for attention with those of his rivals, as they did in the Academy's overcrowded rooms in Somerset House. They would be seen by far fewer people than visited the Academy, but by then Turner had an impressive reputation and a large client list, and he sent invitations to potential buyers, as well as to his professional colleagues and supportive writers such as John Landseer. Having been elected to the Academy Council in 1803, Turner was also acutely conscious that bitter disputes and infighting were damaging the institution to the extent that many feared for its future. In these circumstances the construction of his own gallery was a sound precautionary move.

42
*Venus and
Adonis*,
*c.*1804.
Oil on canvas;
149·9×119·4 cm,
59×47 in.
Private
collection

**43
Anonymous
copy after
Titian**,
*The Death of
St Peter
Martyr*,
seventeenth
century.
Oil on canvas;
141×94 cm,
55½×37 in.
Private
collection

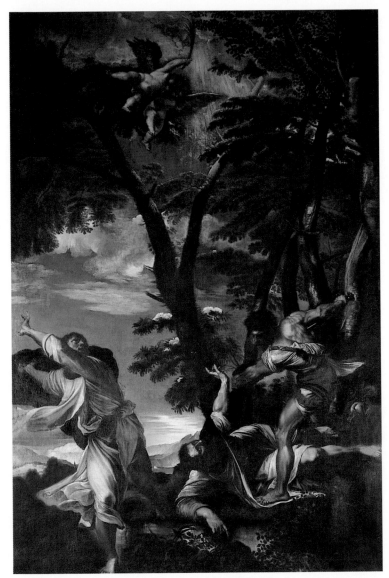

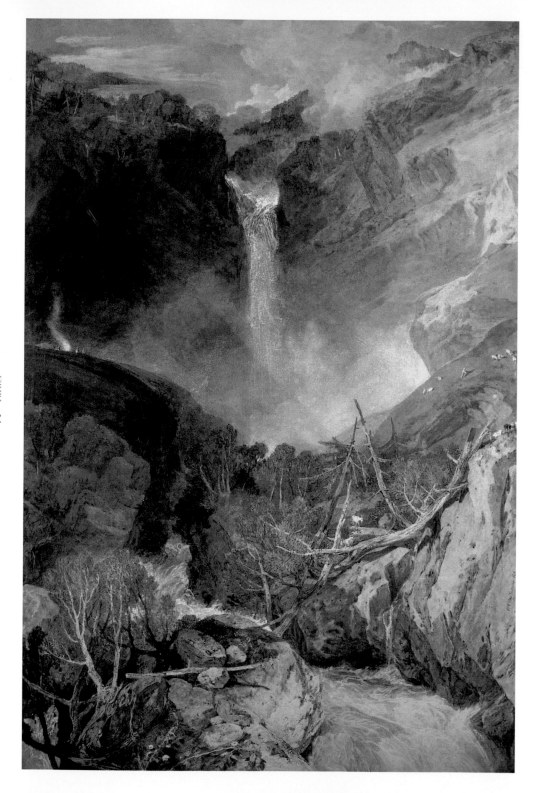

Knowing that he would be unable to travel abroad for the foreseeable future, Turner responded by studying scenery that was close to home, on the banks of the Thames and its tributary the Wey. In late 1804 he rented Sion Ferry House in Isleworth for eighteen months, and the following year he began to explore the river, sometimes from the bank but often from a boat. The results of his excursions may be seen both in the five sketchbooks (45) he used and in a series of oil studies he made on mahogany veneer or canvas. Painting outdoors in oils was very awkward because tube paints had not yet been invented. Turner and his colleagues had to use bladders of ready-mixed colours that were pricked with a pin when required. The smaller oil sketches on

44
Fall of the Reichenbach, in the Valley of Oberhasli, Switzerland, 1804. Watercolour, scratching-out and stopping-out; 103×70·4 cm, 40½×27¾ in. Cecil Higgins Art Gallery, Bedford

45
The Thames at Isleworth with the Pavilion and Syon Ferry, seen from the Surrey Bank, c.1805. Pen and ink on paper; 17·1×26·2 cm, 6¾×10¼ in. Tate, London

wooden panels presented few problems as long as the weather held, but Turner also chose to work on large, unstretched canvases including *Hampton Court from the Thames* (46), whose scale and complexity posed a real challenge. During the early nineteenth century, Turner was only one among many British artists who sketched outdoors in oils. He was, in fact, less assiduous in this respect than many of his colleagues, especially Constable, who made it a cornerstone of his practice. Unlike Turner, for whom agricultural landscapes were only a part of his output, Constable dedicated himself to the faithful transcription of humble domestic scenery. He found it difficult

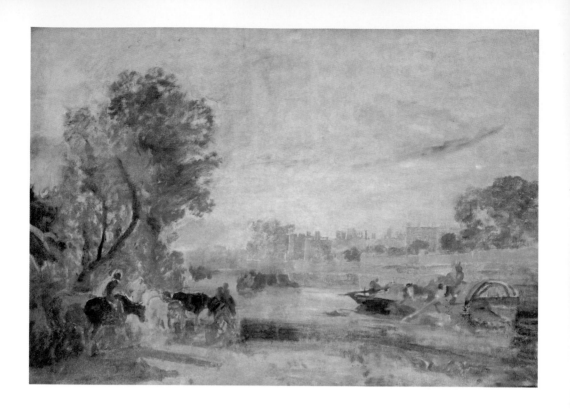

to match the brilliance and freshness of oil sketches such as *East Bergholt Rectory* of 1810 (47) in his exhibition pictures, and for many years he tried where possible to finish his paintings in the open air. Unfortunately, this limited the size of his canvases, which in turn prevented him from being noticed at the Royal Academy. When Turner worked directly from nature he usually made rapid sketches in pencil. His visual memory was so acute that even the most cursory drawing would serve to refresh the original impression he had received before the motif. It seems that he only painted outdoors in oils under special circumstances. Around the turn of the century he produced ten sketches of Knockholt and Chevening parks in Kent, possibly while staying with his close friend the painter William Frederick Wells (1762–1836). Later, in 1813, on his second visit to Devon he was cajoled into it by his friends and companions, but it was on the Thames that he made his largest single group of outdoor studies and sketches in oil. They are the closest he came to Constable's vision of landscape, and mark the beginning of an

involvement with the river and its scenery that later gave rise to some of his most important paintings of the war years.

Turner's initial forays on the Thames were undertaken during a period of growing anxiety, for when the war resumed it entered a new phase in which Napoleon prepared for the invasion of England. He assembled an army of 80,000 and a fleet of several hundred barges at Boulogne, from where they could be escorted across the Channel by the French Navy. The fear that a French army of conquest would land on English shores remained for many years, but the real likelihood of invasion diminished in August 1805, when the obvious superiority of the British Navy caused Napoleon to change tactics. He ordered Berthier, his Chief of Staff, to redeploy what had become known as 'the Army of England' in central Europe. This was despite the fact that he had already set in motion an ambitious plan to clear the Channel of English warships, thus leaving the south coast vulnerable to attack. Napoleon's naval strategy was to decoy Nelson's Mediterranean fleet away to the Caribbean, but the scheme misfired, and on 21 October 1805 Nelson engaged his French counterpart Villeneuve in battle off the Spanish coast at Cape Trafalgar. Nelson was mortally wounded during the encounter, but he inflicted such crippling damage on the fleets of both France and her Spanish allies that the prospect of invading England became more remote than ever.

46
Hampton Court from the Thames, c.1806–7. Oil on canvas; 86×120 cm, 33⅞×47¼ in. Tate, London

47
John Constable, *East Bergholt Rectory*, 1810. Oil on canvas laid on panel; 15.5×24.5 cm, 6⅛×9⅝ in. Philadelphia Museum of Art

Nelson's spectacular victory was overshadowed by his death, which provoked an outpouring of public grief. The poet Samuel Taylor Coleridge eloquently described the mood of the nation when he wrote that 'it seemed as if no man was a stranger to another: for all were made acquaintances in the rights of common anguish'. After the battle, Nelson's corpse, preserved in a lead coffin filled with brandy, was conveyed back to England on his flagship, the *Victory*. Turner made a special journey to see it enter the river Medway, and when it anchored off Sheerness he made copious pencil studies of the vessel itself, as well as other ships that took part in the engagement. He even questioned some of the combatants, jotted down their names and made notes about their uniforms. Like many other artists, including the Academy's second president, Benjamin West, Turner decided to commemorate Nelson's last and most glorious battle. Even Constable was lured away from the Suffolk landscape to paint a watercolour of the subject. Long before Nelson's death an industry had grown up around his name and exploits, producing images and memorabilia of all kinds, from prints and oil paintings to decorated pottery and snuff boxes. Turner originally became involved in 1799, when he exhibited a picture of Nelson's first great triumph, *The Battle of the Nile* (now lost), at the Royal Academy – his earliest exhibited painting of a contemporary event. If he imagined that such a topical subject would advance his reputation, however, he was mistaken. His was one of five treatments in the Academy that year, and he was competing with artists such as Nicholas Pocock (1741–1821) and Robert Cleveley (1747–1809), who specialized in ship portraits and naval actions.

Britain's dependence on the Royal and merchant navies fostered a thriving school of marine painting, dating back to the work of the Willem van de Veldes (elder and younger) during the Third Dutch War of 1672–3. Thereafter, few English victories at sea went unrecorded, and by the outbreak of the war with France, the naval battle was a flourishing sub-genre of painting. With the significant exception of de Loutherbourg, however, it was also a somewhat conservative form, with its emphasis on

the accuracy of historical or nautical details. It favoured specialists, many of whom, like Pocock, had spent a considerable time at sea, during which the minutiae of a ship's appearance (especially its rigging) became second nature. When judged by the exacting standards that typified the genre, Turner's depictions of warships or naval battles were sometimes found wanting. His painting of *The Battle of Trafalgar, as Seen from the Mizen Starboard Shrouds of the Victory* (48) received little notice from the press, largely because he showed it in his own gallery rather than at the Academy. However, Farington, who did see it, wrote in his diary on 3 June 1806 that it was 'a very crude, unfinished performance, the figures miserably bad'. The likelihood is that Turner originally rushed to complete it in the months after Nelson's funeral, while the country was still nursing its sense of loss, then felt compelled to rework the picture in 1808 after its first, lukewarm reception. John Landseer, who saw the painting before and after the alterations, pronounced it 'very much improved' and declared it 'a British epic picture' in which:

Mr Turner … has detailed the death of *his* hero, while he has suggested the whole of a great naval victory, which we believe has never before been successfully accomplished, if it has been before attempted, in a single picture.

It was an exceptionally perceptive judgement, since most artists who depicted the Battle of Trafalgar either concentrated on the death of Nelson or took a larger view of the action in progress. Turner reconciled the two by adopting a slightly elevated vantage point on the starboard side of the *Victory*. Although it was a novel solution, originality was less prized than clarity and accuracy in depictions of war at sea, and the picture remained on Turner's hands. Its strengths emerge clearly when seen alongside a similar but later composition (49) by Denis Dighton (1792–1827), who became military draughtsman to the Prince Regent in 1815. Unlike Turner's, his picture conveys little sense of the chaos

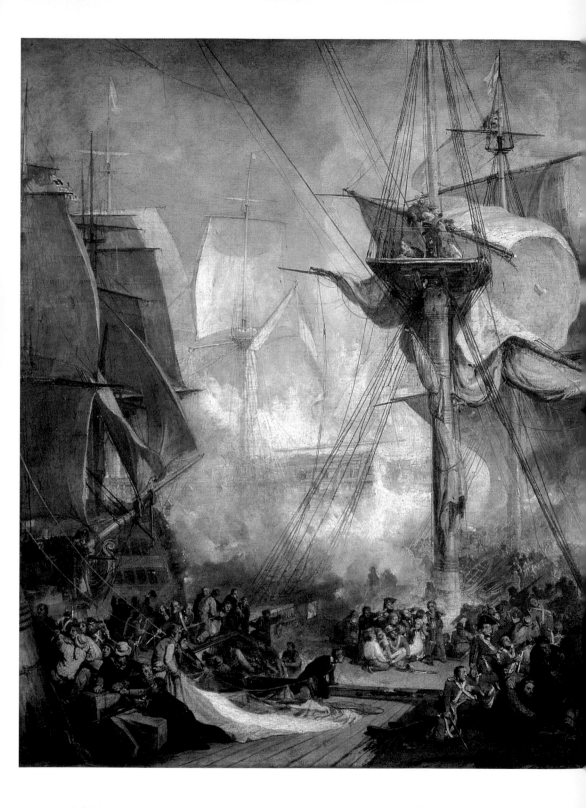

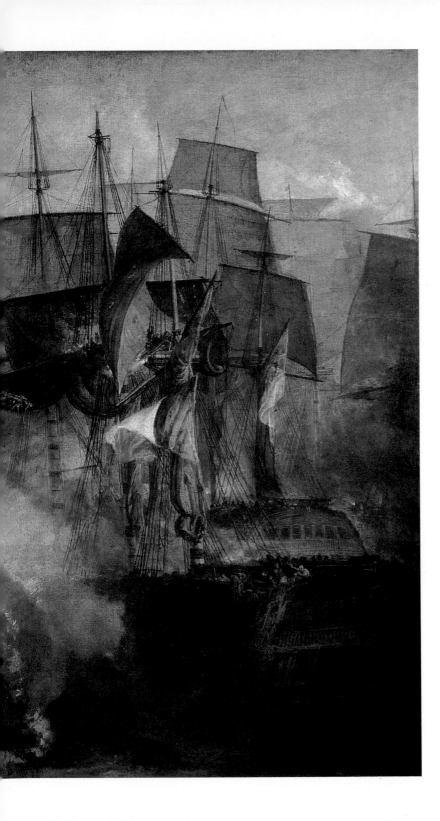

48
*The Battle
of Trafalgar,
as Seen from
the Mizen
Starboard
Shrouds of
the Victory*,
1806–8.
Oil on canvas;
171×239 cm,
67³⁄₈×94¹⁄₈ in.
Tate, London

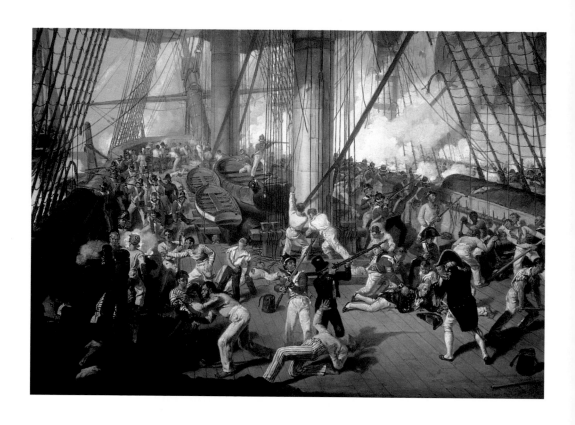

**49
Denis
Dighton**,
*The Battle
of Trafalgar*,
after 1811.
Oil on
canvas;
76×106·5 cm,
30×42 in.
National
Maritime
Museum,
Greenwich

and confusion of vessels fighting at close quarters. Much later in the century, when Turner's status as a great British painter was beyond dispute, his *Trafalgar* scene itself became the subject of '*Twas a Famous Victory*' (50) by Edward R Taylor (1838–1911). This shows a retired naval man using Turner's picture to give a history lesson to two young ratings, which implies that it is both a faithful and necessary record of the event, and one that contributes to the nation's sense of its own identity.

Some of Turner's other paintings around this time are less obviously, but still significantly, influenced by the conflict

with France. In 1807 he showed his first genre (or common life) subject at the Royal Academy. He gave it a lengthy and specific title, *A Country Blacksmith Disputing upon the Price of Iron and the Price Charged to the Butcher for Shoeing his Poney* (51). The quarrel to which it refers was brought about because the government levied a controversial tax on pig iron in 1806 to help pay for the war. It was undoubtedly painted to compete with David Wilkie (1785–1841), who had arrived in London from Scotland in 1805 and enjoyed a spectacular success the following year with his *Village Politicians*, a scene of rural labourers apparently arguing over matters of state in an

ale-house. In 1807 Turner's *Country Blacksmith* was hung next to Wilkie's *Blind Fiddler* (52) at Somerset House, thereby ensuring that comparisons between the two were inevitable. Some commentators admired Turner's picture, but others believed that he was envious of Wilkie's celebrity and had made a misguided attempt to outdo him. Since then the *Country Blacksmith* has often been taken as a sign of Turner's mean-spiritedness.

He and Wilkie later became friendly, but in the early days there was a competitive edge to their relationship, exacerbated by the fact that Sir George Beaumont, who owned the *Blind Fiddler* and had involved himself in its style and execution, supported Wilkie and denigrated Turner. In spite of this, there was more to the latter's *Country Blacksmith* than ill feeling and jealousy, for Turner genuinely disapproved of Wilkie's style. He believed that, like the French, Wilkie had made a serious mistake by renouncing a typically English breadth of handling in favour of meticulous detail. Far from imitating Wilkie, Turner issued a deliberate challenge by painting the *Country Blacksmith* with a broader, looser technique than the young Scot allowed himself. Figures that Wilkie would have shown in sharp focus appear generalized, and facial expressions play a much smaller part than they do in the *Blind Fiddler*. In this, as in *Venus and Adonis* (see 42), he may have been making a virtue of necessity, for it disguised his weakness at painting the human face.

As far as Turner was concerned, the villain of this episode was not Wilkie but his patron Beaumont. He was an amateur painter and an honorary exhibitor at the Royal Academy, although his chief claim to fame was as a wealthy connoisseur who would eventually bequeath his collection to the National Gallery. Unfortunately, he was not content to be merely a patron of the arts, and had appointed himself as an arbiter of correct taste. In this role he repeatedly attacked not only Turner's reputation but also that of his friend and admirer Augustus Wall Callcott (1799–1844). None of Beaumont's gibes appeared in print, but they were picked up and circulated so often that they amounted

51
A Country Blacksmith Disputing upon the Price of Iron and the Price Charged to the Butcher for Shoeing his Poney, 1807.
Oil on panel; 55×78 cm, 21⅝×30¾ in.
Tate, London

52
David Wilkie, *The Blind Fiddler*, 1806.
Oil on panel; 57·8×79·4 cm, 22¾×31¼ in.
Tate, London

**53
John
Hoppner**,
*Sir George
Beaumont*,
*c.*1806.
Oil on
canvas;
77·5×63·9 cm,
30¹₂×25¹₈ in.
National
Gallery,
London

to a campaign of vilification, leading Callcott to complain in 1813 that he had not sold a painting for three years. Even John Hoppner (1758–1810), who painted Beaumont's portrait (53), admitted that 'Sir George does great harm to the Art.'

It is hardly surprising that Turner regarded Beaumont as the epitome of the manipulative connoisseur, motivated not by the love of art but by 'vanity and never ceasing lust to be thought a man of superior taste'. Such men, he angrily claimed, knew little of art beyond their own collections, and nothing at all of nature. Their thoughtless criticism depressed the arts, and their wrong-headed advice was dangerous. They misled inexperienced painters such as Wilkie by drawing their attention exclusively to the Old Masters and away from direct observation of the visible world. Turner believed that a balance had to be struck: young artists had important lessons to learn from their predecessors, but unless they maintained a lifelong dialogue with nature their work would be mannered and derivative.

Whether or not it was true, he was convinced that Beaumont had derailed Wilkie's talent by encouraging him to imitate the work of the Flemish painter David Teniers the Younger (1610–90). He feared that unless the influence of practising artists countered that of such men as Beaumont, the British School of painting would be snuffed out.

There was more at stake here than just a personal dispute between Turner and Beaumont; their mutual hostility was symptomatic of wider developments in British art, particularly the foundation in 1805 of the British Institution. This was a patron-led body whose declared purpose was 'to encourage and reward the talents of the Artists of the United Kingdom', but it was widely seen as a deliberate challenge to the Royal Academy, which was governed by artists themselves. It won over many artists by offering prizes and by providing an additional venue for showing their work in its galleries in Pall Mall. In 1806 it also set up a school where amateur and student painters could study the works of the Old Masters, lent by the Institution's governors, who were all collectors and connoisseurs like Beaumont, and some of whom resented their lack of direct influence in the affairs of the Academy. The painter Thomas Uwins (1782–1857) was outspokenly critical of the new organization, describing it as 'a contemptible tyranny, set up by self constituted judges'. Turner was less vocal, and he showed his work there when it suited him, but he was always suspicious of its motives and disapproved of its approach to art education.

Turner had the arrogance of men such as Beaumont in mind when he wrote, 'to have no choice but that of the patron is the very fetters upon Genius'. The observation broadly coincided with a change in his own clientele, as some of his earlier supporters, including Edward Lascelles and the Earl of Essex, were superseded by others such as Sir John Leicester (who bought the *Country Blacksmith*), George Wyndham, 3rd Earl of Egremont and, above all, the Yorkshire landowner Walter Fawkes of Farnley Hall (54). Some years later, in 1818, Robert

Hunt, editor of the *Examiner*, published an article praising the patronage of Sir John Leicester, but in terms that applied equally to Egremont or Fawkes. Hunt claimed that, in addition to their money, men such as Leicester offered 'the more deserved and better reward of deference'. Neither Turner nor colleagues such as Thomas Uwins were prepared to debase themselves before their patrons. They demanded respect; in 1809, in a fierce spirit of independence Turner wrote:

54
Anonymous,
Walter Fawkes,
c.1815.
Pastel;
78×61 cm,
30³⁄₄×24 in.
Private
collection

Should I even a beggar stand alone
This hand is mine and shall remain my own.

In his eyes Egremont, Fawkes and Leicester represented a different sort of patron – one that nurtured genius by respecting it and allowing it to develop on its own terms. Fawkes was particularly important to Turner, for although he began as a client, whose early purchases included the *Fall of the Reichenbach*

(see 44), he subsequently became a close friend. Turner spent a month or so with his family in Yorkshire almost every year from 1808 until Fawkes's death in 1825, by which time the latter had acquired six of the artist's oils and around 250 watercolours.

Turner's defiant claim that he would rather be a beggar than a slave to his patrons was more than just bravado, but when he composed that couplet he was anything but poor. He began to invest his earnings as early as 1798, at first in government stocks, later in property. By 1810 he reckoned he was worth £11,350, though around £1,000 of this was owed to him by Fawkes, which gives some idea how important the latter's patronage was, even at that early stage in their relationship. By amassing funds in this way Turner cushioned himself against the caprices of public taste and acquired the freedom to follow his own singular vision, irrespective of his critics. His determination to do so is clear from a striking meteorological image he used to describe the creative process. The painter, he wrote:

distils from the materials of the mind a self found knowledge that have imperceptibly, like an accumulation of drops imbibing the surrounding objects of study in the atmosphere to mass swelling in a stream that forces a channel for itself.

Just as water vapour condenses into droplets, the artist's mind reflects on the learning and experience it has accumulated. As raindrops combine into a stream, so this distilled knowledge becomes the material of his art. The art, like the stream, finds its own direction. The simile encapsulates two of Turner's most deeply held beliefs: that anything he may have seen, read or done could legitimately find its way into his pictures; and that the painter must think and judge for himself in all matters concerning his art. These articles of faith help to account for the diversity of his achievements, but they may also explain why a section of Turner's public gradually became estranged from his work.

Turner's belief that practitioners, not patrons, should educate young artists may be one reason why he put his name forward

for the post of professor of perspective at the Royal Academy, but he also knew the effect the title would have on his status within the institution. It was not a love of perspective that moved him to apply, for it was a notoriously dry subject into which it was difficult to inject any life. This probably explains why there were no other candidates, hence Turner's unopposed election on 10 December 1807. When he finally delivered his first course of lectures in 1811, after three years of preparation, he began by warning his audience that, 'The task must be entered upon, however arduous, however depressing the subject may prove, however trite.' It was not an encouraging start.

In the event the lectures had a mixed reception. They were intended primarily for the Academy's students, but outsiders, including journalists, could obtain tickets with little difficulty and they were occasionally reviewed in the press. Today some sections come across as awkward and stilted, but others are confident, even authoritative, as, for example, when Turner deals with the effects of perspective on architectural forms, a theme for which his early work had thoroughly prepared him. To help with the delivery of this otherwise dry material, Turner produced a series of illustrations in watercolour, such as the *Temple of Neptune at Paestum* (55). It was for these that the painter Thomas Stothard regularly attended Turner's lectures, though he was too deaf to hear much of what was being said. Some would have said that Stothard was not missing much. Turner was ill-suited to speaking in public, and he was taken to task for mumbling, for his pronunciation, for frequent 'unhappy pauses' and for racing through the later stages of his texts to end his ordeal as swiftly as possible. On one occasion in 1814 he apparently left his manuscript in the back of a hackney carriage, and the professor of painting, Henry Fuseli, saved the day by agreeing to speak in his place.

55
Temple of Neptune at Paestum, c.1810.
Pencil and watercolour;
47·9×62·1 cm,
18⁷⁄₈×24¹⁄₂ in.
Tate, London

Turner's lacklustre performances could not compete with Sir Anthony Carlisle, the professor of anatomy, who was a natural showman and once galvanized his listeners by passing a human heart and brain around the auditorium. While Carlisle's

performances were always oversubscribed and occasionally threatened to descend into chaos, Turner's audience gradually deserted him. Although his lectures should have been given annually, he delivered them only twelve times in all between 1811 and 1828. After 1828 he ceased to lecture altogether, but clung to his post until 1837, when a Parliamentary Select Committee on the affairs of the Royal Academy was appalled by his neglect of his duties.

Incidents and criticisms of this sort have reinforced the view of Turner as a tongue-tied, largely intuitive artist, whose lectures and writings have little value for the study of his art, but this is untrue. They offer many insights, especially into his deep mistrust of received ideas, which placed him in an awkward position, since linear perspective was usually taught as a set of precepts. Turner's distaste for rules is clearest in his fifth lecture, where he departed from the official curriculum to talk about reflections, an area where the artist's skill and disciplined vision were everything and rules had little to offer. Knowing

it was a topic that would tax the descriptive powers of even the
most eloquent speaker, Turner relied heavily on the illustrations
he made to accompany the lecture, which he hoped would lead
the students to look for themselves. They are justly famous,
partly for their beauty but also for their exploratory quality.
There is something tentative about his study of *Two Glass
Balls, One Partly-filled with Water* (56), which records his
endeavours to grapple with the most elusive optical effects.
He wrote that 'these attempts to define the powers of light
and shade upon such changing surfaces as transparent bodies
[are] like picking grains of sand to represent time' – it was his
way of saying that the task called for infinite patience.

Turner's lecture on reflections suggests just how constrained
he felt by the limitations of perspective as a subject. For his final
talk in 1811 he strayed even further afield with a lecture entitled
'Backgrounds, Introduction of Architecture and Landscape'.
He later removed it from the series, probably because, as his
friend John Soane tartly observed, he was poaching on territory
that belonged to the professors of painting and architecture.
Turner told the writer and engraver John Landseer that his

56
*Two Glass
Balls, One
Partly-filled
with Water,*
c.1810.
Pencil and
watercolour;
22·4×40 cm,
8⁷₈ × 15³⁄₄ in.
Tate, London

real ambition was to become professor of landscape, but no
such post existed, and the Royal Academy stubbornly refused
to create one, presumably because it would compromise the
status of historical painting. In his 'Backgrounds' lecture Turner
attempted to subvert the academic hierarchy of subjects, arguing
that landscape imagery was of paramount importance in the
work of the Old Masters. His text ranged widely through the
history of art, but at its core was a hymn of praise to Titian,
and in particular to his *Death of St Peter Martyr* (see 43),
the picture that had so impressed Turner in Paris in 1802.

This lecture was Turner's most substantial contribution to
the theory of landscape painting, a branch of aesthetics that
expanded rapidly during the late eighteenth and early nineteenth
centuries. The sheer volume of writings reflects the growing
importance of the genre, and many of the texts were also highly
sophisticated and philosophically rigorous. While the defenders
and supporters of history painting tended to repeat threadbare
academic dogmas, landscape theorists explored their topic from
a variety of standpoints, unconstrained by official thinking.
Some introduced and refined new aesthetic categories such as
the picturesque, whereas others, such as Edmund Burke, drew
on the psychological principles of the day to investigate the role
and response of the spectator.

Turner was not a theorist in the conventional sense and left no
systematic body of writing. He valued practice over abstract
thought, and strongly believed that the faculty of vision ought
to be the main means by which a painter acquired knowledge.
At the same time he knew how important ideas could be. While
preparing for his lectures he read widely, but would only accept
those theories that did not contradict the practical wisdom he
had acquired in his professional life. Much of his research drew
on British and European treatises on perspective, whose highly
technical contents formed the bedrock of his subject. But he
also read other books on art and aesthetics by the leading
theorists of his own and earlier ages, and he jotted notes and

quotations from these sources into his sketchbooks. He also occasionally scribbled his responses in the margins or flyleaves of books, including John Opie's *Lectures on Art* and Martin Archer Shee's *Elements of Art*. These private annotations represented his deepest convictions, and they are more candid than he could afford to be in his official capacity as a professor of the Royal Academy. Comparatively little of this wider learning found its way into the lectures, but it helped to shape his attitudes to the practice of painting in general and landscape in particular.

His notes contain a number of tantalizingly brief references to the association of ideas. Their brevity suggests that he took the principle for granted, and that he was already using it to instil meaning into his works. It had been used much earlier in the eighteenth century by the influential thinker David Hartley to explain the workings of the human mind. In philosophical terms, Hartley was an empiricist: he believed that the mind has no innate or inborn ideas, and that all knowledge is derived from impressions received through the senses. These sense impressions then become linked with specific feelings and thoughts, and it is through this process of association that the mind organizes its contents. Hartley's account of human knowledge was adapted by other writers such as Archibald Alison and Richard Payne Knight to explain aesthetic experience or, as they called it, 'taste'. Knight was one of Turner's patrons, and the artist knew his *Analytical Inquiry into the Principles of Taste* (1805). It was a demanding text, but widely read and frequently reprinted. Knight's ideas, together with those of Alison, seriously undermined two of the most fundamental doctrines of the Royal Academy: its belief in ideal beauty and in a hierarchy of subjects. All the European academies taught that although beauty was an objective property of objects in the visible world, nature as we experienced it always fell short of the ideal forms found in classical Greek sculpture, which supplied fixed, universal and unchanging standards of perfect beauty.

Alison and Knight contradicted the Academy by insisting that beauty was not a quality that objects possessed but instead arose through a complex set of associations in the mind of the spectator. Consequently, it was nonsense to talk about absolute standards of beauty when associations varied so much from place to place and from one era to another. These arguments had major repercussions for the art of Turner and his contemporaries. They eroded the Academy's distinction between the so-called 'higher class' of ideal landscape practised by Claude and Poussin and the 'humble' naturalism that characterized Dutch art. All forms of landscape, even topographical watercolours, were replete with associations, and, according to Alison and Knight, it was the number and richness of these associations that determined the intensity of one's aesthetic pleasure. If they were right, then landscape in general and topography in particular deserved a much higher status than the Royal Academy would admit. Turner disagreed with some of Knight's ideas – the notion of ideal beauty, for example, continued to play an important part in his thinking (see Chapter 3). He nonetheless understood the implications of his patron's theories and made repeated use of the association of ideas in his own work.

Pope's Villa at Twickenham of 1808 (57) exemplifies the richness of associations that Knight and Alison sought. The response it elicited from the critic John Landseer demonstrates that Turner's more perceptive contemporaries were equipped to recognize them. Landseer knew that the picture was occasioned by the recent, infamous decision of Baroness Howe to destroy the poet Alexander Pope's villa and replace it with a new house. From this starting point he followed the train of associations prompted by Turner's image. He begins with topographical details, moves on to observe the time of day and the mood it evokes, then considers the figures in the foreground, which, 'by the simplest association of ideas', he takes to be the workmen demolishing the house, now returning home from their labours. Finally, he sums up the way in which all the

57
*Pope's Villa at
Twickenham*,
1808.
Oil on canvas;
91·5×120·6 cm,
36×47½ in.
Sudeley
Castle,
Gloucester-
shire

various elements combine to suggest the passing of time, and with it the poet's fading reputation:

On the banks of a tranquil stream, the mansion of a favourite poet which has fallen into decay, is under the final stroke which shall obliterate it for ever: a ruined tree lies athwart the foreground: the time represented is the decline of day, and the season of the year is also declining.

Landseer explained that by creating an overriding effect of tranquillity, Turner fosters a pensive, melancholy tendency in the spectator, which leads 'the mind ... to compare the permanency of Nature herself, with the fluctuations of fashion'. This astute piece of criticism provides a textbook account of the way in which the process of association was thought to operate, through a series of linked ideas contributing to one strong prevailing sentiment. Landseer was not just reading these things into Turner's picture – they were there to be interpreted by any well-informed and well-educated viewer.

Turner's belief in the superiority of visual knowledge over abstract reasoning played an important part in his decision to devote a huge amount of time and energy to the series of engravings he called the *Liber Studiorum* or 'Book of Studies', which is often described as a visual manifesto of landscape. The scheme took shape in 1806, when Turner was staying at Knockholt in Kent with his friend William Frederick Wells. He tried to persuade Turner to supervise the reproduction of his own works, fearing that they would be vulgarized after his death by unauthorized engravings – the fate that befell the exquisite drawings in Claude's *Liber Veritatis*, which Richard Earlom (1743–1822) clumsily translated into mezzotint in 1777. Turner was reluctant at first because the print market was in a bad way due to the Napoleonic Wars, but when the engraving after his great *Shipwreck* of 1807 collected an impressive list of subscribers, he had a change of heart. Encouraged by this promised success, he drew up plans for a series of one hundred prints and a frontispiece after his designs, to be executed

largely in a combination of etching and mezzotint, and issued in twenty parts.

As it turned out, his reservations were justified, and the scheme was not a commercial success. Turner undertook the task of publishing it himself, but he marketed it in a haphazard fashion. It was launched without a prospectus and never received the publicity it needed, despite the fact that by 1814 he was charging the relatively high price of 2 guineas per part for the highest quality (or proof) impressions. It may have been the poor return on his outlay that led him to halt publication in 1819 after seventy-one plates had appeared, but he did not give up on the series altogether, and may have continued to work on some unpublished plates until 1825.

It has long been recognized that this project was extremely important to Turner, and that he intended it to convey his beliefs and ideas about landscape. These have proved elusive, however, because, unlike most illustrated publications, the *Liber* carried no accompanying text. This apparently strange omission was perfectly consistent with his view that pictures were more effective than words in communicating ideas about art. The similarity between his title and Claude's *Liber Veritatis* led many to assume that he and Turner had similar ends in view, but Claude had copied existing paintings to safeguard his works from forgery, whereas most of Turner's designs were original. Landseer gleaned some information about the scheme during his visit to Turner's gallery in 1808, and he wrote in his *Review of Publications of Art* that it would 'attempt a classification of the various styles of landscape, viz., the historic, mountainous, pastoral, marine and architectural'. Landseer was apparently unaware that Turner added a sixth category when the first issue appeared, probably in June 1807. It was denoted by the letters 'EP', usually taken to stand for 'elevated pastoral', and the images thus inscribed are often reminiscent of Claude. The six categories provided the basis for the organization of the *Liber*, but for the project to have

any lasting value it had to be more than just an exercise in classification. In fact, because there was no written text, it was possible to approach the work in various ways. On one level it provided a guide to landscape composition; through the range of its imagery, it also made a strong case for the versatility of the genre and, of course, for Turner's capacity to excel in every aspect at a time when most of his contemporaries tended to specialize.

In her study of the *Liber*, Gillian Forrester described it as 'a portable history of landscape', in which there are tributes to Old Masters such as Claude, Poussin, Salvator Rosa (1615–73) and Rembrandt (1606–69), but also allusions to a host of British artists. Forrester argues that Turner sought to prove that his compatriots constituted a distinguished school of painting that could challenge any of its continental rivals. Given the heightened patriotism of the war years it is a compelling argument. Besides the illustrious dead such as Thomas Gainsborough (1727–88) and Wilson, Turner introduced scenes reminiscent of de Loutherbourg, Wright of Derby and even his friend Augustus Wall Callcott. He did not simply reproduce or plagiarize these artists' work, since copying others rather than following nature was anathema to him, but he was quite prepared to approach nature with a particular model in mind. He first sketched Dumblain Abbey on a tour of Scotland in 1801, then produced a more elaborate drawing (58) to be engraved for the *Liber*. Though based on observation, it also bears comparison with a *View of Tivoli* by Wilson that belonged to Turner's patron Dr Monro.

At the head of this pantheon of great landscapists was Turner himself. In a sense, the *Liber* summed up his career to date by drawing extensively on the material he gathered on his tours, occasionally reproducing specimens of his earlier work, and alluding to those artists who influenced his development. He also created images that bore little, if any, resemblance to the work of others, such as *Solway Moss* (59). This spare, storm-engulfed Scottish landscape exploited the potential of mezzotint

to create brilliant effects of bright light and deep shadow. He
used many different engravers on the *Liber*, but Thomas Lupton
(1791–1873), who prepared the plate of *Solway Moss*, had no
prior experience of mezzotint, and Turner supervised him closely.
Lupton later said that the process began with a 'slight drawing'
by Turner, which he etched and returned for the artist to amend.
Lupton then worked the copper plate in mezzotint, and at each
subsequent stage he printed a proof (or trial) impression, on
the basis of which Turner would have the plate altered until
he achieved the effect he was looking for. In retrospect Lupton
regarded the work as an education, but in general Turner alien-
ated his engravers with his exacting demands and low rates of pay.

58
*Dumblain
Abbey,
Scotland,*
c.1806–7.
Pencil and
watercolour;
18·4×26 cm,
7¼×10¼in.
Tate, London

59
*Solway
Moss,*
1816.
Etched by
J M W Turner,
engraved by
Thomas
Lupton.
Etching and
mezzotint;
17·6×25·7cm,
7×10⅛in

Beyond the patriotic or autobiographical, other inferences
can be drawn from the *Liber*. By adopting a neutral system of
classification by subject, for example, Turner nimbly sidestepped
the aesthetic categories of his day, especially the picturesque.
By the 1830s this term was so widely and indiscriminately used,
especially by publishers (including Turner's own), that it almost
ceased to have real meaning. Around the turn of the century,
however, it was the subject of vigorous debate. Like Burke's
writings on the sublime, various theories of the picturesque
helped to establish landscape as an object of serious aesthetic
interest. Judging by his unpublished comments, however,

Turner did not find any of them particularly compelling. The two most influential disputants were the Revd William Gilpin, an Anglican clergyman and amateur artist, and Sir Uvedale Price, a landowner and Whig Member of Parliament, who laid out his estate in Herefordshire along picturesque lines.

Although they had their (often considerable) differences, both men sought to establish that the picturesque was distinct from the beautiful, whose effects, according to Edmund Burke, were

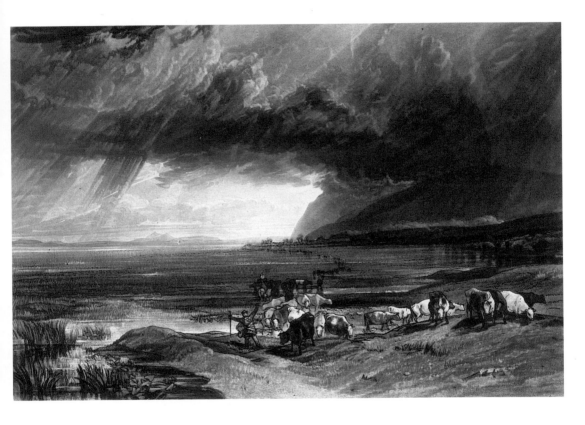

attributable to such qualities as smoothness and regularity. Burke's definition excluded much that was pleasing in both art and nature, which seemed to imply that there was a class of aesthetic experience – the picturesque – that was halfway between the beautiful and the sublime. Its attributes were roughness, irregularity, intricacy and variety, a checklist that perfectly fitted the art of Gainsborough, whom Price admired and patronized. Price was the more rigorous but less accessible

of the two writers. Gilpin was far more influential, through the accounts he published from 1782 of the various tours he undertook in search of picturesque scenery. The sites he recommended, together with his monochrome illustrations of them (60), became a blueprint of the picturesque for countless amateur painters and tourists.

Turner was familiar with the ideas of both men. He copied images from Gilpin's tour of Cumberland and Westmorland when he was only thirteen. The qualities he and Price deemed picturesque are plentiful enough in Turner's work during the 1790s, but by 1809 he was sceptical about the concept. The fact that it *was* a concept explains his unease, for abstract ideas could lead the artist away from nature. The proof was there in Gilpin's own sketches, which took great liberties with the scenery they purported to represent. The writer William Mason even claimed that a visitor to the Wye Valley would look in vain for a view to match the illustrations in Gilpin's published tour. It is possible that when Turner surveyed *The Junction of the Severn and the Wye* (61) from the grounds of Persfield Park – a site Gilpin declared 'unpicturesque' – he was slyly 'thumbing his nose' at the latter's theories. The high viewpoints and lack of variety to

which Gilpin took exception at Persfield Park become positive features of Turner's image. Gilpin would undoubtedly find its broad composition and emphatic horizontals unpicturesque, but they give an unobstructed view of the river Wye as it winds towards its confluence with the Severn in the far distance.

60
William
Gilpin,
Plate from
*Observations
on the
River Wye*,
1782

To Price's more sophisticated writings, Turner replied that all the supposedly picturesque qualities of 'uneveness, broken and undulating lines … may be found in common pastoral', and thus in such images as *Winchelsea* (62). Rather than suggesting that the pastoral category of the *Liber* is simply the picturesque by another name, he implies that the latter is redundant, because his version of 'pastoral' embraced the dramatic and 'unpicturesque' *Solway Moss* as well as *Winchelsea*. It could, therefore, express a range of sentiments far beyond the narrow compass of most picturesque theory.

Turner's use of the term 'pastoral' was unconventional. Whereas it normally implied an idealized landscape, he applied it to the representation of ordinary nature. What others would have described as pastoral loosely corresponded to his category of the 'elevated pastoral'. Turner's use of the term 'elevated' seems to imply that it was a superior class of imagery, but this is not necessarily the case. The 'pastoral' of *Winchelsea* and the 'elevated pastoral' of *The Junction of the Severn and the Wye* both depict domestic scenery, though treated differently so that each embodies its own distinctive sentiment. Turner once wrote that the most commonplace scenery could be powerfully affecting in the hands of a great painter, especially if it was rich in associations. During the war years the kind of scenery he classified as pastoral played an extremely important part in his work. Although pastoral scenes occupied a lowly place in the academic hierarchy of genres, there is little evidence that he ranked them below his more 'elevated' ones.

In the decade 1805–15 agricultural landscapes in general were more highly regarded than they had been during the later eighteenth century, when it was comparatively rare for

61
*The Junction
of the Severn
and the Wye*,
1811.
Etched and
engraved by
J M W Turner.
Etching,
aquatint and
mezzotint;
18·2×26·2 cm,
$7^1_8 × 10^3_8$ in

62
Winchelsea,
Sussex,
1812.
Etched by
J M W Turner,
engraved by
J C Easling.
Etching and
mezzotint;
18·1×26·2 cm,
7¹⁸×10³⁸ in

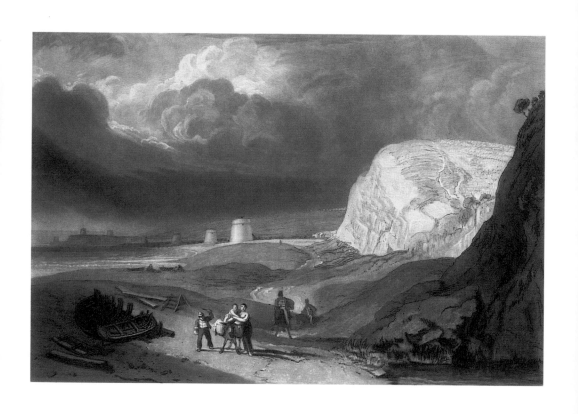

oil paintings to depict farming scenes in named locations. This was partly because the vogue for the picturesque had made them unfashionable. After 1805, however, they occur in the work of Constable, G R Lewis (1782–1871), Peter de Wint (1784–1849), William Delamotte (1780–1863) and, of course, Turner himself. There are several possible reasons for this. The tendency of associationist criticism to place different forms of landscape on an equal footing has already been mentioned. In addition there was an influx of naturalistic Dutch and Flemish landscapes into the London salerooms, because their European owners feared they would be stolen or looted during the hostilities. But above all there was a thorough re-evaluation of what the English landscape and coastline stood for, thanks to a drastic change of tactics on Napoleon's part.

63
Martello Towers near Bexhill, Sussex, 1811.
Etched by J M W Turner, engraved by William Say.
Mezzotint; 18×26 cm, 7¹⁄₈×10³⁄₈ in

Between 1805 and 1807 Napoleon achieved a series of impressive victories that left him in control of much of western Europe, while the British mobilized troops in southern England and continued to build coastal defences to stave off the expected French invasion. Not surprisingly, these developments were felt within Turner's output, for example in the presence of soldiers in the garrison town of *Winchelsea* (see 62), or in the more explicit imagery of the *Martello Towers near Bexhill, Sussex* (63), both published as part of the *Liber Studiorum*. The Martello towers were a series of seventy-four fortified gun emplacements built between 1796 and 1812, at strategic sites along the south and east coasts of England. They took their name and their design from an almost impregnable watchtower at Mortella Point on the island of Corsica, Napoleon's birthplace – an ironic detail that would have appealed to Turner. In his print the Martello towers become a potent image of national resistance, standing between the chalk cliffs of Sussex and the threat posed by Napoleon, symbolized here by a gathering storm about to move inland.

In reality, a French invasion was unlikely because Britain retained its mastery of the seas. Napoleon knew that he could not beat the Royal Navy in a conventional campaign and decided

to wage an economic war instead. His new policy, known as the Continental System, was inaugurated through the Berlin Decrees of 1806, which put in place 'a state of blockade' whereby all trade with Britain or her colonies was outlawed. Any vessels attempting to flout the decrees would be seized, along with their cargoes. In theory these measures would force Britain into submission by cutting off her exports from continental markets and by stopping her imports of raw materials and European wheat. In the event, Napoleon did not enforce the blockade consistently, and even when he tried it was beset with difficulties, thanks to British naval supremacy, which made it possible to impose a counter-blockade. In the first six months of 1808, there was a 25 per cent drop in British exports – enough to induce economic depression but insufficient to bring the country to its knees. Britain had to make up the shortfall in imported foodstuffs by becoming more self-sufficient, domestic industries had to meet the needs of the armed forces, and landowners were encouraged to grow and provide timber for the construction of new ships. The merchant fleet, meanwhile, resourcefully pursued alternative trading partners in South America and the Near East. In 1811, at the height of the blockade, Turner composed his own verses on these matters as part of a larger poem that he hoped would be used as the letterpress (or accompanying text) of *Picturesque Views on the Southern Coast*, a series of engravings published by the brothers George and William Bernard Cooke, after watercolours by Turner and other artists.

64
James Barry, *Commerce, or the Triumph of the Thames*, 1777–84. Oil on canvas; 142×182 cm, 56×71⁵s in. Royal Society of Arts, London

Plant out the ground with seed instead of gold
Urge all our barren tracts with agricultural skill
And Britain, Britain, British canvas fill
Alone and unsupported prove the Strength
By her own means to meet the direful length
Of continental hatred called blockade

Although the Cooke brothers rejected Turner's poem as incomprehensible, his lines convey the psychological effect of the

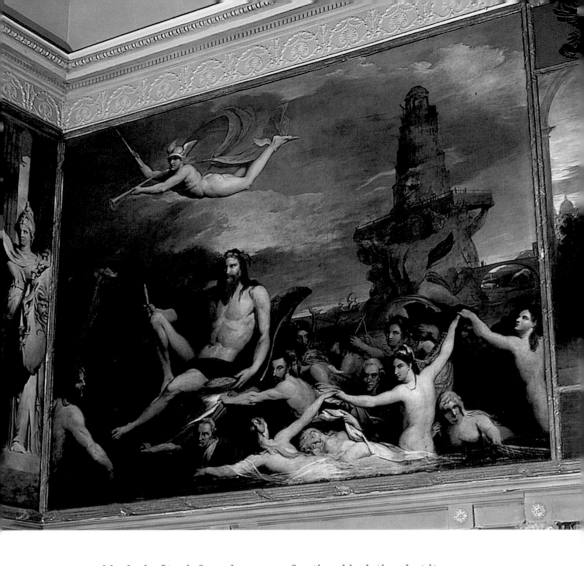

blockade. It reinforced a sense of national isolation, but it also transformed agriculture, forestry, various industries and commercial shipping into aspects of the epic struggle against Napoleon. When represented in a painting or print they had strong patriotic connotations. This is particularly true of those works in which Turner depicted the scenery around the Thames in Surrey, Berkshire and Middlesex, where the meanings attached to this prime agricultural land were strengthened by the powerful associations evoked by the river itself. Its status as the nation's major commercial artery had led the history painter James Barry (1741–1806) to use it as

the basis of his famous but ill-conceived mural *Commerce, or the Triumph of the Thames* of 1777–84 (64). Barry's picture was ridiculed for, among other things, showing the musician Charles Burney treading water while playing a harpsichord.

On the banks of the Thames were sites with strong historical connotations such as Hampton Court (see 46) and Windsor Castle, an emblem of Britain's constitutional monarchy. The Thames also figured prominently in the verse Turner admired. James Thomson, whose poems 'The Seasons' and 'Liberty' provided him with many of his poetic captions and associations, lived at Richmond and was buried there, while Alexander Pope not only lived at Twickenham in the villa Turner had painted (see 57) but had also used the river and its surrounding landscape to celebrate England's power, influence and prosperity in his poem 'Windsor Forest' of 1713. Finally, in the visual arts, Wilson had painted Twickenham (65), Windsor and Richmond, whose beauties even enticed Reynolds, first into acquiring a house in the vicinity and then into a rare attempt at landscape painting. All these associations help to explain why the Thames featured so strongly in Turner's art in this period, and also why he decided to design and build his own house in Twickenham, which he called first Solus and later Sandycombe Lodge (66).

Unlike Barry, Turner and his contemporaries saw no need to resort to ludicrous symbolism when painting the Thames and its scenery. A work such as *Ploughing up Turnips, near Slough* (67) was replete with wartime resonances. It demonstrated that the unaffected depiction of a specific place could achieve much more than Barry's flatulent allegory. The appearance of Windsor Castle in the background, shrouded in mist, ensures that the social extremes of the monarchy and the peasantry are both present in the picture, but the viewer is meant to understand that they are united in their resistance to France and its blockade – the labourers through their work and George III as a benevolent monarch whose interest in farming earned him the nickname 'Farmer George'. The painter's choice of the

65
Richard Wilson,
The Thames near Twickenham,
c.1762.
Oil on canvas;
56×88 cm,
22×34⅝ in.
Marble Hill House, Twickenham

66
W B Cooke after William Havell,
Sandycombe Lodge, Twickenham,
1814.
Engraving;
11×20 cm,
4³⁄₈×7⁷⁄₈ in

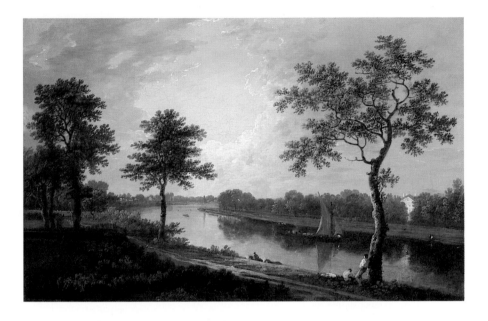

67
Ploughing up
Turnips, near
Slough,
1809.
Oil on canvas;
102×130 cm,
401$_8$×511$_4$ in.
Tate, London

turnip harvest was less eccentric than it appears, for they
were grown in between cereal crops to increase the fertility
of the soil without the need to leave it fallow for a year, and
also as a source of cattle feed. Because neither the land nor
any of its yield goes to waste, the whole image is one of agrarian
productivity. Much further upriver, in *Dorchester Mead* (68),
which Turner showed at his own gallery in 1810, he alludes
to forestry and the timber trade, which played a vital role
in supplying the needs of the British Navy. While cattle cool
themselves in the water, labourers manhandle lengths of wood on
to the flat-bottomed vessels known as lighters. *Dorchester Mead*
and *Ploughing up Turnips* are identical in size and may have
been intended as companions. They represent different times of
the day, divergent activities and distinct stretches of the river,
but they are alike in the way Turner invests them both with a
poetic quality through the manipulation of atmospheric effects.

68
*Dorchester
Mead*,
1810.
Oil on canvas;
101·5×130 cm,
40×51¼ in.
Tate, London

The implications of the subject matter in each of these paintings could be understood by a wide public, but according to the prevailing theories of the day it was the least worthy forms of art that had the broadest appeal. The traditional view of the Royal Academy was that images such as *Dorchester Mead* were inferior precisely because they were easy to enjoy and understand. Claude's landscapes, on the other hand, had a higher status because they pictured an ideal nature that few were discerning enough to appreciate. This doctrine confined 'taste' to a leisured and landed élite, implying that they alone had the independence and detachment necessary to judge whether or not a picture truly synthesized the best aspects of everyday nature. Even the associationist writers Payne Knight and Alison, who denied the existence of ideal beauty, still sought to ensure that culture would remain the preserve of a privileged and highly educated minority. They believed that this group had more intense aesthetic experiences than their social inferiors, because they possessed a richer store of associations drawn from literature, art and history. But their arguments carried less force during the war years, when British minds were occupied by the threat of foreign subjugation, and the national interest was more pressing than aesthetic one-upmanship. The wartime circumstances seemed to support the views of the Scottish philosopher Dugald Stewart, who asserted that *general* associations were far more important than private or restricted ones. Turner often brings such general associations into play in his work of this period, especially those that were destined to be engraved. This is not to suggest that ideal landscapes or others with learned references become less important during this period. Turner produced many such works, including *Pope's Villa at Twickenham* (see 57) and *Thomson's Aeolian Harp* of 1809, a classicized depiction of the Thames at Richmond, complete with nymphs decorating the poet Thomson's tomb. It is rather that naturalistic oil paintings of domestic scenery played a greater part during the war than they would do in his later career.

In the summer of 1811 Turner made an extended tour of Dorset, Devon and Cornwall, collecting material for inclusion in the Cooke brothers' *Picturesque Views on the Southern Coast*. In all, forty of his designs were published between 1813 and 1826, and some contain allusions to the industries that helped to sustain the war. In his watercolour of *Poole, and Distant View of Corfe Castle, Dorsetshire* (69), for example, the most prominent object is a wagon heavily laden with enormous logs on the road to Poole, where ships' masts are visible in the harbour. The town was not only a major port that traded extensively with Newfoundland, it was also an important shipbuilding centre. Turner's public were well aware that the construction of new vessels required a vast quantity of wood – around 2,000 trees to build a 74-gun man-of-war. The fact that the wagon and its load bears more than a passing resemblance to a cannon is probably a deliberate visual pun, intended to reinforce the military associations.

69
Poole, and Distant View of Corfe Castle, Dorsetshire, c.1811. Watercolour; 13·9×21·9 cm, 5¹₂×8⁵₈ in. Private collection

The previous chapter made the case that during the period
1802–11 Turner often used the landscape to represent England
as a stable society, united in its resistance to Napoleonic
tyranny. During the 1810s that image became much more
difficult to sustain. The head of the nation, King George III,
suffered attacks of mental illness brought on by the disease
porphyria, and in 1811 his eldest son became Prince Regent in
his place. The king was eventually confined to Windsor Castle,
the building Turner had used in *Ploughing up Turnips, near
Slough* (see 67) to symbolize his benevolent rule. In May 1812,
the prime minister Spencer Perceval was assassinated by a
businessman with an imagined grievance. At the other social
extreme, radicalism and unrest were increasing. The disturb-
ances took various forms: riots caused by food shortages and
high prices between 1810 and 1813 coincided with episodes of
machine-breaking, known as Luddism (after a mythical figure
called Ned Ludd). These occurred in the industrial counties of
Nottinghamshire, Lancashire and Yorkshire, where increasing
mechanization brought the threat of unemployment. In one
instance a factory-owner was murdered by the mob. Popular
unrest increased after the Battle of Waterloo in 1815, when
more than 300,000 demobilized soldiers found themselves
desperately searching for work during an economic depression.
The violence was exacerbated because those involved had
received a military training. Former members of the regular
army and civil defence volunteers began to demand a greater
share of the British rights and liberties they had been asked to
defend. In 1815 one in fifty men, at most, had the right to vote
and calls for adult male suffrage became increasingly strident,
not least from Turner's friend and patron Walter Fawkes. In
1812 Fawkes delivered a rousing speech to a radical audience,

70
*Frosty
Morning*
(detail of 74)

calling for a House of Commons 'composed of Members fairly, and really and honestly chosen by the People themselves'.

Fawkes's reformist politics were such an important part of his life that it is doubtful whether he and Turner would have been such close friends if the latter had not sympathized to some extent with Fawkes's views. While both men were certainly staunch patriots, this did not mean turning a blind eye to their country's faults, especially once the threat of invasion had receded. As a wealthy and independent man, Fawkes could express his views freely, but, if Turner did share his friend's

opinions, he had to tread carefully, for fear of damaging his professional ambitions. The artist's primary concern between 1811 and 1819 was to advance his reputation and status, both as a painter and lecturer, probably in the hope of emulating his admired Reynolds by becoming Sir William Turner, president of the Royal Academy. These ambitions would have been best served by avoiding controversy, but there were occasions when Turner felt moved to produce contentious works, such as *The Field of Waterloo* (see 87), that were unlikely to win him friends. In this he was not alone; in 1815 David Wilkie, who was

no radical, exhibited a picture entitled *Distraining for Rent* (71) as a protest against the unjust eviction of the poor tenant farmers who were pauperized during the recession. Wilkie suggests the threat of violence by the dispossessed through the bailiff's tight grip on his stick. Even when Turner did become outspoken, however, he was still primarily concerned to extend the potential of landscape painting. He also continued during this period to address issues that had arisen earlier in his art, one of the most pressing being the tension between observable reality and the concept of ideal beauty. Eventually, the end of hostilities enabled him to tour abroad once again, first to Holland, Belgium and the Rhine in 1817; then, two years later, the long-awaited visit to Italy (see Chapter 4).

During this period there were early indications that Turner could rise to the peak of his profession. The Royal Academy exhibition of 1811 included his mythological landscape *Mercury and Herse*, which was praised by the Prince Regent as a work Claude would have admired. With its classical subject, its Claudian composition, warm light and subdued colour it was one of the more traditional works Turner showed at this time. The following year he achieved another, more sensational success with the highly unconventional *Snow Storm: Hannibal and his Army Crossing the Alps* (72). According to the painter C R Leslie (1794–1859), the picture was almost obscured from view by the astonished crowds surrounding it. They were struck by the startling originality of its vortex-like composition, which Constable perceptively described as 'so ambiguous as to be scarcely intelligible in some parts (and those the principal), yet, as a whole it is novel and affecting'. It is significant that Constable, who devoted himself to rendering humble scenery as faithfully as possible (see 47), could acknowledge the power of a work so different from his own. The American artist Washington Allston (1779–1843) went further, describing *Hannibal* as 'a wonderfully fine thing' and Turner as 'the greatest painter since the days of Claude'. In earlier works, such as *The Fifth Plague of Egypt* (see 30) or *Calais Pier* (see 35),

71
David Wilkie, *Distraining for Rent*, 1815.
Oil on panel;
81·3×123 cm,
32×48½ in.
National Gallery of Scotland, Edinburgh

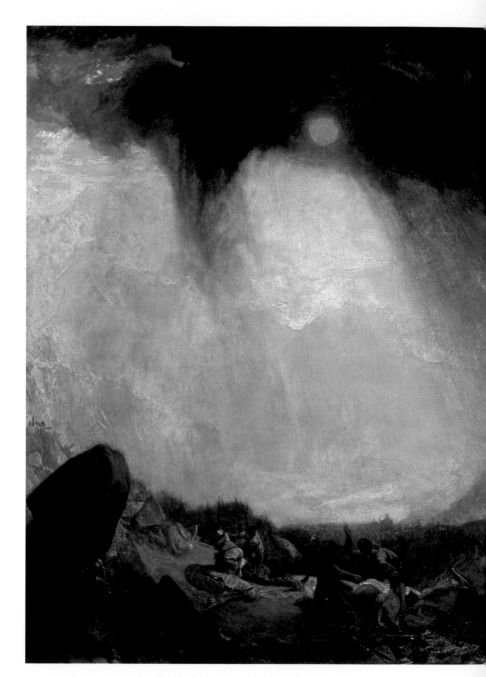

72
Snow Storm:
Hannibal
and his Army
Crossing
the Alps,
1812.
Oil on canvas;
146×237·5 cm,
57½×93½ in.
Tate, London

Turner had begun to structure his imagery around a vortex-like form, but in *Hannibal* everything, even the carefully chosen but small-scale details, became secondary to the vortex itself. It was the normal practice at Somerset House for large paintings to be hung on a line above the heads of spectators, but Turner went to extraordinary lengths to have his *Hannibal* hung relatively low. The reasons for his obstinacy become clear if the picture is viewed at the height he intended, and at fairly close quarters. His details are too small to affect the composition as a whole, and with no strong visual accents to cling to, the viewer is engulfed by the great vortex of the storm. Turner continued to exploit the effect in later works, such as *Snow Storm – Steam-Boat off a Harbour's Mouth* (see 160). Much later, in 1846, the cataclysmic effect of *Hannibal* misled the writer Elizabeth Rigby into thinking that it depicted the end of the world. By then, however, Turner's vortex had almost become a cliché, having been plagiarized by John Martin, who specialized in apocalyptic subjects, such as *The Great Day of His Wrath* (73).

73
John Martin,
*The Great
Day of His
Wrath*,
1851–3.
Oil on canvas;
196.5×303.2 cm,
77³⁄₈ × 119³⁄₈ in.
Tate, London

Although *Hannibal* represented an episode from classical history, it had Napoleonic overtones, due to the comparisons previously made by such artists as David between the achievements of Bonaparte and those of his Carthaginian predecessor, Hannibal. In his great equestrian portrait (see 37) the French artist prominently inscribed the names of both generals on a rock in the foreground. For the first time Turner used a caption from his own fragmentary poem, the 'Fallacies of Hope', to accompany the picture in the Academy catalogue. Although his poetic efforts were constantly ridiculed, his lines invariably play an indispensable part in amplifying the meanings of his images. By composing them himself, rather than borrowing from other writers, he could tailor his own verses to the demands of the subject. On this occasion Turner described the sufferings of Hannibal's troops as they crossed the Alps in 218 BC, attacked by local tribesmen and beaten down by the weather until the route became 'ensanguin'd deep with dead'. The 'low, broad and wan' sun offers hope of an end to their hardships, but the last line contains the phrase 'Capua's joys beware', implying that, once they reach Italy, the enervating effects of luxury and the spoils of war will undermine their martial prowess. Hannibal's grand ambitions are doomed from the outset, not by nature's ferocity, or the enemy's resistance, but by inherent weaknesses of human nature. Without Turner's poetry the picture alone would not convey this pessimistic and provocative conclusion, which visitors to the Royal Academy could extend by implication to predict the failure of Napoleon's imperial schemes.

Throughout the later years of the war, Turner continued to travel during the summer months, but after the success of *Hannibal* in 1812 he remained near Twickenham to supervise the building of his new house, Sandycombe Lodge (see 66). One of his near neighbours was Louis-Philippe, the future French king (r.1830–48) who was then living in exile. The two men developed a cordial relationship that lasted until Turner's last continental tour in 1845. The following year, 1813, he submitted only one oil painting to the Royal Academy – a winter scene entitled

Frosty Morning (74). It made a deep impression on Constable's closest friend, the Revd John Fisher. Having praised Constable's chief exhibit of that year, *Landscape, Boys Fishing*, he confessed 'I only like one better & that is a picture of pictures – the *Frost* of Turner. But then you need not repine at this decision of mine; you are a great man like Buonaparte & are only beat by a frost.' Fisher was alluding to Napoleon's catastrophic Russian campaign of 1812, during which sickness, battle casualties and the winter cold reduced his armies from 650,000 to 93,000 troops. Fisher's quip is indicative of the power Napoleon exerted over the minds of Turner and his contemporaries, in that military associations could be brought to bear on such an unlikely work.

On the evidence of Turner's friend Henry Scott Trimmer, the scene was based on one the artist sketched while journeying to stay with Walter Fawkes in Yorkshire. He identified the young girl as the artist's daughter Evelina and the horse as his 'crop-eared bay'. The painting was reputedly one of Turner's favourites, and it would be tempting to think that he cherished its associations with Fawkes and Farnley Hall, but it is too melancholy for that. *Frosty Morning* is easy to admire, as Fisher did, for its brilliant depiction of the partly frozen earth, and the dawn light, seen through the last remnants of a late autumn or winter's mist. But the more closely it is scrutinized, the more unsettling it appears. To some extent the mood of 'cheerless desolation', as the critic for the *Spectator* later described it, is derived from the season and the bleak aspect of the largely featureless landscape, but it is reinforced by the coach, just visible to the far left, which suggests the idea of departure or leave-taking. Furthermore, the attitudes and activities of the figures themselves are puzzling. The task on which the two labourers are engaged is far from clear, although it may be a late season employment such as ditch-digging. If so, like the other individuals in the scene, they appear curiously still. Facing in different directions, all the human participants seem self-absorbed and uncommunicative, which gives the occasion a sombre, ritual quality.

74
*Frosty
Morning,*
1813.
Oil on canvas;
113·5×174·5 cm,
44¾×68¾ in.
Tate, London

It may well be set in Yorkshire, as Trimmer claimed, but there is nothing in either the title or the topography of *Frosty Morning* that could identify the location. The staging strongly suggests a narrative, but one for which the viewer has been offered no context. Thus, while it provokes conjecture, it simultaneously withholds the prospect of a satisfactory interpretation. What can safely be said, however, is that it is far removed from Turner's earlier paintings of *Ploughing up Turnips, near Slough* (see 67) and *Dorchester Mead* (see 68), which conveyed a positive, patriotic idea of agrarian life and work by representing specific places and recognizable activities. As an image of the country-side, and his last major oil painting of an agricultural landscape, *Frosty Morning* is generalized, perplexing and seemingly indicative of malaise, though whether that had anything to do with Turner's indifferent health at the time, the state of the nation or both, is impossible to say with certainty.

In the summer of 1813 Turner was in a convivial mood when he made a second visit to Devon to collect material for the 'Southern Coast' series and for another Cooke Brothers project on the rivers of Devon, although none of his designs for the latter were ever published. He toured with two local artists, the landscape painter Ambrose Johns (1776–1858) and Charles Eastlake (1793–1865), then only twenty years old, who would later become both president of the Royal Academy and director of the National Gallery. Turner befriended Eastlake when he was a student at the Royal Academy, and it was Eastlake's father who first introduced Turner to Johns in 1811. As an important figure in the artistic life of Plymouth, Johns was able to ensure that all went smoothly on Turner's Devon tours. They were joined in 1813 by Cyrus Redding, an observant journalist who later wrote an account of their experiences. With encouragement from Johns, who was an enthusiastic outdoor sketcher, Turner resumed the practice of working in oils before nature. Now, however, instead of the wood panels or large unstretched canvases he used on the Thames, he recorded the scenery around Plymouth on small sheets of heavy paper that

were covered with a grey ground (75). Johns provided not only the paper but also a portable painting box that contained most of the materials Turner needed to sketch quickly and conveniently. With Johns in attendance to help with the box or its contents, Turner became less furtive than usual in his sketching habits, and even boasted of the speed with which he produced his studies – in one case claiming it was less than half an hour.

Turner had shown four oil paintings of Devon scenery at his own gallery in 1812, and one might have expected him to transform his oil studies into a major picture for the Royal Academy in

75
The Plym Estuary from Boringdon Park, 1813.
Oil on paper; 23·5×29·8 cm, 9¼×11¾ in.
Tate, London

1814. But that year he sent only one oil, *Dido and Aeneas*, to Somerset House, and one of his strangest pictures, *Apullia in Search of Appullus – Vide Ovid* (76) to the British Institution, whose directors (including Sir George Beaumont) had offered a prize for the landscape that would best serve as a companion to a work by Claude or Poussin. It was a competition designed for younger, aspiring artists and Turner had ulterior motives for taking part. His distrust of the British Institution's educational role had intensified over the years, and true to his belief that ideas about painting were best communicated through

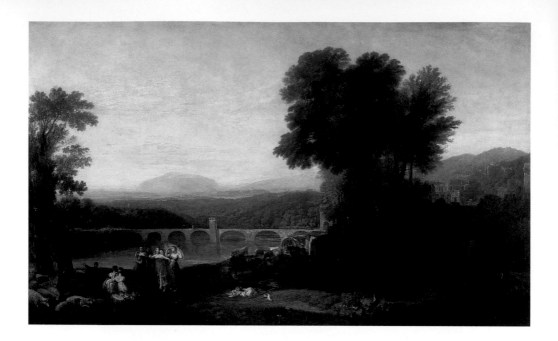

the medium itself, his *Apullia* was meant as an attack on the
Institution's policy of encouraging the rising generation to
emulate the works of the past. Where previously in the *Mâcon*
(see 39) he had adapted Claude's *Landscape with Jacob and
Laban and his Daughters* (see 40), on this occasion he resorted
to outright plagiarism. The theft was deliberate and ironic,
since his subject – freely adapted from the Roman poet Ovid –
is a cautionary tale about the perils of imitation. Appullus, a
shepherd, is turned into an olive tree for his vulgar mimickry
of a group of dancing nymphs. It is not too far fetched to think
of *Apullia* as a Trojan Horse, which used the Institution's much-
publicized prizes to subvert its own principles. It was an
intriguing idea, but the painting itself was probably too obscure
to hit its intended target with any force, although Turner's patron,
the Earl of Egremont, may have taken the point. Not only was he
a director of the British Institution, but he owned the Claude
that Turner had plagiarized, and the episode seems to have
precipitated a rift between the two men that lasted over a decade.

Turner was not alone in his hostility towards the Institution
during these years. After winning many artists over by holding

exhibitions of contemporary British work, it then increasingly
gave priority to shows of Old Master paintings. Some of the
more radical academicians, such as Thomas Uwins, had always
regarded the British Institution as a conspiracy by a wealthy
and privileged clique to extend their influence over the visual
arts, by preventing artists from directing their own affairs.
During the 1810s there were parallels with the wider politics
of the nation, where advocates of parliamentary reform such
as Walter Fawkes challenged the vested interests of a narrow,
unrepresentative élite. The most successful attack on the
British Institution took the form of two anonymous pamphlets,
known as the *Catalogues Raisonnés*, which were circulated
in 1815 and 1816. From their language and sentiments it is
generally thought that the author, or authors, held radical
views, and they have been attributed to various academicians,
as well as to Walter Fawkes himself. They do not mention Turner
by name, but they contain an implicit defence of his reputation,
while delivering such a robust attack on Sir George Beaumont
that, according to Farington, he was left a broken man.

Turner probably returned once more to Devon in 1814. The
following year he distilled his experiences into a major oil
painting, *Crossing the Brook* (77), which was shown to great
acclaim at the Royal Academy. Like *Apullia*, its composition,
with flanking trees, together with a bridge and water in the
middle distance, is based on the ideal landscapes of Claude, but
there the similarities end. *Apullia* is a mythological subject that
clings tightly to its Claudean prototype, whereas *Crossing the
Brook* is a synthesis of the observed and the ideal. Furthermore,
while the pictorial framework that Turner borrowed from his
great predecessor gives his picture the connotations of
permanence and continuity, its details are those of a specific
stretch of English scenery in the second decade of the nine-
teenth century. To combine these contradictory aspects in the
same painting was a tall order, which may explain why Turner
chose to do so with a Devon subject. He told his travelling
companion Cyrus Redding that 'he had never seen so many

76
*Apullia in
Search of
Appullus –
Vide Ovid*,
1814.
Oil on
canvas;
146×238·5 cm,
57$\frac{1}{2}$×93$\frac{7}{8}$ in.
Tate, London

natural beauties in so limited an extent of country as he saw in the vicinity of Plymouth', adding that 'some of the scenes hardly seemed to belong to this island'. Turner evidently felt that the Devon countryside was comparable to the Italian scenery on which Claude had based his paintings, and thus was able to adapt the landscape around Plymouth to a Claudean scheme without unduly falsifying it. Eastlake, who knew the area well, insisted that the picture was 'extremely faithful' to the topography of the Tamar Valley, and underscored the point by observing that Turner even included evidence of mining in the middle distance. In this respect *Crossing the Brook* recalls the earlier *Mâcon* (see 39), for although both works appear idealized at first sight, closer inspection reveals signs of modern industry – copper mines in the Devon picture, and in the *Mâcon* heavily laden barges apparently dredging the river.

Crossing the Brook and *Mâcon* are both examples of Turner's concern to redefine two closely linked concepts that were introduced in the previous chapter – the pastoral and the ideal. The term 'pastoral' evoked the pleasures of a vanished golden age, in which the inhabitants of a mythical rustic paradise known as Arcadia lived a simple, harmonious life, supported by bountiful nature. As the scholar John Barrell wrote, the pastoral was not so much a way of looking at the landscape as of not looking at it. It represented an unchanging world of stable values, whereas in reality the British countryside had been transformed since the eighteenth century. This occurred partly through the introduction of new agricultural machinery, and partly because common land was enclosed for private cultivation, thus depriving labourers and smallholders of the rights to graze animals and collect firewood. In Turner's era these changes, which brought great hardship for the rural poor, could not be ignored, and thus the traditional type of pastoral gradually lost its credibility. Some of the eighteenth-century poets Turner most admired, including James Thomson, John Dyer and Mark Akenside, tried to reconcile the older pastoral form with the part played by agriculture in the

77
Crossing the Brook, 1815. Oil on canvas; 193×165 cm, 76×65 in. Tate, London

78
*Dido
Building
Carthage; or
the Rise of the
Carthaginian
Empire,*
1815.
Oil on canvas;
155·5×232 cm,
61¼×91⅜ in.
National
Gallery,
London

economic life of modern Britain. Turner attempted something similar in *Crossing the Brook*. It is a work that would fit comfortably into the 'elevated pastoral' category of the *Liber Studiorum*, which included both the more traditional, generalized Arcadian scenes and British sites depicted in such a way as to preserve a semblance of ideal beauty without sacrificing observed reality.

Reynolds's *Discourses* gave Turner the lifelong conviction that the ideal was of fundamental importance, but the form in which the late president presented this concept was problematic. As previously explained, Reynolds had described the normal variations in natural forms and climatic conditions as 'deformities' and 'accidents', but these things were the very heart of landscape painting. Turner removed the stigma from the representation of ordinary nature by insisting that the forms of the external world 'are all naturally beautiful in their various kinds'. His version of the ideal was, therefore, not a matter of eliminating deformities, as Reynolds believed, but of synthesizing the everyday beauties of 'nature in her common dress'. In fact, as Turner described it in his annotations to Opie's *Lectures on Painting*, the true artist spent a lifetime accumulating a vast experience of the visible world, looking not just at surface appearances, but also at 'the qualities and causes of things'. This habit of close attention allowed the painter to represent both essential beauty and, as Ruskin would later emphasize, the underlying processes of nature. In *Crossing the Brook* this was achieved without losing the sense of place.

The work was highly praised but did not sell, possibly due to Sir George Beaumont, whose animosity towards Turner reached its peak in 1815. He reserved the worst for *Dido Building Carthage* (78), which was also based on a Claudean format, but this time one derived from his seaports. Beaumont complained that, although Turner had borrowed his composition from Claude, the latter's subtle colouring was forgotten in Turner's strongly contrasted warm yellows and cool greens. Nonetheless,

Turner later ensured that comparisons between his picture and Claude were unavoidable by stipulating in his will that *Dido Building Carthage* should go to the National Gallery on condition that it hang alongside Claude's *Seaport with the Embarkation of the Queen of Sheba* (see 25). *Dido Building Carthage* continued the series of paintings on the history of Carthage that began with the *Hannibal* (see 72) in 1812 and concluded in 1850 with the last oil paintings Turner showed at the Royal Academy (see 179). Queen Dido is on the left, presiding over the creation of her city, and, in a detail cribbed from a *Liber Studiorum* subject called *Marine Dabblers*, young boys launch toy boats in the harbour (see frontispiece), thus hinting at the seamanship that would make Carthage the heart of a great trading empire.

On 18 June 1815, while *Dido Building Carthage* and *Crossing the Brook* were hanging in the Royal Academy, Napoleon was finally defeated at the Battle of Waterloo by the British forces under Wellington and the Prussians under General Blücher. Bonaparte was exiled on St Helena, an Atlantic island 5,000 miles away, while his adversaries assembled first in Vienna, then in Paris, to redraw the map of Europe, pushing France back to its pre-revolutionary boundaries and restoring the old ruling dynasties. At home, the euphoria that greeted Wellington's victory was short-lived, for the nation was exhausted by eighteen years of constant struggle. The peace also brought with it a widespread recession, for it removed the powerful stimulus war had given to the economy. Restrictions on foreign travel were lifted, and some artists, such as Eastlake, were quick to take advantage of this new freedom, but Turner continued at first to paint the domestic landscape, for he had a number of existing commitments.

One of his more important employers during these years was the Revd Thomas Dunham Whitaker, a clergyman and antiquarian who published several books on the landscape and history of Lancashire and Yorkshire. Turner's watercolour of

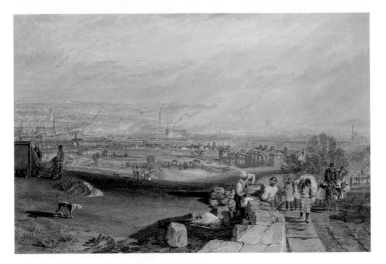

79
Leeds,
1816.
Watercolour;
29×42·5 cm,
11¹₂×16³₄ in.
Yale Center
for British
Art, Paul
Mellon
Collection,
New Haven

Leeds (79) was painted in 1816 as an illustration for Whitaker's history of that town and its surrounding district, and still contains allusions to wartime circumstances. The town was the most important flax-spinning centre in England, and the thread it produced was turned into rope and canvas for use by the navy. The blockade cut off some foreign markets for British cloth, but these opened again once hostilities were over, and the town that Turner painted was a site of vigorous industrial expansion. Fawkes was briefly the Whig Member of Parliament for Leeds, and the artist had a detailed knowledge both of the locality and the industry that sustained it, as is evident from the carefully chosen incidents he includes. There are workers stretching new cloth to dry on tenter frames, and others carrying rolls from the workshops down the hill. In the distance, factory chimneys compete with church spires for our attention, as their smoke is carried away by a strong breeze. The picture was never engraved, probably because Turner's image of Leeds's industrial prosperity contradicted Whitaker's belief that factories were blighting the county. In 1811 only 25 per cent of Britons lived in towns or cities, but many artists and intellectuals, including Blake and Wordsworth, shared Whitaker's concern. In his poem 'The Excursion' of 1814, Wordsworth described towns growing 'from the germ of some poor hamlet', then noted the expansion

in foreign trade and industrial production – which was then increasing by around 3 per cent a year – before concluding:

… I grieve, when on the darker side
Of this great change I look; and there behold
Such outrage done to nature …

There are occasions, such as his *Dudley, Worcestershire* of about 1830–1 (see 126), on which Turner seems ambivalent towards Britain's burgeoning industry, but in general he did not share Wordsworth's distaste.

In 1816 the publisher Longman agreed to pay Turner 3,000 guineas to provide 120 illustrations for Whitaker's proposed seven-volume history of Yorkshire. It proved unprofitable, and only one volume, *The History of Richmondshire*, was ever published. Among the images Turner did produce, however, was a watercolour of what was actually a Lancashire scene, the *Crook of Lune, Looking towards Hornby Castle* (80). It exemplifies his concern not merely to capture the likeness of

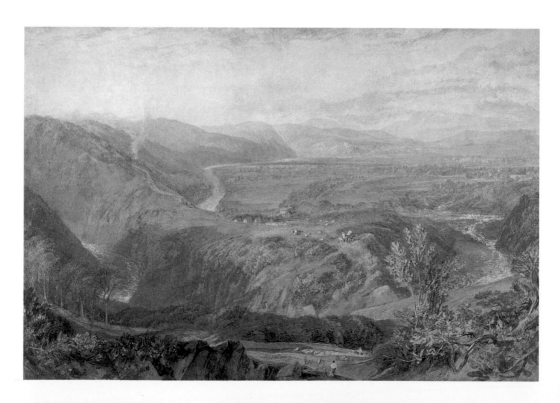

a locality but to represent the processes that had shaped the landscape. From a high vantage point the spectator looks over the land and traces the windings of the river Lune towards the far distance. Turner provides strong visual accents by scratching out small areas of the water. This also suggests its movement, and thus the force with which the Lune continued to alter the terrain by eroding the outside edges of its meanders.

Having witnessed the spectacle of Napoleon's dominions growing and collapsing within a generation, Turner seems to have become convinced that all empires and civilizations followed a pattern of rise and fall, though usually over a longer timescale. It was a widely held belief that often found its way into contemporary travel guides such as J C Eustace's *Tour through Italy* (1813), which Turner consulted when planning his first visit to that country. However commonplace the notion might have been, it became a recurring theme of Turner's work in oils. It was first expressed in 1816, in two paintings that showed the temple of Jupiter Panellenius on the island of Aegina, one in its modern state of dilapidation and the other as it might have looked in its original condition. After creating these contrasting images of Greece's glorious past and sorry present, Turner brought the history of Carthage full circle in 1817 in *The Decline of the Carthaginian Empire* (81). Its full title, which is fifty-two words long, draws on Oliver Goldsmith's *Roman History* (1786) to explain how, rather than going to war, the Carthaginians gave up 300 children as hostages during peace negotiations with Rome. They did so in an attempt to preserve their wealth and luxuries, but to no avail, for war did break out and they could not protect themselves. The work has a similar pictorial structure to *Dido Building Carthage* (see 78), but they differ in other respects. *Dido Building Carthage* is a cooler work owing to the greens of its more abundant foliage. *The Decline of the Carthaginian Empire* is dominated by architecture, which reflects the harsh yellow light of the sun, to give a more oppressive effect. These differences, as much as the detail, allow Turner to construct a narrative of rise and fall.

80
Crook of Lune, Looking towards Hornby Castle, c.1817. Pencil, watercolour, gouache and scratching-out, 29·1×42·1cm, 11$\frac{1}{2}$×16$\frac{1}{2}$in. Courtauld Institute Gallery, London

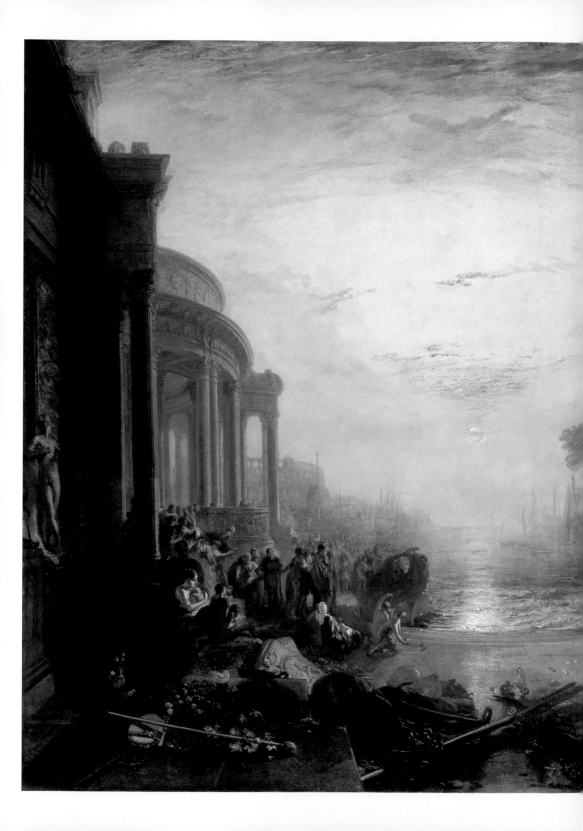

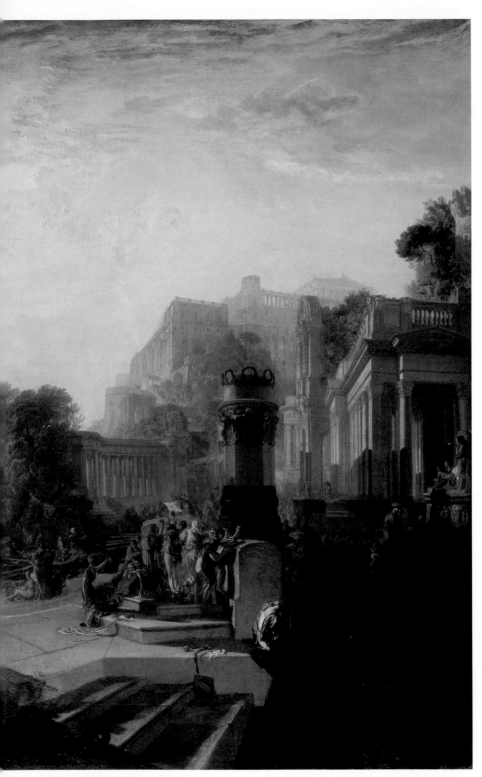

81
*The Decline
of the
Carthaginian
Empire*,
1817.
Oil on canvas;
170×238·5 cm,
67×94 in.
Tate, London

Commentators have long suspected that he intended his audience to draw a parallel between the fate of Carthage and the prospects of newly victorious Britain, for although the latter had a huge overseas empire that claimed sovereignty over one in five people on the planet, it suffered from dissent and unrest at home.

In August and September that year Turner made his first trip abroad since 1802, with an itinerary that took in Belgium, and a journey up the Rhine from Cologne to Mainz and back, before returning home via Holland. At the heart of this demanding schedule were the ten days he spent exploring the Rhine Valley, some by boat but much of it on foot, using the road Napoleon had built on the west bank of the river. He worked intensively, making rapid pencil sketches that were swiftly worked up into a sequence of fifty exquisite watercolours. It seems likely that some were begun when he was abroad and the series was probably completed while staying at Raby Castle in County Durham, soon after his return. Like the others in the series, the view of *Bingen from the Nahe* (82) is painted on heavily sized white writing paper on to which Turner laid a grey

82
Bingen from the Nahe, 1817. Watercolour and gouache with scratching-out; 19·5×31·6 cm, 7³⁄₄×12¹⁄₂ in. British Museum, London

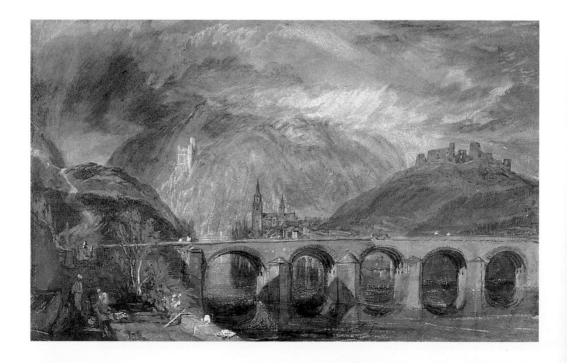

wash, before creating the picture in a combination of water-colour and gouache. In this instance he scratched out highlights to represent ripples, figures on the bridge and washing on the wall. This combination of materials and techniques allowed him to represent a wide range of scenery and climatic effects. The grey-washed paper, in particular, gave a unity to the set that Turner would frequently exploit in future.

In November and December 1817, after returning from the continent, he went to stay at Farnley Hall and sold all the Rhine watercolours to Fawkes for £500. By this stage Fawkes's friendship was just as important to Turner as his patronage. He provided the artist with an environment in which he could both work and relax, while Turner for his part recorded the pleasures of life at Farnley Hall in a series of intimate works that reflect the delight he took in the company of Fawkes and his household. He was a keen participant in their shooting parties, and his image of *Caley Hall* (83), a property that Fawkes maintained as a hunting lodge, includes a group returning with a dead stag. Turner also responded to his friend's expert knowledge of the bird life of the British Isles by contributing twenty watercolours to Fawkes's five-volume album, the *Ornithological Collection*. Some of these, such as the study of the dead *Kingfisher* (84), were so exquisite that later in the century Ruskin would have paid any price to acquire them.

If a single work could represent the ease and spontaneity that Turner felt at Farnley it would be *First-Rate, Taking in Stores* (85) of 1818. One morning over breakfast, Fawkes asked him to make 'a drawing of the ordinary dimensions that would give some idea of the size of a man of war'. Turner treated this casual request as a challenge. He responded by depicting a first-rate ship of the line, which, with its complement of over 110 guns, was the largest class of warship in the British Navy. He made the vessel appear colossal by exaggerating its proportions and adopting a low, fairly close viewpoint from an approaching boat. Turner was normally secretive about his working methods,

83
Caley Hall,
*c.*1818.
Watercolour
and gouache
on buff paper;
29·9×41·4 cm,
11³⁄₄×16¹⁄₄ in.
National
Gallery of
Scotland,
Edinburgh

84
Kingfisher,
*c.*1815–20.
Watercolour
over pencil
with
scratching-
out;
17·8×16·4 cm,
7×6¹⁄₂ in
(whole
sheet).
Leeds City
Art Gallery

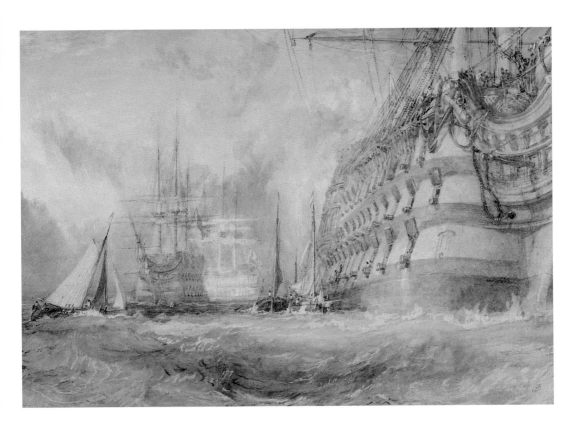

85
*First-Rate,
Taking in
Stores,*
1818.
Pencil,
watercolour,
scratching-
out and
stopping-out,
28·6×39·7cm,
11¼×15⅝in.
Cecil Higgins
Art Gallery,
Bedford

but on this occasion he entertained Fawkes's son by letting him watch his impromptu performance. Hawksworth Fawkes later gave a vivid description of Turner frenziedly pouring paint on the paper, scratching, tearing and scrabbling at it, until 'as if by magic ... the lovely ship came into being'. It is the most dramatic account of the artist at work, but the witness was a young boy who was unfamiliar with Turner's repertory of techniques. Apart from pouring on paint, they included masking or 'stopping out' areas of the paper with a water-resistant varnish, or scratching out highlights, either with the sharp end of the brush, a knife or a demonic thumbnail he grew specifically for the purpose. None of these methods were new, but Turner employed them in combination with such virtuosity that it is easy to see how Hawksworth Fawkes might confuse great skill with sorcery.

Before the Rhineland section of his tour Turner had visited the battlefield of Waterloo, which he explored with the aid of recently published guidebooks, supplemented by local knowledge. He recorded the numbers who had died at each spot in his *Waterloo and Rhine Sketchbook*. At the remains of the manor house of Hougoumont, he wrote 'hollow where the great carnage took place of the Cuirassiers by the Guards'. According to the Duke of Wellington it was the fierce defence of this site, pictured in a watercolour by Denis Dighton (86), which made the British victory possible. Turner also chose it as the setting for his extraordinary picture *The Field of Waterloo* (87), which represents the aftermath of the fighting. On the whole it was poorly received at the Royal Academy in 1818, and although Turner bequeathed it to the nation it was hidden from view until the 1980s. Despite this neglect it now appears to be one of his most important public statements.

The battle was generally presented as a triumph of the British national character, and some of the plans to commemorate it were predictably jingoistic. For example, one of the architectural submissions to the Royal Academy in 1816 was a 'Perspective design for a National Monument ... combining in its structure

86
Denis Dighton, *Coldstream Guards Defending the Château d'Hougoumont at the Battle of Waterloo*, c.1815. Watercolour; 64·7×100·3 cm, 25½×39½ in. National Army Museum, London

87
The Field of Waterloo, 1818. Oil on canvas; 147·5×239 cm, 58×94 in. Tate, London

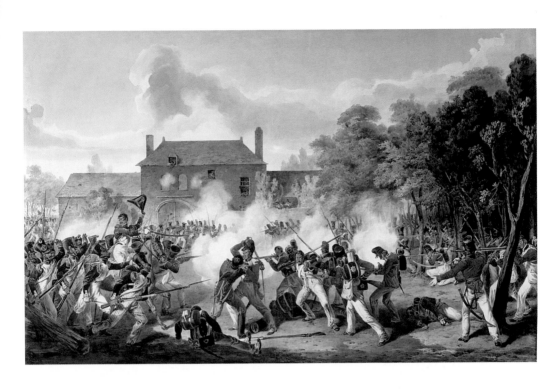
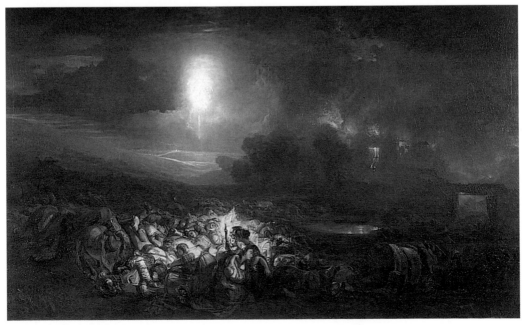

the arts of painting, sculpture and architecture, illustrative of the battle and heroic actions of our gallant countrymen. Trophies executed in bronze from the cannon taken, crowned by wreaths of laurel, surround the upper part, surmounted by a colossal statue of His Grace the Duke of Wellington.' Three years after the battle Turner produced a picture that was consistent with the mood of anticlimax and disillusion that followed the end of the war. *The Field of Waterloo* is a large painting whose bleakness probably made it unsaleable, for it focuses on the casualties of history – the victims rather than the victors. Since he stood to make little or no money from the picture, it seems that he painted it to express his horror at the wasted life and to counter the misrepresentation of warfare as glorious or noble.

As a rule history painting tended to associate death with heroic virtue, and to present it as a morally elevating spectacle, but in Turner's picture it is brutal and unedifying. He shows the common soldiers' wives or mistresses, who were often billeted near the field of battle, searching for their partners by torchlight in a mingled heap of French and British corpses. It is often suggested that *The Field of Waterloo* adapts the chiaroscuro of Rembrandt's *Night Watch*, which Turner saw in Amsterdam. If so, however, he inverts the meanings of Rembrandt's group portrait, which was commissioned to celebrate the patriotism of an Amsterdam militia company, none of whom were ever likely to see active service.

There were few pictorial precedents for such an anti-heroic view of battle. If Turner took his cue from anybody, it was Lord Byron, lines from whose poem *Childe Harold's Pilgrimage* accompanied the painting in the Royal Academy catalogue. Byron's description of 'friend, foe in one red burial blent' is similar to the central image of *The Field of Waterloo*. Although Turner was unaware of them, there were other European artists, such as Francisco Goya (1746–1828), who were prepared to address the cruelties of war. His set of 82 etchings, collectively titled *Disasters of War*, depicted atrocities committed during

88
Antoine-Jean Gros, *Napoleon on the Battlefield of Eylau*, 1808. Oil on canvas; 533×800 cm, 209⅞×315 in. Musée du Louvre, Paris

the French occupation of Spain. Even Baron Gros, one of Napoleon's official painters, allowed an element of revulsion to creep into his *Napoleon on the Battlefield of Eylau* (88). Gros depicts a horrific but inconclusive encounter between Napoleon's army and the Russians that took place on Polish soil in February 1807. His haunting image of the frozen dead is more graphic than Turner's, but his realism is compromised by details such as the French doctor, who is shown ministering to the enemy wounded, when in reality there were insufficient medical personnel to treat the French themselves. For all his candour about death in battle, Gros's painting was still intended as a work of official propaganda, whereas Turner (like Goya) pictured the fate of individuals caught up in events beyond their control.

The Field of Waterloo also had uncomfortable implications for British domestic politics. It encouraged the gallery-going public to ask what these men had sacrificed their lives for. Those who survived the conflict were among the hardest-hit by the postwar depression, since many were released onto the labour

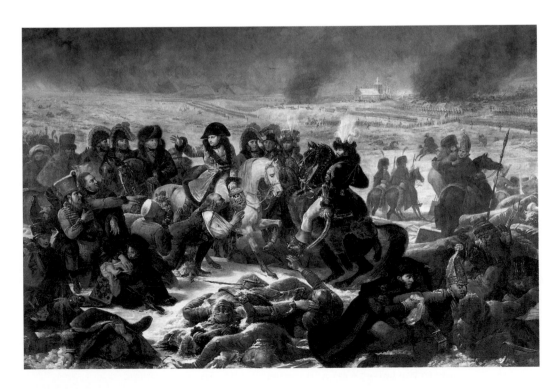

market at a time when unemployment was already increasing and wages falling. In addition, the price of bread was kept artificially high after 1815, when the government of Lord Liverpool introduced the Corn Laws to prevent the import of cheap foreign grain into Britain. As a result of all these circumstances, the cost of poor relief, which stood at £2,000,000 before the war, had quadrupled by 1817. Even this, however, was insufficient to prevent widespread food riots. The army, the volunteer corps and the local militias had attracted men from all classes, localities, religious denominations and political opinions, and the authorities treated them all as patriots who were willing to die for their country. After Waterloo, the Corn Laws were a bitter reminder to those same patriots of how little influence they had in their country's government.

While putting the finishing touches to *The Field of Waterloo*, Turner was also producing a set of watercolours for engraving in James Hakewill's *Picturesque Tour of Italy*. He worked from detailed pencil drawings that Hakewill himself had made on his tour of 1816–17, but the commission also served as preparation for Turner's own visit to Italy. This long-awaited expedition (see Chapter 4) was one of the most important experiences of Turner's life, and he undoubtedly discussed the country at length with Hakewill, who also supplied him with a notebook full of useful information. The last major picture that Turner exhibited at the Royal Academy before leaving for Italy in August 1819 was *England: Richmond Hill, on the Prince Regent's Birthday* (89). The title was phrased with care, for by placing the word 'England' at the beginning, he implies that the work encapsulates the state of the nation in the aftermath of the Napoleonic Wars. The high viewpoint took in both Windsor and Twickenham, thereby recalling his earlier scenes on the Thames, with all their complex associations. Since these included the excellence of British painting and poetry, Turner may have hoped that this vast work would prompt the Prince Regent to recognize the contribution he had made to the nation's art and reward it with royal patronage.

89
England: Richmond Hill, on the Prince Regent's Birthday, 1819. Oil on canvas; 180×334.5 cm, 70⁷⁄₈×131³⁄₄ in. Tate, London

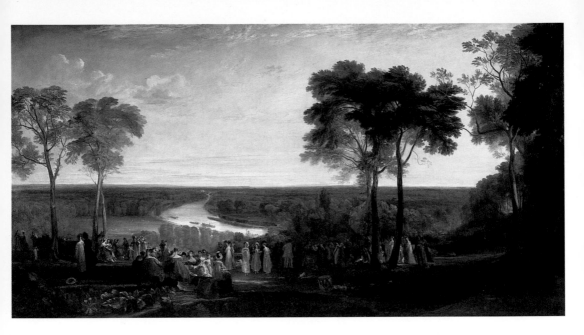

The picture probably alludes to the birthday celebration held
for the Prince Regent by Lady Cardigan at her Richmond house
in August 1817, but with figures borrowed from the French
painter Jean-Antoine Watteau (1684–1721) it has the air of an
elegant fantasy. The imagery implies a nation united under a
benevolent prince, enjoying the benefits of peace, but this was
wildly adrift from the realities of postwar Britain. Within the
Royal Academy the Prince Regent was respected for his interest
in art, but in the country at large he was notorious for his
extravagance, gluttony and debauchery. Just how remote
Richmond Hill was from reality became clear on 16 August
1819, when local magistrates ordered cavalry to suppress a
peaceful demonstration in St Peter's Fields, Manchester.
Eleven demonstrators were killed and 400 injured in the
ensuing carnage, which became known as the 'Peterloo
Massacre' in macabre parody of Waterloo. *Richmond Hill* is
a work that contains passages of great beauty, notably in the
trees, sky and distant scenery. It may also have been partly
motivated by genuine patriotic feeling, but when compared with
the independent spirit he displayed in *The Field of Waterloo* it
appears a rather sycophantic and self-serving gesture.

Whatever Turner's motives, *England: Richmond Hill* had far less effect on the artist's reputation than Fawkes's decision to open his house in Grosvenor Place during May and June 1819 in order to display his collection of watercolours to the London public. Although Turner was one of many featured artists, his sixty works in the show eclipsed those of his contemporaries in number and brilliance. He basked in his success, and occasionally held court at Grosvenor Place amid an asphyxiating crush of fashionable visitors. It was an exhilarating note on which to depart for his first tour of Italy.

The decade between 1819 and 1829 is bookended by Turner's first two visits to Italy, both of which helped to transform his art in its range of subjects and use of colour. He made detailed preparations for his first expedition by consulting friends or knowledgeable patrons such as Hakewill or Colt Hoare and, like any tourist, he acquired the latest guidebooks to help plan his itinerary. At one stage he even jotted down notes on Italian grammar. In a sense, however, his preparations had begun when he entered the Royal Academy Schools. The academic training he received, and indeed the whole canon of great European art, was based on the works of classical antiquity and the High Renaissance, especially Michelangelo (1475–1564) and Raphael (1483–1520). Although the history of landscape painting was dominated by northerners such as Claude and Poussin or, more recently, Wilson and Cozens, their art was shaped by the scenery around Rome and Naples.

Turner also went to Italy with certain historical preconceptions, which were reinforced by reading Canto IV of Byron's *Childe Harold*, published in 1818. The poet lamented the decline of a once great culture, whose gradual enfeeblement had left it prey to French invasion, and then, after Napoleon's defeat, to the restitution of reactionary governments throughout the peninsula. Much of the north, including Tuscany, Lombardy and the Venetian territories, was then controlled by Austria; Naples was ruled by the Bourbon dynasty, while Pope Pius VII returned from exile in 1814 to resume control of Rome and the Papal States. For Byron, as for the poet Thomson before him, Italy signified the loss of liberty, a theme rendered almost unbearably poignant for being set amid the ruins of Rome's former glories and the exquisite beauty of the Italian landscape.

90
Regulus
(detail
of 117)

In reality, the postwar period witnessed the first stirrings of the *Risorgimento*, the movement to unite and liberate Italy. Byron himself was briefly involved with a radical secret society known as the Carbonari, which used his lodgings in Ravenna as a weapons store. Nonetheless, the idea of Italy in melancholy decline appealed strongly to his poetic imagination, and in *Childe Harold* he depicted its heroic past as lost forever. Turner found that Byron's stance chimed with his own belief that civilizations followed a cycle of rise and decline, which in turn implied that another nation would eventually enjoy the cultural pre-eminence once associated with Italy. It was a commonly held view, for artists from France and the German-speaking territories all believed they were the most suitable candidate, and Rome became an arena in which their competing claims were fought out.

Before the outbreak of war with France in 1793, artists of all nationalities flocked to Italy, and Rome in particular. The French and Germans remained there during the hostilities, but only after the defeat of Napoleon could British painters return in their former numbers, and a period of study in Italy became, once again, part of an artist's professional credentials. Turner's friend Chantrey was only half-joking when he said that his main reason for going was to increase public confidence in his abilities. When Turner finally arrived in 1819 he had little to prove to his own countrymen: he was forty-four years old, and his reputation was at its zenith.

Turner's first Italian tour began in August 1819 and lasted six months, including the outward and return journeys through France and Switzerland. In Italy itself he followed a punishing schedule that took in many of the most beautiful sites and cities, and filled nineteen sketchbooks with drawings and notes on all aspects of his experiences. Sometimes, when he stayed in a city for a longer period, as in Venice, Rome and Naples, he would develop selected drawings into larger watercolours, probably during the evenings in his lodgings (see 91, 93 and 94).

With so much to see, working in colour on the spot was out of the question, for as he curtly explained in Naples to someone who wanted to accompany him on a sketching expedition, he 'could make 15 or 16 pencil sketches to one coloured'.

He entered Italy through the Mont Cenis pass, sometimes sketching from the moving carriage, which stopped at Turin, Como, Milan and Verona, before arriving at Venice. The city is so closely associated with Turner's later work from the 1830s onwards that it is surprising to discover how few coloured images he made on his first visit. Four sheets in his *Como and*

91
Venice: San Giorgio Maggiore from the Dogana, 1819. Watercolour; 22·4×28·7cm, 8³⁄₄×11¹⁄₄in. Tate, London

Venice Sketchbook contain washed-in underpainting, and only four more finished watercolour views of Venice itself, but the latter suggest both the skyline of the city and the quality of its dawn light with breathtaking economy of means (91). From Venice he travelled through Bologna, Rimini, Ancona and Foligno, before arriving in Rome probably in late September.

Chantrey reported that Turner was secretive during his stay, refusing to divulge his Roman address. His activities, therefore, must be largely deduced from the sketchbooks, which give the

impression that he worked incessantly, leaving little time to participate in Rome's cosmopolitan art world. He did, however, intend to check out his foreign rivals, for he wrote a list of continental landscape painters then working in the city into one of his Italian sketchbooks. Although he later confided to a friend that 'the art at Rome [was] at its lowest ebb', this did not stop him accepting honorary membership of the prestigious Roman Academy of St Luke when the great sculptor Antonio Canova (1757–1822) put his name forward, along with those of Chantrey, Thomas Lawrence and John Jackson (1778–1831).

It would be surprising if Turner had not moved in international circles, since his friend Charles Eastlake had lived in Rome since 1816 and knew many of the foreign artists resident in the city, partly through attending the Wednesday evening soirées held at the Villa Medici, the Roman division of the French Académie des Beaux Arts. Eastlake also met and became friendly with members of the German group known as the Nazarenes. Two associates of the group, the painter Ernst Fries (1801–33) and the architect Joseph Thürmer (1789–1833), collaborated on

an etching of the *View towards the South East of Rome Taken from the Capitol*, 1824 (92), which gives a good impression of the city's appearance around the time of Turner's visit. Their high vantage point on the tower of the Capitol allowed them to include many of the most important Roman monuments that Turner studied from closer quarters, as well as to emphasize the archeological excavations that were then taking place. The great writer Johann Wolfgang von Goethe had a copy of their print, which reminded him of an occasion during his Italian tour of 1788 when he looked out over the same landscape.

I had only to turn my head slightly to survey a vast panorama, lit by the glow of the setting sun and extending on my left from the Arch of Septimius Severus, along the Campo Vaccino [the Forum Romanum] to the Temple of Minerva and the Temple of Peace. In the background stood the Colosseum, and I let my glance wander beyond it past the Arch of Titus, until it was lost in the labyrinth of the ruins of the Palatine and the wildness around them.

92
Ernst Fries
and Joseph
Thürmer,
*View towards
the South
East of Rome
Taken from
the Capitol*,
1824.
Etching;
55·1×71·7cm,
21³⁄₄×28¹⁄₄in

He told his readers that, although Fries had captured 'the lights and shades of the sunset', they would have to 'imagine for themselves the blazing colours with their shadowy blue contrasts and all the magic which the scene derived from them'. The enchantment that Goethe felt when contemplating the appearance of Rome's former grandeur under the changing conditions of Italian light finds a parallel in some of Turner's watercolours, such as *The Forum with a Rainbow* or the image traditionally known as *The Colosseum by Moonlight* (93). Of all the city's monuments, none had such powerful associations as the Colosseum, where the Romans had used their supreme building technology to stage the most barbaric and depraved spectacles, causing some writers to see it as symptomatic of the Roman Empire's decadence and eventual collapse. The scientist Humphry Davy, who also visited Rome in 1819, experienced visions or hallucinations in the Colosseum. Although his was an extreme response, it was difficult for even the most phlegmatic visitor to contemplate the building's history

in a spirit of cool detachment. Turner depicted the structure not by moonlight, as often supposed, but at twilight, which was more consistent with the theme of Rome's imperial decline.

Like many of his predecessors Turner travelled east to Tivoli, where he filled two sketchbooks with drawings, some of which he annotated with the names of Claude Lorrain and Gaspard Dughet (1615–75), distinguished predecessors who had painted the same places. In October 1819 he began a month-long trip south to Naples. During this part of his tour, Turner studied the remains of Paestum, Pompeii and Herculaneum, as well as the bays of Naples and Baiae. The whole region had great historical and archeological significance. Baiae was notorious as a playground for the wealthiest citizens of the Roman Empire. Pompeii and Herculaneum were buried under a flow of searing ash when the volcano Vesuvius erupted in 79 AD.

When the ruins were rediscovered and excavated in the mid-eighteenth century, the buildings and many wall paintings were found to be well preserved. Once they became widely known through archeological publications, they exerted a

94
*View of
Naples with
Vesuvius in
the Distance,*
1819.
Pencil, partly
finished in
watercolour;
25·4×40·7cm,
10×16in.
Tate, London

great influence on European Neoclassicism. In Turner's study
of Vesuvius (94), the volcano looks fairly quiet, but it was in
fact going through a period of intermittent activity. From the
marks on his *Gandolfo to Naples Sketchbook* it appears that
Turner was showered with hot ash when he climbed its sides.

Paestum, which was renowned for its three impressive, well-
preserved Greek Doric temples, marked the southernmost point
of Turner's travels. As usual, he made only pencil sketches on the
spot, but around the mid-1820s they served as the basis for one
of twelve mezzotint engravings that are known collectively as
the *Little Liber*. It is generally assumed that Turner engraved
the set himself, but it is not clear whether, or in what form, he
intended to publish them. His dramatic print of *Paestum* (95)
shows the site engulfed in a storm, exploiting the potential of
the mezzotint medium to create rich, dense shadows.

On his way back to Rome, Turner took time to study the lakes
of Albano and Nemi, which were renowned for their beauty. He
arrived in mid-November, spending a further month sketching
and studying the city before beginning the journey home by
a route that allowed him to stop for a fortnight in Florence.
Whereas Rome owed much of its splendour to the High Renaissance
of the early sixteenth century, Florence was richly endowed
with medieval and Early Renaissance art and architecture. The

artists in whom Turner was interested, such as Simone Martini (*c*.1285–1344), Giotto (*c*.1267–1337), Donatello (*c*.1386–1466) and Piero di Cosimo (*c*.1462–*c*.1521), had once been regarded as merely a prelude to the High Renaissance but were becoming increasingly fashionable in their own right. It has been pointed out that Florentine architecture, on the other hand, was described as 'dull and heavy' by one of the guidebooks Turner used, although the city was perceived as beautiful from a distance. When he produced a watercolour of *Florence* (96), around 1827, it was from an elevated viewpoint to the north, overlooking the river Arno. The scene contains slight topographical inaccuracies but is beautifully composed, which may explain its commercial

95
Paestum,
c.1825.
Mezzotint;
15·4×21·6 cm,
6×8½in.
Ashmolean
Museum,
Oxford

96
*Florence
from San
Miniato*,
c.1827.
Watercolour
and gouache;
28.6×41.8 cm,
11¼×16½in.
British
Museum,
London

success. Not only was it engraved for the annual publication *The Keepsake*, but Turner also made four versions in watercolour. His outdoor sketching in Florence was probably curtailed by the biting cold, and he continued to suffer the extremes of winter weather on his journey back to London. At one point his coach was overturned in an accident on the Mont Cenis pass and he had to walk several kilometres up to his knees in snow to the nearest town of Lanslebourg. Having spent most of January on the road, he arrived home by 1 February 1820.

Turner produced no finished paintings while abroad, and his late arrival back in London left him little time to prepare for

the Royal Academy exhibition of 1820. He concentrated throughout February and March on one large oil painting that would encapsulate many of his ideas and experiences. *Rome from the Vatican* (97) shows Raphael, accompanied by his mistress, 'la Fornarina', contemplating the pictures he produced to decorate the Vatican loggia for Pope Leo X. The tercentenary of Raphael's death fell on 6 April 1820 and there was no better occasion to celebrate his importance and assess his legacy, both of which Turner set out to do. *Rome from*

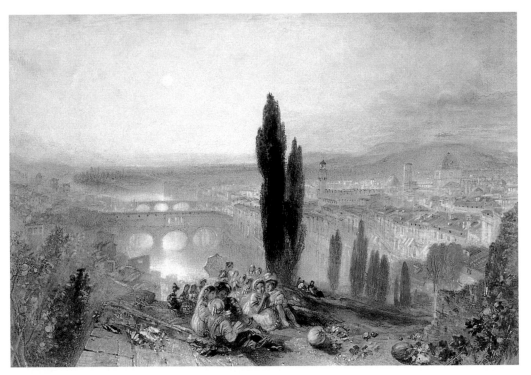

the Vatican is a key work in his career, partly because it is the first of many instances in which Turner borrowed an episode from another artist's life to express his own views, but also because it was arguably his most complex picture to date. Its many-layered meanings offer a foretaste of the problems sometimes encountered in his later work, especially in oils.

There are two main reasons why it is difficult to decipher: the first is Turner's need on this occasion to pack a great deal into a

97
*Rome from
the Vatican.
Raffaelle,
Accompanied
by La
Fornarina,
Preparing
his Pictures
for the
Decoration
of the Loggia,*
1820.
Oil on canvas;
177×335·5 cm,
69¾×132 in.
Tate, London

single exhibition picture; the second concerns the ability (or inability) of the public to make the kinds of connections he hoped for. Many of his earlier major paintings, such as *Pope's Villa* (see 57) or *Hannibal* (see 72), were exhibited with poetry to guide the viewer towards their intended meanings, but not *Rome from the Vatican*. Spectators were left to fathom for themselves what associations the imagery held for the artist, as are his modern interpreters. Turner's other 'pictures of painters' often have an autobiographical element, which may also be the case here, but in general they are smaller in scale. By contrast, this is a huge work, which seems to imply that, whatever its private meanings, it was meant as a public statement. It may have been intended principally for Turner's colleagues in the Royal Academy, many of whom had travelled to Rome and were therefore equipped to follow the kinds of associations the artist expected. One way into the work's complexities begins with two puzzling anachronisms: the first is a Claude-like landscape amid the clutter of pictures and plans attributable to Raphael himself; the second is the presence of the giant colonnade by Gianlorenzo Bernini (1598–1680) in a scene that purports to take place in 1518 or 1519. It is true that Turner was occasionally caught napping on points of detail, but here the anomalies are flagrant and intentional.

Raphael was not a landscape painter, but the background scenery in his biblical and mythological subjects had much to teach those who were. The Claude-like picture may therefore be a symbolic statement of Raphael's importance to Turner and to landscape art in general. The inclusion of Bernini's colonnade makes sense only if he meant to represent the city not as it was in Raphael's lifetime, but during his own recent visit. This raises the possibility that the work is not just about the greatness of Raphael but also about the poor state of contemporary Roman culture as it appeared to him in 1819. Instead of using two contrasting paintings to chart this decline, as he had with ancient and modern Greece, *Rome from the Vatican* collapses past and present into the same picture. He gives a clue to his meaning in the sculpture

of the river god who personifies the Tiber; although he gestures grandly towards the modern city, the infants Romulus and Remus, who stand for Rome's history, tumble neglected from his lap.

The name of Raphael was synonymous with the greatest achievements of the Italian Renaissance. Since Italy was assumed to be in decline, however, northern European artists were keen to present themselves as its heirs, thus enhancing the prestige of their own national schools of painting. Turner's

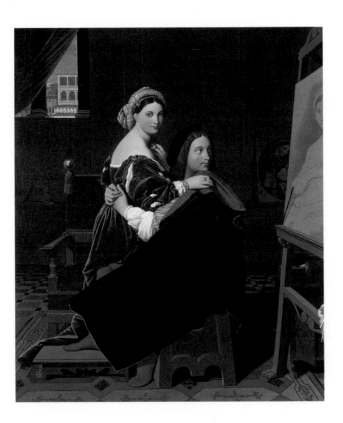

98
Jean-
Auguste-
Dominique
Ingres,
*Raphael
and the
Fornarina*,
1814.
Oil on canvas;
66·3×55·6 cm,
26⅛×21⅞ in.
Fogg Art
Museum,
Harvard
University
Art Museums,
Cambridge,
Massachusetts

picture needs to be seen alongside the work of the celebrated French artist Ingres, who worked in Rome from 1806 to 1820. His obsession with Raphael was such that, when the great painter's body was transferred to the Roman Pantheon, he asked the pope for a relic and was given a small piece of rib. He treated the subject of Raphael and the Fornarina (98) four times. Similarities in their imagery may indicate that one of them was the starting point for Turner's picture. All of Ingres's

versions were small-scale, semi-private works, but in 1827 he painted a much larger picture in which Raphael plays a prominent part. The *Apotheosis of Homer* (99) contains Ingres's selection of the greatest figures from the classical tradition of art and literature, and Raphael is shown holding the hand of the ancient Greek painter Apelles. At the bottom left, Nicolas Poussin directs the viewer towards Homer as the model of perfection to which all artists should aspire. The *Apotheosis of Homer* is a statement of the absolute superiority of classical

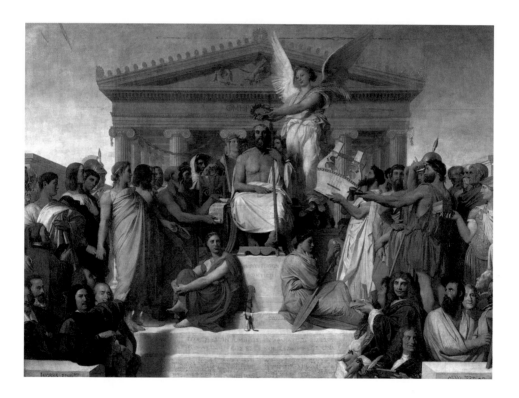

art, but it also implies that custodianship of that great tradition passed long ago from Italian artists such as Raphael to the likes of Poussin, and thus to French art in general.

Turner and Ingres both revered Raphael, but for different reasons that reflect their nationalities. Ingres saw him as personifying supposedly 'French' values of drawing and outline, whereas when Turner sketched the frescos in the Vatican loggia his extensive notes reveal his interest in Raphael's

achievements as a colourist. This was a more typically English response, which provides further circumstantial evidence that *Rome from the Vatican* was Turner's attempt to claim Raphael for the British School of painting. Unfortunately, whereas Ingres's meanings are clear enough, Turner's are expressed in an indirect, elliptical manner.

His Italian researches also formed the basis of a series of finished watercolours for Fawkes, including *The Interior of St Peter's Basilica, Rome* (100). The arches and barrel vaults of St Peter's create horrendous problems of perspective, especially when seen from one side of the nave. This viewpoint creates a spatially interesting, asymmetrical composition but complicates the fore-shortening of the many curved lines. Turner included a discussion of curvilinear forms in his second perspective lecture, but in this picture he was less concerned with obeying rules than with managing the overall effect of the work. Any inconsistencies in the arches, the converging parallel lines or the great vault are less significant than the brilliance with which he staged the scene. St Peter's is too vast for a spectator to be able to see down its left and right aisles simultaneously as one can here, but Turner's picture creates a sense of the building's complex internal spaces. Turner also adopted a low viewpoint close to the picture plane and had the audacity to place one of the great piers almost directly in front of the viewer, so that it becomes an obstacle to be negotiated in the mind's eye. Rather than giving a commanding view of the whole interior from an elevated position, as Piranesi once did, Turner re-created the experience of being a visitor inside St Peter's, overwhelmed by its architecture, just as he previously gave Fawkes an impression of what it was like to be in a small boat alongside a huge warship in *First-Rate, Taking in Stores* (see 85).

For reasons that remain unclear, apart from the works he created for Fawkes, Turner went through a fallow period upon his return from Italy. He continued to tour, travelling to Paris, Rouen and Dieppe in September 1821 to collect material for a series of engravings of the scenery on the river Seine. In the

99
Jean-Auguste-Dominique Ingres,
Apotheosis of Homer,
1827.
Oil on canvas;
386×515 cm,
152×202 in.
Musée du Louvre, Paris

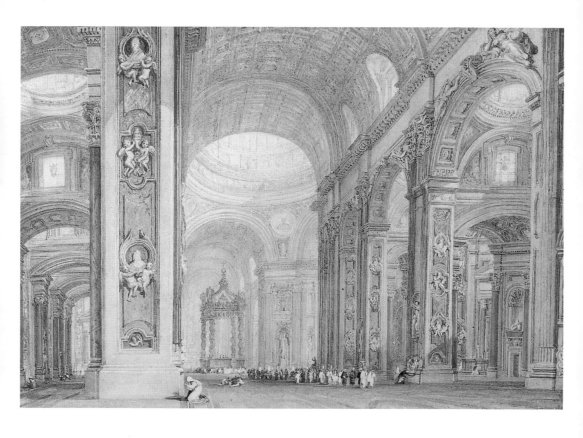

100
*The Interior
of St Peter's
Basilica,
Rome,*
1821.
Watercolour
on board;
29×41.4 cm,
11$\frac{1}{2}$×16$\frac{1}{4}$in.
Pierpont
Morgan
Library,
New York

same year he was working on a set of illustrations for Sir Walter Scott's *Provincial Antiquities of Scotland*, but his finished oils around this time were few in number. On 6 April 1821 Chantrey told Farington that Turner 'has not a single commission for a picture at present', but that his financial circumstances were such that 'he can do very well without any commission'. In 1820 his considerable wealth was augmented when his maternal uncle bequeathed him two cottages at Wapping in east London, which the painter later converted into a tavern called The Ship and Bladebone. It seems that after this unexpected good fortune, Turner was in no rush to resume the former pattern of his professional life. He chose not to deliver his perspective lectures in 1822 or 1823, and from 1821 to 1825 he showed only the occasional work at the Royal Academy. He found other means of keeping his name before the public, however. In 1819 he began to extend his own gallery at Queen Anne Street and it reopened in April 1822 with a display of his earlier unsold pictures. In addition, every year between 1822 and 1824 the Cooke brothers held their own exhibitions of British painting in their premises in Soho Square. Yet again Turner's work stood out, especially his 'Southern Coast' watercolours, which the Cookes marketed as engraved reproductions.

William Bernard Cooke sought to make the most of Turner's exalted reputation by beginning another project in 1822 – a series of prints illustrating *The Rivers of England*. He soon followed it up with another entitled *Marine Views*, after a set of large watercolours. *The Rivers of England* were the first of Turner's works to be engraved on steel plates instead of copper. This innovation dramatically increased the profitability of the process: the print run of a copper plate would be numbered in hundreds, but steel plates could produce up to 30,000 impressions before becoming too worn for further use. Not only was steel engraving more profitable than copper, it also carried Turner's work to a far wider public and became the principal means by which he gained a continental reputation. The engraver Thomas Lupton, who had previously worked with

Turner on the *Liber Studiorum*, went on to develop considerable expertise with the new material. As well as working for the Cooke brothers, he began a collaboration with Turner in 1825 on a sequence depicting *The Ports of England*.

The history of these various engraved series is convoluted because they appeared in instalments and their publication dates overlapped. They all remained incomplete, partly because the publishers were affected by the economic slump of 1825–6, but also because their relations with the painter became strained, eventually to breaking point. The print market was an area where Turner gave free rein to the values he inherited from his father. He was an aggressive negotiator who knew that his name on the prospectus greatly enhanced a publication's chances of success, but his demands eroded the publisher's profits. This led to situations from which nobody emerged the winner. In 1826 Cooke proposed to follow *Picturesque Views on the Southern Coast* with a series entitled *Picturesque Views on the East Coast of England*, but his discussions with Turner became acrimonious, and without his participation Cooke could not obtain the financial backing he needed. Turner then undertook to publish the series himself, but soon gave up, due to competing demands on his time.

101
Stangate Creek, on the River Medway, c.1824. Watercolour; 16·1×24 cm, 6³⁄₈×9¹⁄₂ in. Tate, London

Despite all the bitterness, the watercolours that Turner produced for these schemes were of an exceptionally high quality. They represent a wide range of activities and leave no doubt about the importance of the rivers and ports to the domestic economy, or to the preservation of Britain's national and commercial boundaries. *Stangate Creek, on the River Medway* (101) from *The Rivers of England*, for example, shows the sun rising over a line of hulks, whose purpose was to quarantine goods and people coming from abroad, and thus to prevent the import of diseases. The picture owes much of its aesthetic appeal to the light of the rising sun and to the open, lightly accented composition in which the hulks, and the distances between them, become the main object of the viewer's attention.

The time of day and the intervals between the boats also create the sense that they maintain a permanent, daunting vigil.

Turner collected some of the material for his coastal and marine projects during a sea voyage to Edinburgh in August 1822, but his main purpose was to witness the state visit to Scotland of the newly crowned King George IV (r.1820–30), formerly the Prince Regent. Its ceremonies and pageants were stage-managed chiefly by Sir Walter Scott, and were designed to counter the spread of radical views by evoking what one senior

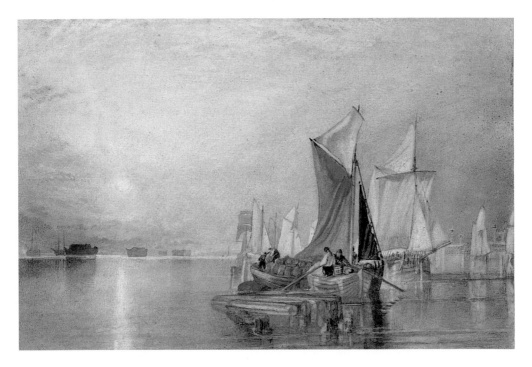

Scottish politician described as 'determined and deep-rooted monarchical feeling'. Like many artists on both sides of the border, Turner grasped the political significance of the occasion, as well as its potential for securing royal patronage.

He planned a suite of nineteen oil paintings to commemorate stages in the king's progress, but the sequence never emerged, probably because Turner received an alternative commission from George IV to paint a vast canvas, *The Battle of Trafalgar*,

for St James's Palace. He did, however, begin four compositions in oils that give a flavour of what the series would have looked like. The number of scenes originally envisaged might suggest that Turner was planning a grandiose scheme to rival the court art of seventeenth-century France, but his unfinished pictures are small and comparatively low key. A work such as *George IV at the Provost's Banquet, Edinburgh* (102) seems very muted in comparison with Wilkie's *The Entrance of George IV at Holyrood House* (103), which borrows heavily from the grand style of the court paintings of Peter Paul Rubens (1577–1640). From the surviving evidence, Turner's series was less concerned with bombast than with producing an extended narrative in which the meaning of each episode spoke for itself, as Scott intended.

Despite his limited output in oils at this time, those he did finish were often of great importance. *The Bay of Baiae with Apollo and the Sibyl* (104) was his only exhibit at the Royal Academy in 1823, but it continued the reflections on his Italian visit that began with *Rome from the Vatican* (see 97). Like the latter, it conflates past and present, because the setting is modern and not ancient Italy. As Ruskin later explained, it is another of Turner's meditations on impermanence. According to legend,

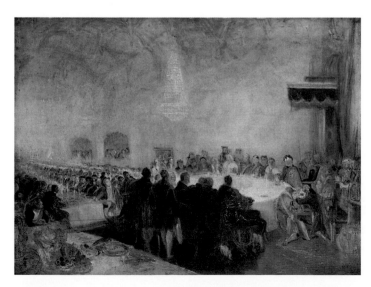

103
David Wilkie,
The Entrance of George IV at Holyrood House,
1822–9.
Oil on panel;
126×198·1 cm,
49⅝×78 in.
Royal Collection

102
George IV at the Provost's Banquet, Edinburgh,
c.1822.
Oil on panel;
68·5×91·8 cm,
27×36⅛ in.
Tate, London

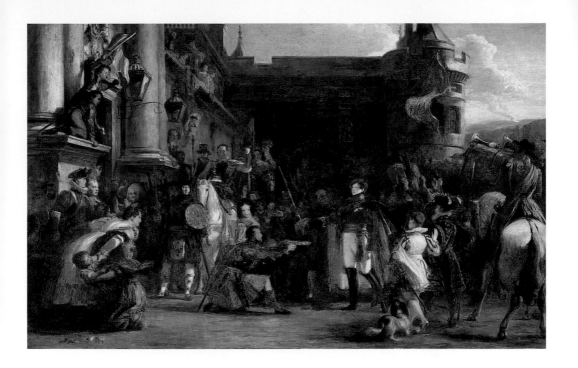

Apollo was infatuated with the Cumaean Sibyl and granted her
a year of life for every grain of dust she could hold in her hand.
When she would not return his love, however, he refused to give
her perpetual youth, and she wasted away until nothing remained
but her voice. To Ruskin she stood for 'the ruined beauty of
Italy', which is borne out by the landscape. The shores of Baiae,
near Naples, were once the setting for luxurious maritime villas,
some of which were built out into the sea on concrete piers –
the Roman poet Horace inveighed against them for destroying
the natural beauty of the bay. In their ruined state they were
tokens of the destructive effects of time. When Turner visited
Naples, the Bourbon regime faced a growing threat from the
Carbonari, who staged a revolution the following year. The
French poet and statesman Alphonse de Lamartine, who became
Secretary to the French Embassy in Naples in 1820, bewailed
their presence amid 'the temples of Baiae and Pozzuoli', because
they made it impossible to indulge in romantic reverie about the
past. By inclination, Turner, like Byron, was a libertarian, but if
he was aware of these political developments they do not figure

104
*The Bay of
Baiae with
Apollo and
the Sibyl,*
1823.
Oil on canvas;
145·5×239 cm,
57¼×94⅛ in.
Tate, London

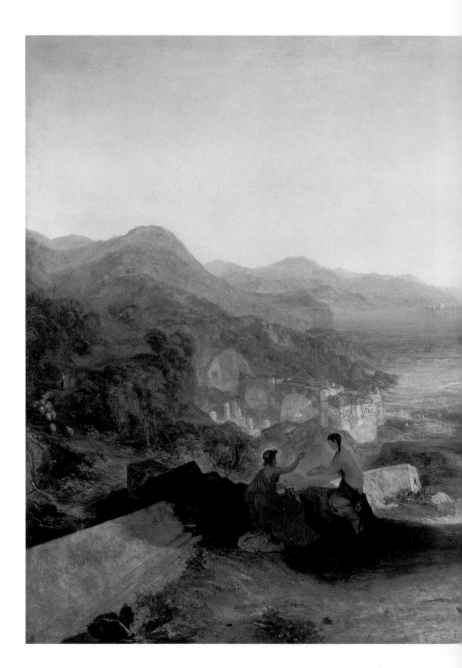

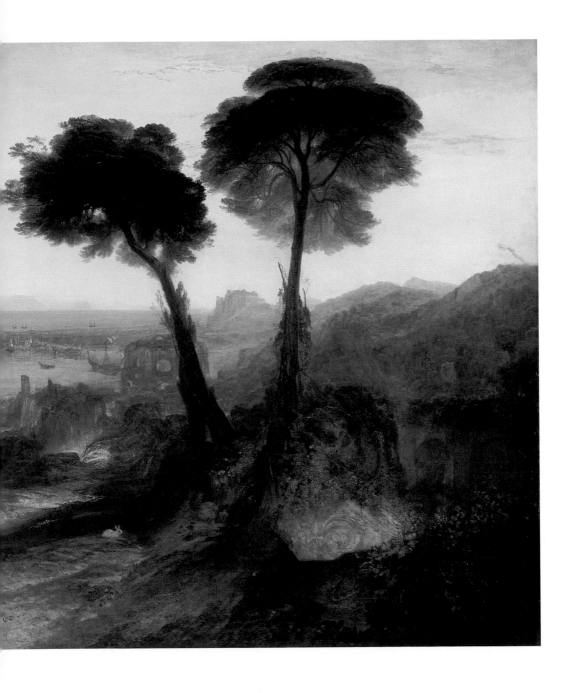

in his work. Again, like Byron, he preferred to see Italy as a poetic lesson in the transience of human achievements.

When the continent opened again to British travellers, the lucrative market for paintings and engravings of European scenes encouraged many British artists to venture abroad more frequently. Beginning in mid-August 1824, Turner undertook a month-long excursion, during which he visited parts of Belgium, Luxembourg, Germany and northern France. The tour centred on the rivers Meuse and Mosel, and followed on from his journey along the Rhine in 1817. Europe's principal waterways formed the basis of many of his travels, partly from convenience – it was generally quicker to go by boat than by road – but also because most historic towns and cities were built on or near navigable rivers.

He prepared part of his route by copying a map of the Mosel into one of his sketchbooks, and as he travelled he made tiny drawings of the scenery, several to a page (105). At one point the river meanders so tightly that Turner took frequent

compass readings and marked them on the miniature sketches.
When he referred to them later, he would know the direction
in which he was looking, and if he decided to develop a drawing
into a larger watercolour, they would enable him to estimate
the position of the sun and the angle of the prevailing light.
As it transpired, the 1824 tour yielded mostly pencil sketches,
although he did experiment with two larger soft-cover sketch-
books that could be rolled up and kept in his coat pocket.
In these he occasionally added colour to his work in pencil,
as in the *Mosel from the Hillside at Pallien* (106). Turner's
drawing of Trèves (now Trier) contains both its ancient
Roman bridge in the distance and, on the right, the large road
bridge built by Napoleon. Turner once referred punningly to
Bonaparte as 'the colossus of roads' – like the Romans before
him, he had created a network of routes that facilitated
the rapid movement of troops across his empire. Napoleon
encouraged his subjects to compare his achievements to those
of Imperial Rome, but after his defeat the comparisons took on
an ironic cast. By 1824 his empire, like the Romans', had been
consigned to history, but the roads remained, and they allowed
Turner to record the geography of post-Napoleonic Europe
more conveniently.

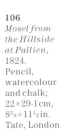

105
*Sixteen
Sketches of
the Mosel
between
Ensch and
Dhron*,
1824.
Pencil;
11·8×7·8 cm,
4⅝×3⅛ in
(each page).
Tate, London

106
*Mosel from
the Hillside
at Pallien*,
1824.
Pencil,
watercolour
and chalk;
22×29·1 cm,
8⅝×11½ in.
Tate, London

In November that year Turner went to Yorkshire once again to stay with Walter Fawkes, who was on the verge of bankruptcy and also seriously ill. They dined together for the last time in London on 27 August 1825. When Fawkes died two months later it was a bitter blow to the painter, who never visited Farnley Hall again. Fawkes's extravagant lifestyle, unwise investments and passion for collecting left him with debts of £69,734, of which Turner was owed £3,000. Notwithstanding his reputation for meanness, it was one debt he made no attempt to recover.

After 1824 Turner chose more often to travel abroad than at home. The main purpose of these travels was to collect material for possible engraved projects, but they also produced topographical oil paintings such as *Harbour of Dieppe (Changement de Domicile)* (107), which was shown at the Royal Academy in 1825. A decade earlier, in *Crossing the Brook* (see 77), Turner organized the scenery he had observed in Devon to resemble a pastoral landscape by Claude; on this occasion he adapted the composition of the latter's seaports to represent a modern French harbour. In his *Backgrounds* lecture Turner had commended his predecessor's port scenes for their impression of bustling activity, but this is even more notable in the *Harbour of Dieppe*. Both artists repeatedly positioned the spectator facing the sun, but whereas Claude was admired for his limpid skies and subtle illumination, Turner's light had a stronger, more disconcerting effect. His picture of Dieppe was heavily criticized for its excessive use of yellow, something Sir George Beaumont first complained of in 1805. By the 1820s his objections had swollen to a chorus of disapproval. The intensification of Turner's colour is usually seen as a response to his experience of Italy and its light, but contemporaries were taken aback when it was used in northern European scenes such as *Dieppe*. Nonetheless, Turner continued to use saturated yellows in paintings of Cologne, and even the banks of the Thames at Mortlake, which caused reviewers to joke that he had contracted yellow fever.

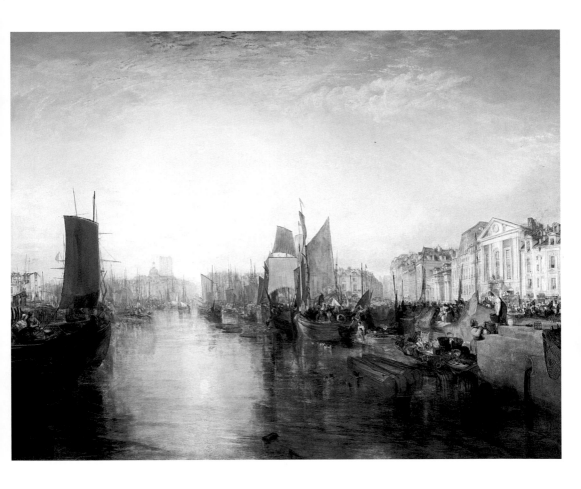

107
*Harbour
of Dieppe
(Changement
de Domicile)*,
1825.
Oil on canvas;
173·7×225·4 cm,
68³⁄₈×88³⁄₄ in.
Frick
Collection,
New York

Although he travelled more frequently on the continent, Turner remained just as involved with his native landscape, often drawing on the vast store of sketchbook material from his domestic tours. In 1825 he signed an agreement with the publisher Charles Heath to produce the most ambitious series of watercolours of his career, *Picturesque Views in England and Wales*. The scheme was originally to consist of 120 engravings, but when it was terminated in 1838, only ninety-six of Turner's designs had been published. Heath was ruined by the venture, partly because the painter insisted on having his watercolours engraved on copper rather than steel plates, then kept many of the best proofs for himself. Ironically, he too finished out of pocket, for although Heath paid him over £3,000 for his drawings, Turner spent it all and a little more to buy back the copper plates and unsold sets of prints at auction in 1839.

If the project was a financial disappointment, in other respects it was an astonishing *tour de force* that used the tradition of the topographical watercolour to survey almost every aspect of contemporary life in England and Wales during a period of drastic social and political change. These developments, and Turner's treatment of them, are discussed in Chapter 5, but here it is worth contrasting the commercial failure of the series with another that proved a huge success – the set of twenty-five illustrations commissioned in 1826 by Samuel Rogers for his collection of poems entitled *Italy*. Byron regarded Rogers as greater than Wordsworth or Coleridge, and although time has dealt harshly with his reputation, Turner's tiny images (known as vignettes) have helped to sustain interest in Rogers's work.

The book comprised a set of poetic reflections on his experiences during his Italian tour. Like Turner's paintings, it depended heavily on the association of ideas. Because Rogers's medium was verbal rather than pictorial he could control the associations he wished his audience to make. His meanings are therefore more precise than in Turner's *Rome from the Vatican*, where the

painter stretched the associative capacities of his public to their limit. Nevertheless, it has been observed that describing the Italian landscape was not Rogers's forte, and Turner's images made up the lack. He used material from his own tour of 1819, and sometimes reprised the subjects of earlier paintings such as *Hannibal* (see 72). Occasionally he produced original compositions such as *Galileo's Villa* (108), whose ownership Turner signifies by placing scientific instruments in the foreground.

These small, richly detailed illustrations were engraved on steel, which allowed the engraver to incise lines of the utmost

108
E Goodall
after J M W
Turner,
*Galileo's
Villa.*
Engraving
from Samuel
Rogers,
Italy, 1830

delicacy. The luxury edition of Rogers's *Italy* was published in 1830, and by 1832 it had sold 6,800 copies; fifteen years later sales reached 50,000, thus spreading Turner's fame far more effectively than any previous publishing venture. Its success also paved the way during the 1830s for a string of commissions for literary illustrations to the works of, among others, Scott, Byron, Milton and Bunyan. These projects remained profitable at a time when the market for topographical engravings was reaching saturation point.

At the head of Rogers's poem 'Rome' was a design by Turner
representing the Roman Forum, which resembled the third of
his great Italian oil paintings, the *Forum Romanum, for Mr
Soane's Museum* (109) of 1826. As the title states, it was
painted for his friend the architect John Soane, who had created
his own museum in his house in Lincoln's Inn Fields, London.
Unfortunately, Soane rejected the picture because it was too
large for its allotted place. In another of Turner's experiments
with the conditions of spectatorship, he makes the viewer
occupy a notional position beneath the soffit of a non-existent
arch. The arch has a double function: in compositional terms it
frames the whole scene; psychologically, it offers the spectator
a point of entry into the picture. Artists had known since the
fifteenth century that looking at a view through a window or
arch could heighten the illusion of reality, but it also emphasized
that the beholder was outside the painted scene. By implying
that the onlooker is directly beneath the arch, however, Turner
creates the impression that we can step from under it into the
Forum. To enhance the effect he chose a low segmental arch of
the kind Soane used in the design of his museum.

109
*Forum
Romanum,
for
Mr Soane's
Museum,*
1826.
Oil on canvas;
145.5×237.5 cm,
57¼×93½ in.
Tate, London

The subject of Turner's painting is comparable to that of Fries and Thürmer's etching (see 92), but their viewpoint was higher and from the opposite direction. Their image was conceived as a topographically accurate record of Rome in 1824, with an emphasis on the excavations taking place in the Forum. Turner, by contrast, shoehorned as many of the various monuments around the Forum as he could into his picture. Although he littered his foreground with the neglected debris of antiquity, he played down the archeological work that was a feature of contemporary Roman life. The Arch of Titus, for example, on the left of the painting, was scaffolded from 1818 to 1822 to support the original Roman structure while its medieval additions were removed. This allowed the architects George Taylor (1788–1873) and Edward Cresy (1792–1858) to measure and record it accurately for their publication *The Architectural Antiquities of Rome* (1821). However valuable it was for their purposes, the temporary wooden framework was too unpicturesque for Turner.

His apparent lack of interest in Roman archeology is puzzling, not only because it had transformed the city, but also because every nationality sought to play a part in recovering the 'true face' of Rome, just as they wished to lay claim to Raphael's legacy. This led to the use of archeology for propaganda purposes, principally by the French and the papacy. When Napoleon occupied Rome in May 1809, he claimed that the popes had neglected its heritage and set out to glorify himself by making it the second city of his empire. It came to resemble a vast building site as 2,000 men worked to clear the dirt and rubble that partly covered its monuments. The impact of this activity is vividly represented in Eastlake's *View of the Forum of Trajan* (110), which shows the once-buried colonnades of the Basilica Ulpia after the French had cleared away houses, two convents and a layer of earth four metres deep.

Turner was apparently more interested in ruins than in archeol-ogy – an approach he shared once again with Byron, though not with most British artists and architects of the day. The

watercolour by Samuel Prout (1783–1852), *Rome: The Forum* (111), for example, shows the Column of Phocas, which is not visible in Turner's painting. It was once thought to date from the time of Caligula (r.37–41 AD), but when the French began to dig out its base in 1813, they uncovered an inscription dated 608 AD to the Byzantine emperor Phocas. In spite of this, Byron, who preferred imagination to erudition, still addressed it in *Childe Harold* as 'Thou nameless column with the buried base'. This is not to say that Turner was as cavalier as Byron, but if scholarly accuracy had been a priority he would not have had to change the inscription on his Arch of Titus, because someone (possibly Soane himself) pointed out that it was incorrect.

Turner may have played down the archeologists' activities, but he placed an emphasis on Catholic piety by including a religious procession and a woman genuflecting before a priest beneath the Arch of Titus. It is not clear what he intended this to signify. He may be suggesting that elements of Rome's pagan religion lingered on in the practices of modern Catholicism. If so, he was on dangerous ground, because some Protestant writers saw this as proof that the Catholic Church was corrupt. It is unlikely that Turner, who had no formal religious affiliations, had a sectarian axe to grind. He seems to have sympathized with those British Catholics who were clamouring for the same civil rights as Protestants. In 1829 the Catholic Emancipation

Act granted them the right to become MPs, judges or officers in the army or navy. That same year Turner produced a view of *Stonyhurst College, Lancashire*, a prominent Catholic school, for inclusion in the *England and Wales* series. Even if he only intended the rituals in his *Forum Romanum* as picturesque details, however, Catholicism was such a controversial issue in Britain during the 1820s that he would have been powerless to control the conclusions a gallery-going public might draw from his imagery.

110
Charles Lock Eastlake,
View of the Forum of Trajan, Rome,
1821.
Oil on canvas;
38·1×90·2 cm,
15×35¹⁄₂ in.
Victoria and Albert Museum, London

111
Samuel Prout,
Rome: The Forum,
1824.
Watercolour and gouache;
42×26·6 cm,
16¹⁄₂×10¹⁄₂ in.
Private collection

Fawkes's death would have made Turner acutely aware of the value of his other friendships, and Soane's refusal to accept the *Forum Romanum* seems to have caused no hard feelings. Around this time he also met and befriended a young Scottish landowner and amateur painter, Hugh Munro of Novar, who became one of Turner's most important companions and collectors during the 1830s and 1840s. More immediately, in the summer of 1827, he went to stay at East Cowes Castle on the Isle of Wight, home of

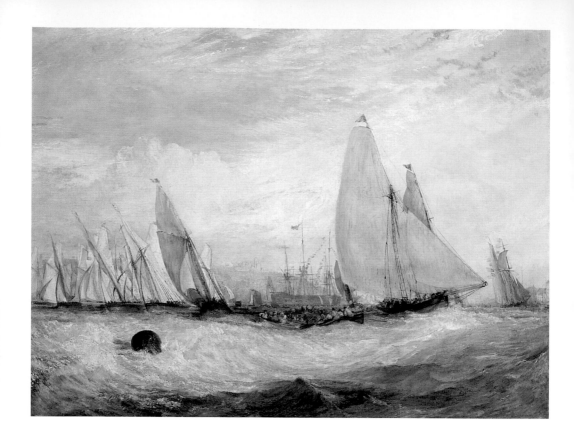

the architect John Nash (1752–1835). He was provided with a
painting room, which enabled him to make several oil sketches
of the annual regatta. These later formed the basis of two
pictures he painted for Nash that were shown at the Academy
in 1828. *East Cowes Castle, the Seat of J Nash Esq; the Regatta
Beating to Windward* (112) depicts the regatta under way
in a high wind, whereas its companion is a calm, Claudian
composition in which the yachts are, in Turner's words, 'starting
for their moorings'. Unlike *Radley Hall from the South East*
(see 8), *East Cowes Castle* is not a portrait of a country house,
nor is it an estate view of the kind created by Wilson, where the
house is seen in the distance surrounded by an extensive park.
In fact, the pictures Turner produced for Nash rework an idea
he first had in 1809, when he painted two views of Tabley House
and lake for Sir John Leicester – one in calm and the other in
blustery conditions. In those works the house was pushed into

the background, but not as far as *East Cowes Castle*, which is completely overshadowed by the regatta.

In autumn 1827 Turner was invited to Petworth House in West Sussex, where George O'Brien Wyndham, 3rd Earl of Egremont (113), kept open house for artists. Egremont had acquired a number of Turner's oils between 1805 and 1812, after which there followed a hiatus in their relationship that was probably caused because Egremont took exception to Turner's *Apullia in Search of Appullus* (see 76). In 1825 the artist visited Petworth once again, though possibly not when the earl was in residence, and relations between them became more cordial still after 1827, when Egremont bought Turner's painting *Tabley House: Calm Morning* in the sale following the death of Sir John Leicester. In the decade that followed, Petworth played an important part in Turner's life, to some extent taking the place of Farnley Hall. The most substantial commission he received was for a quartet of oil paintings to decorate the Carved Room, so called because of its panels by Grinling Gibbons (1648–1721). In the event, Turner produced two sets, the first of which were

112
East Cowes Castle, the Seat of J Nash Esq; the Regatta Beating to Windward, 1828.
Oil on canvas; 90·2×120·7cm, 35½×47½in.
Indianapolis Museum of Art

113
Thomas Phillips, *George O'Brien Wyndham, 3rd Earl of Egremont in the North Gallery*, c.1839.
Oil on canvas; 186·7×155 cm, 73½×61in.
Petworth House, Sussex

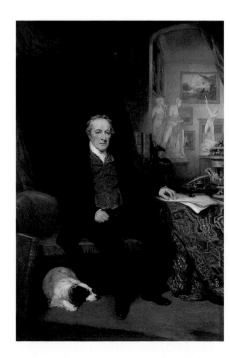

either full-size sketches or first attempts rejected by Egremont. The earlier sequence included *Petworth Park: Tillington Church in the Distance* (114), a scene featuring the earl himself and the pack of dogs that apparently followed him everywhere.

The main interest of the work lies in Turner's use of the long, low format imposed on him by the panelling and decoration of the Carved Room to explore the conditions of vision. In his study of Turner's use of perspective, Maurice Davies showed how the artist ran together material from three pages of his Petworth sketchbook into a single, exceptionally wide vista, the extent of which can be gauged from the angles of the evening shadows, radiating out towards the viewer. In the late eighteenth century painters such as Joseph Vernet recommended that a painting should represent only as much of a landscape as could be taken in at a single glance, without turning the head. At the

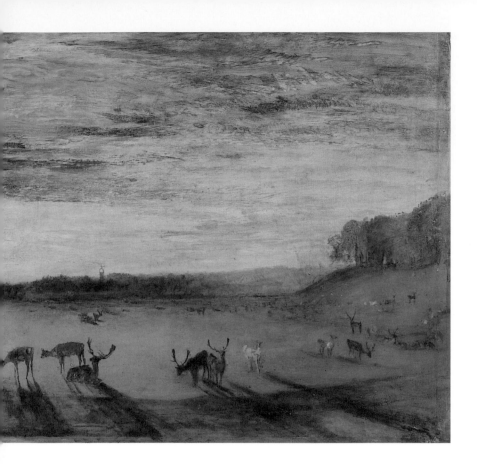

114
*Petworth
Park:
Tillington
Church in the
Distance.*
c.1828.
Oil on canvas;
64·5×145·5 cm,
25⅜×57¼ in.
Tate, London

same time, however, others, including David and Reynolds,
were deeply impressed by the commercial panoramas of their
era – vast, continuous paintings that encircled the spectator
and represented the entire view through 360 degrees from a
given spot. They attracted crowds of paying visitors by offering
the complete illusion of a landscape. In 1802 this led Girtin to
produce the *Eidometropolis*, an ambitious panorama of London.
Petworth Park is inevitably more limited than this, but sets
out to present a greatly extended view on a single, flat surface.

At this stage in Turner's career, Egremont was important less
for his purchases than for providing a sympathetic and support-
ive environment in which to work and relax. The earl was as
unconventional as Turner himself. Having blighted his chances
of a career in public life through his love affairs, he devoted
his energies to agricultural improvements, racehorses and the

115
The North Gallery by Moonlight, 1827.
Pen, ink, watercolour and gouache with scraping-out on blue paper;
14·1 × 19·2 cm, 5½ × 7½ in.
Tate, London

patronage of contemporary British art. He preferred the company of artists to men of his own rank and had little truck with social or domestic formalities. One visitor deplored 'the wants of comfort and regularity, and still more the total absence of cleanliness' at Petworth, but the regime suited Turner perfectly. He was given studio space in the Old Library, he had the companionship of fellow artists, and he could come and go as he pleased. He was even permitted to move pictures from the impressive collection of Old Masters to his studio for his private contemplation, a practice that later gave rise to a series of oils in which he invoked the artists he had studied, sometimes by name.

116
William Witherington, *A Modern Picture Gallery*, 1824.
Oil on canvas; 69·4 × 90·4 cm, 27⅜ × 35⅝ in.
Wimpole Hall, Cambridgeshire

Turner left an impression of life at Petworth in an extended series in gouache on blue paper, some of which represent the rooms themselves, while others depict banquets, entertainments or social occasions. Yet another group shows the making or appraisal of art. Ruskin later dismissed many of them as inconsequential and some as 'rubbish', but he was misled by their informality. In fact they represented a setting where art was genuinely prized and artists often awed by the generous and respectful treatment they received. The centrepiece of *The North Gallery by Moonlight* (115) is the large sculpture of *St Michael Overcoming Satan* by John Flaxman (1755–1826), which is also

prominent in the portrait of the earl (see 113) by Thomas Phillips (1770–1845). Flaxman, who was known and admired throughout Europe for his outline illustrations to Homer, Dante and other classic texts, believed that he and his contemporaries were capable of equalling the achievements of the Renaissance, and in his *St Michael* he set out to prove it. When Egremont acquired it in 1826, it was a profession of faith in British art at a time when writers such as William Carey were doing their utmost to persuade patrons to buy native works rather than those of the Old Masters.

Carey's patriotic arguments were presented in visual form by the landscape painter William Witherington (1785–1865) in his image of *A Modern Picture Gallery* (116). Rather than depicting a specific collection, he assembled a notional gallery of major British paintings, including on the left, above the head of the young girl in white, Turner's *Sun Rising through Vapour* (see 195). In reality the picture was one of several Turners acquired by Sir John Leicester, who, like Fawkes, had opened his London house and its pictures to the public. Leicester's death in 1827

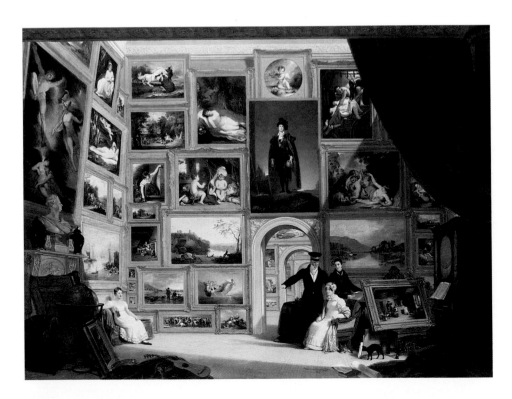

left Egremont as the chief representative of the kind of patron-age Carey and Witherington had in mind, for although the latter's *Modern Picture Gallery* was a work of the imagination, there was a comparable display for real at Petworth.

When Turner set off for Italy again in August 1828, it was partly to paint for Egremont a picture of the town of Palestrina as a companion for his Claude *Landscape with Jacob and Laban and his Daughters* (see 40), although in the event it never entered the collection at Petworth. Turner's outward journey was protracted by his desire to see the South of France, after which he travelled along the Ligurian coast before heading inland to Pisa, Florence and Rome. This time he made no secret of where he was staying in Rome: he moved into a spare room in Eastlake's lodgings at 12 piazza Mignanelli, near the Spanish Steps. He wrote ahead from Paris asking his host to obtain everything he would need to set up a makeshift studio, for during this visit he was less assiduous in his pencil sketching and much more disposed to work in oils. In the three months he spent in Rome he completed three oil paintings, began Egremont's *Palestrina* and commenced work on six others, including three large landscapes.

In contrast to his first sojourn in the city, Turner maintained a consistently high profile in 1828, visiting studios, accepting invitations and generally participating in the social life of Eastlake's circle. Above all, he decided to show his newly painted work in public, knowing that Rome was the most likely place to establish an international reputation. In December he held a small exhibition of his three finished canvases in the via del Quirinale. Their subjects were carefully chosen to suggest the range of Turner's activities and to suit their Italian context: *View of Orvieto* represented a region whose beauty made a strong impression on him during his journey to Rome; *The Vision of Medea* was a mythological figure painting; and *Regulus* (117) was another episode from the wars between Rome and Carthage. By Eastlake's estimate, over 1,000 people saw the pictures, but he

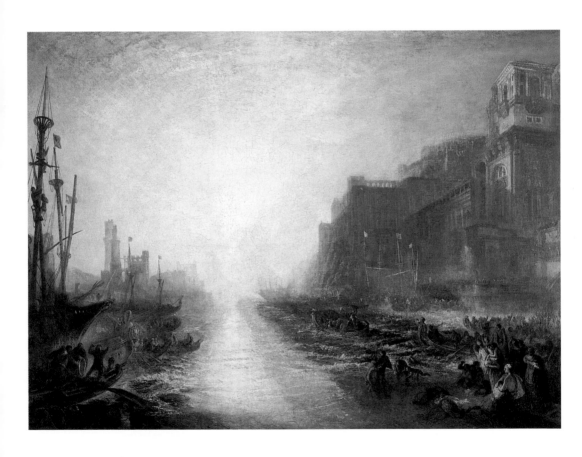

117
Regulus,
1828,
reworked
1837.
Oil on
canvas;
91×124 cm,
35⅞×48⅞ in.
Tate, London

118
Circle of
Josef Anton
Koch,
*Satire on
Turner*,
*c.*1828

later told Thornbury that 'the foreign artists … could make nothing of them'. It was an understatement. The ferocious response included an anonymous print in which a defecating dog declares 'I too am a painter', while Minerva, goddess of wisdom, says 'O charlatan, shit is not art' (118).

The German-speaking community of artists loathed the exhibition. The Austrian painter Josef Anton Koch (1769–1839) was one of the leading continental advocates of an elevated style of landscape and thus might be expected to sympathize with Turner's aims. He and his entourage, however, dismissed them as extravagant, incomprehensible and perverse. Some of this was undoubtedly due to the novelty of Turner's style. The composition of *Regulus* is traditional, in so far as it was based on the formula Turner sometimes borrowed from Claude's seaport subjects (see 25). This gave a degree of continuity to many of his Carthage pictures, although *Regulus*, with its intense white light, is more startling than either *Dido Building Carthage* (see 78) or *The Decline of the Carthaginian Empire* (see 81). According to one observer it was originally 'a mass of red and yellow of all varieties. Every object was in this fiery state', but Turner overpainted it in 1837 before showing it in London, perhaps a tacit admission that its earlier incarnation had been a mistake. Equally problematic for the viewer was the

whereabouts of the Roman hero, Regulus, whose departure for certain death at Carthage is the subject of the picture. It was only in 1980 that he was identified by Andrew Wilton as a minuscule, pale figure descending the steps to a waiting boat on the right-hand side (see 90). *Regulus* is not the only picture from this period in which Turner hid his principal character in a crowd. In *Pilate Washing his Hands* of 1830, for example, Pontius Pilate is a distant figure, concealed by a chaos of gaudily clad bodies. Both works contravene the academic principle that the composition of a painting should emphasize its main protagonists. Although Turner's approach seems perverse, it encourages a more active form of spectatorship by compelling the viewer to search for significant details with which to complete the narrative. Apart from Regulus himself, these would include the labourers on the left manhandling a large barrel – an allusion to the way in which the Carthaginians would later torture and kill him, by rolling him inside a similar barrel driven through with spikes. Before this they cut off his eyelids and exposed him to the sun, which may explain why Turner's repainting of the picture was so blindingly white. What is beyond doubt is that, in dramatic terms, *Regulus* is at the opposite extreme from the calm grandeur of Claude's seaports.

The hostile reception Turner's paintings received was exacerbated by the burgeoning nationalism of the post-Napoleonic era. In 1821 Eastlake had written home explaining that he preferred to stay in Rome because it was free of the 'quackery' of the London art world, and there were others, such as Canova, who maintained a genuinely international outlook. But by 1828 their cosmopolitanism was in shorter supply as Rome increasingly became a collection of jingoistic factions. The Germans were often perceived to be the loudest, and their relations with the French and Italians deteriorated amid suspicions that they were attempting to monopolize the artistic life of the city. In these circumstances it is doubtful whether Turner's exhibition would have been a success, even if the works on show had been less provocative.

After the débâcle of his Roman exhibition, Turner left for home early in the new year in weather conditions as atrocious as those he had experienced in 1820. In a letter to Eastlake he described in vivid detail how he and his companions had to cross Mont Cenis on a sledge, but that once back on the coach (or diligence) it slid off the road on Mont Tarare, near Grenoble, and was only prevented from overturning by a snowdrift. At that point they 'bivouaced in the snow with fires lighted for 3 hours … while the diligence was righted and dug out'. When he was safely back in London, Turner commemorated the episode in a watercolour, *Messieurs les voyageurs on their return from Italy (par la diligence) in a snow drift upon Mount Tarrar, 22nd of January, 1829* (119). Its subject is not the landscape, but the artist, seen right of centre with his back to us, wearing a top hat. The detailed and oddly bilingual title emphasizes that the work is an authentic record of his experience. It was made with one eye on posterity, however, as if to provide an illustration for a future biography.

119
Messieurs les voyageurs on their return from Italy (par la diligence) in a snow drift upon Mount Tarrar, 22nd of January, 1829,
1829.
Watercolour and gouache;
54·5×74·7cm,
211$_2$×291$_2$in.
British Museum,
London

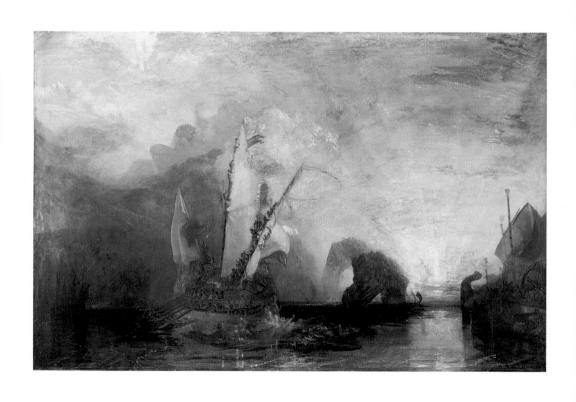

In 1856, when John Ruskin was attempting to present the public with an overview of Turner's career, he claimed that the artist's powers reached their peak between 1829 and 1839. His choice of dates is less arbitrary than it might appear, since that decade began with *Ulysses Deriding Polyphemus* (120) and closed with *The Fighting 'Temeraire'* (see 145), two of Turner's most impressive works. They are also both marine paintings, albeit of very different kinds, and it was this genre that helped to sustain his reputation as an oil painter during the 1830s. Many of the sea-pieces (though not *Ulysses* or the *Temeraire*) had a sober colouring that mollified the critics, whereas his other subjects were increasingly perceived as wayward and idiosyncratic.

In most cases reviewers were oblivious to the nuances of meaning that the different sea-pieces contained, and tended to treat them generically. This was not possible with *Ulysses*, however, for it blended the genres of marine and historical painting in startling prismatic hues. It was, in fact, the most vividly coloured picture Turner had exhibited to date. The reviewer for the *Morning Herald* likened it to a kaleidoscope or a Persian carpet, implying that Turner had deployed his 'positive vermilion, positive indigo, and all the most glaring tints of green, yellow and purple' in a purely arbitrary fashion. For his subject – Ulysses's escape from the one-eyed giant Polyphemus – Turner drew on Pope's translation of Homer, and for the setting he adapted the scenery around the Bay of Naples. But the picture is more than a literary illustration, for it reflects the artist's interest in the natural sciences. He took elements of the narrative and recast them as an allegory of the forces of nature. The red interior of Polyphemus's cave suggests volcanic activity, the sea nymphs or Nereids around the bows of Ulysses's vessel emit the white glow of phosphorescence, and in the distance the

120
Ulysses Deriding Polyphemus – Homer's Odyssey, 1829.
Oil on canvas;
132·5×203 cm,
52⅛×79⅞ in.
National Gallery, London

horses of the sun cross the sky, although this detail is now faded and indistinct, possibly because Turner used a lead-based drying agent on that part of the picture.

Although he may well have been at the height of his powers between 1829 and 1839, in other respects the decade began badly for him. The health of his elderly father had been deteriorating for some time, which may have led Turner to abandon another projected trip to Rome. He obviously felt his father was in no immediate danger, however, because in August 1829 he travelled to Paris and then down the Seine to gather material for future topographical projects. It was either on this occasion or on a subsequent stay in Paris in 1832 that he visited the studio of Eugène Delacroix, who, like many of his younger compatriots, admired the painterly freedom of British art as an antidote to what they perceived as the frozen linearity of much French painting. Unfortunately, the fastidious Delacroix was unimpressed by Turner's manners and appearance, which he later compared to those of an English farmer.

Turner arrived back in London in early September, and shortly afterwards, on 21 September, his 84-year-old father died. William Turner senior had been the anchor of his son's private and professional lives – his companion, studio assistant and factotum. There was nobody to whom he was closer, and the old man's death was a severe blow. He had both dreaded and anticipated it for some time, to the extent that his father's failing grip on life led him to reflect on his own mortality and to draw up his will, which was signed on 30 September, the day after William Turner's funeral. Apart from small bequests to his former mistress, Sarah Danby, to his children Evelina and Georgiana, and to their relative Hannah Danby, who looked after Turner's house and gallery at Queen Anne Street, he earmarked funds to endow a professorship of landscape painting at the Royal Academy. With the remainder of his fortune he wished to found a charity for 'decayed English artists (landscape painters only)'. Of his works he directed that *Dido Building*

121
*Funeral of
Sir Thomas
Lawrence:
A Sketch from
Memory*,
1830.
Watercolour
and gouache;
61·6×82·5 cm,
241$_4$×321$_2$in.
Tate, London

Carthage (see 78) and *The Decline of the Carthaginian Empire* (see 81) were to go to the National Gallery to hang beside pictures by Claude. This clause was at odds with Turner's melodramatic claim to Francis Chantrey that he wished to be buried with *Dido Building Carthage* as his shroud. Chantrey is supposed to have replied that he would dig Turner up to retrieve it.

While still grieving for his father, Turner suffered further losses: first his fellow painter George Dawe (1781–1829), and then Harriet, the daughter of his old friend William Wells. Finally, on

21 January 1830, he helped to carry the coffin of Sir Thomas Lawrence, the Royal Academy's president, into St Paul's Cathedral. Turner recalled the occasion in the *Funeral of Sir Thomas Lawrence: A Sketch from Memory* (121). In a letter to George Jones (1786–1869) he was darkly sarcastic about those eminent sitters who had been immortalized by Lawrence's skills as a portraitist but sent only their empty carriages to his funeral rather than brave the 'snow and muck' of the London streets. One conspicuous absentee was the Duke of Wellington, who was

122
A Skeleton
Falling off
a Horse in
Mid-Air,
*c.*1825–30.
Oil on
canvas;
60×75·5 cm,
23⁵⁸×29³⁴ in.
Tate, London

then prime minister, although one might have assumed that he was the uniformed figure seen from the back in Turner's watercolour. This was the painter's way of redressing a slight to his friend's memory without telling an outright lie. It also preserved the reputation of Wellington himself, whom Turner admired in other respects.

Having been Lawrence's pall-bearer, he began to wonder who would do the same for him, and how soon. It is not surprising, therefore, that the painting sometimes known as *A Skeleton Falling off a Horse in Mid-Air* (122) has often been assigned to this period in Turner's life. A mysterious, unsettling work, it was not intended for exhibition and is extremely difficult to read. Even the position of the skeletal figure is a puzzle, for although it appears to be arching backwards as it falls, the spinal column seems to be uppermost. The difficulties are compounded by Turner's unconventional technique, which included a great deal of rubbing and scratching at the paint. It has the effect of veiling the image in a way that is comparable to the erotic watercolours he confided to his sketchbooks around this time (123). Ruskin later destroyed many such drawings because he thought they revealed a degenerate side to Turner's personality that would damage the artist's reputation. Like them, *A Skeleton Falling off a Horse in Mid-Air* may be an expression of Turner's inner life that was too personal for public scrutiny. It has been argued that it represents the biblical subject of 'Death on a Pale Horse', but this is unlikely because here Death cuts a sorry figure – hardly the apocalyptic marauder from the Book of Revelation. In so far as it can be interpreted, the picture seems to represent a struggle with Death as opposed to his outright victory.

In the last two decades of his life Turner became increasingly distressed whenever a friend or colleague died. In addition, the robust good health he had generally enjoyed until the 1830s was interrupted by periods of illness, which led him to reflect more often on his own demise. The extent to which this caused his work to become increasingly pessimistic is controversial. The

123
Sketch,
*c.*1834.
Watercolour
and pencil;
101×77cm,
39³⁄₄×30³⁄₈in.
Tate, London

first to detect these dark undercurrents was John Ruskin in the
late 1850s, but more recently it has been suggested that Turner's
pessimism was less a matter of conviction and more of an
affectation. It is a difficult but important question, because
it bears on the artist's view of history, human nature and the
notion of progress, all of which are recurrent themes in his work
of the 1830s. As a rule his watercolours are less sombre than his
oil paintings, possibly because it was traditionally thought that
oil was the medium in which an artist would deliver serious
public utterances. In Turner's case that included the series of
oils, often paired, in which he mused on the decay of civilizations.
These represent neither personal despondency nor fashionable
pessimism, however; as suggested earlier, they embody the
common belief that empires and cultures had a 'life cycle'.

This biological or cyclical conception of history questioned the
faith in human progress dear to many thinkers of the European
Enlightenment. This was the dominant philosophical movement
of the eighteenth century; it cherished a belief in human freedom
and equality, and submitted traditions, superstitions and received

ideas to the test of reason. The most optimistic of Enlightenment thinkers was probably the Marquis de Condorcet. In his *Historical Sketch of the Progress of the Human Mind* (1795), Condorcet wrote that 'no limit has been set to the improvement of human faculties [and] the perfectibility of man is really boundless … No doubt this progress may be more or less rapid, but there will never be any retrogression'. He believed that technological development would bring moral improvement in its wake, and that it was possible to learn from history in order to bring about social and cultural advances. To a modern ear Condorcet's views sound naïve, but his optimism is breathtaking, given that his text was written in France in 1793 during what became known as 'The Terror', while he was in hiding from the revolutionary dictatorship, fully aware that his own death was probably imminent. To many outside observers, however, the descent of the French Revolution into remorseless violence destroyed their faith in progress and revealed how unstable a world humanity had made for itself.

Condorcet's radiant faith in human potential had something in common with the views of Edward Gibbon, whose account of *The History of the Decline and Fall of the Roman Empire* (1776–88) helped to shape the belief in historical cycles. Although he chronicled the descent of Rome into barbarism and superstition, Gibbon nonetheless believed that on the whole 'every age of the world has increased, and still increases, the real wealth, the happiness, the knowledge and perhaps the virtue of the human race'. The cyclical view of history was widely disseminated in the travel literature of the day, albeit in a much less sophisticated form than that imagined by Gibbon. These ideas were given further intellectual currency by Byron, whose vision of Italy in terminal decline, and its effects on Turner, were considered in Chapter 4.

Byron's claim in *Childe Harold* that Italy went through stages of 'first freedom, and then glory; when that fails, wealth, vice and corruption' was a simple historical template that could be

applied to other societies and easily lent itself to pictorial expression. It received its clearest statement in the sequence entitled *The Course of Empire*, painted by the American artist Thomas Cole (1801–48) in 1836. Cole was a great admirer of Turner, and his series, which owes a clear debt to the latter's Carthage pictures, traced five stages in the history of a fictitious empire, from its origins, through what he described as its 'consummation' to its decadence and death throes (124). Cole may well have learnt from the way in which Turner adapted the light in his paintings to serve their meanings, for each of the five stages in Cole's *Course of Empire* is illuminated according to its place within the cycle of rise and decline.

In his own paintings Turner dealt with actual rather than hypothetical civilizations, and his view of human progress is more complex than Cole's. He clearly saw that advances in science and technology were transforming the economic and material circumstances of his contemporaries, but unlike Condorcet he drew no connection in his work between these improvements and the moral and spiritual betterment of the species. Turner presents technology as an impressive sign of human ingenuity, but in other respects it is morally neutral, and its effects depend upon the uses to which it is put. For example, in an important picture of 1831, the *Life-Boat and Manby Apparatus Going off to a Stranded Vessel Making Signal (Blue Lights) of Distress* (125), he celebrated an invention with life-saving potential. The knowledge that most wrecks occurred within sight of land had led Captain George William Manby of Great Yarmouth, an acquaintance of Turner, to design an apparatus that fired a stone with a line attached, from a mortar on the shore to a foundering vessel. In the painting its position is revealed only by the puff of smoke on the right, but the wreckage in the foreground suggests the fate of craft that went aground before Manby's device was in service.

In this case technology was guided by a humanitarian impulse, but in other areas of modern life its benefits were less certain.

124
Thomas Cole,
The Course of Empire: Desolation,
1836.
Oil on canvas;
98·1×158·1cm,
38⅝×62¼in.
New York Historical Society

125
Life-Boat and Manby Apparatus Going off to a Stranded Vessel Making Signal (Blue Lights) of Distress,
1831.
Oil on canvas;
91·4×122cm,
36×48in.
Victoria and Albert Museum, London

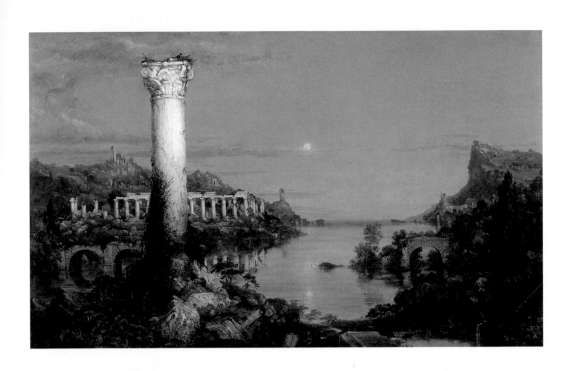

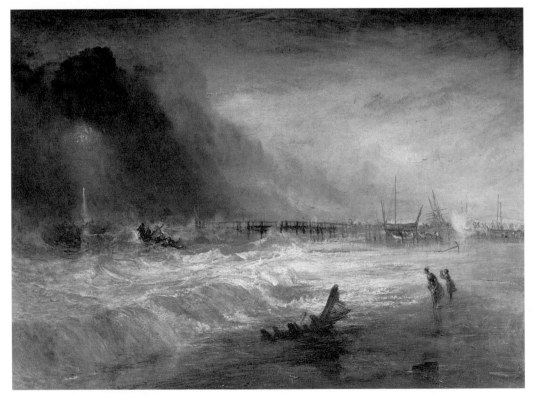

Many contemporaries were particularly alarmed by the way in which new manufacturing processes led not only to the expansion of towns and cities but also to a deteriorating quality of life for their poorer inhabitants. In his *Parliamentary Report on the Sanitary Conditions of the Labouring Population* (1842), Edwin Chadwick observed that, although industrial workers enjoyed relative prosperity, they were at serious risk from epidemic diseases. He concluded that 'the annual loss of life from filth and bad ventilation is greater than the loss from death and wounds in any wars in which the country has been engaged in modern times'. The political philosopher Friedrich Engels was more graphic still in *The Condition of the Working Class in England* (1844–5), especially in his description of the river Irk in Manchester, into which there poured a foul medley of untreated human and industrial effluent.

The unsanitary conditions in the industrial towns and cities were thus a matter of common knowledge. Turner knew how appalling the towns and cities had become, but he sounded no outright note of criticism. It is instructive to compare his *Dudley, Worcestershire* (126), painted around 1831 for the *England and Wales* series, with a plate from the book *Contrasts* (127) published in 1836 by the architect A W N Pugin (1812–52). Pugin was a leading practitioner and theorist of the Gothic Revival, an influential movement that reintroduced medieval forms into art, architecture and design in the eighteenth and nineteenth centuries. For Pugin, this was more than just a matter of taste. In his illustration he compared an imaginary town in 1440 with its conjectural appearance four hundred years later. The factories, asylum, prison, warehouses and decayed churches of the modern town suggest that love of money had replaced the love of God in nineteenth-century Britain, with appalling social and spiritual consequences. As a devout Catholic, Pugin saw the origins of this decline in the Protestantism that emerged from the English Reformation. His solution was a return to the architecture and the catholicism of the Middle Ages, but his imagery would have struck a chord

with all those who harboured doubts about the benefits of unchecked industrialization.

Turner's watercolour also seems to imply that an age of faith had given way to one of rampant capitalism, since he juxtaposed Dudley's ruined castle and medieval priory with modern industry at its most invasive. From this, however, he coaxed an exquisite aesthetic effect, which renders it very different from Pugin's blunt moralizing. The contrast between the ugly foreground imagery and the sheer pictorial beauty of the work suggests a degree of ambivalence about the nation's industrial growth, which he knew nonetheless to be the basis of Britain's postwar economic power. There had been no such ambivalence in his earlier industrial landscape of *Leeds* (see 79).

Despite their economic importance, the expanding industrial towns and cities were inadequately represented in parliament, which fuelled the vigorous movement to reform the British constitution and extend voting rights to a wider section of the population. On this, the most momentous political issue of the day, Turner was less equivocal and more optimistic. Around 1831 he produced a watercolour for the *England and Wales* series depicting the victory celebrations that followed the re-election of Lord Althorp as Member of Parliament for the town of Northampton (128). Althorp was a vigorous advocate of electoral reform, and the scene contains banners with slogans promoting the measure. To judge by other works that allude to the Gunpowder Plot of 1605, or the Glorious Revolution of 1688, English constitutional history was often on Turner's mind in the early 1830s. *Northampton*, however, was the closest he came to an explicit statement of support for the Reformist policies of the Whig government.

Modern historians often view the Reform Act of 1832 as a limited piece of legislation. It removed some of the worst abuses of the electoral system by disenfranchising 'rotten boroughs' – barely inhabited areas that returned members to parliament – and by limiting the influence of powerful

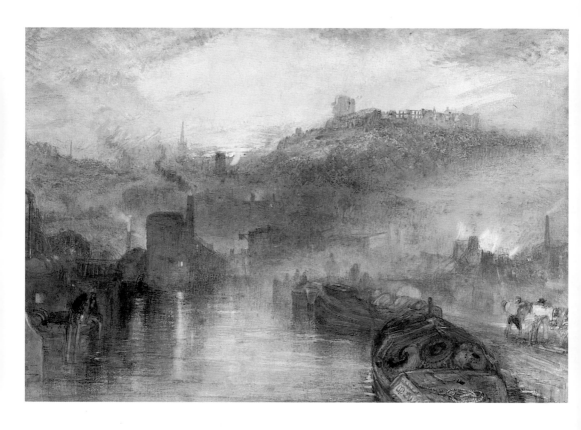

126
Dudley,
Worcestershire,
*c.*1830–1.
Watercolour;
28×42 cm,
11×16¹⁄₂ in.
Lady Lever
Art Gallery,
National
Museums and
Galleries on
Merseyside

THE SAME TOWN IN 1840.

1. St Michaels Tower, rebuilt in 1750. 2. New Parsonage House & Pleasure Grounds. 3. The New Jail. 4. Gas Works. 5. Lunatic Asylum. 6. Iron Works & Ruins of St Maries Abbey. 7. Mt Evans Chapel. 8. Baptist Chapel. 9. Unitarian Chapel. 10. New Church. 11. New Town Hall & Concert Room. 12. Wesleyan Centenary Chapel. 13. New Christian Society. 14. Quakers Meeting. 15. Socialist Hall of Science.

127
A W N
Pugin,
Contrasted
Towns,
from
Contrasts,
2nd edition,
1841

Catholic town in 1440.

1. St Michaels on the Hill. 2. Queens Cross. 3. St Thomas's Chapel. 4. St Maries Abbey. 5. All Saints. 6. St Johns. 7. St Peters. 8. St Alkmunds. 9. St Maries. 10. St Edmunds. 11. Grey Friars. 12. St Cuthberts. 13. Guild hall. 14. Trinity. 15. St Olaves. 16. St Botolphs.

landowners over the selection and election of MPs. It improved the parliamentary representation of the towns and cities, and extended the franchise to many middle-class men. Nonetheless, the north of England remained under-represented, women and most working-class males were still denied the vote, and it has been estimated that, even after 1832, only one in twenty-four adults had the right to participate in an election. The effects of the Act may look modest in retrospect, but Turner's colleague John Constable was one of many who viewed the prospect of a reformed parliament with horror, and his anguish at the proposed changes to the constitution was in marked contrast to Turner's optimism. Constable was terrified by the riots that took place in Nottingham, Derby and Bristol after the failure of the Reform Bill in 1831. He saw his family's landed interests threatened by any legislation that extended the influence of the urban electorate, and he bluntly wrote that if the Bill became law it would 'give the government into the hands of the rabble and dregs of the people, and the devil's agents on earth – the agitators'.

128
Northampton,
Northamp-
tonshire,
1830–1.
Watercolour;
29×44 cm,
11³⁄₈×17³⁄₈ in.
Private
collection

129
David Lucas
after John
Constable,
Old Sarum,
1833.
Mezzotint
engraving;
20·4×28·3 cm,
8×11¹⁄₈ in

These concerns are subtly expressed in the mezzotint engraving
that was made after his stormy oil sketch of *Old Sarum* near
Salisbury. The engraver, David Lucas (1802–81), executed two
plates after Constable's design, and the artist sent a copy of
the initial version to Sir Thomas Lawrence in late 1829, before
the introduction of the first Reform Bill. In his letter of thanks,
Lawrence wrote, 'I suppose you mean to dedicate it to the
House of Commons?' This was an ironic allusion to the fact that
Old Sarum was the site of the first parliament but had since
become the most notorious 'rotten borough' in the country – it
returned two members to Westminster in spite of the fact that it
was uninhabited. When it was deprived of that right in 1832, it
was left only with its ancient historical associations, and for
Constable it came to symbolize an older England whose values
had been sacrificed in the reckless pursuit of democracy. Lucas
re-engraved the scene the following year (129), whereupon
Constable instructed him to intensify the light and shade dra-
matically. Since he believed that chiaroscuro was the principal
means of expression in a picture, the mezzotint is often taken
to be a dramatization of his feelings towards the subject.

Constable's letters during the 1830s frequently expressed his
sense of alienation and his fear that the country was sliding
into anarchy. Turner, on the contrary, was generally sanguine

and sometimes bullish about contemporary Britain. The 'rabble and dregs' who so intimidated Constable, for example, are often represented in his work. It has been observed that one of the notable features of the *England and Wales* project is that the behaviour of the common people is not 'tidied up' for the benefit of the series' wealthy purchasers, some of whom would have shared Constable's fears that the social order was in jeopardy. They had reason to be anxious, for in the absence of an effective police force, even election celebrations such as those depicted in *Northampton* (see 128) could (and sometimes did) turn with little warning into scenes of violence and mayhem.

The *England and Wales* sequence contains many instances of petty lawlessness or unruly behaviour, some of which had the potential to become more serious. For example, *St Catherine's Hill, near Guildford, Surrey* (130) shows the vast crowds that attended the annual fair held on that site every October, but the main focus of their attention is the two men in the middle distance who are engaged in a 'backsword fight'. This was a traditional 'sport' in which the combatants would beat each other over the head with a wooden stick until the blood flowed. Like bare-knuckle boxing, these spectacles were a likely source of disorder. Turner grew up in an area of London that was known for its criminality, and he was a frequent visitor to his property in Wapping, another insalubrious district. It is possible, therefore, that he was more familiar with the social margins than many of his colleagues. Unlike Constable, however, who expressed his attitudes quite candidly in his correspondence, Turner wrote or said little to clarify his views on the working classes. It is difficult to be sure, therefore, whether the portrayals of them in the *England and Wales* illustrations are intended to be sympathetic or not. When the series is taken as a whole, the images appear neither moralizing nor judgemental, but take their place in an immensely complex and diverse picture of English and Welsh life.

130
St Catherine's Hill, near Guildford, Surrey, c.1831. Watercolour and pencil; 29×43 cm, 11^3⁄8×16^7⁄8 in. Yale Center for British Art, Paul Mellon Collection, New Haven

It is difficult to reconcile Turner's support for parliamentary reform, his interest in scientific or technological advances, and the rich diversity of *Picturesque Views in England and Wales* with the idea that he was essentially pessimistic in his outlook. But there is less of a contradiction than at first appears. Given that Turner tended to conceive of history as a spectacle of rising and declining cultures, Britain in the 1830s showed all the signs of having reached a pinnacle of achievement in its arts, commerce, industry, politics and science. This is implicit

in two oils Turner painted for Henry McConnell, a Manchester textile manufacturer, in 1834 and 1835. The first, simply titled *Venice*, was a daylight view of that city; the second, *Keelmen Heaving in Coals by Night* (131), was its companion, adapted from an earlier watercolour of *Shields on the River Tyne*. Like many of Turner's earlier coastal and harbour scenes, such as *Dieppe* (see 107), its pictorial structure is built on double diagonals converging from left and right to a point beneath the

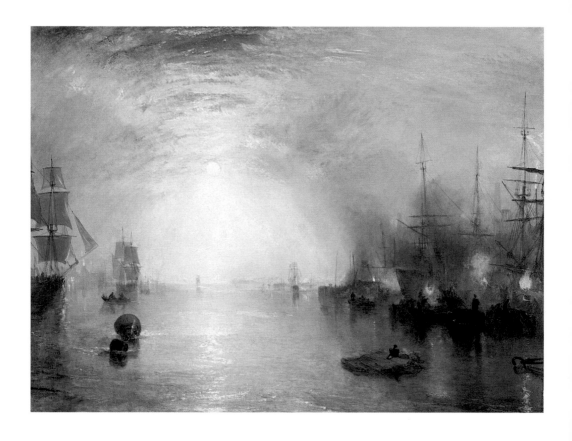

131
*Keelmen
Heaving in
Coals by
Night*,
1835.
Oil on canvas;
90·2×121·9 cm,
35½×48 in.
National
Gallery of Art,
Washington,
DC

source of light. This composition was derived from Claude's seaports, but the debt is more obvious in *Dieppe* than it is in the *Keelmen*, where the scene is illuminated by the moon and much of the painting is in deep shadow. The nocturnal industry and economic power of Tyneside offered a contrast with Venice, which had slid into a humiliating decline since its days as a great maritime trading republic. Turner was not complacent about modern Britain; he knew that, like Venice, it could slide into decline. Joseph Gandy (1771–1843), who worked for John Soane as an architectural draughtsman, went so far as to imagine what London would look like in the future, when his employer's buildings were ruined and crumbling like the Forum Romanum

132
Joseph Michael Gandy, *Architectural Ruins – A Vision (John Soane's Rotunda of the Bank of England in Ruins)*, 1832. Watercolour heightened with white; 53·1×88·8 cm, 20⅞×35 in. Sir John Soane's Museum, London

(132). Turner, however, was content to observe and celebrate British achievements, and only to hint at what might follow.

Although Turner believed that Britain was culturally and economically pre-eminent in the 1830s, he saw it as part of a general historical shift in Europe's 'centre of gravity' from Italy in the south to the nations in the north. He also came across plentiful evidence of prosperity and regeneration during his frequent tours of France and Germany. Apart from the *England and Wales* series, his main topographical project during this period was a survey of the scenery on the rivers Loire and Seine, three volumes of which were published by Charles Heath

as *Turner's Annual Tour* between 1833 and 1835. Like the popular annuals, for which Turner had been contributing designs since the 1820s, these books appeared for sale just before Christmas, but at 2 guineas they were twice the price of rival publications, and Heath found it hard to turn a profit. In 1833 he had optimistically announced that the volumes on the Loire and Seine would be the first in an ambitious series covering *The Great Rivers of Europe*, but it soon became apparent that this would not be commercially feasible.

It is clear from Turner's many French views in the 1820s and 1830s that the disintegration of Napoleon's empire did not bring about the collapse of France itself, which had been ruled since the revolution of July 1830 by King Louis-Philippe, Turner's erstwhile neighbour in Twickenham. He still thought highly enough of the artist to present him with a monogrammed gold snuffbox when he came to London to attend the coronation of Queen Victoria (r.1837–1901) in 1838. For his part, Turner depicted Louis-Philippe's France as thriving, with commercial traffic on the rivers, activity on the quays and crowds in the streets. This was particularly true of Paris, to which he paid the longest of many visits in 1832. His gouache of the boulevard des Italiens (133), made for his *Annual Tour* of 1835, represents the bustling street life of one newly fashionable district. In complete contrast, the view entitled *Paris from Père-la-Chaise: Massena's Monument* (134), produced as an illustration for Sir Walter Scott's *Life of Napoleon Bonaparte*, surveys the city's vitality from a melancholy vantage point in Paris's most famous cemetery. The scene includes the tombs of three of Napoleon's most renowned military leaders, Masséna, Lefebvre and Vice-Admiral Decrès, representatives of the nation's heroic past.

A monument to another Napoleonic hero features prominently in an important German subject, *The Bright Stone of Honour (Ehrenbreitstein) and the Tomb of Marceau, from Byron's 'Childe Harold'* (135). The huge fortress of Ehrenbreitstein, strategically situated over the confluence of the rivers Rhine

133
Boulevard des Italiens, Paris, 1833. Watercolour and gouache on blue paper; 13·8×18·7cm, 5½×7⅜in. Private collection

134
William Miller after J M W Turner, *Paris from Père-la-Chaise: Massena's Monument,* 1835. Engraving; 8×11·7cm, 3⅛×4⅝in

and Mosel at Coblenz, was one of the most potent symbols of Germany's wartime resistance, as well as its postwar resurgence. It had held out against the French for five years before finally surrendering in 1799. After Napoleon's defeat, the Prussians decided to rebuild it and to improve on its original fortifications so that it would stand guard once again over the Rhine. Turner never tired of sketching it, first in 1817, and then on every subsequent tour that took him along the river, including his journey to Venice in 1833. His usual practice was to provide his

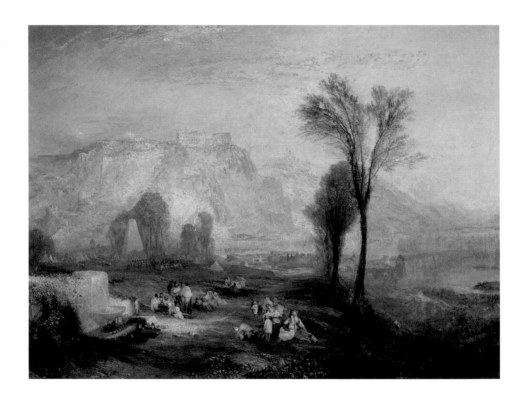

engravers with watercolour drawings from which to work, but John Pye requested an oil painting of the subject. Marceau was a French general who died at the siege of Ehrenbreitstein in 1796, and Byron wrote of the respect in which he was held, even by his enemies. This is implied in the painting through the Prussian soldiers who are bivouacked around his pyramidal tomb, while the relaxed attitudes of the civilians in the foreground suggest the benefits of peace and reconciliation.

In the event that Britain and northern Europe began to decline, Turner, like Byron, thought that it would be due to flaws in human nature. In such pictures as *Hannibal* (see 72) and the *Bay of Baiae with Apollo and the Sibyl* (see 104), he strongly implied that there comes a point where cultures or societies are seduced by their own success. At that stage the qualities that helped them to rise give way to indolence, complacency and even cruelty. This does not mean that Turner was misanthropic – his work abounds with examples of human fallibility on the one hand and courage and self-sacrifice on the other, although these aspects are rarely shown simultaneously. An exception is *Wreckers – Coast of Northumberland, with a Steam-Boat Assisting a Ship off Shore* (136), which was exhibited in 1834. As often happened with his sea-pieces, the critics praised it for its naturalism, but failed to comment on the imagery. It is one of several works from these years to feature wreckers: men and women who supplemented their meagre livelihoods by salvaging the cargoes, and even the rope, timber, canvas and nails of vessels that had run aground. Shipwrecks happened often enough, but in some cases wreckers deliberately lured craft on to the rocks by placing misleading lights in the most dangerous locations.

Turner's wrecker subjects are the ignoble counterpart to his painting of Manby's life-saving apparatus (see 125). In *Wreckers*, the two contrasting impulses, to profit from tragedy and to avert it, are held in a fragile equilibrium, with men and women hauling salvaged debris ashore while a steam-boat attempts to prevent the same thing from happening to another ship in difficulty. Instead of pessimism the work represents a complex view of human behaviour that acknowledges the potential for both self-interest and compassion. As he grew older, more infirm and less certain that his reputation would endure, Turner began to relinquish this balanced outlook, and his later works often sound a more overtly pessimistic note.

In the 1830s, however, Turner rarely doubted that posterity would remember him. To many of his contemporaries the

135
The Bright Stone of Honour (Ehrenbreit-stein) and the Tomb of Marceau, from Byron's 'Childe Harold', 1835. Oil on canvas; 93×123 cm, 36⅝×48⅜ in. Private collection

136
Wreckers –
Coast of
Northumber-
land, with a
Steam-Boat
Assisting
a Ship off
Shore,
1834.
Oil on canvas;
91·4×121·9 cm,
36×48 in.
Yale Center
for British Art,
Paul Mellon
Collection,
New Haven

strength of Britain's art, like that of its manufacturing industry, was evidence of a society at its zenith, and Turner wished to ensure that his status as one of its most illustrious practitioners was beyond dispute. Numerous oil paintings produced during these years continue the distinct sub-category within his output of 'pictures about painters', which began a decade earlier with *Rome from the Vatican* (see 97). While in Europe as a whole there was a growing interest in the biographies of Old Masters, Turner's images had a decidedly personal dimension, as is evident in the two examples he showed at the Royal Academy in 1833: *Bridge of Sighs, Ducal Palace and Custom-House, Venice: Canaletti Painting* (137), and *Van Goyen Looking out*

137
Bridge of Sighs, Ducal Palace and Custom-House, Venice: Canaletti Painting, 1833. Oil on panel; 51×82·5 cm, 20⅛×32½in. Tate, London

for a Subject (138). Despite their differences in genre and appearance, they were motivated by the same impulse, and, while it is possible to see them as tributes to painters Turner admired, there was also an aggressive and competitive element in their creation. The periodical writers reported that the *Bridge of Sighs, Ducal Palace and Custom-House, Venice* was produced to rival his colleague, William Clarkson Stanfield (1793–1867), who had submitted *Venice from the Dogana*, but it was Canaletto (Giovanni Antonio Canal, 1697–1768) as much as Stanfield that Turner had in his sights. Before 1833 he had never exhibited an oil painting of Venice, and yet to invoke

138
Van Goyen
Looking out
for a Subject,
1833.
Oil on canvas;
91·8×122·9 cm,
36$\frac{1}{8}$×48$\frac{3}{8}$ in.
Frick
Collection,
New York

Canaletto in that context was to force comparisons with the most renowned painter of Venetian scenes. It was a monumental act of hubris on Turner's part, but the reviewer for the *Athenaeum* took the bait, declaring that his style was 'worth Canaletti's ten times over'.

Turner's other biographical picture of 1833 shows the seventeenth-century Dutch painter Jan van Goyen (1596–1656) studying the sea and shipping from a boat, with the city of Antwerp in the distance. As with his depiction of Canaletto at work, Turner invites the viewer to conclude that his abilities were as great as, if not greater than, those of a distinguished predecessor. The imagery also implies that Turner's marine subjects, like Van Goyen's, were based on direct experience. This was in fact the case. In 1831, for example, while visiting Abbotsford, the home of Sir Walter Scott, he had made an excursion by steam ship in extremely turbulent weather around the island of Staffa, and commemorated it the following year in his oil painting *Staffa, Fingal's Cave*.

These instances of posthumous rivalry with Van Goyen and Canaletto, like the desire to have his work hung alongside Claude's in the National Gallery, forced Turner's contemporaries to acknowledge his status as a modern master. During the 1830s they were supplemented by more spectacular demonstrations of his brilliance on the Varnishing Days that preceded the opening of the Royal Academy's annual exhibition. By this stage the term 'Varnishing Days' was a misnomer, for rather than just varnishing their works *in situ*, academicians were amending and repainting them to ensure they would be noticed. On the crowded walls of Somerset House a gaudy picture could annihilate its more restrained neighbour, and critics often assumed that the intense colour of Turner's later oils was just a ploy to grab the spectator's attention. In fact, he knew how to enhance the impact of his works dramatically with the subtlest of modifications. In 1832 he eclipsed Constable's brightly painted depiction of the opening of Waterloo Bridge by applying the merest touch of red lead to

his otherwise sober marine picture *Helvoetsluys*. There was no love lost between the two men, since Constable had apparently used his position on the hanging committee of the 1831 exhibition to replace a picture by Turner with one of his own. Turner was rarely so aggressive. In 1833, he and his friend George Jones playfully outpainted each other, and he occasionally offered advice and practical help to younger artists such as Richard Redgrave (1804–88) and Daniel Maclise (1806–70).

By 1835 Turner was no longer merely adjusting and fine-tuning the appearance of his pictures. In some well-attested cases he used the Varnishing Days to do much of the painting. The most detailed account was given by the artist E V Rippingille (1798–1859), who watched for three hours while Turner worked at the British Institution on his canvas *The Burning of the House of Lords and Commons, 16th October, 1834* (139). On the night the old parliament buildings caught fire, Turner was among the crowds who watched their destruction from the south bank of the Thames, and at some point he took to the river on one of the boats that were charging sightseers for a better view of the blaze. The subject was bound to appeal to him for its topicality, but also because it was a rare example of the cataclysmic power of the elements in a modern urban context. Despite the sublimity of the scene, however, many of those who watched as the buildings were razed to the ground were entertained rather than terror-struck. The reporter for the *Gentleman's Magazine* described how the crowds cheered when the roof of the Lords collapsed, primly attributing it to the sheer spectacle rather than the malicious glee of those to whom the Reform Act of 1832 had failed to give the vote.

When first submitted, the picture was, in Rippingille's words, '"without form and void", like chaos before the creation', and a small crowd of onlookers gathered to observe the process by which it was transformed into a finished piece. In the past Turner shunned this kind of attention, and because opportunities to see him at work were rare, even Augustus Callcott

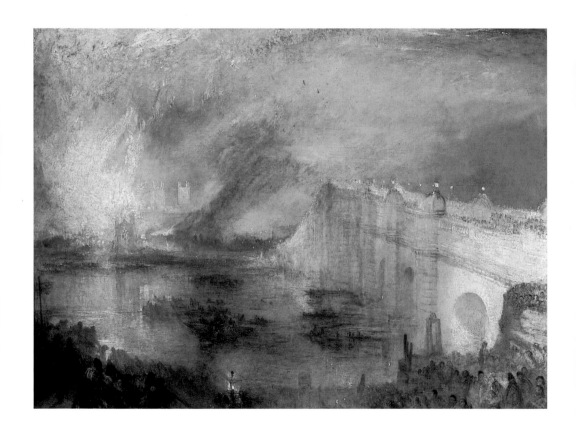

139
*The Burning
of the House
of Lords and
Commons,
16th October,
1834,*
1835.
Oil on canvas;
92×123 cm,
36¹⁄₄×48¹⁄₂ in.
Philadelphia
Museum of Art

joined the watching group. Although they had known each other for three decades, he was as mystified by his friend's technique as the rest. At one stage, Rippingille saw Turner 'rolling and spreading a lump of half-transparent stuff over his picture, the size of a finger in length and thickness'. When he asked Callcott what it was, the latter replied, 'I should be sorry to be the man to ask him.' In fact, Joyce Townsend's research into Turner's materials has shown that he used a range of paint media, including various waxes and resins as well as oils, and that he generally finished his paintings by repeatedly applying scumbles, delicately coloured glazes and thickly impasted paint to un-finished sketches.

Turner's performances on Varnishing Days, which were occa-sionally sketched by his colleagues (140), were a demonstration of his authority. They showed above all that his way of painting was purposeful, not capricious. Rippingille's account stressed the unbroken concentration and complete conviction with which he worked, standing close to the painting, never stepping back to check its progress, or even to contemplate the results when he had finished. It implied that Turner had a clear idea of what he wanted to achieve and total command of the means of doing so. As Daniel Maclise, another of the onlookers, remarked, 'There, that's masterly, he does not stop to look at his work; he knows it is done, and he is off.'

Others were less impressed by Turner's exhibited work of 1835. Gustav Friedrich Waagen, a renowned scholar and the director of the Royal Gallery in Berlin, visited the Royal Academy during a tour of England. Like many foreigners, he knew of Turner only from 'his numerous, often very clever compositions for annuals, where they appear in beautiful steel engravings'. But the preci-sion and detail of these monochrome images did not prepare Waagen for the colour or handling of the *The Bright Stone of Honour (Ehrenbreitstein) and the Tomb of Marceau, from Byron's 'Childe Harold'* (see 135), which horrified him. Among British critics none was more hostile to Turner during this

140
William
Parrott,
Turner on
Varnishing
Day at the
Royal
Academy,
1846.
Oil on panel;
25·1×22·9 cm,
9⅞×9 in.
Collection of
the Guild of
St George,
Ruskin
Gallery,
Sheffield

period than the Revd John Eagles, a Bristol clergyman, amateur artist and reviewer for *Blackwood's Edinburgh Magazine*, a widely read literary and critical journal that had once been a platform for Tory opposition to parliamentary reform.

Eagles, who wrote from a sense of deep conviction, scourged Turner with particular savagery because he, more than any other painter, violated the clergyman's cherished personal aesthetic. In many respects Eagles's attitudes were comparable to those of Sir George Beaumont, for he not only practised but sought to promote a form of landscape that offered 'a poetical shelter from the world'. It was largely based on the work of the seventeenth-century painter Gaspard Dughet, and represented nature only in 'placid, smiling, inviting, or her higher and dignified mood[s]'. Neither the subject matter nor the execution of a picture should interfere with its overall sense of tranquillity, which Eagles thought was best achieved through the judicious use of shade and depth of tone. This explains his criticism of *Ehrenbreitstein*, for he could not reconcile its 'raw white and unharmonizing blue' with the mood of melancholy repose in the

accompanying caption from Byron's *Childe Harold*. The picture had, he said, 'no more poetry than the paring of a toe-nail'.

Like Constable, Eagles felt powerless and ill at ease with the modern world. In contrast to Turner, who often embraced modernity in his work, he sought refuge in landscape painting from all those aspects of contemporary life he most loathed. In place of the shady, modest and timeless scenes for which he longed, however, Turner gave him brilliant colour, bravura handling, and in many cases modern subjects. It was to be expected, therefore, that he would see a parallel between Turner's late style and recent politics, both of which seemed to him to grasp at novelty for its own sake. He made the link explicit in his review of the Royal Academy's 1835 exhibition:

In our extravagant conceit for improvement and novelty, in a word, for *reforming*, whatever has been done before is to be put down as wrong. If others loved shade, we will have light. There must be universal mountebanking, political, moral and religious.

Whereas Turner saw his own work as part of modern Britain's economic, political and cultural superiority, Eagles was equally convinced his stylistic 'excesses' were part of a general decline in moral and social values, which explains the flashes of genuine anger in his writings.

The following year, 1836, Eagles became more venomous than ever. *Juliet and her Nurse* (141), he wrote, contained 'so many absurdities, we scarcely stop to ask why Juliet and her nurse should be at Venice' – his point being that Shakespeare's *Romeo and Juliet* was actually set in Verona. He was not the only one to notice the incongruity, which is more difficult to account for than the anomalies in *Rome from the Vatican* (see 97). In one respect, however, *Juliet and her Nurse* was consistent with other, less problematic Venetian scenes, because it had explicit associations with the city's corruption and decline. The Venice carnival was synonymous with debauchery and sexual indulgence, because the habit of going about incognito removed social

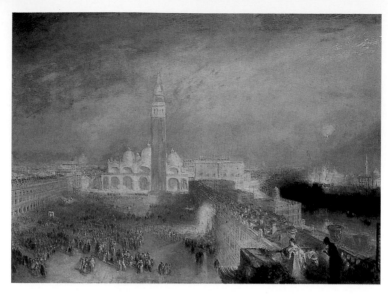

141
Juliet and her Nurse,
1836.
Oil on canvas;
92×123 cm,
36¹⁴×48³⁸ in.
Private collection

distinctions and constraints. Turner's high viewpoint, which is unique among his scenes of Venice, gives the spectator an overview of the city's decadence. Although this may seem difficult to reconcile with Turner's own erotic watercolours, those represented personal fantasies or memories, whereas *Juliet and her Nurse* implies the intrusion of private sexual impulses into public life.

Eagles's abuse of Turner's 1836 exhibit stirred the seventeen-year-old John Ruskin to a fury, and he wrote a long, rhapsodic letter in its defence. Before posting it to *Blackwood's* he sent it to the artist himself. Turner replied, 'I never move in these matters. They are of no import save mischief,' but offered to send the manuscript to Hugh Munro of Novar, the owner of *Juliet and her Nurse*. The episode is important because, as Ruskin later explained, his letter was the seed from which *Modern Painters*, with its monumental defence of Turner, would grow, and whose arguments are discussed at length in Chapter 6.

142
Snow-Storm, Avalanche and Inundation – a Scene in the Upper Part of the Val d'Aouste, Piedmont,
1837.
Oil on canvas;
91·5×122·5 cm,
36×48¹⁴ in.
The Art Institute of Chicago

From July to September 1836, after the exhibition closed, Turner and Munro accompanied each other on a sketching tour of France and Switzerland. It was Turner's first expedition to the Alps since 1802, and it reawakened an interest in Swiss

scenery that prompted annual visits between 1841 and 1844. These late Swiss tours produced some of his most highly regarded watercolours but only one oil painting, *Snow-Storm, Avalanche and Inundation – a Scene in the Upper Part of the Val d'Aouste, Piedmont* (142), which was shown in 1837 at the Royal Academy's first exhibition in its new premises in the National Gallery.

In the winter of 1836–7 Turner was afflicted with influenza, and his physician, Sir Anthony Carlisle, instructed him to remain indoors until the weather improved. He continued to paint, though suffering from what he described as 'lassitude' and a feeling of 'sinking down', a mood doubtless aggravated by the death of two of his oldest friends, William Wells in November 1836 and John Soane the following January. Having received little royal favour, he was not directly affected by the death of William IV in April 1837, though he does seem to have nursed short-lived hopes of recognition from his successor, Victoria. Of far greater personal significance was the death of the Earl of Egremont. Turner paid his last social visit to

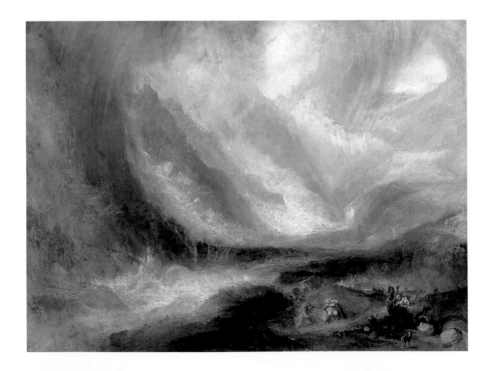

Petworth in October 1837; when he returned on 21 November, it was for the funeral, where he led the group of artists who mourned the earl's passing. The occasion marked the end of Petworth as a focus of artistic sociability, because Egremont's son intended to run it as a conventional Great House.

Once again Turner's health was poor that winter. At one stage he suffered badly from a fever, in spite of which he carried out extensive official duties for the Royal Academy in 1838, including service as a visitor (or instructor) in both the life drawing classes and the painting school. For the first time in fifteen years he did not tour, either at home or abroad. Instead,

143
Figures on the Shore, 1835–40. Watercolour and gouache on grey paper; 22·3×29·2 cm, 8³⁄₄×11¹⁄₂ in. Private collection

144
Caspar David Friedrich, *Monk by the Sea*, 1809. Oil on canvas; 110×171·5 cm, 43×67¹⁄₂ in. National-galerie, Berlin

with Petworth now closed to him, he spent August and September at Margate. He had known it as a child and began to return there in the 1830s, staying in the lodging house of a widow, Sophia Booth. His landlady eventually became his devoted companion and wife in all but name, who not only cooked and cared for him, but also cleaned his brushes and acted as studio assistant, much as Turner's father had done. The scenery on that stretch of the Kent coast provided the subject matter for many of his later marine views, including the haunting *Figures on the Shore* (143), which probably came from a sketchbook Turner used at Margate. It is comparable to Caspar David

Friedrich's earlier (1809) and more celebrated *Monk by the Sea* (144) in the way it suggests the fragility and impermanence of human life by isolating tiny figures against broad horizontal bands of land, sea and sky. Unlike Friedrich's, Turner's image was not intended for public view, but its radically simple design and economy of detail reappear in major oil paintings of the 1840s such as *Snow Storm – Steam-Boat off a Harbour's Mouth* (see 160) and *The Angel Standing in the Sun* (see 170).

Not all reviews of Turner's oil paintings in the late 1830s were as destructive as those of John Eagles, but even at best they

were rather mixed. The only real exception to this was *The Fighting 'Temeraire', Tugged to her Last Berth to be Broken up, 1838* (145), the centrepiece of Turner's submission to the Royal Academy in 1839. He called it his 'darling' and refused to sell it at any price because he knew that it was one of the chief pillars on which his reputation would rest, and he planned to leave it to the nation. The distinguished marine painter W L Wyllie (1851–1931), who wrote a life of the artist in 1905, was one of few who thought it was 'by no means up to Turner's best work'. He felt that its success owed less to its painterly qualities than to the nostalgic

145
*The Fighting
'Temeraire',
Tugged to her
Last Berth to
be Broken
up, 1838*,
1839.
Oil on
canvas;
91 × 122 cm,
35⅞ × 48 in.
National
Gallery,
London

and patriotic sentiments it inspired. In some respects this was a perceptive judgement, since the picture is untypical of Turner's later oils, which can be difficult to interpret. The *Temeraire*, by contrast, seemed remarkably accessible. Even the accompanying quote from the poet Thomas Campbell in the exhibition catalogue – 'The flag which braved the battle and the breeze, No longer owns her' – was simple and to the point. The work aroused such deep feelings that lacklustre reviewers became eloquent, and the articulate ones positively rhapsodic: William Makepeace Thackeray, writing in *Fraser's Magazine*, compared it to 'a magnificent national ode, or piece of music'.

Turner dubbed the vessel the *Fighting 'Temeraire'* in recognition of its role in the Battle of Trafalgar, where it sustained a ferocious onslaught against the enemy long after it was dismasted and rudderless. Although it was later refitted, it served out most of its remaining years first as a prison ship, then as a victualling and receiving ship for seamen who were waiting to take up active duties. It was finally sold for £5,530 to the shipbreaker and timber merchant John Beatson, who hired two tugs to tow it upriver to his wharf at Rotherhithe in September 1838. Several unreliable stories place Turner as an eyewitness at some point in this final, two-day journey, but he probably had all he needed in newspaper accounts of the event, for as Wyllie pointed out, the *Fighting 'Temeraire'* is a work of the imagination, which suggests the silent, stately progress of a funeral cortège. It is not a documentary image of the 2,000-ton dismasted hulk that was tugged laboriously up the Thames.

Most critics interpreted the picture both as a lament for the passing of a glorious epoch in British naval history and, more generally, as a modern *vanitas* subject – a reminder that time and death overtake men and ships alike. Many writers cast the steam tug as the villain of the piece, deploring its supposed ugliness and in one case likening it to an executioner, but there is no evidence that Turner intended any such meaning. One of the most original scientists of the age, the French

engineer and theoretical physicist Sadi Carnot, once remarked that Britain's continued existence as a great nation depended more on the steam engine than on the fighting spirit of its navy. This observation presents the *Temeraire* in a very different light and serves as a reminder that Turner's many images of steam technology had strong patriotic connotations, even though they lacked the sentimental appeal of a super-annuated warship.

It was Carnot who laid the foundation for the modern science of thermodynamics. According to the eminent historian of science Michel Serres, Turner's work often provides a visual counterpart to his ideas. Carnot realized that, although British engineers were continually improving the design of steam engines, there was no adequate theory to explain the way in which they worked. His essay *On the Motive Power of Fire* (1824) proved that the mechanical efficiency of an engine depended on the extent of the heat flow from the boiler to the cold region of the condenser: the greater the temperature difference between the two, the more power is generated. In Turner's output there are many images not merely of steam engines but also of the motive power (fire), substance (water) and the steep temperature gradients that cause them to work. In fact, as Serres pointed out, the conjunction of fire and water, or fire and ice, is a constant and striking theme of his later pictures, including the *Temeraire* and *Rain, Steam and Speed* (see 169), *The Burning of the House of Lords and Commons* (see 139) and the *Keelmen Heaving in Coals by Night* (see 131).

Carnot's new science of thermodynamics also questioned some of the assumptions of Newtonian physics, especially the belief that there were no chance effects in a mechanical system. Instead, there was a growing awareness of stochastics – the unpredictability to be found in the unstable borders of clouds, the movements of tides or the effects of vapour. These phenomena have a particular importance in meteorology, and

a corresponding importance in Turner's art, but there are few
examples more astonishing than the multiple catastrophes
in his *Snow-Storm, Avalanche and Inundation* (see 142)
of 1837. When Serres described him as 'the first genius of
thermodynamics', he was adding his voice to those who, from
Ruskin onwards, affirmed that Turner had particular insight
into the workings of nature and not just its appearances.

After witnessing the tremendous popular and critical acclaim that greeted the *Temeraire*, Turner left for the Continent on 3 August 1839, travelling to Belgium, Luxembourg and Germany, along the Meuse, Mosel and Rhine, as he had done fifteen years earlier. In addition to his usual pencil sketches, this tour produced more than a hundred gouaches, each of them little bigger than a postcard and made from large sheets of blue paper that he folded and tore into sixteen pieces. As usual they were not done on the spot but created later from the images in his sketchbooks, probably during the autumn and winter of 1839. Until recently they have rarely been shown in public, though works such as *Klotten and Burg Coraidelstein from the West* (147) are remarkable for their free handling and chromatic daring.

146
Peace –
Burial
at Sea
(detail
of 158)

As he worked on the gouaches from his 1839 tour, Turner was also preparing his submission for the Royal Academy exhibition in 1840, a substantial exhibit of seven oils. Unfortunately, the success of the *Temeraire* was only a temporary respite from the critical drubbing that was generally meted out to Turner's new oil paintings. If anything, the invective reached new levels of savagery in 1840. None of the works emerged unscathed, but the one that provoked the most bile was his anti-slavery picture, *Slavers Throwing Overboard the Dead and Dying –* *Typhon Coming On* (148), the painting Ruskin would have chosen if he had been forced 'to rest Turner's immortality on a single work'. Even today the *Slave Ship*, as it is often known, arouses controversy. The scholar Albert Boime castigated it for 'subsuming human suffering to the taste for high tragedy', while his colleague John McCoubrey replied that it was, on the contrary, a deeply felt and sincere gesture. Such disagreements are instructive because they highlight the problems Turner faced in finding a visual language to express extremes of human

cruelty without falling into the trap of aestheticizing the anguish and misery it caused. It is a dilemma that confronts any artist, photographer or film-maker who seeks to use their work to mobilize public opinion for humanitarian ends.

The *Slave Ship* does not illustrate a specific event. It draws on the associations that the slave trade held in the minds of Turner's contemporaries, and it is necessary for a modern reader to be aware of the scandals that were widely publicized

by the abolitionists in their campaign against the trade. It has often been linked to the story of the *Zong*, a Liverpool vessel whose captain deliberately drowned 132 diseased and dying slaves *en route* from West Africa to Jamaica in 1781, so that the ship-owners could claim insurance for them as goods lost at sea. The anti-slavery campaigner Granville Sharp wanted to have the crew arraigned for murder, but John Lee, the Solicitor General, and counsel for the ship-owners, stated with inhuman clarity

'What is all this vast declaration of human beings thrown overboard? ... they are goods and property: whether right or wrong, we have nothing to do with it.' The episode so thoroughly exposed the moral vacuum in which the slave trade operated that it spurred on the abolitionist cause and lingered in the minds of Turner's generation.

Turner does not illustrate the story of the *Zong*, because to do so would imply that such atrocities were a thing of the past. In reality, although the British parliament outlawed the traffic in human beings from its dominions in 1807, and finally granted slaves their freedom in 1833, similar massacres still took place.

147
Klotten and Burg Coraidelstein from the West,
c.1839.
Gouache and watercolour on blue paper;
14×18·9 cm,
5½×7½ in.
Tate, London

In an attempt to stamp out the continuing illegal trade, a British squadron was sent to the West African coast. Its activities were commemorated in engravings, most of which depicted the spectacular chases, some over hundreds of miles, in which the squadron ran down illegal (usually Spanish and Portuguese) slavers. But its officers testified to the unspeakable cruelties that still occurred when an anti-slavery chase ended badly. William Ramsay, who commanded the *Black Joke*, reported that when he had pursued two Spanish vessels in 1831 they disposed of the evidence by 'throw[ing] their slaves overboard, by twos shackled together by the ankles, and left [them] in this manner to sink or swim'. Given that the British vessels were paid a bounty for every slave rescued *at sea* but not if they were still in harbour, it was sometimes alleged that the squadron's activities caused these tragedies by waiting for slave ships to set sail before making a move. Whether or not this was true, the fact that slaves had a monetary value both to their tormentors and their would-be rescuers was morally offensive.

When the West Africa Squadron's operations ended in disaster they were rarely publicized, for they called the effectiveness of British anti-slaving policy into question. However, the National Maritime Museum has an unofficial, undated and anonymous drawing with the following self-explanatory title: *Slaver, 500 slaves after a long chase by HMS Rifleman ran on shore near*

148
Slavers
Throwing
Overboard
the Dead
and Dying –
Typhon
Coming On,
1840.
Oil on
canvas;
91×138 cm,
$35^7/_8 × 54^3/_8$ in.
Museum of
Fine Arts,
Boston

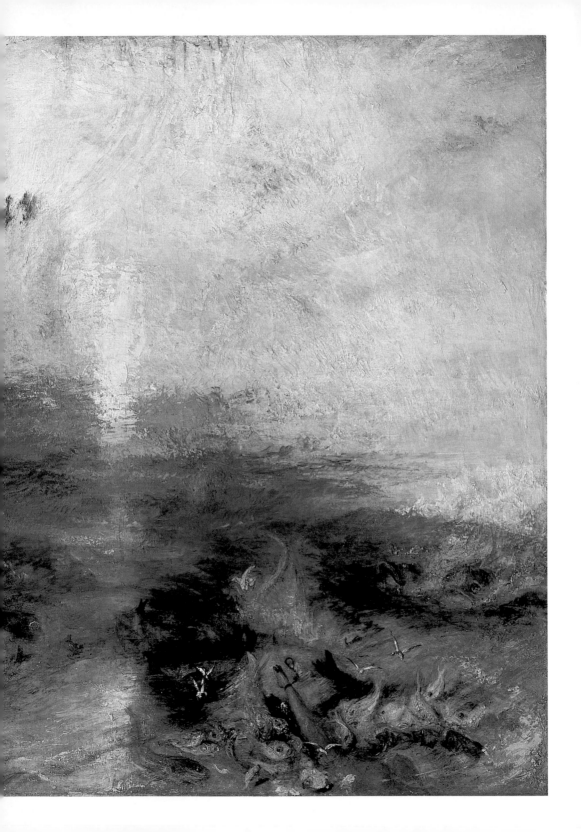

*Cape Frio, Brazil – Next morning the decks were covered with
dead bodies 40 slaves were found alive, many doubtless got
on shore but most were drowned* (149). For all its mysterious
origins, its brutal subject seems to have much in common with
Turner's more renowned picture.

The only productive comments to emerge from the tide of
adverse criticism came from the novelist William Thackeray
who, though unable to decide whether the picture was 'sublime
or ridiculous', nonetheless pronounced it 'the most tremendous
piece of colour that was ever seen'. In spite of his professional
flippancy he understood that Turner's shrieking reds and yellows
were a response to his barbaric theme, whereas most other critics
seized on his colour as a means of *not* addressing the subject
matter. Rather than being moved by the plight of the slaves, they
claimed to pity the artist for his onset of delirium. They ridiculed
foreground details such as the upraised leg of a drowning
slave, attacked by a shoal of fish, or 'the floating of iron cable
chains and other unfloatable things', as Mark Twain later put it.
However odd they might appear, even today, these were symbolic
details: the fish were Turner's way of acknowledging, as Herman
Melville observed in *Moby Dick*, that 'sharks ... are the invariable
outriders of all slave ships', and the chains were a symbol of
slavery itself. At the time they were taken not as a sign of the
artist's compassion for the enslaved, but of his mental debility.

149
Anonymous,
*Slaver, 500
slaves after a
long chase by
HMS
Rifleman ...
near Cape
Frio, Brazil.*
Black crayon
on prepared
green paper
with scraped
highlights;
14×22·3 cm,
5¹⁄₂×8³⁄₄ in.
National
Maritime
Museum,
Greenwich

150
Anonymous,
*The Slave
Ship
'Brookes', of
Liverpool*,
1791.
Wood-
engraving

The *Slave Ship* is an extraordinary painting, but its impact
on public opinion was negligible compared to the stark clarity
of a diagram made of the Liverpool slaver *Brookes* in 1788,
which showed how slaves were crammed together on the vessel's
storage decks to maximize the ship-owner's profits. It became
a stunning publicity coup for the abolitionists, not only in Britain
but in revolutionary France, and it was still able to shock Pope
Pius VII when the abolitionist William Wilberforce showed it to
him years later. The diagram was extensively reproduced (150),
and its effectiveness as propaganda was not compromised by
aesthetic considerations. As a single image, whose qualities did
not lend themselves to engraving, and a high art object, the *Slave
Ship* could not approach such an effect.

Turner's 1840 exhibit was so vilified that only one work found a
purchaser through the Academy. He later entrusted the sale of
the *Slave Ship* and the *Rockets and Blue Lights (Close at Hand)
to Warn Steam-Boats of Shoal-Water* (see 161) to his dealer,
Thomas Griffith, of Norwood in Surrey. The latter eventually

sold the *Slave Ship* to John Ruskin's father, John James Ruskin, who gave it to his son as a New Year present in 1844. But more immediately, on 20 June 1840, while it still hung on the Academy walls, Griffith invited the future critic to a dinner at his house. It was here that Ruskin was introduced to Turner for the first time. In his autobiography, *Praeterita*, written in the mid-1880s, Ruskin claimed to transcribe the diary entry that recorded his initial impression of the man he described as 'beyond doubt the greatest of the age':

Everybody had described him to me as coarse, boorish, unintellectual, vulgar. This I knew to be impossible. I found in him a somewhat eccentric, keen-mannered, matter-of-fact, English-minded gentleman: good-natured evidently, bad-tempered evidently, hating humbug of all sorts, shrewd, perhaps a little selfish, highly intellectual, the powers of his mind not brought out with any delight in their manifestation, or intention of display, but flashing out occasionally in a word or a look.

Ruskin concluded the passage by congratulating himself on his powers of intuition, but it now appears that the text was freshly composed for *Praeterita* rather than taken from his diary. It was an attempt to persuade his readers that he had a strong and instantaneous empathy with Turner, and consequently that nobody had a better claim to interpret his art.

A month or so after the dinner at Griffith's, Turner embarked on what was to be his last journey to Venice, where he stayed for two weeks at the Hotel Europa. Here he met his colleague William Callow (1812–1908), and the two men took their meals together. As Callow recalled: 'one evening whilst I was enjoying a cigar in a gondola I saw in another one Turner sketching San Giorgio, brilliantly lit up by the setting sun. I felt quite ashamed of myself idling away the time whilst he was hard at work so late.' Once again, Turner may have worked up such sketches in his hotel room. In spite of the fact that they were not finished works, nearly two dozen late Venetian watercolours were removed from a soft-back sketchbook and acquired by collectors, six of them by Ruskin. In general the watercolour sketches from

151
Venice: Storm in the Piazzetta, 1840. Watercolour, gouache and scraping-out, with some pen and red colour; 22.1×32.1 cm, $8\frac{3}{4} \times 12\frac{5}{8}$ in. National Gallery of Scotland, Edinburgh

the 1840 visit give an ethereal, evanescent picture of the city, but four of those that found their way into private hands, including *Venice: Storm in the Piazzetta* (151), present a less familiar, more dramatic aspect of the place.

Turner travelled home through Austria and Germany along the Danube, Main and Rhine, stopping at the principal towns and cities as usual, but also taking the time to visit and sketch the Walhalla, near Regensburg, which was then approaching completion. This huge Neoclassical structure was modelled on

the Parthenon and designed by the architect Leo von Klenze (1784–1864) at the behest of King Ludwig I of Bavaria (r.1825–48), who intended it as a secular temple dedicated to the glorification of German cultural, scientific and military achievements. Turner was among its first British visitors and three years later he made its grand opening the subject of a large oil painting (see 166). From Regensburg, he detoured to Coburg, the home town of Prince Albert of Saxe-Coburg-Gotha, who had married Queen Victoria in February 1840. The careful

studies he made of the town and its surrounding castles are evidence of his intention to capitalize on the recent wedding. His subsequent oil painting, *Schloss Rosenau, Seat of HRH Prince Albert of Coburg, near Coburg, Germany* (152), was a portrait of Albert's birthplace, which Turner probably hoped would attract a royal purchaser. Unfortunately, Victoria and her consort were no more inclined to patronize Turner than her predecessors had been, but thanks to its subject it attracted much comment at the Academy in 1841, most of it abusive. The critic of the *Athenaeum* described the fierce yellow sunlight and the warm, russet-toned scenery as the product of 'a diseased eye and a reckless hand'. In order to understand why Turner's later oils routinely offended contemporary taste it is useful to compare *Rosenau* with the kind of painting that was widely admired. *A Summer's Afternoon* (153) is typical of the work of Thomas Creswick (1811–69), whose career took off during the 1840s and whose prices remained high four decades later. In his *Dictionary of Artists of the English School* (1878), Richard Redgrave attributed Creswick's success to his careful finishing and to the natural, pure and simple colour with which he rendered homely domestic scenery. When compared with the unassertive style of *A Summer's Afternoon*, it is easy to see why Turner's *Rosenau* affronted the critics.

The abuse heaped on *Rosenau* was in marked contrast to the three Venetian oils he showed that year, which produced a collective sigh of relief from the critics. The *Ducal Palace, Dogana, with part of San Georgio, Venice* (154), for example, which was painted for his friend Chantrey, presented no great difficulties of interpretation because it could be understood as an exercise in atmosphere and reflected light. Unlike *Schloss Rosenau*, its colour was restrained by the subject matter. The Venetian scenes continued to uphold his reputation during the early 1840s, although Chantrey had little time to enjoy his picture, as he died in November 1841. His death, like that of David Wilkie five months earlier, greatly affected Turner.

152
Schloss Rosenau, Seat of HRH Prince Albert of Coburg, near Coburg, Germany, 1841.
Oil on canvas;
97×124·8 cm,
38¼×49⅛ in.
Walker Art Gallery, National Museums and Galleries on Merseyside

153
Thomas Creswick, *A Summer's Afternoon*, 1844.
Oil on canvas;
101·6×127 cm,
40×50 in.
Victoria and Albert Museum, London

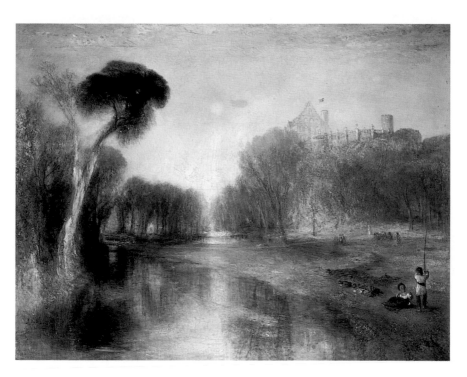

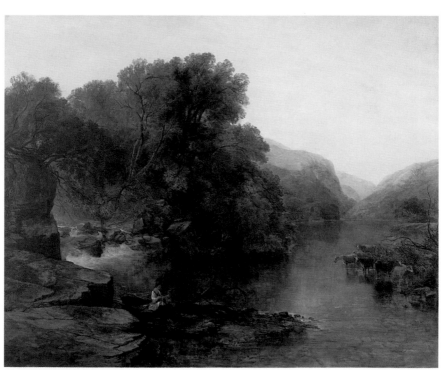

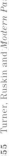

The destination for Turner's annual tour in 1841 and on each of the three years that followed was Switzerland. He distilled his experiences into some of his most beautiful finished watercolours. Unlike much of his previous work in the medium, they were neither shown in public nor engraved. Turner had stopped exhibiting new watercolours in the mid-1830s, and by the 1840s there were few opportunities to contribute to the kind of engraved series that had given him an international reputation. Nonetheless, Turner still wished to see his work

appear in engraved form, for he planned to publish prints after five of his oil paintings at his own expense, which may explain why he was keen to find buyers for his new Swiss watercolours.

They were sold to a small circle of private patrons through his agent, Griffith. Turner prepared six 'sample studies' from material in his Swiss sketchbooks, which were shown to potential purchasers, who would then commission the artist to paint a finished watercolour from the study or studies of their

choice. In addition, he produced four specimen works to give his patrons an idea of what the completed images would look like. Each picture in the proposed series of ten was priced at 80 guineas; Turner had hoped to charge more but Griffith told him that the novelty of their style would make collectors reluctant to pay a higher price. For example, Benjamin Godfrey Windus, who owned probably the largest collection of Turner's water-colours, was slow to participate in the scheme. A work such as *The Red Rigi, Lake of Lucerne, Sunset* (155) has a strong appeal for modern viewers who accept the subtleties of light and colour in Monet's *Grain Stacks* as ample compensation for their minimal imagery, but Windus had grown accustomed

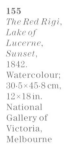

154
Ducal Palace, Dogana, with part of San Georgio, Venice, c.1841.
Oil on canvas; 63·5×93 cm, 25×36⅝ in.
Allen Memorial Art Museum, Oberlin College, Ohio

155
The Red Rigi, Lake of Lucerne, Sunset, 1842.
Watercolour; 30·5×45·8 cm, 12×18 in.
National Gallery of Victoria, Melbourne

to the detail and incident to be found in Turner's *England and Wales* series. He was therefore slower to respond to the late Swiss watercolours than either Ruskin or Munro of Novar, who occasionally competed (not always in a spirit of friendly rivalry) for the same work. Between them they bought twenty of the twenty-six Swiss watercolours that Turner sold through Griffith in 1842, 1843 and 1845.

Taken as a whole the series has a wide expressive range that is largely due to the artist's virtuoso manipulation of colour. At one extreme stands *The Red Rigi* (first owned by Munro), whose effect of meditative calm is achieved through the delicate

juxtaposition of pale pink against subtly shifting blues. At the other expressive pole is the *Goldau* (156), in which the same colours are deployed but with such fierce intensity that Ruskin, who acquired the work in 1843, was reminded of the lurid sky in the *Slave Ship* (see 148). In 1806, 457 inhabitants of the village of Goldau were buried under a colossal rockfall, which strengthened Ruskin's intuition that the watercolour was essentially a tragic work.

The collectors who purchased the late Swiss designs formed the nucleus of Turner's clientele in his later years, and in most cases they also collected his new work in oils. Apart from Munro, who was a landowner, Turner's late patrons were largely middle-class entrepreneurs and industrialists. Ruskin depended for his purchases on the wealth of his father, who made his fortune importing Spanish sherry as a partner in the firm of Ruskin, Telford and Domecq. Windus was a coachmaker who also marketed an opium-based throat medicine, and Elhanan Bicknell had interests in the Pacific sperm-whale fisheries. Others included Joseph Gillott, a Birmingham manufacturer of steel

pens, and John Sheepshanks, a Leeds clothing magnate. They were less inclined by their education and background to collect the works of the Old Masters, which were in any case extremely expensive, and more likely to purchase modern British art.

As Ruskin realized, this shift in Turner's patron base reflected the growing importance of the commercial and manufacturing sectors in British social and economic life. In wider terms, their influence was felt in the 1832 Reform Act, and in the Anti-Corn Law League, founded in 1839 to lobby for the repeal of legislation that protected landed interests and curtailed free trade. Robert Vaughan, who published *The Age of Great Cities* in 1843, saw a clear link between these developments and the cultural health of the nation, insisting that 'we have become great in art, as we have become great in commerce, and only in that proportion'.

The Royal Academy exhibition of 1842 included some of Turner's most deeply felt works in oil, but only the Venetian pictures found a ready sale. The others remained on the painter's hands until he bequeathed them to the nation. They included two pictures that were intended as pendants (or paired paintings), each of which was square in format but framed in such a way as to remove the corners. *War: the Exile and the Rock Limpet* (157) is a picture of Napoleon musing in exile on the island of St Helena, and *Peace – Burial at Sea* (158) is a pictorial tribute to Sir David Wilkie, who died while returning from a journey to the Middle East the previous year and was given a traditional shipboard funeral off Gibraltar. *War* and *Peace* were the first of three sets of square pendants that Turner exhibited in the 1840s. In each case the square format favoured a centralized composition, in which the viewer's attention is drawn to the setting sun of *War* and the torchlight of *Peace*. In colour and theme, however, they are opposites – *War* has an aggressive palette of mainly red and yellow, whereas *Peace* is painted with cooler blue, black and white. If the colour contrasts had been any stronger, the pictures would have undermined each other when hung side-by-side. Turner avoided

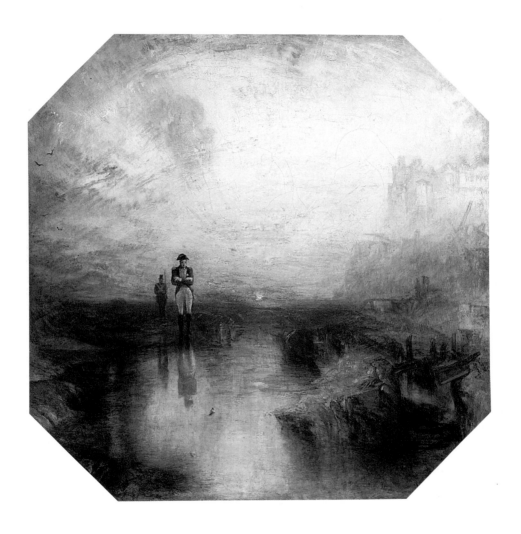

157
*War: the
Exile and the
Rock Limpet,*
1842.
Oil on
canvas;
79·5×79·5 cm,
31¼×31¼ in.
Tate, London

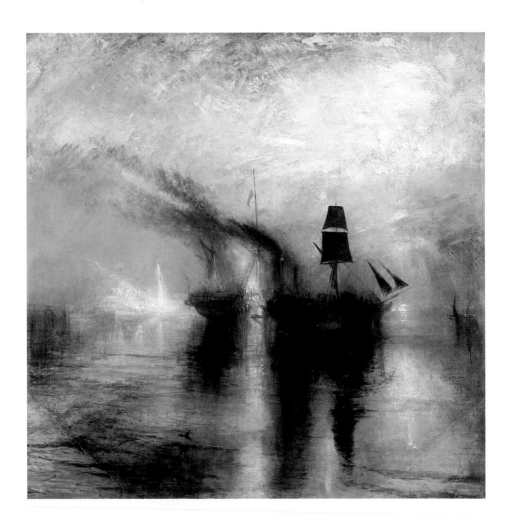

158
*Peace –
Burial at
Sea*,
1842.
Oil on
canvas;
87×86·5 cm,
34¼×34⅛ in.
Tate, London

this by subtly introducing the dominant hues of each image into its companion – Wilkie's torches are red and yellow, while Napoleon is dressed in black and white. It was a solution that produced both contrast and harmony, while simultaneously emphasizing the principal subject in both works.

When Turner's colleague Clarkson Stanfield took him to task for the unnatural blackness of the sails in *Peace*, Turner reportedly said, 'I only wish I had any colour to make them blacker,' the clearest indication he ever gave that his use of colour was at times symbolic. The early rivalry between Turner and Wilkie had changed over the years into a warm mutual regard, and his funereal black expressed the sorrow he shared with many of his colleagues in the Academy. His friend George Jones planned his own picture of Wilkie's burial, seen not from a distance, as in Turner's painting, but at close quarters (159) alongside the deck of the *Oriental*. When the tiny torchlit group in *Peace* is magnified (see 146), it is found to contain many of the details that are in Jones's drawing.

159
George
Jones,
*The Burial
at Sea of Sir
David
Wilkie*,
1842.
Watercolour;
36·8×26·7cm,
14^12×10^12in.
Private
collection

Although Napoleon had died in 1822, the return of his remains to Paris for a state burial in October 1840 gave *War* a topical aspect. It is likely, however, that in addition to Bonaparte, the picture alludes to another artist – Wilkie's close friend Benjamin Robert Haydon (1786–1846). In contrast to Wilkie, who became rich and successful as a genre painter, Haydon was ruined by his single-minded commitment to historical subjects for which there was little demand. To save his family from destitution he mass-produced pictures of Napoleon contemplating past glories on St Helena, and sold them for 5 guineas each. To a certain extent Haydon was the author of his own misfortunes, but he blamed his humiliating situation on the Royal Academy. Perhaps only Turner's colleagues would have seen the connection between Napoleon and Haydon, and realized that the pendants contrasted not only war and peace, but two artistic careers.

Turner rarely responded to critical jibes, but according to Ruskin he was stung by the description of one of his 1842 exhibits as 'soapsuds and whitewash'. The work in question was his *Snow Storm – Steam-Boat off a Harbour's Mouth, Making Signals in Shallow Water and Going by the Lead. The Author was in this Storm the Night the 'Ariel' Left Harwich* (160). Ruskin describes an angry and hurt Turner muttering to himself, 'soapsuds and whitewash! What would they have? I wonder what they think the sea's like? I wish they'd been in it.' The painting is one of the most impressive and yet puzzling oils of his later years, not because its meanings are dense and layered as was sometimes the case, but because it has become cocooned in myth and misinformation, much of which is attributable to the artist himself. Turner made extravagant and frankly unbelievable claims for the work, but he would not have done so had it not meant a great deal to him. Divested of its mythology, the painting offers a revealing insight into Turner's attitudes to his art and to the public.

Any reappraisal must begin by trying to match the painted image to the title. In fact the latter is both a title and an

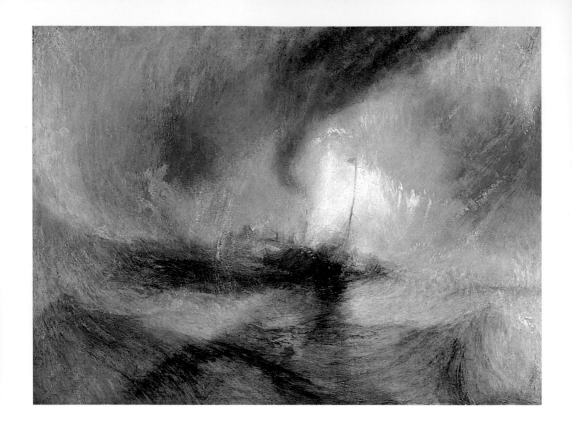

160
*Snow Storm
– Steam-Boat
off a
Harbour's
Mouth,
Making
Signals in
Shallow
Water and
Going by the
Lead. The
Author was
in this Storm
the Night the
'Ariel' left
Harwich,*
1842.
Oil on
canvas;
91·5×122 cm,
36×48 in.
Tate, London

explanation, whose unusual length is a sign of Turner's concern that the public should understand the picture and of his fear that they will not. It seems likely, however, that the critics were merely provoked by what they took to be the discrepancy between the wordy title and a meagre image. On close inspection, some of what Turner describes in words is present in the picture, including the vessel itself, the suggestion of figures on deck who may be using the traditional lead weight to take soundings of the water's depth, and the wooden slats of a jetty on the right. The painting gives us the force of the storm; the title guides our reading of the detail. Together they suggest the plight of a 200-ton coastal steamer, negotiating a sea lane in treacherous waters, with barely sufficient power to prevent it being driven in to the shallows.

The mythmaking commences in the title's final sentence, *the Author was in this Storm on the Night the 'Ariel' left Harwich,*

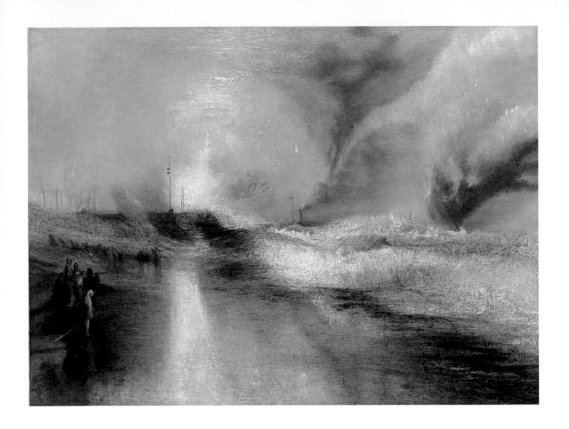

which strongly implies that the picture is a piece of reportage rather than a product of his imagination. It is a flimsy claim because the origins of the image can be traced in Turner's earlier output, especially the *Rockets and Blue Lights* (161) of 1840. He retained the steam-boat, the rockets and the treacherous shallows to be found in the earlier picture, but leached away much of the blue from the sky, thus creating a darker and more ominous impression. The curving trail of smoke in *Rockets and Blue Lights* is transformed into a vortex-like structure, which Turner used to suggest a violent snowstorm as he had forty years earlier in *Hannibal* (see 72). The form in which the vortex appears in *Snow Storm – Steam-Boat off a Harbour's Mouth*, however, is a highly abstract 'yin–yang' pattern.

Much has been made of the fact that no vessel called the *Ariel* sailed out of Harwich during these years, but he may have confused the name with the *Fairy*, which left the port in

November 1840 and sank with all hands in foul weather. More disconcerting is Turner's claim, in conversation with his friend the Revd William Kingsley, that he had himself lashed to the mast of a vessel for four hours in order to observe the storm. It is not merely that such an ordeal might have proved fatal to a man of sixty-five; it is also the suspicion that he borrowed the story from the biographies of two other painters, Joseph Vernet and Ludolf Bakhuyzen (1630–1708).

Turner's first-hand experience of rough seas is well documented, yet from the outset his marine paintings were compared not with nature but with the Old Masters. In 1833 he even forced such comparisons with *Van Goyen Looking out for a Subject* (see 138), where the viewer is meant to infer that, like Van Goyen, Turner also researched his sea-pieces on open waters. In the case of *Steam-Boat off a Harbour's Mouth*, however, his critics goaded him into a rash game of one-upmanship. Instead of employing the Old Masters as 'stand-ins', he commandeered events from their lives, exaggerated them, then used them to support the veracity of his own picture. This may help to explain why he used the word 'author' rather than 'artist' to describe himself in the title. Turner the artist was often accused of embellishing the truth, but writers who survived peril at sea, such as William Falconer, author of the popular poem 'The Shipwreck', rarely had their integrity questioned.

The most puzzling aspect of this whole episode is Turner's attitude to the Revd William Kingsley's mother, who accompanied her son to Turner's Queen Anne Street gallery and found the picture completely truthful. When he later told Turner that his mother had been transfixed by it, his reply, according to Kingsley, was dismissive: 'he said "I did not paint it to be understood, but I wished to show what such a scene was like … no one had any business to like the picture". "But", said I "my mother once went through just such a scene and it brought it all back to her". "Is your mother a painter?" "No". "Then she ought to have been thinking of something else."'

Turner's behaviour here is thoroughly irrational. He refuses to concede that Mrs Kingsley had any grounds on which to like, understand or judge the picture, even though she was well placed to know, in his words, 'what such a scene was like'. In fact it seems to have been her claim to have undergone a comparable ordeal that caused him to become so irritated. His attitude to the picture and to the experience it purports to record is jealous and proprietorial; it implies that his experience as a painter – and a painter of genius – was of a different order to that of the rest of humanity.

162
After
George
Richmond,
John Ruskin,
1843.
Photogravure
of a lost
watercolour;
47·2×30·2 cm,
18½×11⅞ in

Ruskin (162) was abroad in Switzerland in the summer of 1842 when he heard of the abuse heaped on Turner's Academy pictures, and it stung him into commencing work on what he thought would be a pamphlet defending the artist. As his writing gathered momentum, however, the pamphlet turned into the book that was published the following May as *Modern Painters*, and in the seventeen years that followed, that one volume became five. *Modern Painters* is now regarded as one of the greatest monuments of Victorian literature, but it did not make an

immediate impact. The publisher John Murray turned the book down without reading it, on the grounds that 'the public cared little about Turner', and were more interested in modern German art. When it did appear, however, it acquired some distinguished literary admirers, including the novelists George Eliot, Charlotte Brontë and Mrs Gaskell, as well as the poets Wordsworth and Samuel Rogers. George Eliot even praised its author as 'one of the great teachers of the day … with the enthusiasm of a Hebrew prophet'. Because the book was first published anonymously and credited only to 'a Graduate of Oxford', however, she was unaware that her Hebrew prophet was only twenty-four years old. Nonetheless, her description captured the sermonizing quality of some of Ruskin's writing, as well as the sense of moral and aesthetic certainty that runs through the text.

The freshness and originality of the first volume of *Modern Painters* is partly due to the fact that Ruskin composed it semi-secretly, without soliciting the outside advice that might have moderated his fiercely partisan judgements, for the book is not a work of art history – it is a sustained polemic. Its full title – *Modern Painters: Their Superiority in the Art of Landscape to all the Ancient Masters, Proved by Examples of the True, the Beautiful and the Intellectual, from the Works of Modern Artists, especially from those of J M W Turner, Esq. RA* – is effectively a synopsis of Ruskin's argument. He researched Turner's work by visiting the artist's gallery, by consulting engravings, and above all at the home of B G Windus, part of whose large collection of Turner watercolours is shown in a work (163) of 1835 by John Scarlett Davis (1804–45). About the Old Masters Ruskin was far less well informed, deriving much of his first-hand knowledge from Dulwich Picture Gallery and the holdings of the fledgling National Gallery, but he was nevertheless prepared to deliver some harsh verdicts against them.

To those with broader knowledge and sympathies, such as the poet Robert Browning, Ruskin's views on the Old Masters were extreme, although his extremism was to some extent forced

163
John Scarlett Davis, *The Library of Benjamin Godfrey Windus at Tottenham*, 1835. Watercolour; 28·8×55·1cm, 11³⁄₈×21³⁄₄in. British Museum, London

on him by the newspaper and periodical critics, who were, so
to speak, the 'villains' of *Modern Painters*. They never tired
of repeating that Turner's later work was unnatural, but they
made these judgements by comparing Turner not to nature
itself but to earlier landscape painting. Ruskin, on the other
hand, drew upon his close observation of the natural world to
argue that it was Turner's works that were 'true' to nature,
whereas the Old Masters were lazy and formulaic. From this
hypothesis it followed that Turner became truly great only when
he emancipated himself from the tutelage of Claude, Poussin,
Salvator Rosa and their like. This led Ruskin both to undervalue
Turner's earlier work and to dismiss as 'nonsense pictures'
even those later classical subjects such as *Regulus* (see 117)
in which Claude in particular had a lingering influence.

Such an apparent lack of critical insight on Ruskin's part was
the direct result of his pluralist and religious views of nature,
which were very different from the ideas prevailing in Turner's
youth. Previous chapters have explained how Turner, who was
old enough to be Ruskin's grandfather, was taught by the Royal
Academy that the greatest landscape painters idealized their
subjects by selecting the most beautiful aspects of the visible
world. For Ruskin, nature, no less than the Bible, was the word
of God, and the notion that it should be 'improved' was anathema.

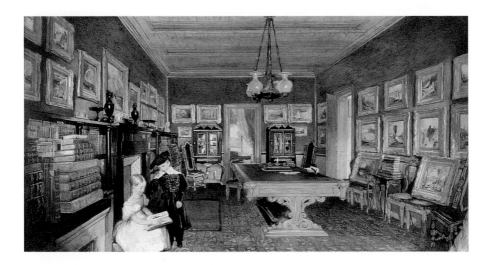

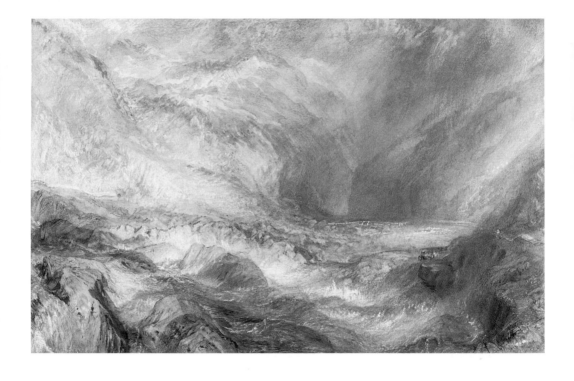

164
*The Pass of
St Gotthard,
near Faido,*
1843.
Pencil,
watercolour,
with
scratching-
out;
30·5×47cm,
12×18½in.
Pierpont
Morgan
Library,
New York

He was enthralled by nature's infinite diversity, and profoundly aware of those processes by which the landscape was formed. To him, Turner was only 'impressive and powerful' in so far as his work represented these 'truths' of nature, hence the eloquent descriptive passages in *Modern Painters* where Ruskin matches Turner's pictures to natural phenomena. If those pictures were hitherto regarded as untruthful, he claimed, it was because Turner looked at the world so acutely he could present visual facts that were outside most people's experience.

One of his most impressive pieces of Turner criticism concerned *The Pass of St Gotthard, near Faido* (164), which he and his

165
John Ruskin,
*The Pass of
Faido on the
St Gotthard*,
1845.
Brown ink and
watercolour,
with gouache,
on brown
paper;
24·8×34·5 cm,
9³⁄₄×13⁵⁄₈ in.
Fogg Art
Museum,
Harvard
University Art
Museums,
Cambridge,
Massachusetts

father commissioned from the second set of Swiss sample studies in 1843. While travelling in Switzerland in 1845 he found the site represented in the watercolour, but was astonished to discover, as he wrote to his father, that 'the mountains, compared with Turner's colossal conception, look pigmy and poor', and he produced his own version (165) to prove it. Instead of concluding that Turner had falsified the alpine topography, Ruskin insisted in Volume IV of *Modern Painters* that he had actually presented 'a higher and deeper truth' – a truth of *impression* rather than a strict fidelity to appearances. It embodied not merely what the artist saw, but what he felt and

experienced, having arrived at that spot after travelling 'through one of the narrowest and most sublime ravines of the Alps … [and encountering] … the highest peaks of the Mont St Gothard'. Only the greatest painters were capable of conveying this more profound kind of truth, which set Turner apart from the other British painters Ruskin admired, such as J D Harding (1798–1863) or Copley Fielding (1787–1855).

The publication of the first volume of *Modern Painters* in May 1843 was timed to coincide with the Royal Academy exhibition, which included *The Opening of the Wallhalla, 1842* (166), three Venetian subjects and another pair of pendants that referred to Goethe's *Theory of Colours*. Eastlake had given Turner a copy of his translation of the work in 1840, and the latter had added his own annotations, some of them critical of Goethe's hypotheses. *Light and Colour (Goethe's Theory) – the Morning after the Deluge – Moses Writing the Book of Genesis* and its companion, *Shade and Darkness – the Evening of the Deluge*, reveal Turner's interest in contemporary scientific debates, especially where they had a bearing on his profession. The works gained a high profile when they were stolen from an exhibition in Germany in 1994 and then resurfaced in 2002.

The Goethe pictures were generally regarded as impenetrable. The *Wallhalla*, on the other hand, received a surprisingly good press, which may have misled Turner into thinking that it would enhance his reputation abroad. When he sent it to the Congress of European Art in Munich in 1845 it had the opposite effect. The poetic caption from the 'Fallacies of Hope' leaves no doubt that the work was (like the Walhalla itself) intended to celebrate the rise of Germany from its humiliation by Napoleon after the battles of Austerlitz (1805) and Jena (1806) to its restored eminence in the arts and sciences. The picture was dedicated to Ludwig I of Bavaria, and the figures crowded into the foreground and on the road behind suggest a people celebrating the pleasures and benefits of peace. It is clear from Von Klenze's own rendering of the building (167) that the architect intended his Walhalla to stand above and distinct from the surrounding countryside, but Turner placed it in the background, where it tends to merge with its landscape setting. The contrast between the two images may partly explain why the Bavarians mistook Turner's celebratory picture for a satire on both the building and the nationalist sentiments it embodied – they were not prepared for its unorthodox figures, loose handling and unconventional colour. The artist was incensed when it was returned with £7 to pay in transport charges and slightly damaged, although according to Ruskin the

166
The Opening of the Wallhalla, 1842,
1843.
Oil on wood;
112·5×200·5 cm,
44¼×79 in.
Tate, London

167
Leo von Klenze,
Walhalla,
1836.
Oil on canvas;
95×130 cm,
37½×51¼ in.
State Hermitage Museum, St Petersburg

picture had begun to crack as soon as it was completed in 1843. He has often been accused of alarmism over the condition of Turner's works, but the conservation scientist Joyce Townsend's analysis of the *Wallhalla* has shown that it was created using an unusually wide range of paint media, including linseed oil, resin, wax and an oil/bitumen mix. Painting on top of these various formulations before they were sufficiently dry would have caused the cracking that Ruskin observed.

168
The Sun of Venice Going to Sea, 1843.
Oil on canvas;
61·5×92 cm,
24¼×36¼in.
Tate, London

Turner's Venetian pictures were usually well received, but one of his 1843 exhibits, *The Sun of Venice Going to Sea* (168), found little favour with the critics. It was not so much the painting they found objectionable, as the accompanying verses in the Academy catalogue, which Turner adapted from 'The Bard' by Thomas Gray:

Fair Shines the morn, and soft the zephyrs blow,
Venezia's fisher spreads his painted sail so gay
Nor heeds the demon that in grim repose
Expects his evening prey.

These bleak lines completely undermine the tranquillity of the image by hinting that the fishing vessel faces impending tragedy, which disturbed those writers who had previously seen Turner's Venetian pictures as works of uncomplicated charm. Ruskin, who read the poetic captions carefully, pointed out that the painter would 'express an extreme beauty where he *meant* that there was most threatening and ultimate sorrow', and Turner's Venetian scenes are nothing if not extremely beautiful. It is no coincidence that he and Ruskin both admired Byron, for whom, as explained earlier, the city's medieval and Renaissance buildings were a reminder of its former greatness and its lost liberty. Thus his Venetian paintings are exquisite, but their light and atmosphere often render the architecture insubstantial, as if its beauties were ultimately as transient as the Venetian Republic itself. Unlike the German states, whose resurgence formed the subject matter of Turner's *Wallhalla*, Venice remained enfeebled and under Austrian control until 1866.

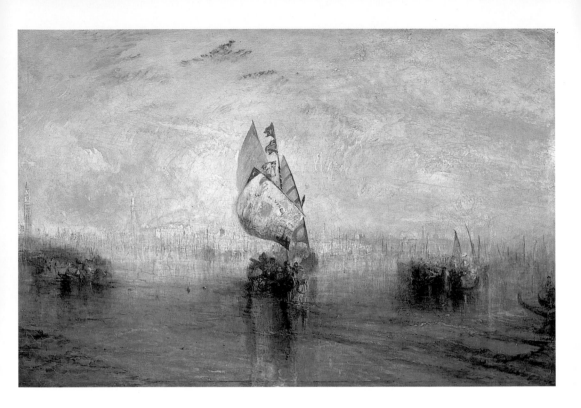

The effect of *Modern Painters* on Turner's sales was gradual,
which may explain why he waited nearly eighteen months
before finally thanking Ruskin for his efforts. His Academy
submissions in 1844 received a better press than usual, with
Rain, Steam and Speed: The Great Western Railway (169)
attracting the most attention. In contrast to some of the
unwieldy titles Turner attached to his pictures, *Rain, Steam and
Speed* pithily evokes what was, for Turner's contemporaries,
the novel experience of rapid movement through the landscape.
It worked perfectly in tandem with the image, as Thackeray
explained in his review for *Fraser's Magazine*. The novelist was
astounded by the way Turner had managed to suggest something
as elusive and intangible as the sensation of high speed with the
most assertively physical of means, including rain like 'dabs of
dirty putty slapped onto the canvas with a knife'. He was not
exaggerating when he told his readers that 'the world has never
seen anything like this picture'.

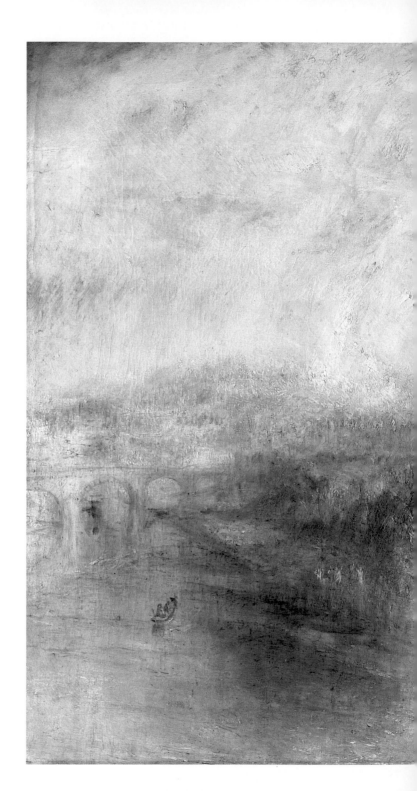

169
Rain, Steam
and Speed:
the Great
Western
Railway,
1844·
Oil on
canvas;
91×122 cm,
35³⁄₄×48 in.
National
Gallery,
London

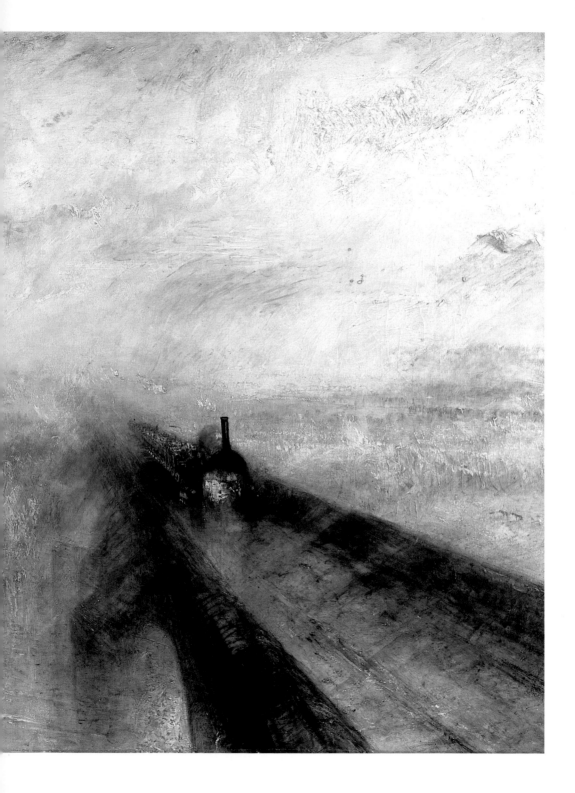

If Thackeray seemed enthusiastic about the railway mania of the day, to others it was a source of acute distress. In December 1844 Wordsworth wrote two letters to the *Morning Post* complaining bitterly about the extension of a railway line 'with its scarifications, its intersections, its noisy machinery [and] its smoke' into the heart of his beloved Lake District. The proponents of the scheme defended it on the grounds that it would enable the urban working classes of northern England to exchange, however briefly, their confinement in the cities for the experience of clean air and picturesque scenery. Wordsworth's condescending reply was that such 'pleasure seekers' had to be taught to appreciate nature, and that most of those who used the proposed Kendal to Windermere railway would think 'that they do not fly fast enough through the country which they have come to see'. Ruskin grew to share Wordsworth's point of view, and such was his distaste for the subject matter of *Rain, Steam and Speed* that he studiously avoided referring to it, except to claim that Turner only painted it to show what he could do with an ugly subject. Had Ruskin looked as closely at *Rain, Steam and Speed* as he did at Turner's other works, he would have noticed a hare running for its life in front of the train. The nine-year-old son of the painter C R Leslie watched Turner add the creature during Varnishing Days at the Academy in 1844 and suggested, years later, that the *Speed* in the title might refer to the hare rather than the locomotive. Ruskin's hostility towards modern technology blinded him to the possibility that there was more to the picture than first appears.

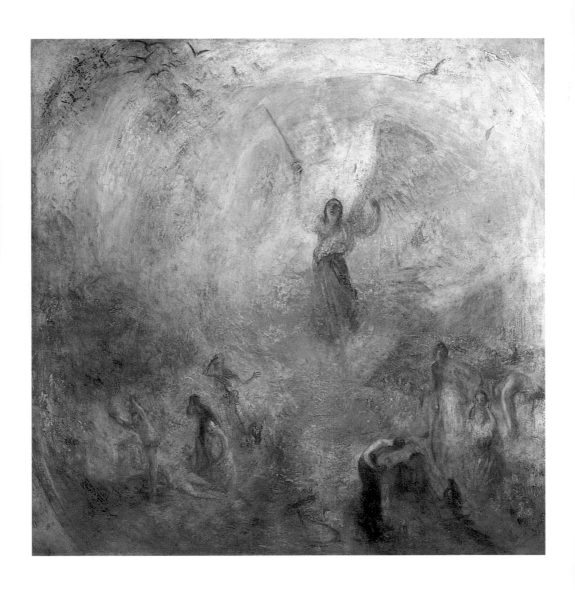

Ruskin was fiercely devoted to Turner, but he also believed that intellectual and physical degeneration blighted the artist's last years, and that after 1845 his work displayed only the remnants of a great talent. Although this judgement has often been reiterated, it is possible to give a less clear-cut, more balanced account of this last stage in Turner's career. If one were to believe Ruskin, for whom a picture such as *The Angel Standing in the Sun* (170) of 1846 was a sign of 'mental disease', then Turner might be comparable to the modern American painter Willem de Kooning (1904–97), whose last works provoked controversy because they were produced after the onset of Alzheimer's disease. In fact, Turner remained as sharp as ever. The poet and anthologist Francis Palgrave met him socially a few months before his death and wrote that 'he appeared as … firm in tone of mind, as keen in interest, as when I had seen him years before'. As Palgrave implies, he lost none of his intellectual curiosity – for example he often visited the studio of the photographer J J E Mayall (1813–1901) to investigate the new process for himself, though when Mayall discovered his identity the visits stopped. He was also fascinated by the construction of the Crystal Palace, the vast iron and glass structure in Hyde Park designed by Joseph Paxton (1801–65) to house the 1851 Great Exhibition, an international display of art, technology and manufacturing.

Turner became increasingly secretive during this time and probably seemed more eccentric than before, but there were many others besides Palgrave who testified that his mind was quite sound. On the other hand, his frequent physical illnesses affected his ability to paint and to travel. He made his last European tour in September and October 1845, visiting Dieppe and the Picardy coast. His itinerary took him to Eu, the site of

170
The Angel Standing in the Sun, 1846.
Oil on canvas; 78·5×78·5 cm, 30⁷⁄₈×30⁷⁄₈ in.
Tate, London

a royal chateau (171) where, by chance, his erstwhile neighbour King Louis-Philippe was then resident.

Thereafter, Turner's travels were limited to Margate and Deal on the Kent coast, where he went to paint or to recuperate. His health was not the only cause of anxiety to him, since he was obliged, as the most senior academician, to accept the appointment in July 1845 as deputy president of the Royal Academy. The president, Sir Martin Archer Shee, was forced to resign through illness, and, although Turner shared the duties with his friend George Jones, they were still (in his words) 'tiresome and unpleasant', spoiling his happiness, his appetite and his

171
View of Eu, with the Cathedral and Chateau of Louis-Philippe, 1845. Pencil and watercolour with pen; 23×33·2 cm, 9×13 in. Tate, London

plans to journey abroad in 1846. He was profoundly relieved when he relinquished his responsibilities in December that year.

It is remarkable, under the circumstances, that he managed to prepare six oils for the Academy's exhibition in 1846, including *Undine Giving the Ring to Massaniello, Fisherman of Naples* and its companion *The Angel Standing in the Sun* (see 170). In the latter, broad concentric arcs of yellow and white paint suggest the blazing light emanating from the angel in the biblical Book of Revelation, creating the kind of unconventional, highly centralized composition that often featured in Turner's oil

paintings during the 1840s. The effect is so marked in *The Angel Standing in the Sun* that Turner probably originally intended to give it a tondo (circular) format and decided only at a late stage to finish and exhibit it as a square picture. The reviews were mixed, but the critic for the *Spectator* was impressed by the way in which 'the gross materials of the palette can be made to emulate the source of light', while lamenting the fact that the figure drawing had 'taken leave of form altogether'. In truth, the blinding power of Turner's apparition was not consistent with detailed figure drawing, but some of those represented are identifiable, including on the left a skeleton with an infant at its feet, before which Adam and Eve are shown discovering the dead body of their son, Abel. Those on the right have been more tentatively identified as the Old Testament figures Samson and Delilah, together with Judith and Holofernes. It is not clear, however, what these characters stand for, and there is still no agreement about the overall meaning of *The Angel Standing in the Sun* or how it relates to its companion, *Undine Giving the Ring to Massaniello*. Some of the most closely argued interpretations come to very different conclusions. Charles Stuckey, drawing on a passage from *Modern Painters* in which Ruskin compared Turner to 'the great angel of the Apocalypse', saw them as containing a coded reply to the artist's critics, especially the Revd John Eagles. Gerald Finley detected allusions to the attempted assassination of Louis-Philippe on 16 April 1846, while Sheila M Smith interpreted them as commenting on contemporary movements for national independence and political liberty.

Conflicting interpretations of a painter's work often arise because commentators approach the picture or the artist from different historical or methodological perspectives. In this case all the writers who have attempted to explain these images have done so from broadly the same standpoint. They begin with the paintings and their associated texts, then relate them either to the artist's life or to aspects of contemporary history or culture that may have impinged on his consciousness. This approach is based on the crucial role played by the association of ideas in

Turner's art. Nevertheless, these and some other late oil paintings are so ambiguous that neither Turner's contemporaries nor modern scholars have been able to follow his train of thought with any certainty. Since it is unlikely that there will ever be a definitive reading of *The Angel Standing in the Sun*, it may be more profitable to ask how he came to produce such cryptic images.

Turner was generally unwilling to explain his paintings, although on one occasion he did drop hints to Ruskin. He seems to have wanted the viewer to struggle with their meanings, but he may not have realized quite how impenetrable some of them were. It is possible that allusion, metaphor and association were not just devices he used, but were deeply ingrained habits of mind which became more pronounced as he got older. If so, one would expect to find them as often in his speech as in his pictures, and his contemporaries were indeed sometimes as puzzled by his conversation as they were by his art. When, for example, he learnt in 1846 that Benjamin Robert Haydon had committed suicide, he remarked to his astonished colleague Daniel Maclise that Haydon had 'stabbed his mother'. This outrageous figure of speech expressed his lingering anger at the attacks Haydon had once launched on the Royal Academy. In Turner's mind, the Academy was a surrogate mother that nurtured and supported him, unlike his biological mother who was reputedly unstable and violent. He thought it was the duty of every painter to be a loyal son to the Academy and could not forgive Haydon, even in death, for his lack of respect. Maclise, who could not be expected to share these essentially private associations, took him literally.

The rest of Turner's 1846 exhibit was more accessible. As in the previous year, he showed two whaling scenes, and although Ruskin described them as 'altogether unworthy of him' they are an important addition to his activity as a marine painter. In general this type of subject was painted for clients who worked or invested in the whaling industry. Turner probably hoped to sell his to the entrepreneur Elhanan Bicknell, although one of

the pictures represents the Arctic fleet that sailed out of Hull, Dundee and Aberdeen, rather than Bicknell's Pacific ventures.

Whalers (Boiling Blubber) Entangled in Flaw Ice, Endeavouring to Extricate Themselves (172) alludes to the hardships the northern fleet suffered during the two successive winters of 1835 and 1836, when it pursued the depleted whale stocks into the uncharted regions of the Arctic and became trapped. Although Turner shows the sailors sawing at the ice to free themselves, they were released only with the onset of warmer weather, and in their weeks of captivity were afflicted with frostbite, starvation and scurvy. The episode was originally depicted by the Hull-based painter Thomas Binks (1799–1852), who supplied more details of the ships and the environment (173). Herman Melville, the American author of *Moby Dick* (1851), knew of Turner's whaling pictures from a visit to London in 1849, and when at one stage in his novel he describes an anonymous painting of a whale hunt on an inn wall, there is little doubt that it was Turner he had in mind.

In the autumn of 1846 Turner decided to move out of his house in Queen Anne Street in central London, possibly because the place had become so run down and chaotic that he was obliged to leave and start again elsewhere. He rented a small house in Chelsea, at 6 Davis Place, although he made sure that Sophia Booth appeared as the lessee in order to maintain his privacy. For the remaining five years of his life Turner kept his identity hidden from his neighbours, some of whom called him Admiral Booth, in the belief that he was Sophia's husband and a retired naval man. He was equally secretive towards his colleagues, for although he still took an active part in the social life of the Royal Academy, he refused to divulge his new address and went to extraordinary lengths to ensure that he was not followed home. The house in Davis Place was small but it offered a good view of the Thames, so Turner had an observation platform constructed at roof level, and from here he watched the sun rise and set over the water.

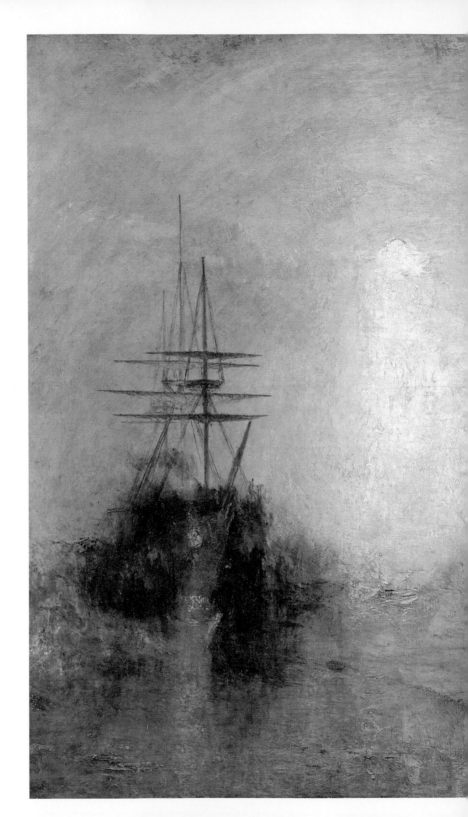

172
*Whalers
(Boiling
Blubber)
Entangled
in Flaw Ice,
Endeavouring
to Extricate
Themselves,*
1846.
Oil on canvas;
90×120 cm,
35¹⁄₂×47¹⁄₄ in.
Tate, London

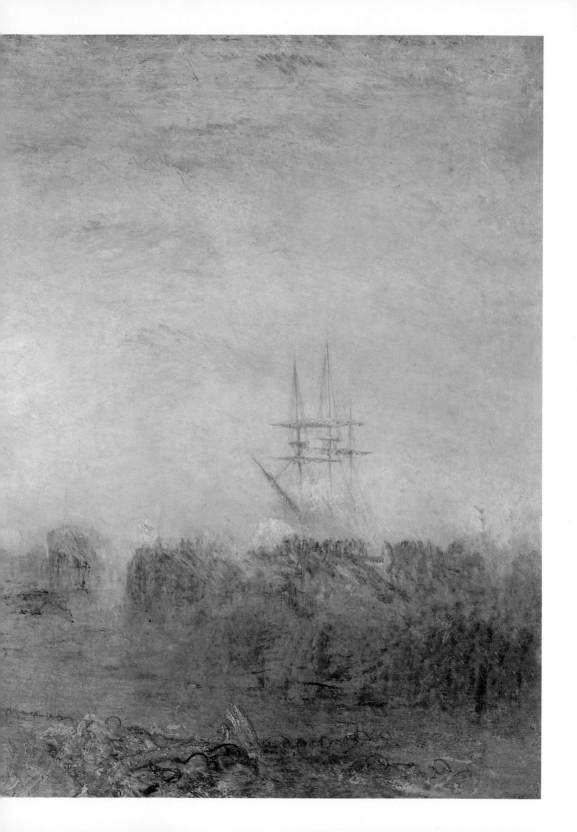

Turner was secretive but not solitary. He accepted invitations to dine until the last year of his life, when his decayed teeth were removed and he became acutely self-conscious about his eating habits. Until then he was a frequent visitor to the Ruskin household in Denmark Hill, southeast London. By the critic's own account it was not so much his companionship Turner sought but that of Ruskin's father, John James, who was closer to the artist in age and outlook. Since Elhanan Bicknell and Thomas Griffith also lived near by, this area provided him with a network of friends and patrons whose company and hospitality replaced that of Walter Fawkes and Lord Egremont.

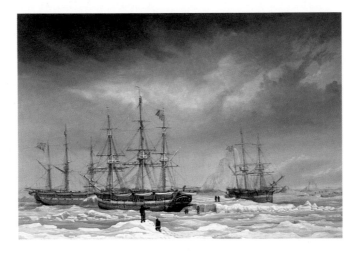

173
Thomas Binks, *The Viewforth, Middleton and Jane Beset in the Ice*, 1836. Oil on canvas; 76×108·9 cm, 29⁷₈×42⁷₈ in. Hull City Museums and Art Galleries

174
The Lauerzersee, with the Mythens, c.1848. Watercolour, pen and ink, and scratching-out; 33·7×54·5 cm, 13¼×21½ in. Victoria and Albert Museum, London

Although he makes few references to his health in his correspondence of 1847, it seems likely that he found painting difficult. Nevertheless, he was still able to create works such as *The Lauerzersee with the Mythens* (174), which may belong to a final set of large Swiss watercolours intended for sale through his agent, Griffith. Those he produced earlier in the decade, such as the *Goldau* (see 156) or *The Red Rigi* (see 155), had a looseness of handling and lack of detail that discouraged some of Turner's clients, but these qualities are even more marked in *The Lauerzersee*. The figures are more crisply defined in the *Goldau*, and the rocks on which they are perched have a solidity

that is missing from the geological forms of *The Lauerzersee*.
It is possible that the latter was unfinished, and perhaps
that old age and illness were beginning to mar Turner's
draughtsmanship. If so, the effects of his infirmity were partly
disguised in his watercolours, for although *The Lauerzersee*
lacks precision, this creates a luminous, dematerialized
landscape that leaves much to the spectator's imagination.
Oil, on the other hand, was a more solid and physically
taxing medium that tended to expose the painter's debility.

In 1848 Turner submitted only one oil painting to the Academy,
The Hero of a Hundred Fights (see 2), and even this was a
repainted canvas from four decades earlier. To one colleague
who commented on his meagre showing, he retorted 'you will
have less next year'.

Until recently, *The Hero of a Hundred Fights* has received little
serious attention, but, although it is in poor physical condition
and the mismatch of his early and late styles is jarring, it is

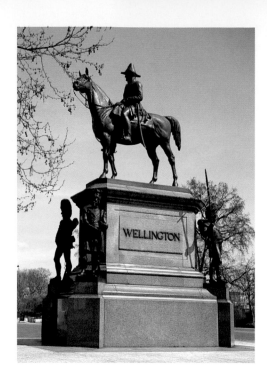

**175
Matthew
Cotes
Wyatt**,
*The Duke of
Wellington*,
1847.
Bronze

more than just a desperate expedient on Turner's part to keep
his name before the public. His subject, the casting of Wyatt's
colossal equestrian statue of the Duke of Wellington (175), was
chosen with care. The 11-metre-high sculpture was at the centre
of intense public controversy: although the casting (in sections,
not in one piece as Turner depicts it) was a technical *tour de
force*, the work itself was deemed an artistic catastrophe,
unworthy of its place on Constitution Arch near Apsley House,
the duke's London residence. It was not the fate of the statue
(which now languishes near the army town of Aldershot) that
concerned Turner, so much as the reputation of Wellington
himself, who let it be known that if it were not sited as planned
he would consider it a personal affront. Turner admired
Wellington and once mischievously claimed to have been born in
the same year, but by 1848 they were both generally regarded as
long past their glorious best. In Turner's mind the fierce debate
over the location of Wyatt's sculpture suggested the fickleness of
public opinion and the transience of fame, just as the demolition
of Pope's villa had done four decades earlier (see 57).

In 1848, true to his word, Turner showed nothing at the Academy and thoughts of his own mortality led him to tinker with the terms of his will. This may also explain why he decided to take on a young studio assistant, Francis Sherrell. It seems a surprising move, partly because Turner had previously resented intrusions into his working space, but also because his output of new oil paintings was dwindling. The works that he planned to leave to the nation, on the other hand, lay dirty and neglected in the damp conditions of his Queen Anne Street gallery and thus in need of Sherrell's attention. Late in the year Turner fell victim to an outbreak of cholera, but was nursed back to health by Sophia Booth. He was not well enough to prepare new work for exhibition in 1849, but he borrowed a much earlier sea-piece that he had sold to Hugh Munro of Novar and reworked it over a period of six days while Munro looked on nervously. *The Wreck Buoy* (177) is more harmonious than *The Hero of a Hundred Fights* but just as sombre in its implications, since Turner often used shipwreck as a metaphor for the collapse of human ambitions. This is evident from a watercolour study he produced around this time depicting a vessel on its beam ends (176) and on which he inscribed the following lines: 'Lost to all hope she lies/each sea breaks over a derelict/on an unknown shore ...'.

176
'Lost to all Hope', *c.*1845–50. Watercolour and pencil; 22·9×32·5 cm, 9×12¾ in. Yale Center for British Art, Paul Mellon Collection, New Haven

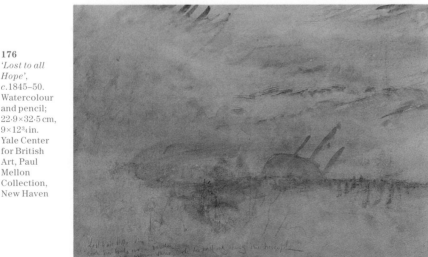

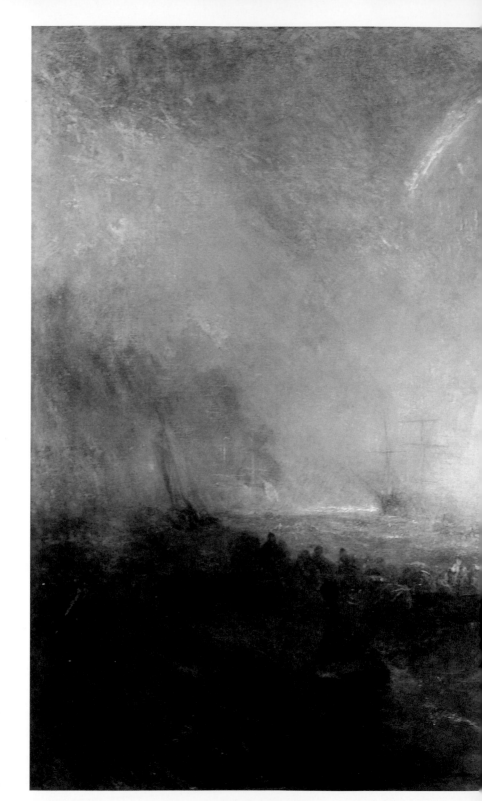

177
The Wreck Buoy,
*c.*1807,
reworked
1849.
Oil on canvas;
92·7×123·2 cm,
36$\frac{1}{2}$×48$\frac{1}{2}$ in.
Walker Art
Gallery,
National
Museums and
Galleries on
Merseyside

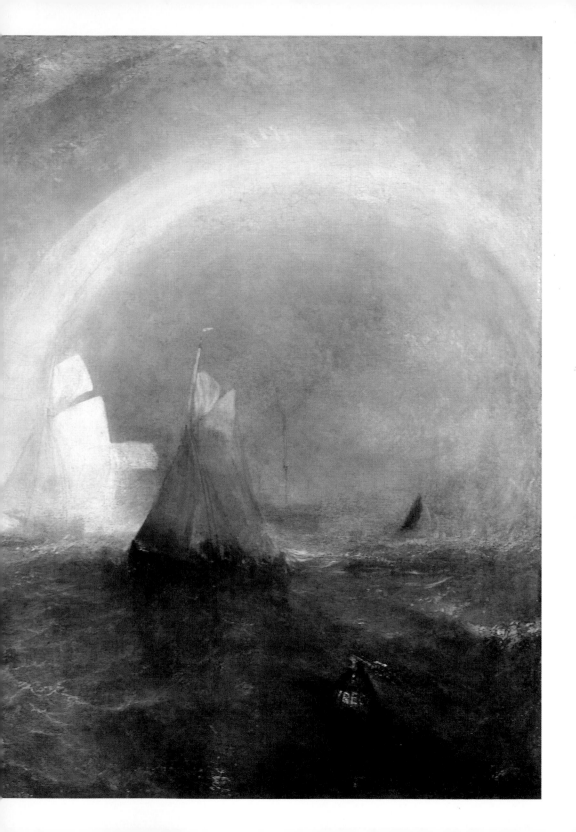

He turned down an offer from the Society of Arts to mount a
retrospective exhibition of his work, which he may have seen as
tempting fate. In any event, his career was not over, for in 1850,
contrary to expectations, he summoned the energy to complete
a quartet of pictures telling the story of Dido and Aeneas –
the last offering he would send to the Royal Academy. In his
final decade he frequently returned to themes and works he
had treated as a younger man. *Norham Castle, Sunrise* (178)
is one of several unfinished late canvases based on plates that
originally appeared as part of the *Liber Studiorum*. It is not
known whether they were essentially private works or if he

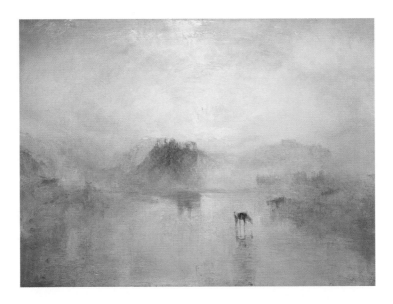

178
*Norham
Castle,
Sunrise,*
1845.
Oil on canvas;
90·8×121·9 cm,
35³⁄₄×48 in.
Tate, London

179
*The Visit to
the Tomb,*
1850.
Oil on canvas;
91·5×122 cm,
36×48 in.
Tate, London

intended to complete them on the Academy's Varnishing Days,
but their generalized forms anticipate those to be found in
Turner's last exhibited pictures. *Norham Castle*, however, is
radiantly beautiful and enduringly popular, whereas the Dido
and Aeneas paintings are more problematic.

Aeneas Relating his Story to Dido was probably destroyed
when the Tate Gallery was flooded in 1928, and although the
remainder are vividly coloured, their painted surfaces lack
the vigour or subtlety of his earlier handling. As with the
Lauerzersee watercolour (see 174), it is tempting to attribute

this to his infirmity. Ruskin recalled one occasion when Turner
wept because his hands would no longer obey him, while
Francis Sherrell described him mixing his chromes in a bucket
with his hands and then applying them to his canvas in the
same way. Although Turner routinely manipulated paint
with his fingers and even left his prints on many of his oils,
in extreme old age he may have lacked the manual dexterity
to handle his brushes effectively.

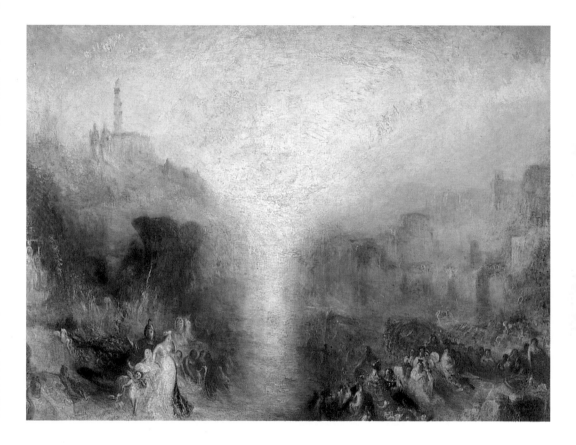

Moreover, like the artist, the paintings themselves have
suffered the ravages of time. *The Visit to the Tomb* (179),
for example, has cracked as it aged, the canvas has sagged, the
varnish has yellowed, and there is a long history of conservation
work. Given the paintings' poor condition, it is difficult to
assess the extent of Turner's physical powers in his last
productive year, but his ambition and the force of his intellect

are beyond doubt. He had previously told the stories of Dido, Aeneas and the conflict between Carthage and Rome in single pictures at intervals throughout his career. He repeatedly returned to these subjects because they allowed him to ruminate on the fortunes of individuals, the fate of empires and the ways in which the two were interlinked. But his decision to paint a sequence of four pictures for display as an ensemble was unprecedented in his work. According to Sophia Booth, he laboured on them concurrently, switching from one picture to another, as he is known to have done in his watercolours. In his precarious state of health the effort must have cost him dear, and given his earlier stated fear that he would not live to see another Academy exhibition, the Carthage pictures of 1850 come across as a self-conscious final statement.

He worked with a strong controlling idea for the series, supplementing Virgil's account with material drawn from Ovid in order to shape the story to his own ends. In his final retelling of the tale Aeneas arrives in Carthage and recounts his exploits to Dido, who falls in love with him. She attempts to stifle her infatuation by reviving memories of her first husband through a visit to his tomb, but to no avail. Aeneas remains in Carthage to pursue the affair, but the god Mercury is sent to chastise him for lingering. Bowing to divine pressure, he and his fleet set sail and eventually Aeneas becomes the founder of Rome. Dido, distraught, takes her own life. Aeneas risked the wrath of the gods if he stayed with Dido, but by causing her suicide he precipitated the enmity between Carthage and Rome that formed the subject of so many of Turner's pictures. Earlier in his career Turner's vision of history preserved an element of ambiguity, whereby human achievements were set alongside human failings. This last quartet of oils, however, presents an unremittingly bleak narrative in which the protagonists are powerless to control their own destinies, and where the actions they are obliged to take have appalling repercussions for their descendants, and indeed for whole empires. At a time when classical themes were unfashionable because they seemed to

180
John Everett Millais,
Christ in the House of His Parents,
1849–50.
Oil on canvas;
86·4 × 139·7 cm,
34 × 55 in.
Tate, London

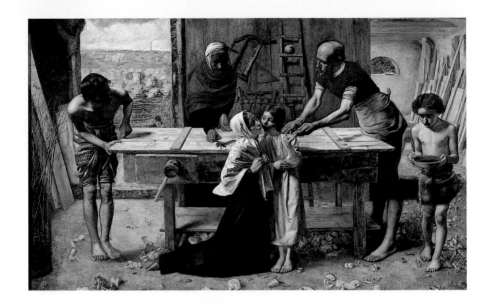

have no relevance to the modern industrial world, Turner defi-
antly maintained their importance. He knew that technologies
changed, but believed that the lessons of classical literature
remained valid, however grim and pessimistic they might be.

Few critics thought highly of the pictures, and their reviews
give no sense that this might have been the last great creative
effort by the nation's most distinguished painter. The impact
of Turner's quartet at the Royal Academy was overshadowed by
the furore that greeted the five paintings submitted by a group
of young artists who called themselves the Pre-Raphaelite
Brotherhood. Its most celebrated members were Dante Gabriel
Rossetti (1828–82), William Holman Hunt (1827–1910) and
John Everett Millais (1829–96), all of whom were out of sympathy
with what they believed to be the empty ideals of the Royal
Academy. They set out to paint with feeling and with the closest
possible attention to nature, and by calling themselves the Pre-
Raphaelite Brotherhood they declared their preference for the
precise and pious art of fifteenth-century Italy over the power
and perfection that Reynolds found in Michelangelo and Raphael.

Millais's picture of *Christ in the House of His Parents* (180)
was universally vilified. The *Literary Gazette* described it as

a 'nameless atrocity' and the novelist Charles Dickens likened Millais's depiction of the Virgin Mary to 'a monster in the vilest cabaret in France or the lowest gin shop in England'. But although such invective was as bad as – if not worse than – anything Turner had previously received, within a decade the Pre-Raphaelite qualities of precise, uniform detail, accessible symbolism and coherent narrative became defining features of Victorian taste. Turnerian allusion and 'indistinctness', by contrast, became distinctly unfashionable.

In the remaining eighteen months of his life Turner's health suffered an accelerated decline, but he continued to work in watercolour, producing a handful of Swiss and Italian views,

181
Genoa,
*c.*1850–1.
Pencil and
watercolour,
with blotting
out;
37×54·3 cm,
14⁵⁄₈×21³⁄₈ in.
Manchester
City Art
Gallery

182
**George
Jones**,
*Turner's
Coffin in his
Gallery at
Queen Anne
Street*,
*c.*1852.
Oil on panel;
14·4×22·6 cm,
5⁵⁄₈×8⁷⁄₈ in.
Ashmolean
Museum,
Oxford

such as *Genoa* (181), based on earlier material. He was attended by two doctors, David Price, who first treated him during his visits to Margate, and a local Chelsea practitioner, William Bartlett. His condition deteriorated to the point where he summoned medical attention on an almost daily basis, and at one stage, according to Bartlett, he was surviving on a daily diet of up to eight pints of rum and milk. Price's diagnosis was that Turner's heart 'was very extensively diseased', and he warned him that death was imminent. Turner replied, 'So I am to become a non-entity, am I?' His use of the cryptic phrase 'non-entity' puzzled the doctor, but it lends credence to Ruskin's view that Turner did not share the Christian belief in an afterlife. It was

also reported that he uttered the words 'the Sun is God' in his last weeks, which suggests that whatever religious opinions he did hold were highly unorthodox. The strong likelihood is that, like the poet Shelley, he looked for immortality only from his art.

He died on 19 December 1851, and his body was removed from Chelsea and taken to Queen Anne Street for his friends and colleagues to pay their respects (182). Turner would have been aghast at the post-mortem indignities to which he was then subjected by those who admired him most. The sculptor Thomas Woolner (1825–92) took a cast of his lifeless features (183), and Ruskin showed a copy to the phrenologist Gustavus Cohens to determine whether the signs of his genius could be read from

the shape of his skull. They were probably unaware how anxious Turner was to dissociate his appearance from his work, fearing that his looks would undermine his reputation as a great painter. Some of his relatives, meanwhile, were desperate to get their hands on his vast estate, for Turner had left them nothing. At first his father's family alleged that the painter was of unsound mind. When that failed, they contested the terms of the will by arguing that the clauses intended to create an institution to care for destitute painters breached the law relating to trusts and charities. Turner's executors, who included his solicitor Henry Harpur and the painter George Jones, were sufficiently worried by the challenge to settle out of court. They reached a

compromise that was given legal force in a decree dated 19 March 1856, according to which the relations received the bulk of Turner's property and government stocks, while all the works remaining in the artist's studio 'without any distinction between finished and unfinished are to be deemed as well given for the benefit of the Public'. The National Gallery took possession of them six months later, but lacked the space to show them adequately, and for many years they were also exhibited at other locations, including Marlborough House and the South Kensington Museum (now the Victoria and Albert Museum). The circumstances under which they should be kept and displayed have been debated – and sometimes bitterly disputed – ever since his death. Turner had hoped that his charitable foundation, together with the bequest of his works to the nation, would help to secure his enduring fame. In the event his route to immortality was very different from any he could have imagined, as the following chapter demonstrates.

**183
Thomas
Woolner**,
Death mask
of J M W
Turner,
1851.
Plaster.
National
Portrait
Gallery,
London

Turner had good reason to suspect that his immortality was not a foregone conclusion, for, as the art historian Francis Haskell observed, the 1850s was a decade of particularly unstable and shifting tastes. In 1867 the sculptor Henry Hugh Armstead (1828–1905) did include him on the frieze of great artists, writers and musicians that decorated the Albert Memorial in Hyde Park, where he kept company with his revered Raphael and Titian. But Armstead cast his net as widely as possible in an attempt to cater for all tastes and opinions, and for all its solidity and permanence, the Albert Memorial could not guarantee Turner lasting fame. During the two decades following his death, he was more often admired than emulated in Britain, and some areas of art in which he was undoubtedly influential, such as stage and scenery design, carried a relatively low status.

Ruskin did his utmost to preserve his idol's artistic legacy. In 1855 he published *The Elements of Drawing*, an instruction manual in which he commended the detailed study of Turner's works to aspiring watercolourists. In that medium, however, his unparalleled virtuosity was never in doubt, and so it is not surprising to find frequent Turnerian echoes in the work of later nineteenth-century watercolour painters such as Alfred William Hunt (1830–96) or Hercules Brabazon Brabazon (1821–1906). Turner's legacy as an oil painter was more problematic, because, as suggested in Chapter 7, Victorian tastes increasingly favoured the clarity of detail and meaning to be found in the work of the Pre-Raphaelite Brotherhood (see 180). When Ruskin began to champion their art in 1851 he tried to forge connections between them and Turner. He argued that by painting 'the truths around them as they appeared to each man's mind, not as he had been taught to see them', Millais,

184
Claude
Monet,
*Waterloo
Bridge*,
1899–1900.
Oil on
canvas;
65·4×92·7cm,
25³⁄₄×36¹⁄₂in.
Santa
Barbara
Museum
of Art

Holman Hunt and Rossetti shared the qualities of integrity and independent vision with their great predecessor. This intriguing hypothesis did not convince Millais, who confided in a letter that he and Ruskin disagreed over Turner: 'He believes that I shall be converted on further acquaintance with his work, and I that he will gradually slacken in his admiration.' Even Holman Hunt, who genuinely admired the painter, regarded him as a glorious relic of an earlier epoch.

Turner's influence abroad was another matter. Despite the fact that few of his pictures had entered foreign collections, he had a greater impact on major European and American painters than on his own compatriots. In America during his lifetime his admirers included Washington Allston and Thomas Cole, and after his death echoes of his work can still be found in the work of Samuel Colman (1832–1920) and of the British-born artist Thomas Moran (1837–1926). Turner's modern reputation was given a more significant boost when the French Impressionist painters Claude Monet (1840–1926) and Camille Pissarro (1831–1903) arrived in London as refugees from the Franco-Prussian War in 1870. Before returning home the following year they visited the exhibition of pictures from the Turner Bequest on display in the new South Kensington Museum and were impressed by what they saw. Their relationship with him is more complex and fascinating than the misleading word 'influence' conveys, for after a youthful period of enthusiasm they discounted the importance of Turner once they became renowned and influential themselves. Later in life, Monet took Turner to task for 'the exuberant romanticism of his fancy', and in 1903 Pissarro wrote to his son Lucien that 'Turner and Constable, while they taught us something, showed us in their works that they had no understanding of the analysis of shadow, which in Turner's painting is simply used as an effect, a mere absence of light.'

Their apparent change of heart needs to be put in context. When they first came to London they already had a clear set of priorities, painting as far as possible in the open air and seeking

185
Camille Pissarro, *Hoarfrost, the Old Road to Ennery,* 1873. Oil on canvas; 65×93 cm, 25⅝×36⅝ in. Musée d'Orsay, Paris

out fugitive effects of light and climate. As Pissarro later explained, their enthusiastic response to Turner (and British landscape art in general) was based on what they took to be shared ambitions. This is also implicit in Monet's pithy description of *Frosty Morning* (see 74) as having been painted 'with open eyes'. If that picture is juxtaposed with Pissarro's highly atmospheric *Hoarfrost, the Old Road to Ennery* of 1873 (185), the reasons why he and Monet felt an initial affinity with Turner become clearer still. It was fitting, therefore, that Turner

should enjoy a symbolic presence at the first Impressionist Exhibition in 1874, thanks to the engraver Félix Bracquemond (1833–1914), who submitted his etching after *Rain, Steam and Speed* (186). The original fascinated the Impressionist circle, not merely for its atmospherics but also because it represented a shared interest in modern life and modern experience. It was one of the few pictures that Monet would admit to having studied carefully.

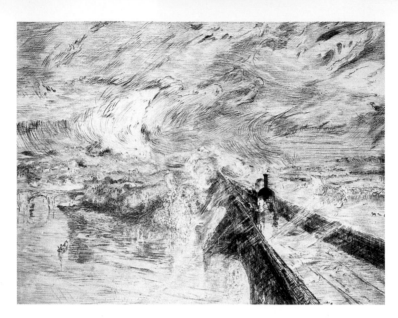

186
Félix
Bracquemond
after J M W
Turner,
*Rain, Steam
and Speed*,
1874.
Etching

There are many possible reasons why he and Pissarro seemed
to grow lukewarm towards Turner. The most compelling is that
they grew increasingly aware of the real differences between
their art and his, and that he was the product of a vanished
age with a different set of values. When Monet criticized 'the
exuberant romanticism of his fancy' he was drawing attention
to the role of the imagination in Turner's work, which was hard
to reconcile with their commitment to the direct transcription
of natural effects. Pissarro's detailed critique of Turner's
shadows drew upon thirty years' intense observation of nature,
together with a deep interest in colour theory. Thus by 1903
any kinship he may once have felt between his *Hoar Frost* and
Turner's *Frosty Morning* could easily have diminished. Although
they have much in common, Pissarro's painting is distinguished
by its stronger, positive use of colour, even in the shadows.

As young men, when they were shunned by France's official
art institutions and rarely able to exhibit their work, Turner's
example helped to sustain their morale. Unaware of his fierce
loyalty to the Royal Academy, they pictured him as a dogged,
independent figure who pursued his own path and challenged
the aesthetic conventions of his day. By 1900 the situation had

changed. The Impressionists had no shortage of patrons, their status was assured and their former identification with Turner became a liability. Jules de Goncourt, for example, used Turner as a stick with which to beat Monet, by comparing their works and pronouncing that Monet was inferior by far. Ironically, Monet and Pissarro were less irritated by such detractors than they were by one of their fervent admirers, the Manchester-born painter Wynford Dewhurst (1864–1941), who modelled his style on Monet's.

In the conservative world of late nineteenth-century British painting, Impressionism was regarded as a foreign virus, so that when Dewhurst published the first major book on the movement in English in 1904, he tried to mollify his readers by insisting that it originated not in France but with Turner and Constable in England. This allowed him to launch a defence of his own work and that of the other English Impressionists by arguing that they were practising a home-grown style. Pissarro died in 1903 before the book was published, but he knew what Dewhurst intended to claim and it infuriated him. The Englishman proposed simultaneously to undervalue his originality and offend his national pride, which may further explain why he sought to distance himself from Turner.

Monet was becoming tired of hearing that Turner was the first Impressionist well before the publication of Dewhurst's book. He realized that he could not escape the comparisons being made between their works, but he could confront them head-on. He returned to London in the 1890s and produced a series of paintings of the Thames (see 184), the river by which his great predecessor grew up and eventually died, fully aware that they would summon Turner to mind. The critic Louis Kahn made the connection instantly when he saw thirty-seven of Monet's London paintings at Paul Durand Ruel's Paris gallery in 1904. He wrote that just as 'Turner liked to compare certain of his works to certain of Claude Lorrain's, then one might place certain Monets beside certain Turners'. Had this ever taken

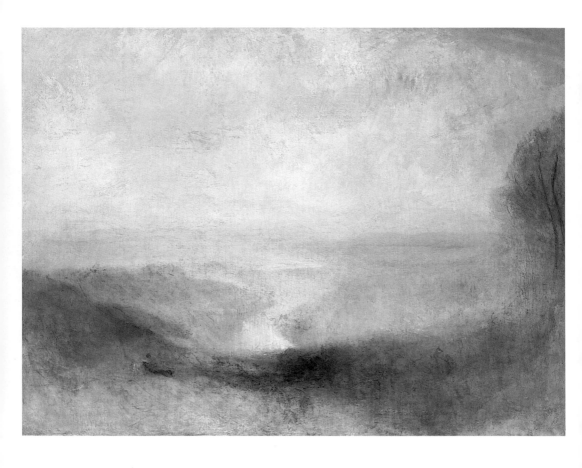

187
*Landscape
with a River
and a Bay in
the Distance,*
c.1845.
Oil on
canvas;
94×123 cm,
37×48½ in.
Musée du
Louvre, Paris

place it would have underlined the differences as well as the similarities between their pictures, for although Turner painted the Thames on many occasions, few of his oils offer a direct comparison with Monet's. Furthermore, the banks of the river had changed drastically since Turner painted the burning of the old Houses of Parliament in 1835 (see 139) and the new buildings by Charles Barry (1795–1860) went up in their place. With his London paintings, Monet was clearing a space for himself, establishing his own originality and consigning Turner to the past. It was a similar tactic to the one Turner himself sometimes employed when dealing with the Old Masters.

It is ironic that, while the Impressionists took him to task for allowing his imagination free rein, their contemporaries in the Symbolist movement admired him for the same reason. This was because the Symbolists' outlook was anti-naturalistic, and they cherished those pictures by Turner that were on the cusp between the observed and the imagined. The differences between the two movements are encapsulated in their reactions to Turner's unfinished *Landscape with a River and a Bay in the Distance* (187), a late, unfinished picture, based on a subject from the *Liber Studiorum*. It then belonged to the collector Camille Groult, and was one of the few paintings by Turner accessible to Parisian artists in the 1890s. Pissarro valued it for its effect of light, but the novelist and critic Joris Karl Huysmans, a prominent Symbolist, described it more fancifully as a 'fairy place', comparable to the mythical lands of Eden and Eldorado.

The *Landscape with a River and a Bay in the Distance* was the kind of image Turner would not have shown in his lifetime, but the works he bequeathed to the nation included a large body of incomplete oils, many of which looked much more like visual impressions than Turner's exhibited works. As the art of Monet and his associates became increasingly popular, these unfinished items were exhumed from the Bequest and put on display. Thus began a two-way process in which the achievements of French painters helped to bring about a revaluation of Turner's

achievements, while he in turn continued to influence them. It was appropriate, given its importance in the history of French painting, that in 1967 Camille Groult's picture became the first oil by Turner to enter the Louvre. Henri Matisse (1869–1954) studied it on the advice of his teacher, the Symbolist painter Gustave Moreau (1826–98), and then chose London as the destination for his honeymoon in 1898 in order to see more of Turner's work. This experience helped to prepare Matisse for the intense light and colour he encountered during the eighteen months he subsequently spent on Corsica and the Mediterranean coast. Some years later, in 1906, André Derain (1880–1954), Matisse's colleague in the Fauve group of artists, wrote that Turner authorized them 'to create forms that go beyond conventional reality'.

When Huysmans described Turner's art it was in dazzling prose, but the painter Paul Gauguin (1848–1903), who was also associated with the Symbolists, was more measured and analytical. Although his own pictures look nothing like those of Turner, Gauguin was one of the first to suggest that Turner's vibrant colour made him an important precursor of the modern movement. While he was living in Tahiti between 1896 and 1898, Gauguin began to write a history of recent developments in painting, which he saw as progressing towards 'an art of colour alone as the language of the listening eye'. His odd use of the phrase 'listening eye', with its deliberate confusion of vision and hearing, reflects his belief that painting could become more like music, and that colours could have a profound effect on the spectator, just as musical tones could, without the need to ask what they represented. In effect, Gauguin separated out these 'musical' elements from the subject matter of a painting, which he referred to as its 'literary' aspect. He brought the same distinction to bear in his discussion of Turner, of whom he wrote:

Although they are cloudy the literary descriptions in his paintings actually prevent us from knowing whether, in his case this art of colour

stemmed from instinct or from a very deliberate and definite intellectual determination.

Gauguin's prose is hard to follow, but his comments are perceptive. When he notes the 'cloudy literary descriptions' in Turner's later works, he is referring to the artist's so-called indistinctness, but he cannot decide whether he was using colour intuitively, as an expressive language in itself, or in a conscious way determined by his subject matter. He seems to have concluded pragmatically that it was the *effect* of the works that mattered, and he stops short of saying that Turner's narratives were unimportant. Not so the Neo-Impressionist painter Paul Signac (1863–1935).

Like many others, Signac first thought of Turner as a precursor of Impressionism, but a visit to London in 1898 forced him to think again, whereupon he decided that the later works were 'no longer pictures, but aggregations of colours, quarries of precious stones, *painting* in the most beautiful sense of the word'. These views are characteristic of the critical theory known as Modernism, which dominated the explanation of modern art for much of the twentieth century. It emphasized the effect produced by the formal qualities of a painting but played down the importance of the subject, believing that anecdote and narrative were best left to literature. Such values are implicit in the distinction Signac made between a *picture*, which depends heavily for its meaning on the things it depicts, and a *painting*, whose impact is produced mainly by its colour and form.

The American writer Clement Greenberg – the shrewdest and most influential Modernist critic – insisted that Turner belonged to the late eighteenth and early nineteenth centuries. '[He] may have astounded the taste of his time,' wrote Greenberg, 'but he did not really break with it, or at least not in a radical way.' But other, less cautious Modernist critics have presented him as a visionary figure who outpaced his contemporaries, and for decades this became the basis of Turner's modern reputation.

The most persuasive exponent of this view was the British artist and writer Lawrence Gowing (1918–91), who curated a famous exhibition, *J M W Turner: Imagination and Reality*, at the Museum of Modern Art, New York, in 1966.

Gowing attempted to link Turner with American Abstract Expressionist artists such as Jackson Pollock (1912–56), Mark Rothko and Clyfford Still (1904–80), who became internationally famous in the 1950s and 1960s (188), and whose work was represented in the Museum of Modern Art's permanent collection. Gowing's elegant catalogue essay contained a

188
Nina Leen, *The Irascibles*, photograph of the Abstract Expressionist artists in *Life* magazine, 1951. Standing left to right: Richard Pousette-Dart, William Bazioles (front), Willem de Kooning (rear), Adolph Gottlieb, Ad Reinhardt, Hedda Stearne, Clyfford Still, Robert Motherwell, Bradley Walker Tomlin; seated left to right: Theodoros Stamos, Jimmy Ernst, Barnett Newman (front), Jackson Pollock (rear), James Brooks, Mark Rothko

189
Jackson Pollock, *Going West*, c.1934–8. Oil on gesso on composition board; 38·4×53 cm, 15¹⁄₈×20⁷⁄₈ in. National Museum of American Art, Smithsonian Institution, Washington, DC

brilliant characterization of Turner's late style, but it was also frankly anachronistic – it severed the work from its historical context. He claimed that Turner's subject matter was an afterthought, and that the artist 'had no doubt that art was founded upon art, and … everything else, even nature, was of secondary importance'. This belief that art was autonomous – independent from the wider world – was central to Modernist thought, but not only was it completely contrary to Turner's views on painting, it is also difficult to reconcile with the recorded opinions of the Abstract Expressionists themselves.

That many of them did nurse a deep respect for Turner is beyond dispute. Jackson Pollock, the most famous figure within the group, made no public mention of him. Nevertheless, as the art historian David Anfam pointed out, if Pollock painted his early picture *Going West* (189) without seeing a reproduction of Turner's *Hannibal Crossing the Alps* (see 72), then their compositional similarities are a remarkable coincidence. Barnett Newman (1905–70) is known to have admired Turner, and Robert Motherwell (1915–91), who was the most articulate

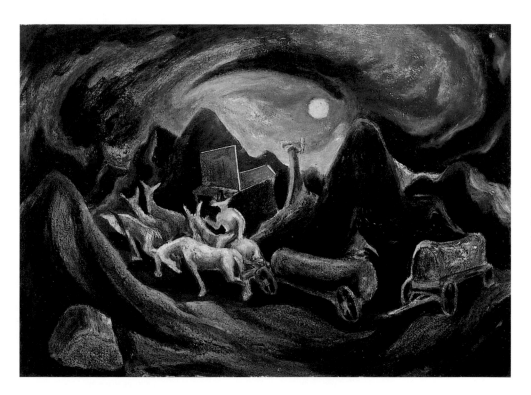

of the group, with a deep knowledge of art history, named him along with Charles Dickens and the poet Gerard Manley Hopkins as the most extraordinary creative minds that Britain produced during the nineteenth century. Clyfford Still, who had a low opinion of most earlier painters, was a secretive man who jealously guarded his privacy, but his friends and former students testified to the esteem in which he held Turner's later work, along with that of Rembrandt and Titian, all of whom

were notable for their powerful handling of paint, as well as their imposing colour and chiaroscuro. Among Still's earliest pictures was a copy after one of Turner's Venetian scenes, but unfortunately, like many of his early works, it remains hidden from view because his estate does not allow it to be reproduced. Despite Still's habitual reticence, he once declared that 'Turner painted the sea, but to me the prairie was just as grand.' He was referring to his upbringing in the flat expanses of southern Alberta in Canada, and perhaps also to his own early landscape paintings, but he also implied that there was common ground between him and Turner – an experience of the sublime immensity of nature.

Although he is the Abstract Expressionist whose output is most often likened to Turner's, Rothko seems to have known little of his art before visiting Gowing's exhibition in the company of Sir Norman Reid, then director of the Tate Gallery. According to Reid he wryly observed that 'this man Turner, he learnt a lot from me'. Behind this throwaway humour lies Rothko's surprise at discovering an unsuspected affinity with a much earlier artist. Reid later said that the feeling was so strong that he donated the famous *Seagram Murals* (including 190) to the Tate because he wished to see his work hang near Turner's.

190
Mark
Rothko,
*Red on
Maroon*,
1959.
Oil on
canvas;
266·7×238·8 cm,
105×94 in.
Tate, London

Rothko, Still and Motherwell responded not merely to the optical and physical qualities of Turner's painted surfaces but also to what they saw as their deep moral resonances. In other words, they admired him, not because he relinquished subject matter as Gowing believed, but because Turner seemed to have found a new way of expressing enduring human concerns. To them the word 'subject' meant more than just narrative and anecdote; it also embraced the states of mind and feeling that colour, form and the handling of paint could produce. As Rothko, together with his colleague Adolph Gottlieb (1903–74), once wrote: 'There is no such thing as good painting about nothing. We assert that the subject is crucial.' He later told the critic Selden Rodman that he was 'interested in expressing only

191
Robert
Motherwell,
*Elegy to the
Spanish
Republic
No.134*,
1974.
Acrylic on
canvas;
237·5×300 cm,
93½×118⅛in.
Graham Gund
Collection,
Cambridge,
Massachusetts

the basic human emotions – tragedy, ecstasy, doom'. Since he believed that great art was inconceivable without these things, it seems clear from the strength of Rothko's response that he also discerned them in Turner.

Motherwell certainly did. His fame rests chiefly on his series of large-scale painted elegies (191), which at first sight seem to have little to do with Turner; but it was Motherwell who stated most clearly that he and his colleagues shared with the English painter a grand vision dominated by a tragic sensibility. When asked by the writer Max Kozloff why the Abstract Expressionists painted such huge pictures, he replied:

The large format, at one blow, destroyed the century-long tendency of the French to domesticize modern painting, to make it intimate. We replaced the nude girl and the French door with a modern Stonehenge, with a sense of the sublime and the tragic that had not existed since Goya and Turner.

Motherwell, Newman and Still all invoked the concept of the sublime when discussing their work. This has created some confusion because they were abstract painters whose work did

not depend for its effects on resemblance to the visible world, whereas the term 'sublime' was closely associated with figurative and especially landscape art. In the mid-1970s this led the American scholar Robert Rosenblum to argue that there was a direct link between Turner's imagery and the pictorial language employed by Rothko, Pollock and Still. Turner, he claimed, had isolated nature's primordial forces of light and energy, which then reappeared in a more distilled, abstract form in the work of the American artists. They vigorously denied it. Rothko said, 'There is no landscape in my work', and although Still's paintings, with their jagged forms, uningratiating colour and unyielding surfaces, suggest the qualities of terror and awe that Burke identified as sublime (192), he nonetheless insisted, 'I paint only myself, not nature.' If Turner's paintings are not abstract works before their time, as Gowing claimed, and those of the Abstract Expressionists are not landscape-based, as Rosenblum would have it, there might seem to be little common ground between their art and his. There is, however, much evidence to suggest that they shared a strong sense of human powerlessness and mortality in the face of a hostile world. Whereas nature was still the greatest source of terror for Turner's contemporaries, it was largely superseded in the 1940s and 1950s, as Motherwell pointed out, by 'the Second World War, the atomic bomb and the beginnings of the electronic era'. Rather than simply illustrate these and other terrors of the modern world, the Abstract Expressionists looked inward and attempted to represent their own consciousnesses. To borrow Still's phrase, they were 'painting themselves', with whatever anxieties or emotions they experienced in contemporary life. They also detected a similar 'inwardness' in late Turner, as Motherwell explained:

The game is not what things look like. The game is organizing, as accurately and with as deep discrimination as one can, states of feeling; and states of feeling when generalized, become questions of light, color, weight, solidity, airiness, lyricism, sombreness, heaviness, strength, whatever – this is especially visible in artists of a wide range … such as J M W Turner.

**192
Clyfford
Still**,
Untitled,
1951–2.
Oil on
canvas;
288×396 cm,
113^{3}/$_{5}$×155^{7}/$_{8}$ in.
San
Francisco
Museum of
Modern Art

Motherwell and his colleagues thought of Turner's later pictures as expressive fields of modulated colour, capable of communicating profound meanings – much the same as their own imagery. By approaching his art with their own preoccupations in mind they played down the literary element in Turner's work, but it attuned them to the pessimism of his later years and imparted an acute sense of the ways in which light and colour became powerful constituents of his pictures' meanings. Motherwell and his contemporaries rarely referred to specific examples of Turner's art, but there are many instances, such as his watercolour *Figures on the Shore* (see 143), in which broad expanses of exquisitely nuanced colour convey a mood of deep melancholy. These field-like qualities that the Abstract Expressionists admired become more marked in the later stages of Turner's career. He became more sparing with pictorial detail, dispensed with conventional structures and relied increasingly on effects of light and hue. Although this is most marked in his unfinished or private works, it is sometimes found in those he sent to the Royal Academy in the 1840s. To maintain that the New York artists had an insight into this aspect of Turner's art is not to say that the details in his paintings are unnecessary, or 'synthetic' as Lawrence Gowing claimed. If anything, as suggested earlier, the fewer details there are, the more significance they carry.

The alertness shown by Motherwell and his colleagues to Turner's expressive qualities and to the meanings of his pictures becomes clearer still when their approach is contrasted with that of Carl André (b.1935), who deliberately tried to isolate the optical and physical qualities of Turner's canvases. On the face of it, André seems an unlikely admirer, but he once wrote, 'My vocation is to be a *matterist*. I would like to achieve a severing of matter from depiction as Turner began the severing of colour from depiction.' Here André was attempting to recruit Turner in the service of his own artistic project. With their simple, repeated forms and ordinary industrial materials (193), his sculptures jettison conventional notions of what a

work of art should be and do, some of which Turner himself would have taken for granted. André was not so much reading Turner as creatively *mis*reading him, and by so doing he acquired a simple set of terms in which to explain his mission. He used Turner's art to underwrite his own, implying that, however audacious his ideas and sculptures might appear, they were not unprecedented.

By the late 1960s, Gowing's kind of Modernism began to lose ground to other forms of criticism that were more prepared to consider the historical contexts and meanings of art. Consequently, the image of Turner as a prototypical abstract artist became more difficult to sustain. This transformation was partly brought about by the appearance in 1969 of the book

193
Carl André,
Equivalent VIII,
1966.
Firebricks;
12×229×68 cm,
4³⁄₄×90¹⁄₈×26³⁄₄ in.
Tate, London

Colour in Turner: Poetry and Truth by John Gage, a monumental work of scholarship that restored the artist to his own era. It also reaffirmed Ruskin's conviction, disregarded by Gowing, that Turner was engaged in a lifelong pursuit of visual truth. Gage's book had an enormous impact on its academic readership, but the 1970s also saw a huge increase in popular enthusiasm for the painter, centred on the exhibition to mark the bicentenary of Turner's birth held by the Royal Academy in the winter of 1974–5. This show, together with an exhibition of 300 watercolours at the British Museum, introduced the public to an unprecedented quantity of Turner's work, and thus to the sheer range of his achievements. The intense interest aroused by the bicentenary displays was reflected in the continuing rise in Turner's prices. In 1951 the art historian Sir Kenneth Clark bought the late *Seascape: Folkestone* for £5,500, but when it was auctioned in 1984 it was sold for £7,370,000, which at that time was a record price for an oil painting.

Seascape: Folkestone was one of many works by Turner to be sold to collectors or institutions in the United States, which may partly explain why he continues to interest American artists. James Turrell (b.1943) recently reiterated how much Turner's treatment of chromatic light in such pictures as *Norham Castle* (see 178) or *Landscape with a River and a Bay in the Distance* (see 187) had to offer the Abstract Expressionists, especially Rothko, in whose work effects of luminosity played such an important part. Turrell is well placed to judge Turner's atmospherics because light – real light, not its painted equivalent – is the medium with which he works. Turrell's most spectacular project is the remodelling of Roden Crater (194) on the edge of the Painted Desert in Arizona, where he has spent more than twenty years transforming this extinct volcano into a series of observation points, from which the viewer can watch the sky and the light of the sun, moon or stars. He has spoken of his concern to render light almost palpable, and he detected a similar quality in Turner's art, where, as he put it, the light often seems to 'inhabit' the air.

194
James
Turrell,
Roden Crater
(looking
northeast),
1977 –
present.
Volcanic
mountain.
Flagstaff,
Arizona

195
*Sun Rising
through
Vapour,*
1807.
Oil on canvas;
134·6×179·1 cm,
53×70¹₂ in.
National
Gallery,
London

He also shrewdly observed that the greatest masters of atmosphere, such as Turner, came from northern Europe, where sunlight is more precious because it is rationed, and where the clouds and shifting weather patterns create the subtlest atmospheric nuances.

Two further engagements with Turner's art were made for an exhibition entitled *Encounters*, held at the National Gallery, London, in 2000, in which twenty-four contemporary artists

196
Louise
Bourgeois,
*Cell XV
(for Turner)*,
2000.
Steel, painted
aluminium,
mirrors, glass,
water and
electric light;
274·3×304·8×
172·7cm,
108×120×68in.
Private
collection

were invited to create work in response to a painting in the gallery's collection. The sculptor Louise Bourgeois (b.1911) chose Turner's *Sun Rising through Vapour* (195) as the basis for her *Cell XV (for Turner)* (196). *Cell XV* is one of a series of works in which the artist uses steel mesh, mirrors and other materials to create enclosed spaces. The various elements function as a symbolic exploration of human relationships – in this case a state of harmony, equivalent to that of a couple

whose lives mesh. The light, water and reflections that had
always fascinated Bourgeois in Turner's paintings are literally
present in her sculpture.

By her own admission, *Sun Rising through Vapour* was just
the starting point for Bourgeois's work, but Cy Twombly
(b.1928), who also contributed to the *Encounters* exhibition,
has a deeper affinity with Turner. His *Three Studies from the
Temeraire* (197) are large canvases whose apparent *naïveté*
seems a world apart from the sophistication of the great
marine subject from which they take their cue (see 145). But
Twombly's output offers stronger parallels with Turner than
any other contemporary painter. They both make extensive
use of classical subjects and the Italian landscape; they have
a complex relationship with the art of their predecessors;
and they frequently use the written word – titles, allusions,
dedications and quotations – to instil meaning in their paintings.
In the art of both Twombly and Turner the relationship between
word and image can be highly problematic, but the literary
element is never irrelevant.

The *Three Studies after the Temeraire* belong to a distinct
category of work in which Twombly, like Turner before him,
deliberately invokes major figures and monuments from the
art and literature of the past. Both artists' careers contain a
long dialogue with their most distinguished predecessors, but
whereas Turner was often aggressive and competitive in his
dealings with the Old Masters, Twombly is less boisterous.
In other words, while Turner tried to elbow his way into the
canon, Twombly is more tentative, using a range of strategies
to declare his allegiances and explore his involvement with
the Great Tradition. In a few rare instances he takes an
exceptionally famous painting and produces a response to
it. Judging by the previous pictures to which he turned his
attention, which include Raphael's *School of Athens* and
Rembrandt's *Night Watch*, his choice is guided not merely
by personal considerations but also by their status within
the history of European art.

In both these cases he maintained his distance from the
originals, but it may be indicative of his relationship with

Turner that he drew far closer to the *Temeraire*. Besides sharing an unmistakable elegiac quality with the work Turner called his 'darling', Twombly's *Three Studies* have subtle correspondences with his predecessor's other marine paintings. His vessels carry oars like those of antiquity, and thus recall the galley in *Ulysses Deriding Polyphemus* (see 120). In addition, their beautiful, funereal colouring is reminiscent of the ship bearing Wilkie's body in *Peace – Burial at Sea* (see 158).

Twombly's triptych is a deeply felt tribute to his predecessor's achievements, but it is unlikely to be the last. In 1987 a new wing, then known as the Clore Gallery for the Turner Bequest, was added to what is now Tate Britain, thereby reuniting the vast majority of works he left to the nation. Furthermore, thanks to a series of important shows held since the bicentenary, Turner's reputation now extends beyond Europe and America to Australia and Japan. Scholars and curators continue to prepare exhibitions that will keep his art before an international public for the foreseeable future. Turner was not renowned for his humility, but the extent of his fame now far exceeds even his wildest expectations.

Glossary | Brief Biographies | Key Dates | Map |
Further Reading | Index | Acknowledgements

Glossary

Academic Adjective used to denote the shared precepts and doctrines of the various European academies of art. These included a belief in the hierarchy of subjects, the superiority of drawing over colour and the need to idealize observed nature. Their proponents believed that academic values were universally valid and transcended national boundaries, but they were eroded by the rise of nationalism in the nineteenth century.

Associationism A psychological doctrine which viewed the mind's capacity to make connections between sense impressions and ideas, or between one idea and another, as the main principle governing the ordering of human experience and the acquisition of knowledge. It played a major part in eighteenth- and early nineteenth-century aesthetic theories. Landscape painters in particular used the associations of a place to generate meanings in their works. It remains an important principle of modern psychology.

Engraving A traditional means of reproducing visual imagery in black and white by cutting or incizing the design into a metal plate. The plate is inked and put through a press, wherupon the image is printed in reverse on paper. It is a general term that covers a number of methods including **line engraving** and **mezzotint**, and distinctions are usually drawn between those made from less durable copper plates and steel engravings, which were introduced during the 1820s. The harder and more resistant steel permitted a much larger print run.

Etching Printmaking technique in which the design to be reproduced is eaten into the plate using acid. The plate is covered with an acid-resistant resinous ground through which the image is then drawn with an etching needle to expose the metal beneath. It is then immersed in an acid bath until the lines are cut to the required depth, whereupon the ground is removed, the plate inked and the design printed.

Genre painting Usually the depiction of scenes from ordinary life. In the eighteenth and early nineteenth centuries genre painting is often associated with the representation of the peasantry or the rural poor, typically on a fairly small scale and with a high degree of detail. In these respects British genre pictures often recall those painted by seventeenth-century Dutch and Flemish artists such as Jan Steen (1626–79), Adriaen Brouwer (1605/06–38) and, above all, David Teniers the Younger (1610–90), whose works were avidly collected by British connoisseurs. During Turner's lifetime some artists, such as Richard Parkes Bonington (1802–28), painted historical genre scenes, while others such as Jean-Auguste-Dominique Ingres (1780–1867) depicted real or imagined moments from the lives of great artists.

Gouache A form of watercolour paint containing an admixture of lead white, which renders it opaque, as opposed to the transparency of normal watercolour. It is also known as bodycolour.

Guinea An antiquated form of currency once used to price luxury goods. It was worth 21 shillings (or £1 1 shilling), hence 20 guineas was equivalent to 21 pounds.

Impasto The application of thick oil paint onto a canvas or panel.

Line engraving An **engraving** technique in which the design is cut into the metal plate by hand using a burin, a tool resembling a chisel with a v-shaped blade. Line engraving was a specialist craft that required enormous skill and a long apprenticeship.

Mezzotint Form of **engraving** that enjoyed great popularity in eighteenth- and early nineteenth-century Britain. Before the design is transferred the plate is worked over using a tool called a rocker. This covers it with small pits or dots, around each of which it leaves upstanding burr. When the plate is inked the dots and burr together hold the ink and at this stage the plate would print completely black. Half lights are created by scraping away areas of the burr so that the plate retains less ink in those places, and highlights are achieved by polishing the plate in the required areas with a burnisher. Mezzotint was a means of achieving rich shadows and subtle tonal gradations. It was used in combination with other techniques such as **line engraving** and **etching**.

Proof A term used in print production to describe the first impressions taken from a plate before the commercial edition is sold to the public. Proofs were keenly collected partly owing to their rarity and also because the images were printed in pristine condition before the metal plates gradually wore down in the press. An engraver's proof was one

taken during the preparation of the plate in order to judge its progress and to assess whether changes needed to be made.

Reform Term used to denote the impulse for constitutional change in Britain in the nineteenth century. This involved abolishing the many abuses of the electoral system, extending the right to vote to a wider section of the population and redistributing parliamentary seats in order to represent more fairly the interests of the towns and cities. The **Whig** administration of Lord Grey attempted to inaugurate the process in 1831 through the first Reform Bill, but it was rejected by the House of Lords. The defeat was followed by extensive rioting. In 1832 William IV was obliged to create sufficient new peers to enable the Bill to become law. In spite of the controversy it aroused the legislation was limited in its effects and reform continued to be a major political issue for decades.

Scumbling Technique used in both oil and watercolour in which paint is dragged across the support using a lightly laden brush, leaving the colour underneath partly visible.

Scratching-out A means of creating strong highlights by scraping though the paint to the white paper beneath, either using a knife, fingernail or the wooden end of a brush. Scratching-out creates sharp, precise highlights and may be used in combination with '**stopping-out**' or 'sponging-out' colour.

Stopping-out A technique used in watercolour painting whereby an area of the picture is covered with a 'stopping-out' agent such as gum in order to prevent it from being overpainted in subsequent **washes**.

Sublime A class of imagery that produces a state of awe, astonishment or terror in the spectator, as opposed to the pleasure occasioned by beautiful objects. In his *Philosophical Inquiry into the Origin of our Ideas of the Sublime and Beautiful* (1757) **Edmund Burke** attempted a systematic explanation of its physiological and psychological effects on the nervous system, as well as a survey of the kinds of phenomenon classifiable as sublime.

Vignette A literary illustration on a small scale, usually printed on the page without lines or borders.

Wash In watercolour painting, the application of colour over a broad area of the paper.

Whig One of the two great British political factions of the late eighteenth and early nineteenth centuries, the other being the opposing Tory party. The term was first used around 1679 to refer to those who wished to prevent James, Duke of York, from becoming king on the grounds that he was a Catholic. Thereafter the Whigs were increasingly associated with attempts to consolidate the powers of parliament at the expense of those of the monarch. In the early nineteenth century they advocated and introduced legislation intended to **reform** the British electoral system.

Brief Biographies

Sir George Beaumont (1753–1827) English collector, connoisseur, amateur artist and Turner's most persistent and hostile critic during the early stages of his career. Besides establishing an impressive collection of Old Master paintings (some of which he bequeathed to form the nucleus of the National Gallery), Beaumont was an important patron of British art and literature who supported the careers of the painter **David Wilkie** and the poets William Wordsworth and Samuel Taylor Coleridge. From 1803 to 1815 he repeatedly denounced the novelties of Turner's style, which he believed were corrupting the nation's taste.

William Beckford (1760–1844) Connoisseur, traveller and writer, author of the gothic novel *Vathek* (1786). One of the wealthiest men in Britain who used the fortune he derived from Caribbean plantations to collect Old Master paintings, to patronize contemporary British art and to build Fonthill Abbey, an enormous gothic country house in Wiltshire. Beckford was an important patron of Turner's earliest work, but disliked his later style and ceased to buy from him.

Edmund Burke (1729–97) Member of Parliament, statesman and author. It was originally intended that Burke would become a lawyer but he was never called to the Bar. Instead he had a long career as a writer and politician. In the latter he advocated the abolition of slavery, but opposed the French Revolution virtually from its outset and published his highly critical *Reflections on the Revolution in France* in 1790. He made a significant contribution to the field of aesthetics with his *Philosophical Inquiry into the Origin of our Ideas of the Sublime and Beautiful* in 1757. His close friends included **Sir Joshua Reynolds** and Samuel Johnson.

George Gordon, Lord Byron (1788–1824) English poet and satirist, educated at Harrow School and Trinity College, Cambridge, whose unprecedented level of celebrity in Britain and abroad was partly due to the popularity of his writings, and partly to his scandalous personal life. Turner often quoted from Byron's *Childe Harold's Pilgrimage* (1812–18) in the captions to his paintings, and he responded strongly to Byron's vision of Italy in decline, and to the poet's passionate enthusiasm for the cause of human liberty. It was this commitment that brought about Byron's death. In 1824 he went to Missolonghi to take part in the Greeks' struggle for independence from Turkish domination, but succumbed to a fever later that year.

Sadi Carnot (1796–1832) French engineer and theoretical physicist. The son of the French revolutionary, Lazare Carnot, he was educated at the École Polytechnique in Paris and was one of many students who resisted the invading armies who eventually occupied Paris in 1814. Carnot became an army officer but retired on half-pay in 1819 and devoted himself to science and technology. His greatest work was in the field of thermodynamics, but although his crucial paper *On the Motive Power of Fire* was published in 1824, he went largely unrecognized in his lifetime and died in the European cholera pandemic of 1832.

Sir Francis Legatt Chantrey (1781–1841) The leading British portrait sculptor of his era, and a close friend of Turner, with whom he shared an enthusiasm for, among other things, science and fishing. Chantrey's rise to fame was less rapid and sensational than that of his friend. He made a precarious living in his early career, and did not become an associate of the Royal Academy until 1816. But he became increasingly fashionable and like Turner he left an enormous fortune for the benefit of his profession, establishing a fund to purchase important works by artists resident in Britain.

Claude Gellée, also known as Claude Lorrain (1600–82) French landscape painter who spent most of his life in Italy, where alongside Nicolas Poussin (1594–1665) he became one of the great exponents of classical landscape. His work became so highly sought after that from around 1635 onwards he began to safeguard himself against forgery by preparing an extensive series of 195 drawings after his paintings. The scheme became known as the *Liber Veritatis* or 'Book of Truth'. Claude's work had a profound influence on the history of European landscape art, but it was particularly marked in Britain, where his pictures were avidly collected.

Thomas Cole (1801–48) Landscape painter. Cole was born in Lancashire, England, but his family emigrated to

America, where he was trained at the Pennsylvania Academy of Fine Arts. He returned to Europe during the years 1829–32 and again 1841–2. From 1826 he made his permanent home in Catskill, on the banks of the Hudson river, and from there he embarked on sketching tours, gathering material for oil paintings of the region. He met Turner and admired his work, but not the man himself.

John Constable (1776–1837) English landscape painter. The son of a prosperous Suffolk corn merchant, he trained at the Royal Academy where he was slower to build a reputation than Turner, becoming an associate at the age of forty-three and a full member of the institution in 1829. His landscapes were characterized by a high degree of naturalism and unlike many of his colleagues he did not travel abroad, preferring to paint scenery he knew well in Suffolk, Hampstead and Salisbury.

Jacques-Louis David (1748–1825) French painter and radical politician. He was trained by the history painter Joseph-Marie Vien (1716–1809), then spent six years in Italy on a government scholarship. After returning to France in 1780 he made his name with a series of powerful Neoclassical history paintings that included *The Oath of the Horatii* (1785) and *The Lictors Bringing to Brutus the Bodies of his Sons* (1789). From 1792 David took an active part in French Revolutionary politics and he voted for the execution of Louis XVI. Much of his energy was devoted at this time to organizing revolutionary pageants, but he fell from power and influence in 1794 and was briefly imprisoned. He was subsequently employed by Napoleon, for whom he produced impressive propaganda images. When Napoleon was defeated in 1815, David was exiled to Brussels where he died ten years later.

John Eagles (1783–1855) Bristol-based clergyman, translator, amateur poet and artist. He studied art in Italy before taking Holy Orders and contributed reviews to *Blackwood's Edinburgh Magazine* under the pen-name 'The Sketcher'. Eagles was conservative in both his tastes and his politics, becoming the most caustic of Turner's later critics. His withering review of the latter's paintings in 1836 provoked the teenage **John Ruskin** to write a letter in Turner's defence, which Ruskin claimed contained the seeds of his great work *Modern Painters*.

Sir Charles Lock Eastlake (1793–1865) Painter, art historian, art administrator. He became a student at the Royal Academy Schools in 1809, where he met and befriended Turner, with whom he travelled around his native Devon in 1813. After the end of the Napoleonic Wars Eastlake went abroad and spent most of the period between 1818 and 1830 in Italy, where he became a well-known figure within the Roman art world. Here he developed the knowledge of Italian art and the international contacts that served him well when, after returning to England in 1830, he gradually shifted his activities from painting to art history, curatorship and administration. Eastlake became president of the Royal Academy in 1850 and director of the National Gallery five years later, serving with great distinction in both capacities. In 1849 he married the writer and intellectual, Elizabeth Rigby, who was also friendly with Turner.

George Wyndham, 3rd Earl of Egremont (1751–1837) Landowner, agricultural improver, magnate, collector and racehorse breeder. Egremont provided generous and informal hospitality for artists at his country seat, Petworth House, in Sussex. He had an impressive collection of Old Masters, but was also greatly respected for his patronage of British painters and sculptors.

Walter Ramsden Fawkes (1769–1825) Landowner, collector, politician, writer and close friend of Turner. He offered the artist not only his generous patronage, but also the hospitality of Farnley Hall, his country seat in Yorkshire, which Fawkes had inherited in 1792. In this relaxed environment Turner produced a series of informal **gouaches** depicting the house, the surrounding estates, the leisure pursuits and the general sociability in which he took part. Fawkes was a man of strong and fairly radical political convictions who was briefly a **Whig** Member of Parliament; he and Turner seem to have shared certain political convictions, including the need to reform the constitution and to abolish slavery. In 1819 Fawkes gave his contemporaries the chance to see a large number of Turner's watercolours together on display in his London house; the exhibition helped to confirm Turner's reputation as the pre-eminent landscape artist of his day.

David Hartley (1705–57) English physician and psychologist. Hartley was originally educated as a clergyman, but became a doctor instead and practised in London and Bath. His major work was his *Observations on Man, His Frame, His Duty and His Expectations*, which was published in 1749. In it he tried to analyse human mental processes in terms of the association of ideas, a concept that still plays a part in modern psychology.

Charles Heath (1785–1848) Engraver and publisher. He was trained as an engraver by his father James Heath (1757–1834) and became successful through the production and publication of annuals – illustrated gift-books such

as the *Keepsake*. Turner provided images for these, but more importantly, Heath published Turner's three-volume *Rivers of France* (1832–4), as well as the *Picturesque Views in England and Wales* (1827–38), an ambitious and expensive project that helped to ruin Heath financially.

George Jones (1786–1869) Soldier, painter of battle scenes and historical subjects. Jones studied at the Royal Academy, but also became a militia captain, in which capacity he was part of the army that entered Paris after Napoleon's defeat at the Battle of Waterloo in 1815. He and Turner became close friends; they both enjoyed the hospitality of the **Earl of Egremont**, and shared a passion for fishing. After Turner's death Jones wrote his *Recollections* (unpublished) of their friendship.

Richard Payne Knight (1751–1824) Writer, connoisseur, poet and aesthetic theorist. Knight was a versatile and distinguished scholar who built up an impressive collection of ancient sculpture, coins and works of art by both Old Masters and contemporary British painters. He played an important part in expanding the holdings of the fledgling British Museum, not least through his own donations, but his achievements in this respect and as an aesthetic theorist were overshadowed by his disastrous involvement in the British government's purchase of the Parthenon sculptures from Lord Elgin, who had brought them back from Greece. Knight rashly and erroneously advised against the purchase on the grounds that they were inferior Roman works, a blunder from which his reputation never fully recovered.

John Landseer (1769–1852) Engraver, author and one of the most acute contemporary critics of Turner's work. His reviews were published in his own journals, the *Review of Publications of Art* (1808) and the *Probe* (1839 and 1840). Landseer gave such a detailed and perceptive account of the pictures in Turner's own gallery in 1808 that it is tempting to believe that he had conversed with the artist about them. He was the father of Edwin Landseer (1803–73), one of the most successful of Victorian painters.

Louis-Philippe (1773–1850) King of France. After the execution of his father the Duke of Orléans during the French Revolution, he fled France and eventually made his home in Twickenham, where Turner was a near neighbour. After the July Revolution in 1830 he became King of France and reigned until he was ousted from power in the 1848 Revolution. He returned to England once again and died in exile there two years later.

Philippe Jacques de Loutherbourg (1740–1812) Alsatian landscape painter. Born at Strasbourg, where he was at first educated for the Lutheran Church, but went to Paris where he became a pupil of Carle Vanloo (1705–65). In 1762 he was elected a member of the French Academy, then he toured Europe before settling in England in 1771, where he was employed by the actor-impresario David Garrick to design and manage the scenery and machinery of Drury Lane Theatre. At the same time he began to exhibit his landscapes at the Royal Academy, of which he was elected a member in 1781. Though renowned for his paintings and his work in the theatre, he became notorious through his activities as a faith healer and his interests in alchemy.

Thomas Malton Jnr (1748–1804) English watercolour painter and teacher. The son of an architectural draughtsman and teacher of perspective, he trained initially as an architect before entering the Royal Academy Schools and becoming a painter. During his career he worked as a scenery painter and a drawing master, in addition to his production of architectural and topographical watercolours, many of which he published.

John Martin (1789–1854) British landscape painter specializing in apocalyptic and **sublime** subjects. His training, which included a spell with a coach painter and a glass painter, was highly unconventional, but Martin became one of the most famous artists of his day, whose work circulated widely throughout Europe thanks to the **mezzotints** he made to illustrate Milton's *Paradise Lost*. In spite of his enormous popularity his works were often disparaged within the Royal Academy for their sensationalism, and to the end of his life the institution continued to snub him.

Dr Thomas Monro (1759–1833) Specialist in the treatment of mental illness and senior physician at Bethlem Hospital, whose patients included George III, the painter John Robert Cozens (1752–97) and Turner's mother. Monro was also an amateur artist and passionate collector of watercolours and drawings, who employed Turner, Thomas Girtin (1775–1802) and other young painters to make copies of works in his own and his friends' collections.

Hugh Andrew Johnstone Munro of Novar (1797–1864) Scottish landowner and amateur painter who began by collecting Old Masters but became a close friend of Turner and one of the most constant patrons of his later career. He eventually owned sixteen oils and more than 130 of the artist's watercolours. Although Turner generally preferred to travel alone, he and Munro visited the Alps together in 1836.

Horatio, Viscount Nelson (1758–1805)
Vice-admiral. He entered the Navy as
a boy in 1780 and lost his right eye serving
with Lord Hood during the capture of
Corsica in 1794, then his right arm in
1797. He was rapidly promoted, first to
the rank of commodore in 1796 and then
to rear-admiral for his part in the Battle
of Cape St Vincent in 1797. Nelson was
a brilliant strategist who became a
national hero owing to engagements
such as the Battle of the Nile (1798), the
attack on Copenhagen (1801), and finally
the Battle of Trafalgar (1805) in which
he lost his life.

The Prince Regent, later George IV
(1762–1830) Regent and King of
England. As the monarch's eldest son,
George became Regent and *de facto*
ruler in 1811 because of George III's
mental illness, which had become
increasingly worse from 1788 onwards.
On his father's death in 1820 he became
king in his own right. He was notorious
throughout his life for his promiscuity
and his extravagance, the latter
occasioning frequent arguments in
parliament about the Civil List, the
moneys granted for the maintenance of
the Royal Family. His unpopularity was
such that on one occasion in 1817 his
carriage was stoned by an angry mob.

Sir Joshua Reynolds (1723–92) English
portrait painter, administrator and writer
on art. The son of a Devon clergyman,
he studied under the portrait painter
William Hudson. After a period of study
in Italy he returned to London in 1752
and began to build a reputation as a
portraitist, and to publish occasional
writings on art. Reynolds was respected
by his colleagues and admired by leading
literary men of the day such as Samuel
Johnson. He was unanimously elected
the first president of the newly formed
Royal Academy in 1768, and in this
capacity he delivered his *Discourses*
(1769–90), a lucid and undogmatic
statement of **Academic** principles that
had a very considerable effect upon
Turner's generation of artists.

Samuel Rogers (1763–1855) English
poet. In daily life Rogers was employed
by the bank in which his father was a
partner, but when his father died in 1793
he came into a considerable fortune,
which allowed him to travel, to indulge
his tastes as a connoisseur and to mix
with artists, writers and men of influence.
He became a mainstay of London
intellectual life, and he invited his wide
circle of cultured and creative friends,
including Turner and **Byron**, to his
celebrated breakfast parties. He earned
a considerable reputation for his verse
and was offered, but declined, the post
of poet laureate in 1850.

John Ruskin (1819–1900) English critic
who became the foremost interpreter of
Turner's work, and whose writings on

art and society had an enormous
influence on Victorian attitudes. With
his father John James Ruskin he built up
a collection that included Turner's late
Swiss watercolours, designs for the
England and Wales series and the oil
painting, *The Slave Ship*. Ruskin's
passionate defence of Turner began
in 1836 with a brief riposte to **John
Eagles**, the conservative critic of
Blackwood's Edinburgh Magazine,
but culminated in his monumental, five-
volume *Modern Painters* (1843–60).
This colossal work provided the
Victorian public with an explanatory
framework for understanding Turner's
later art, which had previously often
been stigmatized as incomprehensible.
During the course of his career
Ruskin's interests diversified to include
architecture, education and the nature
of society itself, but his outlook also
darkened and the last volume of *Modern
Painters* presented an image of Turner's
work as essentially tragic and despairing.
In 1878 he suffered the first attack of the
mental illness that impaired the remaining
years of his life.

Sir Walter Scott (1771–1832) Scottish
poet, historian, biographer and novelist.
Like **Byron**, Scott was a phenomenal
literary success, who is often credited
with the invention of the historical
novel. In the series of books known as
the *Waverley* novels (which were at first
published anonymously) he combined
his gift for storytelling with a deep
knowledge of his country's history.
He had a considerable influence on
subsequent European and American
novelists.

Sir John Soane (1753–1837) Architect
and connoisseur. The son of a Berkshire
builder, he became a full member of the
Royal Academy in 1802, the same year
as Turner (with whom he enjoyed a
lasting friendship), and its professor of
architecture four years later. Soane was
one of the most distinctive and original
architects of his day, who redesigned
part of the Bank of England as well as
Dulwich College Picture Gallery, which
housed the mausoleum and collection
of Sir Francis Bourgeois. But it was
Soane's own house in Lincoln's Inn
Fields that became his lasting memorial.
He built it between 1808 and 1824 to
house his enormous collection of art,
books and antiquities, and in 1833
obtained parliamentary sanction to turn
it into a museum.

William Makepeace Thackeray
(1811–63) English novelist and critic.
He studied law, then considered
becoming a painter. When he began to
write exhibition reviews under the pen-
name 'Michael Angelo Titmarsh' for
Fraser's Magazine, his flippant tone
could not altogether hide his critical
acumen. His literary reputation is now

based on his novels, *Vanity Fair*
(1847–8) and *The History of Henry
Edmond, Esq.* (1852).

**Arthur Wellesley, 1st Duke of
Wellington** (1769–1852) Soldier and
politician. Wellington began as a career
soldier, who inflicted a series of
punishing defeats against Napoleon's
armies, driving them out of Portugal and
Spain and eventually invading France
itself in 1814. His most famous victory
was at the Battle of Waterloo in 1815,
where Napoleon, who had returned from
exile, was finally defeated. After the war
Wellington became a Tory politician and
in 1828 prime minister. In this role he
promoted the Catholic Emancipation
Act in 1829, but he subsequently became
a vigorous opponent of parliamentary
reform, a stance that made him extremely
unpopular and led to his resignation in
1830. He later served as a minister under
Sir Robert Peel and retired from public
life in 1846.

William Frederick Wells (1762–1836)
English watercolour painter, etcher and
teacher. Wells's career profile was
typical of a modestly successful early
nineteenth-century landscape painter.
He exhibited regularly at the Royal
Academy and the Old Watercolour
Society, and was employed as a drawing
master by the East India Company, but
he is chiefly remembered now for his
long and extremely close friendship
with Turner, who often visited him at
his home at Knockholt in Kent.

Sir David Wilkie (1785–1841) Versatile
Scottish painter who arrived in London
in 1805, gravitated towards the circle
of **Sir George Beaumont** and made his
reputation with a series of highly
acclaimed **genre** subjects. There was
some rivalry between him and Turner,
who was initially disparaging of his
work, but became an admirer of the
broader style that Wilkie developed
in his later years. Like Turner he
responded to the circumstances and
events of his day, from the widespread
agricultural distress (in *Distraining for
Rent*, 1814) to **George IV**'s state visit to
Scotland in 1822. In spite of the fact that
Wilkie achieved the honours and royal
patronage that Turner desired but never
received, the latter was deeply moved by
his death on the return journey from a
visit to the Holy Land. He commemorated
Wilkie's shipboard funeral in *Peace –
Burial at Sea.*

Key Dates

Numbers in square brackets refer to illustrations

The Life and Art of J M W Turner

A Context of Events

1775 J M W Turner born, probably 23 April, in London at 21 Maiden Lane, Covent Garden

1775 American War of Independence (to 1783). Birth of Jane Austen

1778 Mary Ann, Turner's sister, born (dies 1783)

1781 British surrender at Yorktown

1782 James Watt develops first rotary steam engine

1785 Turner stays at Brentford with his uncle and aunt. Attends John White's school

1785 First issue of *The Times* published. Cartwright invents power loom

1786 Turner sent to stay at Margate where he makes his first drawings from nature

1786 Threshing machine invented

1789 Employed first by the architect Thomas Hardwick, then later works with Thomas Malton. Admitted to the Royal Academy Schools

1789 French Revolution – the storming of the Bastille. George Washington becomes president of USA. First steam-driven cotton factory in Manchester

1790 Exhibits his first watercolour at the Royal Academy: *The Archbishop's Palace, Lambeth* [9]

1790 Burke publishes *Reflections on the Revolution in France*

1791 First sketching tour. Stays at Bristol with the Narraways, friends of his father and visits Malmesbury and Bath

1791 William Wilberforce's first anti-slave trade petition. Ordnance Survey established

1792 Admitted to the life class at the Royal Academy. Meets John Soane and W F Wells. Tours South Wales

1792 Republic proclaimed in France. First use of the guillotine. Thomas Paine publishes *The Rights of Man*. Death of Sir Joshua Reynolds

1793 Probable date of first contact with Dr Monro and first attempts at oil painting. Tours of Herefordshire in the summer, Sussex and Kent in the autumn

1793 Execution of Louis XVI and Marie Antoinette. France declares war on Britain and Holland

1794 Tours Midlands and North Wales. Makes copies at Monro's house in the company of Thomas Girtin. Begins to give drawing lessons

1794 Admiral Howe defeats the French on 'The Glorious First of June'

1795 Tours South Wales and the Isle of Wight

1795 Anti-war demonstrations in England

1796 Exhibits his first oil painting, *Fishermen at Sea* [21], at the Royal Academy. Sold for £10

1796 Peace talks with the French collapse. Napoleon conducts successful campaign in Italy

1797 Tours the north of England and the Lake District. Visits Harewood House to fulfil commission from Edward Lascelles

1797 Naval mutinies at the Nore and Spithead. Financial crisis in Britain. Introduction of the first £1 note. French invade Egypt

1798 Turner takes advantage of new Royal Academy ruling allowing painters to append lines of poetry to the titles of their

1798 Nelson defeats the French Navy in the Battle of the Nile. Joseph Haydn composes his *Nelson Mass* and first

	The Life and Art of J M W Turner	A Context of Events
	pictures. Tours Wales and visits Richard Wilson's birthplace. Fails to become an associate of the Royal Academy	performance of his *Creation*. Wordworth and Coleridge publish the 'Lyrical Ballads'
1799	Lord Elgin approaches Turner to accompany him on his expedition to Greece but negotiations break down. Works for William Beckford at Fonthill. Elected associate of the Royal Academy. Takes lodgings at 64 Harley Street. Begins liaison with Sarah Danby	1799 Napoleon receives the title of First Consul. British prime minister William Pitt introduces income tax. Austria declares war on France
1800	Shows *The Fifth Plague of Egypt* [30] at the Royal Academy and paints *Dutch Boats in a Gale* [33] for the Duke of Bridgewater for a fee of 250 guineas. His mother is admitted to Bethlem Hospital	1800 Alessandro Volta discovers electricity. Napoleon beats the Austrians at the Battle of Marengo
1801	Tours Scotland and returns through the Lake District. Probable date of birth of his daughter Evelina	1801 The first national census is held. The population of London reaches one million. Union of Ireland and England. Nelson victorious at Copenhagen
1802	Elected a full member of the Royal Academy. Makes his first continental tour between July and October, visiting the Swiss Alps and spending three weeks in Paris, where he makes extensive studies in the Louvre	1802 The Peace of Amiens is signed with France. Napoleon becomes president of the Italian Republic. Death of Thomas Girtin
1803	First official duties as an academician – member of the council and the hanging committee of the annual exhibition. Sir George Beaumont first criticizes Turner's work	1803 The Peace of Amiens collapses and war resumes with France. Robert Fulton first propels a boat by steam power
1804	Death of Turner's mother. Opens his own gallery on the corner of Queen Anne Street and Harley Street	1804 Napoleon becomes emperor of the French
1805	Exhibits at his own gallery rather than the Royal Academy. Rents Sion Ferry House, Isleworth, on the Thames,where he keeps a boat and explores the river. Sketches Nelson's flagship, the *Victory*, on its return from the Battle of Trafalgar	1805 Death of Nelson at the Battle of Trafalgar. Founding of the British Institution
1806	Exhibits at the first exhibition held by the British Institution. W F Wells gives him the idea of creating the *Liber Studiorum*	1806 Napoleon closes continental ports to British ships
1807	Elected professor of perspective at the Royal Academy. Publishes first number of the *Liber Studiorum*. Acquires a plot of land at Twickenham. First French review of his work published in *Magazine Encyclopedique*	1807 William Wilberforce's Act to abolish the British slave trade is passed. Gas lighting first introduced in London Streets. France invades Portugal
1808	Stays with Sir John Leicester at Tabley Hall, Cheshire, and later at Farnley Hall, Yorkshire, with Walter Fawkes. John Landseer publishes a long review of the work on show in Turner's gallery in his *Review of Publications of Art*. First German notice of Turner's work published by J D Fiorillo	
1809	Visits Petworth House in Sussex and later tours the north of England	1809 Alliance with Austria against France.
1810	Changes his London address to 47 Queen Anne Street West. Visits Sussex to make	1810 Goya executes the first of his *Disasters of War* series.

commissioned drawings for Jack Fuller of Rosehill. Spends August with Fawkes at Farnley Hall and thereafter becomes a regular visitor

1811	Delivers his first series of perspective lectures at the Royal Academy. Tours the West Country in search of material for Cooke's *Picturesque Views of the Southern Coast of England*. Writes his own accompanying poem which is rejected by the publisher	**1811** The Prince of Wales becomes Prince Regent. John Nash lays out Regent's Park, London. Luddites riot and destroy textile machinery. Wellington defeats the French in Portugal
1812	Begins to build Sandycombe Lodge in Twickenham to his own design. Shows *Snow Storm: Hannibal and his Army Crossing the Alps* [72] at the Royal Academy, with the first accompanying caption from his own poem, the 'Fallacies of Hope'	**1812** War between Britain and USA. Napoleon invades Russia and is forced to retreat from Moscow. Wellington defeats the French at Salamanca and enters Madrid. Cantos I and II of Byron's *Childe Harold's Pilgrimage* published
1813	Sandycombe Lodge completed. Tours Devon and makes outdoor oil sketches. Shows *Frosty Morning* [74] at the Royal Academy	**1813** Napoleon defeated at the Battle of Leipzig. Allies invade France. Jane Austen publishes *Pride and Prejudice*
1814	First instalments of the *Southern Coast* series issued. Tours Devon again	**1814** Paris falls and Napoleon abdicates. Stephenson builds first steam locomotive
1815	The sculptor Antonio Canova visits Turner's gallery and calls him a 'great genius'. Shows *Dido Building Carthage* [78] and *Crossing the Brook* [77] at the Royal Academy	**1815** Napoleon returns to France but is defeated at the Battle of Waterloo. Riots in London follow the introduction of the Corn Laws
1816	Tours Yorkshire to gather material for Whitaker's *History of Richmondshire*. Becomes visitor (tutor) at the Royal Academy's Painting School	**1816** Income tax abolished
1817	Visits Belgium, Holland and the Rhineland. Later visits Farnley Hall and sells 51 Rhine watercolours to Fawkes	**1817** Potato famine in Ireland. Death of Jane Austen
1818	Shows the *Field of Waterloo* [87] at the Royal Academy. Travels to Scotland to discuss plans to illustrate Scott's *Provincial Antiquities of Scotland*	**1818** Publication of last Canto of Byron's *Childe Harold*. The *Savannah* becomes first steamship to cross the Atlantic
1819	*England: Richmond Hill* [89] shown at RA. Turner's work is also shown at Sir John Leicester's London gallery and Walter Fawkes's London house. Turner travels to Italy	**1819** Peterloo Massacre – 11 dead and 400 wounded when a cavalry attack is launched against peaceful radical demonstrators in Manchester
1820	Returns home from Italy in February. Inherits property in Wapping. Begins to enlarge his Queen Anne Street house and gallery. Shows *Rome from the Vatican* [97] at the RA	**1820** The Prince Regent succeeds his father as King George IV. Géricault's *Raft of the Medusa* shown in London. Cato Street conspiracy to murder British ministers
1821	Travels to Paris, Rouen and Dieppe	**1821** Napoleon dies on St Helena. Constable shows the *Hay Wain* at the RA
1822	Turner watercolours shown in W B Cooke's premises in Soho Square. Turner opens his new gallery. Travels by sea to Edinburgh in August to witness George IV's state visit. Receives Royal commission for *The Battle of Trafalgar*, his biggest oil and his only instance of Royal patronage	**1822** L J M Daguerre invents the Diorama. The poet Shelley drowns in Italy

The Life and Art of J M W Turner	A Context of Events
1823 First *Rivers of England* engravings published	
1824 Visits East Anglia. Then tours Belgium, Luxembourg, Germany and northern France. Visits Farnley Hall for the last time	**1824** Death of Byron during the Greek War of Independence. Repeal of the Combination Acts leads to increase in Trade Union activity
1825 Begins work on the *Picturesque Views in England and Wales*. Tours the Low Countries. Death of Walter Fawkes	**1825** Opening of the Stockton to Darlington railway. Financial crisis hits publishes and printsellers
1826 Sells Sandycombe Lodge and tours northern France. Samuel Rogers commissions him to illustrate *Italy*, his collection of poems	**1826** Joseph Nicephore Niepce takes the first photographic images
1827 Death of Sir John Leicester. Visits the Isle of Wight and stays with the architect John Nash	**1827** Treaty of London between England, Russia and France to secure autonomy of Greece
1828 Gives his perspective lectures for the last time. Visits Petworth House, Sussex. Leaves for second Italian tour in August	**1828** Duke of Wellington becomes Prime Minister (to 1830). Red Cross founded
1829 Returns from Italy in February. Visits Paris, Normandy and Brittany. Death of his father	**1829** Catholic Emancipation Bill passed. Formation of London's first police force
1830 Tours the Midlands. Publication of Samuel Rogers's *Italy* with Turner's illustrations.	**1830** George IV dies and is succeeded by William IV. Louis-Philippe becomes King of France after July Revolution. Death of Sir Thomas Lawrence
1831 Travels to Scotland to stay with Sir Walter Scott. Spends Christmas at Petworth	**1831** Riots after Reform Bill is rejected by the House of Lords. Charles Darwin begins scientific expedition on the *Beagle*
1832 In France during September and October collecting materials for the *Rivers of France* series	**1832** Reform Bill passed. European cholera epidemic
1833 Shows his first two oils of Venice at the RA. In September his tour takes in Berlin, Dresden, Prague, Vienna and Venice	**1833** The death of the anti-slavery campaigner William Wilberforce coincides with the abolition of slavery throughout the British Empire
1834 Sketches the burning of the Houses of Parliament from a boat on the Thames. Visits Oxford	**1834** Charles Babbage invents the first digital computer. Poor Law Amendment Act leads to the introduction of workhouses
1835 Shows his two oils of the *Burning of the House of Lords and Commons* [139], one at the RA and one at the British Institution. Visits Denmark, Germany and Bohemia in the summer	**1835** Total of railway track in Britain grows to 338 miles. Death of John Nash
1836 His exhibit at the RA, including *Juliet & her Nurse* [141], savagely attacked by John Eagles. Ruskin responds with a letter defending the works. Tours France and Switzerland	**1836** Compulsory registration of births, deaths and marriages introduced. Potato famine in Ireland
1837 Travels to France and visits Paris and Versailles. Resigns as professor of Perspective. Stays at Petworth for the last time. Death of the Earl of Egremont	**1837** Death of William IV. Victoria becomes Queen. Death of John Constable
1838 *England and Wales* series ceases publication	**1838** Publication of People's Charter

	The Life and Art of J M W Turner	A Context of Events
		calling for the working class right to vote, improved employment conditions and an end to the new Poor Law
1839	Summer tour to Belgium, Luxembourg and Germany. *The Fighting 'Temeraire'* [145] shown at the RA to great acclaim	1839 Civil disturbances in support of the People's Charter (Chartist riots). Charles Dickens publishes *Nicholas Nickleby*
1840	First meeting with Ruskin. *Slavers Throwing Overboard the Dead and Dying* [148] widely ridiculed at the RA. Travels to Venice and visits Schloss Rosenau [152], Prince Albert's birthplace, on the return journey	1840 Marriage of Queen Victoria to Prince Albert of Saxe-Coburg-Gotha. Introduction of the Penny Post
1841	Shows three Venetian oils at the RA. Tour of Switzerland	1841 Deaths of Sir David Wilkie and Sir Francis Chantrey. Great Western Railway from London to Bristol completed
1842	Visits Switzerland again. Commences first series of commissioned watercolours, largely of Swiss scenes. Shows *Peace–Burial at Sea* [158] and *Snow Storm – Steam-Boat* [160] at the RA	1842 Britain acquires Hong Kong. Income tax re-introduced
1843	Publication of the first volume of Ruskin's *Modern Painters*. Second series of Swiss watercolours	1843 Wordworth becomes Poet Laureate. Thomas Carlyle publishes *Past and Present*
1844	Shows *Rain, Steam and Speed* [169] at the RA. Final tour of Switzerland	1844 Samuel Morse uses his new code to send first telegraphed message from Washington to Baltimore
1845	Becomes acting, then deputy president of the RA during the illness of Martin Archer Shee. *Staffa: Fingal's Cave* bought by James Lenox of New York – the first work by Turner to go to America. Last foreign excursion to northern France	1845 Great Irish potato famine. Friedrich Engels completes *The Condition of the Working Class in England*
1846	Moves with Sophia Booth into 6 Davis Place, Chelsea. Resigns as deputy president of RA	1846 Repeal of the Corn Laws
1847	Repeatedly visits the London studio of the American photographer, J J E Mayall	1847 The Factory Act restricts length of the working day in the textiles industry.
1848	Takes on Francis Sherrell as studio assistant. Shows nothing at the RA	1848 Revolutions in Europe. Louis-Philippe deposed in France. Karl Marx and Friedrich Engels publish *The Communist Manifesto*. Foundation of the Pre-Raphaelite Brotherhood
1849	His health deteriorates markedly. Declines offer from the Society of Arts to mount a retrospective exhibition of his work	1849 Women admitted to London University
1850	Exhibits his last pictures at the RA: four works telling the story of Dido and Aeneas [179]	1850 First submarine telegraph cable laid between Dover and Calais.
1851	Attends an Academy Club dinner in May for the last time. Under constant medical supervision from October. Dies at 10 am on 19 December	1851 Construction of Paxton's Crystal Palace and opening of the Great Exhibition. Melville publishes *Moby Dick*. Death of Wordsworth

Borders shown are those at the beginning of the 21st Century

SCOTLAND

North Sea

Baltic Sea

Edinburgh

Kendal
Farnley
Leeds
Manchester
Caernarvon
Sheffield
Beddgelert
Hull

Berlin

Dudley Great Yarmouth
WALES ENGLAND
Oxford Cambridge
Stourhead Harwich Amsterdam
Windsor London NETHERLANDS
Poole Petworth Margate GERMANY
Plymouth Knockholt Deal
ISLE Calais
OF WIGHT Cologne
Waterloo
BELGIUM Ehrenbreitstein
Dieppe Eu Coburg
Klotten
Rouen Bingen
Paris Trier Mainz

Walhalla

Munich

Atlantic
Ocean FRANCE Vienna
Mâcon Lucerne Goldau
SWITZERLAND AUSTRIA
Faido
Grenoble
Lanslebourg Como
Turin Milan
Verona
Venice
ITALY
Genoa Raveuna
Bologna Rimini
Florence
Pisa Ancona
Foligno
CORSICA
Mediterranean Sea
Tivoli
Rome
Pompeii
Naples
Paestum

0 250 500 miles
0 250 500 kilometres

Further Reading

The literature on Turner is vast and what follows is necessarily a brief selection. It is drawn largely from works published since the artist's bicentenary in 1975, but with the inclusion of some of the more important earlier writings. The journal *Turner Studies*, published by the Tate Gallery between 1980 and 1993, contains a wealth of material on the artist. A substantial bibliography and a review of Turner scholarship may be found in *The Oxford Companion to J M W Turner*.

Biographies

Anthony Bailey, *Standing in the Sun: A Life of J M W Turner* (London, 1997)

Alexander J Finberg, *The Life of J M W Turner RA* (London, 1939)

James Hamilton, *Turner. A Life* (London, 1997)

Jack Lindsay, *J M W Turner: His Life and Work* (London, 1966)

Walter Thornbury, *The Life of J M W Turner, RA* (2nd edn, London, 1877)

Works about Turner

Martin Butlin and Evelyn Joll, *The Paintings of J M W Turner* (New Haven and London, 1984)

Martin Butlin, Evelyn Joll and Luke Herrmann, *The Oxford Companion to J M W Turner* (Oxford, 2001)

John Gage, *Colour in Turner: Poetry and Truth* (London, 1969)

—, *J M W Turner: 'A Wonderful Range of Mind'* (London, 1987)

—, *Turner: Rain, Steam and Speed* (London, 1972)

John Gage (ed.), *Collected Correspondence of J M W Turner* (Oxford, 1980)

Luke Herrmann, *Turner Prints: the Engraved Works of J M W Turner* (London, 1990)

David Hill, *In Turner's Footsteps through the Hills and Dales of Northern England* (London, 1984)

—, *Turner on the Thames: River Journeys in the Year 1805* (London, 1993)

Kathleen Nicholson, *Turner's Classical Landscapes: Myth and Meaning* (Princeton, 1990)

Ronald Paulson, *Literary Landscape: Turner and Constable* (New Haven and London, 1982)

Cecilia Powell, *Turner in the South: Rome, Naples, Florence* (London, 1987)

Eric Shanes, *Turner's Human Landscape* (London, 1990)

—, *Turner's Picturesque Views in England and Wales* (London, 1979)

—, *Turner's Rivers, Harbours and Coasts* (London, 1981)

Andrew Wilton, *The Life and Work of J M W Turner* (London, 1979)

—, *Turner in his Time* (London, 1987)

Historical and Cultural Background

Malcolm Andrews, *Landscape and Western Art* (Oxford, 1999)

John Barrell, *The Dark Side of the Landscape* (Cambridge, 1980)

—, *The Political Theory of Painting from Reynolds to Hazlitt* (New Haven and London, 1986)

David Blayney Brown, *Romanticism* (London, 2001)

Alasdair Clayre (ed.), *Nature and Industrialization* (Oxford, 1977)

Linda Colley, *Britons. Forging the Nation 1707–1837* (London, 1994)

Matthew Craske, *Art in Europe 1700–1830* (Oxford, 1997)

Joseph Farington, *Diary*, eds Kenneth Garlick, Angus Macintyre and Kathryn Cave, 16 vols (London, 1978–84)

Charles Harrison, Paul Wood and Jason Gaiger (eds), *Art in Theory 1648–1815* (Oxford, 2000)

—, *Art in Theory 1815–1900* (Oxford, 1998)

Andrew Hemingway, *Landscape Imagery and Urban Culture in Early Nineteenth Century Britain* (Cambridge, 1992)

Tim Hilton, *John Ruskin: the Early Years 1819–1859* (New Haven and London, 1989)

Sidney C Hutchinson, *The History of the Royal Academy 1768–1968* (London, 1968)

David Irwin, *Neoclassicism* (London, 1997)

Charlotte Klonk, *Science and the Perception of Nature* (New Haven and London, 1996)

Kay Dian Kriz, *The Idea of the English Landscape Painter* (New Haven and London, 1994)

Christiana Payne, *Toil and Plenty. Images of the Agricultural Landscape in England, 1780–1890* (New Haven and London, 1993)

Sir Joshua Reynolds, *Discourses on Art*, ed. Robert Wark (New Haven and London, 1975)

Michel Serres 'Turner translates Carnot' in Norman Bryson (ed.), *Calligram: Essays in New Art History from France* (Cambridge, 1988)

Sam Smiles, *Eye Witness: Artists and Visual Documentation in Britain 1770–1830* (Aldershot, 2000)

Carolyn Springer, *The Marble Wilderness: Ruins and Representation in Italian Romanticism* (Cambridge, 1987)

William T Whitley, *Art in England 1800–1837*, 2 vols (New York, 1973)

William Vaughan, *Romantic Art* (London, 1978)

Exhibition Catalogues

Since exhibition catalogues on the artist often represent the research and curatorial activity of one scholar, they are given here alphabetically by author.

Maurice Davies, *Turner as Professor: The Artist and Linear Perspective* (Tate Gallery, London, 1992)

Judy Egerton, *Making and Meaning: Turner, The Fighting Temeraire* (National Gallery, London, 1995)

Gillian Forrester, *Turner's 'Drawing Book': the Liber Studiorum* (Tate Gallery, London, 1996)

John Gage (introduction), *J M W Turner* (Grand Palais, Paris, 1983)

Colin Harrison, *Turner's Oxford* (Ashmolean Museum, Oxford, 2000)

Robert Hewison, Ian Warrell and Stephen Wildman, *Turner, Ruskin and the Pre-Raphaelites* (Tate Gallery, London, 2000)

Martin Krause, *Turner in Indianapolis* (Indianapolis Museum of Art, 1997)

Cecilia Powell, *Turner's Rivers of Europe: The Rhine, Meuse and Mosel* (Tate Gallery, London, 1991)

—, *Turner in Germany* (Tate Gallery, London, 1995)

Eric Shanes, *Turner's Watercolour Explorations 1810–1842* (Tate Gallery, London, 1997)

—, *Turner: the Great Watercolours* (Royal Academy, London, 2001)

Joyce Townsend, *Turner's Painting Techniques* (Tate Gallery, London, 1993)

Ian Warrell, *Through Switzerland with Turner: Ruskin's First Selection from the Turner Bequest* (Tate Gallery, London, 1995)

—, *Turner on the Seine* (Tate Gallery, London, 1999)

Ian Warrell, David Blayney Brown and Christopher Rowell, *Turner at Petworth* (Tate Gallery and the National Trust, London, 2002)

Andrew Wilton and Rosalind Mallord Turner, *Painting and Poetry; Turner's Verse Book and his Work of 1804–12* (Tate Gallery, London, 1990)

Index

Numbers in **bold** refer to illustrations

Abstract Expressionists 312–18, 322; **188**
Aeneas and the Sibyl, Lake Avernus 47; **3**
Aeneas Relating his Story to Dido 294–5
Akenside, Mark 132–5
Albert, Prince Consort 253–4, 281
Alison, Archibald 94–5, 115
Allston, Washington 121, 304
Althorp, Lord 211
André, Carl 320–1; **193**
Anfam, David 313
The Angel Standing in the Sun 6, 237, 281, 282–4; **170**
Angerstein, John Julius 32, 47–9
Apollo Belvedere **12**
Apullia in Search of Appullus – Vide Ovid 129–30, 189; **76**
The Archbishop's Palace, Lambeth 22–3; **9**
Archer Shee, Sir Martin 49, 94, 282
Aristotle 69–70
Armstead, Henry Hugh 303
Austen, Jane 13, 15

Bakhuyzen, Ludolf 266
Barrell, John 132
Barry, Charles 309
Barry, James 109–10; **64**
Bartlett, William 298
The Battle of the Nile 78
The Battle of Trafalgar 173–4
The Battle of Trafalgar, as seen from the Mizen Starboard Shrouds of the Victory 79–83; **48**
The Bay of Baiae with Apollo and the Sibyl 174–8, 223; **104**
Beaumont, Sir George 9, 67, 84–7, 129, 131, 135, 180, 232; **53**
Beckford, William 52
Bernini, Gianlorenzo 166
Bicknell, Elhanan 258, 284–5, 288
Bingen from the Nahe 142–3; **82**
Binks, Thomas 285; **173**
Blake, William 6, 8, 137
Boime, Albert 245
Booth, Sophia 236, 285, 291, 296
Boswell, Henry 19; **7**
Boulevard des Italiens, Paris 220; **133**

Bourgeois, Louise 325–6; **196**
Brabazon, Hercules Brabazon 303
Bracquemond, Félix 305; **186**
Bridge of Sighs, Ducal Palace and Custom-House, Venice: Canaletti Painting 226–8; **137**
Bridgewater, Duke of 16, 57
The Bright Stone of Honour (Ehrenbreitstein) and the Tomb of Marceau 220–3, 231, 232–3; **135**
British Institution 87, 129–31, 229
British Museum 322
Brontë, Charlotte 268
Brown, David Blayney 40
Browning, Robert 268
Bunyan, John 183
Burke, Edmund 41–2, 93, 100, 101, 317
Burney, Charles 110
The Burning of the House of Lords and Commons, 16th October, 1834 229–31, 241, 309; **139**
Byron, Lord 8, 9, 148, 155–6, 175, 182, 183, 186, 207, 222–3, 233, 274

Caernarvon Castle (engraving) 19, 47; **7**
Caernarvon Castle (watercolour) 47–9; **26**
Calais Pier, with French Poissards Preparing for Sea 62–3, 121–4; **35**
Calais Pier Sketchbook 62
Caley Hall 143; **83**
Callcott, Augustus Wall 84–6, 99, 229–31
Callow, William 252
Campbell, Thomas 240
Canaletto 226–8
Canova, Antonio 158, 197
Cardigan, Lady 151
Carey, William 193, 194
Carlisle, Sir Anthony 90–1, 235
Carnot, Sadi 241
Catalogues Raisonnés 131
Catholic Church 186–7
Chadwick, Edwin 210
Chantrey, Francis 16–17, 156, 157, 158, 171, 203, 254
Christ Church from near Carfax 33, 35; **17**
Clark, Sir Kenneth 322
Claude Lorrain 43, 47–9, 53,

67–9, 95, 97, 98, 99, 115, 121, 129–32, 135–6, 155, 160, 180, 194, 196, 219, 228, 269, 307; **25**, **40**
Cleveley, Robert 78
Cobbett, William 17
Cohens, Gustavus 299
Cole, Thomas 208, 304; **124**
Coleridge, Samuel Taylor 78, 182
Colley, Linda 61
Colman, Samuel 304
The Colosseum by Moonlight 159–60; **93**
Como and Venice Sketchbook 157
Condorcet, Marquis de 207, 208
Constable, John 8, 18, 19, 26, 35, 75–6, 78, 107, 121, 126, 214–16, 228–9, 233, 304, 307; **47**, **129**
Cooke, George 108, 116, 128, 171–2
Cooke, William Bernard 108, 110, 116, 128, 171–2; **66**
A Country Blacksmith Disputing upon the Price of Iron... 83–4, 87; **51**
Cozens, John Robert 33–5, 63, 155; **18–19**
Creswick, Thomas 254; **153**
Cresy, Edward 185
Crook of Lune 138–9; **80**
Crossing the Brook 131–2, 135, 136, 180; **77**

Danby, Hannah 202
Danby, John 49
Danby, Sarah 49, 202
David, Jacques-Louis 8, 62, 65, 125, 191; **37**
Davies, Maurice 190
Davis, John Scarlett 268; **163**
Davy, Humphry 159
Dawe, George 203
Dayes, Edward 24, 29, 33; **11**
Debussy, Claude 10
The Decline of the Carthaginian Empire 139–42, 196, 203; **81**
Decrès, Vice-Admiral 220
Delacroix, Eugène 8, 202
Delamotte, William 107
Deleuze, Gilles 10
Derain, André 310
Dewhurst, Wynford 307
Dickens, Charles 298, 313
Dido and Aeneas 129
Dido Building Carthage 135–6, 139, 196, 202–3; **frontispiece**, **78**

Dighton, Denis 79–83, 146; **49, 86**
Dolbadarn Castle 51–2; **29**
Donatello 162
Dorchester Mead 114–15, 128; **68**
The Dormitory and Trancept of Fountain's Abbey – Evening 43–4; **23**
Ducal Palace, Dogana, with part of San Georgio, Venice 254; **154**
Dudley, Worcestershire 138, 210, 211; **126**
Dughet, Gaspard 160, 232
Dulwich Picture Gallery 268
Dumblain Abbey, Scotland 99; **58**
Dutch Boats in a Gale 16, 57, 63; **33**
Dyer, John 132–5

Eagles, Revd John 232–3, 234, 237, 283
Earlom, Richard 97
East Cowes Castle 188–9; **112**
Eastlake, Charles Lock 128, 132, 136, 158, 185, 194–6, 197, 198, 272; **110**
Egremont, George Wyndham, 3rd Earl of 67, 87–8, 130, 189–90, 191–2, 193–4, 235–6, 288; **113**
Elgin, Lord 49
Eliot, George 268
Engels, Friedrich 210
England: Richmond Hill, on the Prince Regent's Birthday 150–2; **89**
engravings 97–100, 171–2, 182–3, 256
Enlightenment 206–7
Essex, Earl of 32, 87
Etty, William 27–8
Eustace, J C 139

Falconer, William 266
Fall of the Reichenbach, in the Valley of Oberhasli, Switzerland 51, 63, 71, 88–9; **44**
Farington, Joseph 32, 33, 49, 50, 63, 79
Fauves 310
Fawkes, Hawksworth 146
Fawkes, Walter 87–9, 119–20, 126, 131, 137, 143–6, 152, 169, 180, 187, 288; **54**
The Festival upon the Opening of the Vintage at Mâcon 67–9, 130, 132; **39**
The Field of Waterloo 120, 146, 148–9, 150, 151; **87**
Fielding, Copley 272
The Fifth Plague of Egypt 52–3, 121–4; **30**
The Fighting 'Temeraire', Tugged to her Last Berth to be Broken up 201, 237–41, 245, 326–8; **145**

Figures on the Shore 236–7, 320; **143**
Finley, Gerard 283
First-Rate, Taking in Stores 143–6, 169; **85**
Fisher, Revd John 126
Fishermen at Sea 37–40, 49; **21**
Flaxman, John 192–3
Florence from San Miniato 162; **96**
Forrester, Gillian 99
The Forum with a Rainbow 159
Forum Romanum, for Mr Soane's Museum 184–7; **109**
French Revolution 207
Friedrich, Caspar David 8, 26, 236–7; **144**
Fries, Ernst 158–9, 185; **92**
Frosty Morning 126–8, 305, 306; **70, 74**
Fry, Roger 18
Funeral of Sir Thomas Lawrence 203–5; **121**
Fuseli, Henry 24, 35, 46, 63, 90

Gage, John 322
Gainsborough, Thomas 99, 101
Galileo's Villa 183; **108**
Gandolfo to Naples Sketchbook 161
Gandy, Joseph Michael 219; **132**
Garrick, David 41
Gaskell, Mrs 268
Gauguin, Paul 310–11
Genoa 298; **181**
genre painting 83–4
George III, King 26, 29, 110, 119
George IV, King 119, 121, 150–1, 173–4
George IV at the Provost's Banquet, Edinburgh 174; **102**
Gibbon, Edward 207
Gibbons, Grinling 189
Gillott, Joseph 258–9
Gilpin, Revd William 29, 43, 101–3; **60**
Giotto 162
Girtin, Thomas 29–32, 33, 34, 43, 50, 58, 191; **18, 28**
Goethe, J W von 159, 272–3
Goldau 258, 288; **156**
Goldsmith, Oliver 139
Goncourt, Jules de 307
Goodall, Edward **108**
Gottlieb, Adolph 314; **188**
gouaches 245
Gowing, Lawrence 7, 312, 314, 317, 320, 321, 322
Goya, Francisco 148–9, 316
Goyen, Jan van 228, 266
Gray, Thomas 274
Greenberg, Clement 311
Griffith, Thomas 251–2, 256, 257, 288

Gros, Antoine-Jean 62, 149; **88**
Groult, Camille 309, 310

Hakewill, James 150, 155
Hampton Court from the Thames 75, 110; **46**
Hannibal 121–5
Harbour of Dieppe (Changement de Domicile) 180, 217, 219; **107**
Harding, J D 272
Hardwick, Thomas 21
Harpur, Henry 299
Hartley, David 94
Haskell, Francis 303
Havell, William 110; **66**
Haydon, Benjamin Robert 263, 284
Hazlitt, William 23
Hearne, Thomas 33
Heath, Charles 182, 219–20
Helvoetsluys 229
Herculaneum 160–1
The Hero of a Hundred Fights 7–8, 289–90, 291; **2**
history painting 70, 148, 201
Hoare, Sir Richard Colt 35, 47, 52, 155
Hogarth, William 63
Hopkins, Gerard Manley 313
Hoppner, John 86; **53**
Horace 175
Howe, Baroness 95
Hunt, Alfred William 303
Hunt, Robert 87–8
Hunt, William Holman 297, 304
Hutton, Charles 17
Huysmans, Joris Karl 309, 310

Impressionists 304–9, 311
Ingres, Jean-Auguste-Dominique 8, 167–9; **98–9**
The Interior of St Peter's Basilica, Rome 169; **100**

Jackson, John 158
Johns, Ambrose 128–9
Jones, George 203, 229, 262, 282, 299; **159, 182**
Juliet and her Nurse 233–4; **141**
The Junction of the Severn and the Wye 102–3; **61**

Kahn, Louis 307
Keelmen Heaving in Coals by Night 217–19, 241; **131**
The Keepsake 162
Kingfisher 143; **84**
Kingsley, Mrs 266–7
Klenze, Leo von 253, 273; **167**
Klotten and Burg Coraidelstein from the West 245; **147**

Knight, Richard Payne 94–5, 115
Koch, Josef Anton, circle of 196; **118**
Kooning, Willem de 281; **188**
Kozloff, Max 316

Lamartine, Alphonse de 175
landscape painting
 status of 24–6, 115
 the 'sublime' 41–3, 317
 tours 42–3
 techniques 43, 44
 Reynolds and 46–7
 theory of 93
 association of ideas 95
 Liber Studiorum 97–100
 Picturesque movement 100–3, 107
 agricultural landscapes 103–7
 pastoral and 'elevated pastoral' 103, 132–5
Landscape with a River and a Bay in the Distance 309–10, 322; **187**
Landseer, John 71, 79, 92–3, 95, 97, 98
Lascelles, Edward 50, 87
The Lauerzersee, with the Mythens 288–9, 294; **174**
Lawrence, Sir Thomas 28, 67, 158, 203–5, 215
Lee, John 246–7
Leeds 137, 211; **79**
Leen, Nina **188**
Lees, John 19
Leicester, Sir John 87–8, 188, 189, 193–4
Leslie, C R 121, 278
Lewis, G R 107
Liber Studiorum 97–9, 103, 107, 135, 136, 172, 294, 309
Life-Boat and Manby Apparatus Going off to a Stranded Vessel Making Signal (Blue Lights) of Distress 208, 223; **125**
Light and Colour (Goethe's Theory) – the Morning after the Deluge – Moses Writing the Book of Genesis 272–3
Linnell, John **4**
Little Liber 161
Liverpool, Lord 150
Longman (publisher) 138
'Lost to all Hope' 291; **176**
Louis XVI, King of France 61
Louis-Philippe, King of France 125, 220, 282, 283
Loutherbourg, Philippe Jacques de 40–1, 78, 99; **22**
Louvre, Paris 63–4, 65–6, 70, 310
Lucas, David 215; **129**
Ludwig I, King of Bavaria 253, 273
Lupton, Thomas 100, 171–2

McConnell, Henry 217
McCoubrey, John 245

Maclise, Daniel 229, 231, 284
Malton, Thomas 14, 21, 29; **6**
Manby, Captain George 208, 223
Mansfield, Lord 33
Marceau, General 222
marine paintings 37–40, 62–3, 78–9, 173, 188–9, 201, 228, 236, 263–7, 284–5, 328; **112**
Martello Towers near Bexhill, Sussex 107; **63**
Martin, John 8, 124; **73**
Mason, William 102
Matisse, Henri 310
Mayall, J J E 281
Melville, Herman 250, 285
Mercury and Herse 121
Messieurs les voyageurs on their return from Italy 198; **119**
Michelangelo 69, 155, 297
Millais, John Everett 297–8, 303–4; **180**
Miller, William 220; **134**
Milton, John 44–6, 183
Modernism 311–12, 321
Monet, Claude 6, 257, 304–9; **184**
Monro, Dr Thomas 29–32, 33–4, 99; **15–16**
Moran, Thomas 304
Moreau, Gustave 310
Morning amongst the Coniston Fells, Cumberland 44–6, 53; **24**
Mosel from the Hillside at Pallien 179; **106**
Motherwell, Robert 313, 314, 316–18; **188**, **191**
Munro of Novar, Hugh 187, 234, 257, 258, 291
Murray, John 268
Museum of Modern Art, New York 312

Napoleon I, Emperor 61, 63, 65, 77, 107–9, 125, 126, 136, 139, 142, 149, 155, 156, 179, 185, 220, 259–63, 273
Napoleonic Wars 4, 61–2, 67, 77–8, 107–9, 110, 115, 119, 136, 146–50, 222
Nash, John 188
National Gallery, London 84, 136, 203, 228, 268, 300, 325
Nazarenes 158–9
Nelson, Admiral 77–8, 79–83
Neo-Impressionists 311
Newman, Barnett 313, 316–17; **188**
Norham Castle, Sunrise 294, 322; **178**
Northampton, Northamptonshire 211, 216; **128**

oil paintings 35–40, 206
Old Masters 37, 69, 86, 87, 93, 99, 131, 192, 193, 226, 259, 266, 268–9, 309, 327

The Opening of the Wallhalla 253, 272, 273–4; **166**
Opie, John 94, 135
Ovid 130, 296

Paestum 161; **95**
Palestrina 194
Palgrave, Francis 281
The Pantheon, the Morning after the Fire 24; **10**
Paris 63–5, 169, 202, 220, 263
Parrott, William 231; **140**
Pasquin, Anthony 37, 40
The Pass of St Gotthard near Faido 271–2; **164**
Paulson, Ronald 7
Paxton, Joseph 281
Peace – Burial at Sea 259–62, 328; **146**, **158**
Perceval, Spencer 119
Petworth: the North Gallery by Moonlight 192–3; **115**
Petworth House, Sussex 189–90, 192–4, 236
Petworth Park, Tillington Church in the Distance 190–1; **114**
Phillips, Thomas 193; **113**
Picturesque 93, 100–3, 107
Picturesque Views in England and Wales series 182, 187, 210, 211, 216, 217, 219, 257
Picturesque Views on the East Coast of England 172
Picturesque Views on the Southern Coast 108, 116, 128, 172
Piero di Cosimo 162
Pilate Washing his Hands 197
Piranesi, Giovanni Battista 35, 169
Pissarro, Camille 304–7, 309; **185**
Pitt, William the Younger 52
Pius VII, Pope 155, 251
Ploughing up Turnips, near Slough 110–15, 119, 128; **67**
The Plym Estuary from Boringdon Park 129; **75**
Pocock, Nicholas 78, 79
Pollock, Jackson 312, 313, 317; **188**, **189**
Poole, and Distant View of Corfe Castle, Dorsetshire 116; **69**
Pope, Alexander 95, 110, 201, 290
Pope's Villa at Twickenham 95–7, 110, 115, 166; **57**
The Ports of England 172
Poussin, Nicolas 47, 53, 64, 95, 99, 129, 155, 168, 269; **31**
Pre-Raphaelite Brotherhood 297–8, 303–4
Price, David 298
Price, Sir Uvedale 101–2, 103

Proust, Marcel 10
Prout, Samuel 186; **111**
Pugin, A W N 210–11; **127**
Pye, John 222

Radley Hall from the South East 21–2, 188; **8**
Rain, Steam and Speed: the Great Western Railway 241, 275–8; **169**
Ramsay, William 247
Ranke, Leopold von 9
Raphael 155, 163, 166, 167–9, 185, 297, 303, 327
The Red Rigi, Lake of Lucerne, Sunset 257–8, 288; **155**
Redding, Cyrus 128, 131–2
Redgrave, Richard 229, 254
Regulus 194, 196–7, 269; **90, 117**
Reid, Sir Norman 314
Rembrandt 57, 99, 148, 313–14, 327
Reynolds, Sir Joshua 8, 24, 26, 27, 46–7, 53–7, 69–70, 110, 120, 135, 191, 297; **41**
Richmond, George **162**
Rigaud, John Francis 21
Rigby, Elizabeth 124
Rippingille, E V 229, 231
The Rivers of England 171, 172–3
Roberts, David 19
Robertson, Andrew 64–5
Rockets and Blue Lights 251, 265; **161**
Rodman, Selden 314
Rogers, Samuel 65, 182–4, 268
Roman Academy of St Luke 158
Rome 155, 156, 157–60, 161, 163–7, 179, 184–6, 194–8
Rome from the Vatican 163–7, 169, 174, 182–3, 226, 233; **97**
Rooker, Michael Angelo 29; **13–14**
Rosa, Salvator 99, 269
Rosenblum, Robert 317
Rossetti, Dante Gabriel 297, 304
Rossi, Charles 49
Rothko, Mark 6, 10, 312, 314–16, 322; **188, 190**
Royal Academy 13, 26–7, 71, 166, 236
Turner as professor of perspective 18, 21, 42, 61, 90–4, 169, 171
Turner first exhibits at 22–4
hierarchy of genres and media 24–6, 35–7, 67, 94, 95, 115
Turner's election to 40, 49, 57, 61, 71
belief in ideal beauty 94–5
commemoration of battle of Waterloo 146–8
Turner endows

professorship of landscape painting 202
Varnishing Days 228–9, 231, 278, 294
Turner becomes deputy president 282
Turner bicentenary exhibition 322
Royal Academy Schools 14–15, 16, 21, 27, 37, 155
Rubens, Peter Paul 174
Ruskin, John 10, 135, 143, 174–5, 192, 201, 205, 206, 234, 245, 252, 257, 258, 267–75, 278, 281, 283, 284, 288, 295, 298, 303–4; **162, 165**
Ruskin, John James 252, 271, 288

St Catherine's Hill, near Guildford, Surrey 216; **130**
St Erasmus and Bishop Islip's Chapel, Westminster Abbey 4; **1**
Sandby, Paul 29
Sandycombe Lodge, Twickenham 110, 125; **66**
'scale practice' 29
Schloss Rosenau, Seat of HRH Prince Albert of Coburg, near Coburg, Germany 254; **152**
Scott, Samuel 14, 57; **5**
Scott, Sir Walter 171, 173, 174, 183, 220, 228
Seascape: Folkestone 322
Serres, Michel 241, 242
Shade and Darkness – the Evening of the Deluge 272–3
Shakespeare, William 233
Shanes, Eric 29
Sharp, Granville 246–7
Sheepshanks, John 259
Sherrell, Francis 291, 295
Shields on the River Tyne 217
The Ship and Bladebone, Wapping (tavern) 171
Shipwreck 97
Siddons, Sarah 69–70; **41**
Signac, Paul 311
Simone Martini 162
Sixteen Sketches of the Mosel between Ensch and Dhron 178–9; **105**
A Skeleton Falling off a Horse in Mid-Air 205; **122**
Sketch (c.1834) 205; **123**
The Slave Ship 'Brookes' of Liverpool (Anonymous) 251; **150**
Slaver, 500 slaves after a long chase by HMS Rifleman... (Anonymous) 247–50; **149**
Slavers Throwing Overboard the Dead and Dying – Typhon Coming On 245–52, 258; **148**

Smith, Adam 17
Smith, Sheila M 283
Snow-Storm, Avalanche and Innundation – a Scene in the Upper Part of the Val d'Aouste, Piedmont 235, 242; **142**
Snow Storm: Hannibal and his Army Crossing the Alps 121–5, 136, 166, 183, 223, 265, 313; **72**
Snow Storm – Steam-Boat off a Harbour's Mouth 124, 237, 263–7; **160**
Soane, John 16, 57, 92, 184, 186, 187, 219, 235
Society of Arts 294
Solway Moss 99–100, 103; **59**
South Kensington Museum, London 300, 304
Staffa, Fingal's Cave 228
Stanfield, William Clarkson 226, 262
Stangate Creek, on the River Medway 172–3; **101**
Stewart, Dugald 115
Still, Clyfford 312, 313–14, 316–17; **188, 192**
Stonyhurst College, Lancashire 187
Stothard, Thomas 14, 90
Stuckey, Charles 283
Study of the Head and Torso of the Apollo Belvedere 27; **12**
Sun Rising through Vapour 193, 325, 326; **195**
The Sun of Venice Going to Sea 274; **168**
Symbolists 309, 310

Tabley House: Calm Morning 189
Tate Gallery, London 294, 314, 328
Taylor, Edward R 83; **50**
Taylor, George 185
Temple of Neptune at Paestum 90; **55**
Teniers, David the younger 87
Thackeray, William Makepeace 240, 250, 275–8
Thames, River 75, 76–7, 109–10, 114, 115, 150, 180, 285, 307–9
The Thames at Isleworth with the Pavilion and Syon Ferry, seen from the Surrey Bank 75; **45**
Thomson, James 110, 115, 132–5, 155
Thomson's Aeolian Harp 115
Thornbury, Walter 13, 17
Thürmer, Joseph 158–9, 185; **92**
Titian 64, 66, 70, 93, 303, 313–14; **36, 43**
Towne, Francis 63
Townsend, Joyce 231, 274
Trancept of Ewenny

Priory, Glamorganshire 35; **20**

Trimmer, Henry Scott 126, 128

Turner, Evelina (daughter) 49, 126, 202

Turner, Georgiana (daughter) 49, 202

Turner, Joseph Mallord William
portraits of **4, 16**
ambitions 4–5, 61, 120
posthumous reputation and influence 4–7, 237, 303–28
influences on 8, 40, 53, 163, 166
patrons 9–10, 15–16, 67, 87–9, 136–7, 189, 256–7, 258–9
early life 13–21
closeness to his father 13, 19, 202
relations with women 13, 49, 236
at Royal Academy Schools 14–15, 16, 21, 27, 155
social insecurity 14–17
professor of perspective at Royal Academy 18, 21, 42, 61, 90–4, 169, 171
as an architectural draughtsman 21–3, 34–5
first exhibits at Royal Academy 22–4
teaches himself to paint 27–33
collaboration with Girtin 32, 34
election to Royal Academy 40, 49, 57, 61, 71
domestic tours 42–3, 116, 128–9, 131–2, 182
children 49
working methods 50, 51, 71, 143–6, 229–31, 274, 295
Napoleonic Wars 61–2
in France 62–3, 169, 178, 202, 220, 281–2
Swiss tours 63, 234–5, 256–7, 271–2
weakness at painting faces 70, 84
association of ideas 70–1, 94, 95–7, 115, 283–4
gallery 71, 171, 299; **182**
sketchbooks 75, 179, 182, 245; **105**
paints outdoors 75–7, 128–9
wealth 89, 171
belief in ideal beauty 95, 121, 132–5
poetry 108–9, 125
homes 110, 125, 285
foreign travels 121, 180–2, 245
vortex structures 124, 265
criticism of 135, 180, 231–3, 234, 245, 250, 263, 266, 267, 269
will 136, 202–3, 291, 299–300
belief in 'life cycle' of empires 139, 156, 206–8
in Germany 142–3, 178–9, 220–2, 245, 253–4
in Italy 150, 152, 155, 156–69, 175, 182–3, 194–8, 252–3
'pictures about painters' 163–7, 226–8, 327
use of colour 180, 201, 228–9, 250, 259–62, 311
literary illustrations 182–4
at Petworth 189–90, 192–4, 236
pessimism 203–6, 217, 223, 320
erotic watercolours 205, 234; **123**
and political reform 211–17
ill-health 235, 236, 281, 291, 298
as 'first genius of thermodynamics' 241–2
square pendants 259–63
last years 281–99
deputy president of the Royal Academy 282
secretiveness 285–8
death 299; **183**

Turner, Mary (mother) 13

Turner, William (father) 13, 14, 15, 19, 202; **4**

Turner Bequest 5, 259, 291, 300, 304, 309–10, 328

Turner Prize 5

Turner's Annual Tour 220

Turrell, James 322–5; **194**

Two Glass Balls, One Partly-filled with Water 92; **56**

Twombly, Cy 326–8; **197**

Ulysses Deriding Polyphemus – Homer's Odyssey 201–2, 328; **120**

Undine Giving the Ring to Massaniello, Fisherman of Naples 282, 283

Uwins, Thomas 87, 88, 131

Valley of the Glaslyn, near Beddgelert, with Dinas Emrys 50; **27**

Van de Velde, Willem the elder 78

Van de Velde, Willem the younger 57, 78; **34**

Van Dyck, Anthony 66; **38**

Van Goyen Looking out for a Subject 226, 228, 266; **138**

Varley, Cornelius 32

Varley, John 32; **15**

Vaughan, Robert 259

Venice 157, 219, 226–8, 233–4, 252–3, 254, 259, 274

Venice 217

Venice: San Giorgio Maggiore from the Dogana 157; **91**

Venice: Storm in the Piazzetta 253; **151**

Venus and Adonis 70, 84; **42**

Vernet, Joseph 40, 190, 266

Victoria, Queen 220, 235, 253–4

View of Eu, with the Cathedral and Chateau of Louis-Philippe 282; **171**

View of Naples with Vesuvius in the Distance 161; **94**

View of Orvieto 194

Virgil 47, 296

The Vision of Medea 194

The Visit to the Tomb 295; **179**

Waagen, Gustav Friedrich 231

Wainewright, Thomas 23

War: the Exile and the Rock Limpet 259–63; **157**

watercolours 35, 37, 71, 256–8

Waterloo and Rhine Sketchbook 146

Watteau, Jean-Antoine 151

Wellington, Duke of 7, 136, 146, 148, 203–5, 290; **175**

Wells, Harriet 203

Wells, William Frederick 76, 97, 203, 235

West, Benjamin 57, 78

Westminster Abbey, London 4; **1**

Whalers (Boiling Blubber) Entangled in Flaw Ice, Endeavouring to Extricate Themselves 285; **172**

Whitaker, Revd Thomas Dunham 136–7, 138

White, John 17

Wilberforce, William 251

Wilkie, Sir David 83–4, 86–7, 121, 174, 254, 259–62, 263; **52, 71, 103**

William IV, King 235

Wilson, Richard 40, 47, 53–7, 99, 110, 155, 188; **32, 65**

Wilton, Andrew 197

Winchelsea, Sussex 103, 107; **62**

Windus, Benjamin Godfrey 257, 258, 268

Wint, Peter de 107

Witherington, William 193, 194; **116**

Woolner, Thomas 299; **183**

Wordsworth, William 8, 16, 137–8, 182, 268, 278

The Wreck Buoy 291; **177**

Wreckers – Coast of Northumberland, with a Steam-Boat Assisting a Ship off Shore 22; **136**

Wright of Derby, Joseph 40, 99

Wyatt, James 24

Wyatt, Matthew Cotes 7, 290; **175**

Wyllie, W L 237–40

Yarborough, Lord 67

Acknowledgements

Like any publication on Turner, this book is indebted to all those scholars, past and present, who have explored the painter's vast output. I would also like to record a debt to the work of Matthew Craske, whose observations on cyclical views of history provided a starting point for key aspects of chapters four and five. Heartfelt thanks are due to John Gage, not only for his scholarship but also for his generous support. Others to whom I owe particular gratitude for their help and/or advice include Bob Downs, Cecilia Powell, Ian Warrell and Joyce Townsend. David Blayney Brown and Eric Shanes both read an early draft of the book and made invaluable suggestions for improving it. Liz Moore worked tirelessly researching the illustrations, while at Phaidon Press, David Anfam, Pat Barylski and especially Julia MacKenzie lent support, advice and guidance at various stages. I would like to offer two posthumous tributes: the first to Michael Kitson, who was a model of humane and open-minded scholarship; the second to Evelyn Joll, whose knowledge of Turner was equalled only by his kindness and courtesy. The book is dedicated to Val, Toby and Kaya Venning, who are only too pleased to see it finished.

B V

Photographic Credits

Allen Memorial Art Museum, Oberlin College, Ohio: 154; The Art Institute of Chicago: 142; Ashmolean Museum, Oxford: 11, 95, 182; Bibliothèque Nationale, Paris: 186; Bildarchiv Preussischer Kulturbesitz, Berlin: 144; Birmingham Museums and Art Gallery: 50; Bridgeman Art Library, London: British Museum 119, Fitzwilliam Museum, University of Cambridge 59, 61, 62, 63, 129, Leeds City Art Gallery 84, Manchester City Art Gallery 181, New York Historical Society 124, Private collection 111, 133, 135, 150, Royal Society of Arts, London 64, Santa Barbara Museum of Art 184, Sheffield City Art Galleries 39, Victoria and Albert Museum, London: 6, 125, Yale Center for British Art, Paul Mellon Collection: 32, 79, 130, 136, 176, York City Art Gallery: 23; British Museum, London: 19; Trustees of Cecil Higgins Art Gallery, Bedford: 44, 85; Cheim & Read, New York: photo Christopher Burke 196; Christie's Images: 42; Collection of the late Sir Brinsley Ford: photo Ian Bavington Jones 43, 159; Collections: 175; Courtauld Institute Gallery, London: 80; Dia Art Foundation, New York: 194; Trustees of Dulwich Picture Gallery: 41; English Heritage Photo Library/Marble Hill House, Twickenham: 65; Fogg Art Museum, Harvard University Art Museums: bequest of Grenville L Winthrop, photo Katya Kallsen: 98; Frick Collection, New York: 107, 138; Hounslow Library Services, Chiswick Library, photo Ian Bavington Jones: 7; Hull Maritime Museum: 173; Indianapolis Museum of Art: gift in memory of Dr and Mrs Hugo O Pantzer 9, bequest of Kurt F Pantzer 16, John Herron Fund 18, gift in memory of Evan F Lilly 30, gift of Mr and Mrs Nicholas Noyes 112; Mead Art Museum, Amherst College, Massachusetts: purchased in honour of Susan Dwight Bliss 22; Mountain High Maps © 1995 Digital Wisdom Inc: p.342; Museum of Fine Arts, Boston: Henry Lillie Pierce Fund (99.22) 148; National Army Museum, London: 86; National Gallery, London: frontispiece, 25, 33, 35, 53, 78, 120, 145, 169, 195; National Gallery of Victoria, Melbourne: Felton Bequest (1947) 155; National Gallery of Art, Washington, DC: Widener Collection 131; National Gallery of Canada: 17; National Gallery of Scotland: 71, 83, 151; National Maritime Museum, Greenwich: 49, 149; National Museums and Galleries on Merseyside: Lady Lever Art Gallery, Port Sunlight 126, Walker Art Gallery, Liverpool 152, 177; National Museums and Galleries of Wales, Cardiff: 20; National Trust: Petworth House, Sussex 40, 113, Wimpole Hall, Bambridge Collection, photo Roy Fox: 116; National Portrait Gallery, London: 183; Philadelphia Museum of Art: John G Johnson Collection 47, John Howard McFadden Collection 139; Pierpont Morgan Library, New York: Thaw Collection 164; Rex Features/Nina Leen/TimePix: 188; RMN, Paris: 37, 88, 185, 187; Royal Academy of Arts, London: 13, 29; Royal Collection © 2003 Her Majesty the Queen: 103; Royal Society of Arts, London: 64; Ruskin Foundation, Ruskin Library, University of Lancaster: 162; San Francisco Museum of Modern Art: gift of the artist © Clyfford Still 192; Scala/Galleria Palatina, Florence: 38; Sheffield Galleries & Museums Trust, by permission of the Ruskin Gallery, Collection of the Guild of St George: 140; Trustees of Sir John Soane's Museum, London: 132; Smithsonian American Art Museum, Washington, DC: gift of Thomas Hart Benton 189; Städelsches Kunstinstitut, Frankfurt: 31; Sterling and Francine Clark Art Institute, Williamstown: 161; © Tate, London 2003: 2, 3, 4, 8, 12, 14, 21, 24, 27, 36, 45, 46, 48, 51, 52, 55, 56, 58, 67, 68, 70, 72, 73, 74, 75, 76, 77, 87, 89, 90, 91, 93, 94, 97, 101, 102, 104, 105, 106, 108, 109, 114, 115, 117, 121, 122, 123, 134, 137, 146, 147, 157, 158, 160, 166, 168, 170, 171, 172, 178, 179, 180, 190, 193; Toledo Museum of Art, Ohio: purchased with funds from the Libbey Endowment, gift of Edward Drummond Libbey 34; Victoria and Albert Museum, London: 15, 110, 153, 174

Phaidon Press Limited
Regent's Wharf
All Saints Street
London, N1 9PA

Phaidon Press Inc.
180 Varick Street
New York, NY 10014

www.phaidon.com

First published 2003
© 2003 Phaidon Press Limited

ISBN 0 7148 3988 4

A CIP catalogue record for this book is
available from the British Library.

Typeset in Century

Printed in Singapore

Cover illustration *The Fighting 'Temeraire'*
Tugged to her Last Berth to be Broken up,
1838, 1839 (see pp.238–9)